Art in the World

Stella Pandell Russell Nassau Community College

RINEHART PRESS / HOLT, RINEHART AND WINSTON
SAN FRANCISCO

Library of Congress Cataloging in Publication Data

Russell, Stella Pandell.
 Art in the world

 Bibliography: p.
 Includes indexes.
 1. Art appreciation. I. Title.
N7477.R87 701'.18 74-23538
ISBN 0-03-011051-3

© 1975 by Rinehart Press
5643 Paradise Drive
Corte Madera, Calif. 94925

A division of Holt, Rinehart and Winston, Inc.

PRINTED IN THE UNITED STATES OF AMERICA

5 6 7 8 071 9 8 7 6 5 4 3 2 1

Preface

This text is a brief introduction to art appreciation and is intended to provide a foundation in basic concepts, materials and methods, and history of the visual arts. Although many fine books are available for this course, there has remained a need for a clearly written introductory text that gives broad coverage to each of these three major areas. Besides fulfilling this need, this book focuses on three areas that are all too often given insufficient attention in other texts.

1. *Contemporary art.* For most students, the art of our own time, and the twentieth century generally, is difficult to understand, let alone appreciate. For this reason, an entire section of the text is devoted to twentieth century art, and whenever appropriate, modern and traditional works of art are compared and contrasted throughout the text.

2. *Applied arts.* Another emphasis of this text is to treat the applied arts with the same respect accorded the fine arts of painting, sculpture, and architecture. It is in these applied arts, after all, where most of us have daily contact and experience. If this book can help the reader to appreciate the value and beauty in well-made objects of everyday use, much will have been accomplished.

3. *Non-Western art.* A separate chapter is devoted to a general discussion of non-Western art and its influence on the Western world. In addition, examples of non-Western art are discussed and illustrated within the context of specific media whenever comparisons or contrasts with the Western tradition would be instructive.

While these emphases distinguish this book from other art appreciation texts, considerable effort has been made to retain a simple, flexible organization that is adaptable to many teaching styles and approaches. Part One introduces the principles of art, Part Two materials and methods, and Parts Three and Four a chronological history of art. These main divisions may be taken up in any order to suit the needs of the instructor and students.

Art in the World includes 450 illustrations, 39 in full color. With the exception of the color plates, most illustrations appear in close proximity to the textual discussion, usually on the same page or facing page. The appendix contains several features

worthy of mention. Activities and exercises arranged by chapter are included to provide studio experiences and additional projects for interested students. A glossary of terms is provided to aid in review, and a bibliography and annotated list of suggested readings is included to help students in writing term papers or pursuing topics of interest in depth.

It is hoped that this book will prove to be a valuable guide to the world of art as well as art in the world of the readers, and that its readers will find stimulation for the continuing experience of art in their lives.

Acknowledgments

The author wishes to thank the many able professionals, artists, teachers, students, and friends who have helped in the preparation of this book. Among my colleagues at the State University of New York and in the art department of Nassau Community College who provided special help are Robert Carter, James Warwick, Thomas Nealon, Carol Houston, Helen Sissernon, Stanley Kaplan, Judith Pestrank, John Fink, Charles Reina, Helen Muller, Salli Zimmerman, and Leon Frankston.

Many thanks are due a multitude of museums, art galleries, private collectors, and other businesses and agencies as well as Nicholas Manley, Judith Pestrank, and Salli Zimmerman, whose cooperation in providing illustrations was essential to the book's completion. And, of course, a warm acknowledgment goes to all the artists of the present and past whose works are reproduced in this book.

I wish to thank Gordon Ekholm for all he has taught me, for his guiding eye and hand for many long years. I am especially indebted to my editor, Emmett Dingley, for his advice and labor during the writing of this book, to Charlotte Speight, whose editorial skills turned a manuscript into a book, and to Constance Belyea and Sally Thompson for their persistence in locating elusive works. Acknowledgment is also due Joe diChiarro for the book's functional design, to Sally Thompson for art direction and layout, and to Christopher Swan for all the line drawings included in the text.

Contents

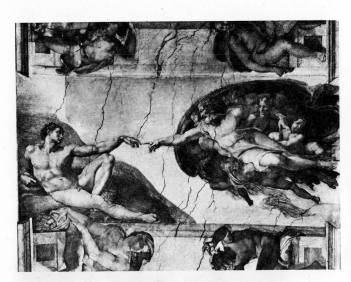

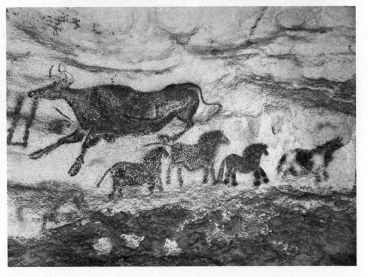

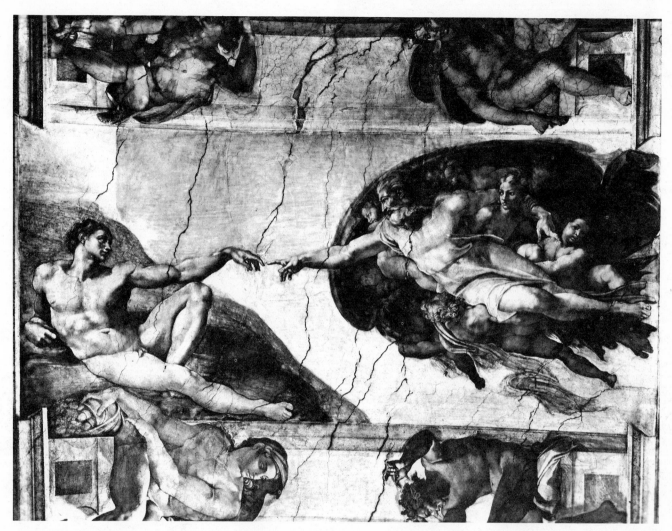

1-1 Michelangelo, *The Creation of Adam* (detail of the Sistine Ceiling). 1508-12. Fresco. Alinari/Florence.

Humanity and Art: Creation and Response

What Is Art?

Cold exactitude is not art;
ingenious artifice, when it
pleases or when it *expresses,*
is art itself.

Eugène Delacroix

Art touches us in every part of our lives. Our homes, schools, offices, city streets, televisions, magazines, music, even the utensils we use in our jobs or homes, represent to some degree the human impulse to create. Yet we are apt to think of art as something mysterious which only a scholar or an art critic can truly understand or define. We expect to find art when we visit museums and galleries, but who hasn't heard the term applied to such varied activities or products as music, dance, theater, even sport?

Obviously, there is a common element in all these uses of the term *art,* and that is the recognition of some skill or talent. But when we think of art we usually mean something more than mere skill. There are many skillful activities, but art is special. Great art has nearly universal appeal because it has a message that moves us deeply or because it awakens us to new insights or understanding. Sometimes the message is explicit, as in Michelangelo's *Creation of Adam;* sometimes it is less evident, as in Albers's *Homage to the Square* (Plate 1). Though these works are very different, they have in common an important message creatively expressed.

Certainly there are many forms of great art. Music, literature, and drama are some easily recognizable fields of impressive artistic achievement. We cannot hope to discuss all such areas of art, but in this book we must confine ourselves to the visual arts alone. By visual arts we mean those arts that affect us primarily, though not exclusively, through our eyes. We include under this term the "fine arts" of drawing, painting, printmaking, sculpting, designing architecture, and the applied and industrial arts, such as making ceramics, weavings, jewelry, and mass-produced furniture and utensils.

It is important at this point to emphasize that such terms as "fine" and "applied" art are frequently used in art histories, but should not be taken to mean that painting, for example, is somehow more worthy of our attention than, say, weaving. Though the applied arts are sometimes called minor arts they are often as impressive for beauty, skill, and the message they offer as any of the so-called fine arts. If we can learn to experience art rather than categorize it, then perhaps we can see art in places we may not have expected to find it.

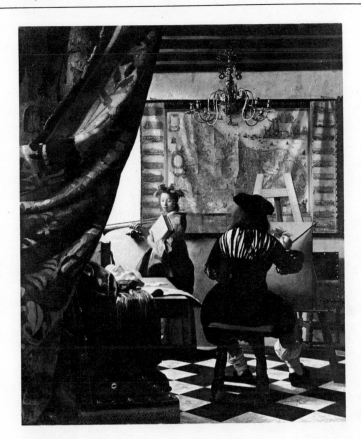

1-2 Jan Vermeer van Delft.
The Studio. Oil on canvas.
Kunsthistorisches Museum, Vienna.

The Artist

It is impossible to discuss art without discussing the artist. Art is a product of the individual creative process, a human expression of thought or emotion. All art, no matter how painstakingly it reflects nature, is nevertheless the product of human interpretation. The artist looks at his world deeply and sensitively and abstracts the essence of an idea. His skill gives physical expression to his vision so that the observer can feel and understand the world in the same way. A mere recording of nature, if that were possible, would not be art. It is the interpretation and creative expression of the artist that makes art. And because no two people, artists or otherwise, can see the world in the same way, each work of art will be unique—a reflection of the artist's

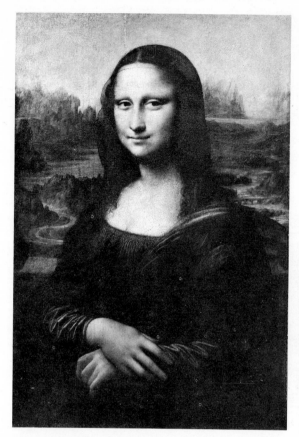

perception, insight, and experience. The contrast between the *Mona Lisa* and *Ma Jolie* reflects such characteristic differences in viewpoint. The difference between da Vinci's and Picasso's portraits of women is as much a result of each artist's personal perspective and genius of expression as the five hundred years which separate them.

1-3 Leonardo da Vinci. *Mona Lisa.*
c. 1503-05. Panel, oil on wood.
Cliché des Musées Nationaux.

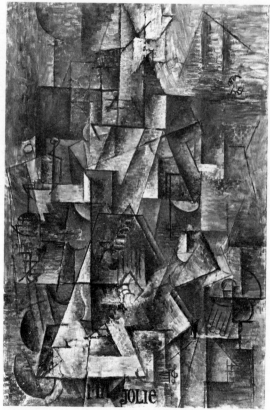

1-4 Pablo Picasso. *Ma Jolie.* 1911-12.
Oil on canvas, 39⅜″ x 25¾″. Collection,
The Museum of Modern Art, New York.
Acquired through the Lillie P. Bliss Bequest.

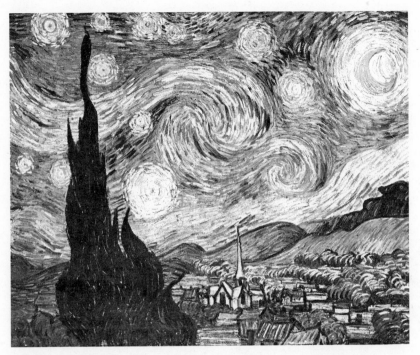

1-5 Vincent Van Gogh. *The Starry Night*. 1889. Oil on canvas, 29″ x 36¼″.
Collection, The Museum of Modern Art, New York. Acquired through the
Lillie P. Bliss Bequest.

In order to express this individual
viewpoint, the artist consciously selects
certain elements, adds others, eliminates
others, and exaggerates still others. In
addition to selecting those elements best
suited to his purpose, the artist also chooses
the materials, colors, shapes, and lines that
will best communicate a particular perception
and viewpoint. As the artist works, the image
takes shape until the work of art is fully
evolved into an artistic statement. Van
Gogh's excited response to his perception of
the night sky, for example, is communicated
to us by his exaggerated swirling shapes and
tense brush strokes.

We will find that the more we learn about
art and the expressive methods of the artist,
the more sensitive and discerning our own
responses can become. And it is this
responsiveness which is necessary for a
deeper understanding of art. If we, ourselves,
are unaware or unreached by a work of art,
then it might just as well have never existed
—at least for our subjective self. If this
introduction to art is to be of value, we must
open our eyes to as many forms of artistic

expression as possible and must attempt to understand the ideas and emotions which creative people past and present have expressed in visual form.

Art Appreciation

We are used to thinking that the sole purpose of art is to give us pleasure, to be beautiful in the strictest sense. But art can shock, disturb, or horrify us as well as soothe, delight, or pleasurably excite us. What all art has in common is the ability to move us in some way. It may be the overwhelming emotion we feel in the nave of

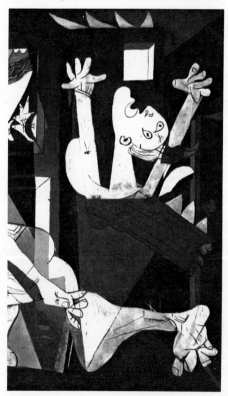

a cathedral surrounded by soaring arches and the colors of stained glass. Or it may be the shock we feel when we look at Picasso's mural *Guernica*, his expression of horror at the killing of innocent villagers in the Spanish civil war. Both experiences move and change us in some way. However, not all art moves us so intensely. We may walk into a living room and feel pleasure when we see attractive groupings of furniture and the subtle use of color. This, though of a lesser degree, is also an emotional response to artistic expression. In developing an appreciation of art such emotional responses are important for they imply a certain sensitivity. Whether you love or hate a work of art or are delighted or shocked by it is actually less important than whether you really try to see it fully before evaluating it. For example, try to see and experience fully the interwoven web of colors and shapes created by Jackson Pollock (Plate 2).

We will also discover that enjoyment and appreciation of art is not only a matter of understanding and experiencing vicariously the emotions expressed by the artist. Nor is it simply experiencing our own emotional response to a piece of art. Art appreciation also involves the aesthetic and sensual satisfactions that our eyes, hands, or bodies can receive from the art object itself. These satisfactions may range from the pleasure we get from a particular grouping and combination of colors in a painting to the exhilaration of walking through an exciting series of spaces in a building or the enjoyment of using a well-designed spoon,

1-6 Pablo Picasso. *Guernica* (detail). 1937, May - early June. Oil on canvas, 11'5½'' x 25'5¾''. On extended loan to The Museum of Modern Art, New York, from the artist.

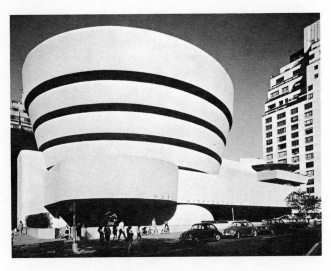

1-7 Frank Lloyd Wright. The Solomon R. Guggenheim Museum (exterior). 1956-59. New York.

and are separate from the emotional content of art and its subject matter. In each of these situations the aesthetic experience comes from an interaction between the art object and the observer.

Heightening the Aesthetic Response How can we as viewers and users of art learn to enhance our own aesthetic response? Training ourselves to see with a child's fresh eye instead of just looking will help us develop our sensitivity and responsiveness. How long is it since you picked up a pebble and let your eyes examine its curves and colors while your hands explored and enjoyed its smooth or grainy texture? How long since you stopped and studied the reflection of lights in a rain puddle? Once you begin to open yourself up to the world, you can find pleasure in the most unexpected places. Even the pattern of cracked paint on a wall or the crowd of people on a train can give pleasure to someone who is open to it.

One way we can be more responsive to art is by learning to focus our attention fully. In today's fast-paced world our attention is fragmented by the thousands of images and

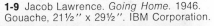

1-9 Jacob Lawrence. *Going Home.* 1946. Gouache, 21½″ x 29½″. IBM Corporation.

1-8 Don Wallance. Flatware. 1956. Stainless steel. Mfr.: G. Hugo Pott, Germany. Collection, The Museum of Modern Art, New York. Gift of H. E. Lauffer Co., U.S.A.

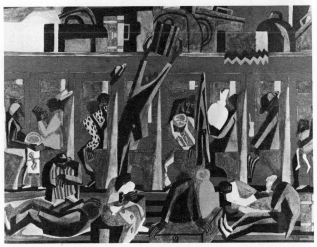

stimuli thrown at us. Just walking down a city street we are bombarded by flashing lights and colors, the sounds of cars and people, and advertisements urging us to buy this or that. We have to relearn to focus our eyes and minds and to make full use of our senses.

If seeing and touching are the two most important senses needed to enjoy a piece of sculpture by Henry Moore, then learn to shut out the sounds of the radio, the conversation of a companion, or the inner brooding on yesterday's bad grade and concentrate only on the sculpture. See it. Feel it or, since most museums frown on people touching art, try to imagine how it would feel to run your hands over the curves of the figures.

Symbols in Art Artists often use symbols in their work to help express their ideas. Sensitivity to such symbolism can help us to understand an artist's purpose and vision and will enhance our own enjoyment. The symbols used in contemporary art are probably the easiest for us to understand because they are usually derived from our own culture. Because we know what a car means to many Americans, it is not difficult to decipher some of the message in *I Love You with My Ford,* by James Rosenquist. In contrast, we may have to learn something about Islam before we can understand the abstract symbols woven into a fifteenth-century North African prayer rug.

Perceptual Awareness

An effort on our part to develop our ability to see can also greatly increase our enjoyment of art. Perceptual awareness involves much more than casual observation of objects and incidents. We begin with the taking in of visual sensations presented by the environment. The eye is aided by the mind to see how an object is formed. By using insight and memory, our understanding of structure reveals a pattern of order and the relationship of all parts to the whole configuration. This kind of awareness heightens our sensitivity to the physical world and to all that transpires in it. Not only is it fundamental to our full appreciation of art, it is also basic to an artist's vision and creativity.

1-10 Henry Moore. *Family Group.* 1945. Bronze, 9⅜″ high, 8½″ x 5⅛″ at base. Collection, The Museum of Modern Art, New York. Acquired through the Lillie P. Bliss Bequest.

1-11 James Rosenquist. *I Love You with My Ford*. 1961. Oil on canvas, 84¼″ x 95⅝″. Nationalmuseum, Stockholm.

In addition, some understanding of the way in which the human eye and brain react to visual stimuli can help us achieve a richer enjoyment of art. Aldous Huxley defines the art of seeing as three processes which occur almost simultaneously. These processes are sensing, selecting, and perceiving. Sensing is an instinctual response of the eyes and nervous system. The eye scans a crowd of people, receives details of color, light and dark, and shapes. The physiological process takes care of sending these impulses to the brain. Selecting is the process of focusing intensely on one part of the total visual field.

1-12 Persian Prayer Rug. 19th century. Wool, 63½″ x 42⅛″. The Metropolitan Museum of Art, Mr. and Mrs. Isaac D. Fletcher Collection; Bequest of Isaac D. Fletcher, 1917.

Out of the huge number of stimuli which the eye takes in, the brain selects that which has meaning to it. Perceiving gives meaning and significance to the whole act of seeing. Our perception is influenced by past experiences, knowledge, emotions, and expectations. What we finally say we ''see'' is the result of these processes of sensing, selecting, and perceiving.

You might like to try an experiment to see how reality is "in the eye of the beholder." Arrange a group of objects on a table: bottles, fruit, a book, a bowl. Make a few simple line drawings of the arrangement from different viewpoints and eye levels. Observe how your changing vantage point alters what you see. Ask a friend to do the same and compare your drawings. Can you explain your different perceptions of the same objects?

Past experiences affect our perceptions to a far greater extent than most people are aware. We often see what past experience has led us to expect rather than what is really there. Psychiatry also teaches us that we project many of our inner emotions onto people and objects outside of ourselves, and that such projection has an important effect on what we perceive.

The Cultural Context of Art

Our intelligent appreciation of art not only requires an openness to the artist's vision and a keen perceptual awareness and sensitivity, but it also is greatly aided by a knowledge of the historical situation, the social context, and the prevailing ideas of the age during which the artist worked. We must keep in mind that an artist responds to and expresses a reaction to the surrounding social conditions. As a consequence, the art of a particular period usually is related to the prevailing conditions of the time, either expressing them or opposing them. If we are to understand or fully appreciate a work of art, we must make an effort to put ourselves into the world in which the artist lived. Not only can we more fully enjoy the art of the past if we know something about what

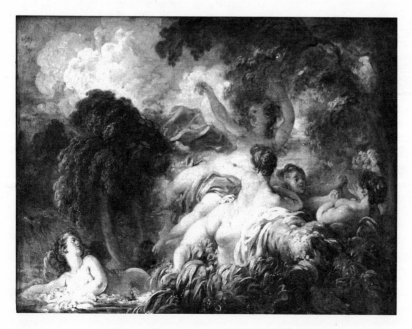

1-13 Jean-Honoré Fragonard. *The Bathers*. c. 1765. Canvas, 25¼" x 31½". Cliché des Musées Nationaux.

people felt, thought, and experienced during a particular historical period, but art can in turn teach us a lot about historical and social situations. As an example, Fragonard painted during the days of the highly artificial French court. We can understand that luxurious court life better by examining his painting.

However, some experiences—particularly birth, love, and death—are universal human experiences. When art deals with them, we, as observers, usually have less trouble understanding the artwork. But even these emotions are experienced differently in certain cultures, so some knowledge of social and religious attitudes helps us to understand the artist's meaning. For example, prehistoric art was more concerned with magic than the beautiful. The Willendorf Venus may have been considered beautiful 22,000 years ago, but it is likely that it was revered more as a fertility symbol.

There is no doubt that human concepts of beauty have changed throughout history and from culture to culture. Apparently, the question of what is beautiful is greatly affected by cultural factors which tend to blur whatever universal characteristics of the beautiful may exist. A fine example of this is the concept of beauty as seen in the human form or in its decoration. A Nigerian woman achieved distinction in her tribe by undergoing torture to be decorated. If we did not know this, we would have a more superficial understanding of the simplified versions of scarification seen in African sculpture. Andy Warhol's painting of Marilyn Monroe and Gainsborough's *Mrs. Sheridan* (Figure 7-24) are examples of changing concepts of human attractiveness within Western culture.

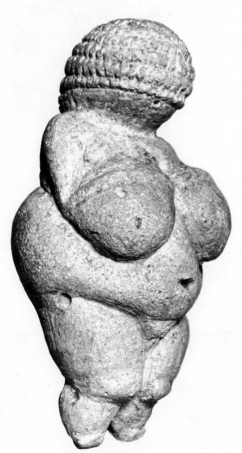

1-14 *Venus of Willendorf.* c. 15,000-10,000 B.C. Stone, 4⅜″ high. Museum of Natural History, Vienna.

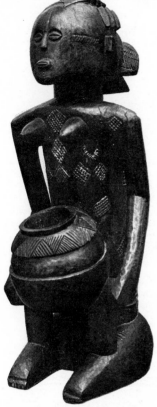

1-15 Baluba Mendicant Figure. Congo, Africa. Wood, 22″ high. Collection of Dr. Stella Russell.

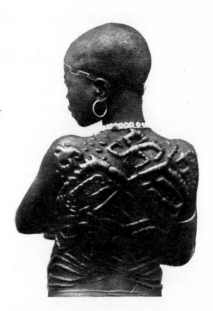

1-16 Maipimbe tattooing. Boma district, Congo Free State. Courtesy of the American Museum of Natural History.

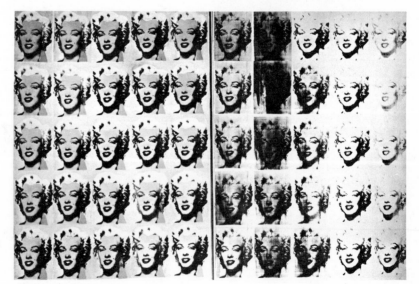

1-17 Andy Warhol. *Marilyn Monroe Diptych.* 1962. Oil on Canvas, 82″ x 114″ (2 panels, each 82″ x 57″). Collection of Mr. and Mrs. Burton Tremaine.

Evaluating Art

We make judgments in every phase of living. Our everyday purchases involve evaluations of size, quantity, color, shape, and style. Deciding where to live or what courses to take or what job offer to accept all involve forms of judgment and evaluation. We also use our critical abilities to make aesthetic judgments. Obviously, the question of value in art is a complex one. To help simplify it, we should avoid confusing the process of appreciation with that of evaluation. Evaluation depends on the experiences and education of the judge. Appreciation, on the other hand, is something each of us can achieve through openness and sensitivity to the artistic creation and to the spirit that produced it.

Art Criticism Value judgments by art critics can certainly guide us in our appreciation of the visual arts, but they should not serve as the only basis through which we discover meaning in art. A critic's viewpoint is helpful when it provides us with a fresh interpretation of a work of art. Often a critic's knowledge of art methods and aesthetic tools will open our eyes to new facets of the work. Some works are so startling and open up such new avenues of exploration that we, being used to more familiar art, are unable to accept them as art. In such situations a critic may be able to clarify what the artist is trying to say and help us to look at otherwise intensely disturbing art with a more tolerant vision.

However, critics are not infallible and they can be prejudiced or unwilling to accept new ideas. This view of *Boulevard des Italiens* in Paris was painted by Camille Pissarro in

1-18 Camille Pissarro. *Boulevard des Italiens, Morning, Sunlight.* 1862. Oil on canvas, 28⅞″ x 36¼″. Chester Dale Collection. National Gallery of Art, Washington, D.C.

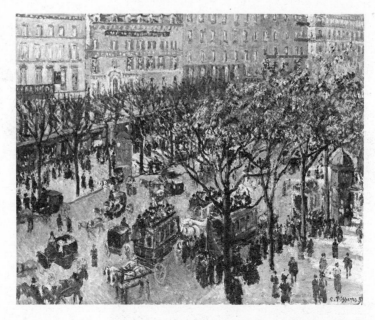

1862. It is a pleasant painting and is not disturbing or startling to us today for we have seen many paintings of this type. But when it was created, critics condemned Pissarro for his lack of sensitivity and said the painting was a "slice of life" without any creative contribution from the artist. Even the point of view, from a lofty studio window, was considered a deficiency by Pissarro's critics.

Ultimately, then, what is most important is what the artist says directly to each individual observer. Though we can take a critic's comments as a guide to the appreciation of the visual arts, they should not determine the extent of our own appreciation, nor should they serve as our only criteria of evaluation.

Experiencing Art We should recognize that since the artist is intensely sensitive to the world around him, he is often able to provide us with new insights into the character of our society. Many people find contemporary art enjoyable and fascinating. Yet others find it bewildering, unskillful, and sometimes even ugly. But its great variety reflects the complexity of today's world and the differences in artists' reactions to it. We do not all have to like the same things. Nor do we all have the same tolerance for the new or the disturbing or the disagreeable. In many situations what the artist is telling us about our world or ourselves may be difficult to face. But if we shut our eyes to everything that seems unpleasant or difficult to understand, if we refuse to expand our minds and look at art with a sense of adventure, we will lose an opportunity to hear what the artist has to say. Certainly in such a situation the pioneering artist will suffer, but the greater loss is likely to be our own. So when you look at a startling piece of contemporary art like this *Spiral Jetty* by Robert Smithson, remember that the artist may be saying something important to you if you can only hear it.

Our encounter with art can be made more satisfying if we explore *how* the artist creates as well as what is created. Some experience with easy-to-use art materials and mediums such as clay, chalk, poster paint, and collage can help us understand the process of creation.

As a part of our exploration of art in the world, in the next chapter we will study such basic elements as line, mass, color, light, and shade. These are aesthetic tools the artist uses to convey a message. To discover the meaning of the message we must consider as well the way structure is developed in an artwork by skillful use of unity, balance, rhythm, and proportion.

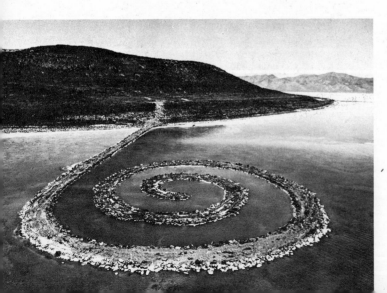

1-19 Robert Smithson. *Spiral Jetty*. 1970. Black rock, salt crystals, earth, red water (algae), 1500′ long, 15′ wide. Great Salt Lake, Utah. John Weber Gallery.

The Artist's Language

Art is human intelligence
playing over the natural scene,
ingeniously affecting it toward
the fulfillment of human purposes.

Aristotle

The quest for knowledge has taken man above the earth, deep within its crust, and to the depths of the seas. From the dawn of his awareness on earth, man has reacted to the world around him in conscious and unconscious expressions, some of which can be called art. In fact, observations of the natural environment and of human experiences within it have been the inspiration for much art. The artist selects, summarizes, and then interprets what he has seen and experienced. He reworks and transforms his perceptions and emotions in order to present an artistic expression. As artist Paul Klee said, the artist is "the trunk of the tree, gathering vitality from the soil, from the depth [the unconscious], and transmitting it to the crown of the tree, which is beauty."

Human beings appear to have a need to seek clarity, order, and, ultimately, truth. The artist, in particular, searches for this order and truth with the zeal of a scientist. During the Renaissance Leonardo da Vinci recorded thousands of explorative details of human anatomy, botany, zoology, even mechanics. He studied such things as bone formations, the human head, and cannons by examining their external and internal structures.

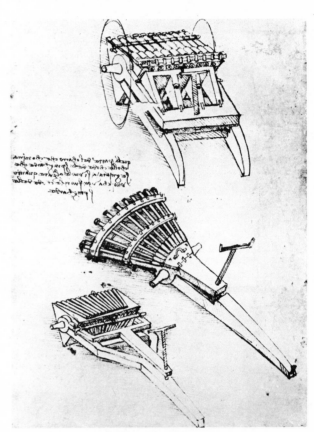

2-1 Leonardo da Vinci. *Triple-Tier Machine Gun.* c. 1485-88. Pen and ink. Ambrosiana, Milan. Collection of IBM Corporation.

However, the artist's purpose is not so much to duplicate nature as it is to know nature well enough to be able to comment on the world and to take from it inspiration for shape, line, color, texture, and mass. The artist abstracts from nature and reinterprets it to give us heightened aesthetic experiences.

Sometimes the artist must be adventurous in his creativity in order to force us to *see*. He must have the courage to face the unknown and upset the visual order, often upsetting us by his disturbing images. By tossing away preconceptions, the artist can bring us a new vision through new symbols and a new point of view. So, paradoxically, in order to convey an idea or produce a desired emotional response the artist may have to disrupt and disturb our usual expectations by presenting us with a visual statement whose structure is based on the familiar natural world, but which may be deeply disturbing to us.

The Structure of Art

There are certain basic elements of visual art which are used both consciously and unconsciously by the artist to develop his work to its fullest expression. Though these same elements are basic to all art, the manner in which each artist organizes them is unique. A contemporary painting and a Greek vase from 1000 B.C. are different in purpose, materials, time, and place of origin, but they are related in that each uses some of the same basic artistic tools. Line, mass, texture, and color have been organized in both works to provide an aesthetic experience.

Technical Devices of the Artist

In the following section we will see how these technical tools are utilized in different examples of artistic expression. Once we are familiar with the artist's tools, we will be able to see how he uses them to develop unity, balance, and rhythm in visual composition.

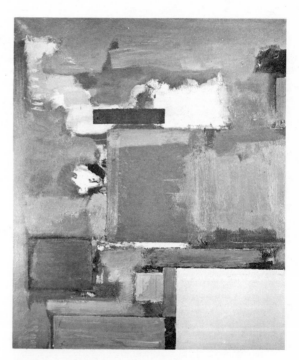

2-2 Hans Hofmann. *The Golden Wall. 1961*. Oil on canvas, 60″ x 72¼″. Collection of Mr. and Mrs. Frank G. Logan. Courtesy of The Art Institute of Chicago.

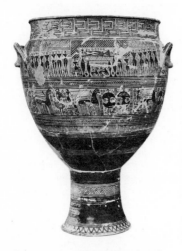

2-3 Greek Dipylon vase (attic). Eighth century B.C. 40½″ high. The Metropolitan Museum of Art, Rogers Fund, 1914.

Line A moving point forms a line. The path followed by a speeding arrow and the line formed by a moving flashlight on a time-exposure photograph are visual examples of how a moving point creates a line. In the visual arts line can be an actual mark drawn with a pencil, pen, or brush, or it can refer to the outline or contour of a shape. In some paintings there are no actual drawn lines visible, but the edges formed by contrasts of light and shadow or different colors and shapes suggest lines. Whether actual or implied, line is one of the artist's basic tools and it can enclose space, suggest mass, or create a feeling of movement. Lines may vary from thick to thin to convey form. Where light falls on the edges of an object, the outline may be lightly drawn. Where the shadow is deepest, thicker lines can suggest it and provide emphasis.

Line also has the ability to convey emotion, and in this role it is one of the artist's most eloquent tools. Line may be used forcefully, nervously, or smoothly to create a mood or express a personality. In Rembrandt's drawing of his wife, Saskia, and their son, short jerky lines suggest the restlessness of the child. In contrast, the full sweeping lines of the mother's robe emphasize her serenity and define her protective concern for her baby. A different use of line can be seen in this painting of a head by Paul Klee. To avoid breaking the flow of motion the artist used a nearly continuous thin line.

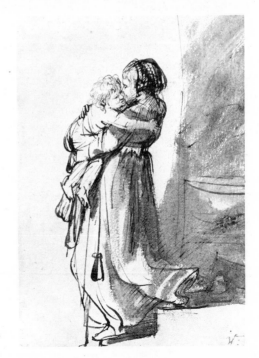

2-4 Rembrandt van Rijn. *Woman Carrying a Child*. c. 1636. Pen and bistre, wash. The Pierpont Morgan Library.

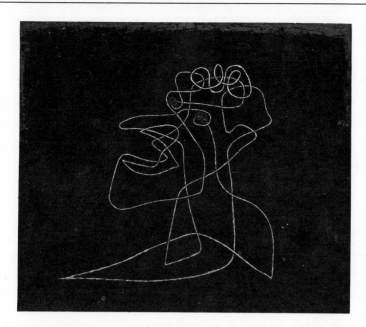

2-5 Paul Klee. *The Mocker Mocked.*
1930. Oil on canvas, 17″ x 20⅝″
Collection, The Museum of Modern
Art, New York. Gift of J. B. Neumann.

Another kind of line is seen in the painting *The Birth of Venus* by Sandro Botticelli in which the edges of shapes—their contours—produce lines which form a dominant feature of the composition. The edges or outlines of the shapes in this painting are so strong that you could draw a simple line diagram of it. Though this linear element is not always so easy to see, it exists in all works of art. In the three-dimensional arts of sculpture and architecture, lines are suggested by the profile of a figure, the upward thrust of a vault, or the long horizontal edge of a roof.

Shape and Mass In painting, any area enclosed by a line is usually perceived as a whole entity or shape. A shape can also be made to stand out from its surroundings by strong color or value contrasts or by differing textures. Shapes can be geometric or organic, symmetrical or asymmetrical, related to known objects or nonobjective. Artists use shape, like line, to express different moods. The playful organic shapes in Calder's mobile (Figure 2-16) create a gay mood, while the heavy dark shapes in Motherwell's painting (Figure 18-6) project a somber mood. Artists often develop their own style of shapes. Note the contrast between the kinds of shapes Giacometti used in his sculpture (Figure 4-12) and those of

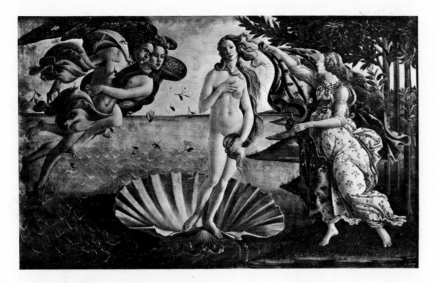

2-6 Sandro Botticelli. *The Birth of Venus.* c. 1480. Canvas, 5'8⅞'' x 9'1⅞''. Uffizi Gallery, Florence. Copyright Staatsbibliothek, Berlin.

2-7 Line Drawing of Botticelli's *Birth of Venus.*

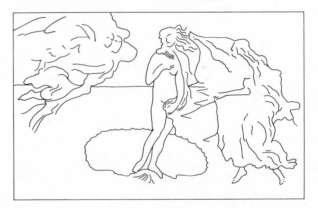

Rubens (Figure 12-13). The term *shape* usually refers to areas in a painting or drawing, while *mass* is used more often in discussions of sculpture and architecture. However, the term *mass* may also be used in connection with paintings where the artist has created an illusion of mass. During the Renaissance, artists studied and used the principles of geometry and linear perspective to create the illusion of three-dimensional space on a two-dimensional surface, creating heavy solid-looking forms. In addition, painted shadows helped produce a feeling of solid mass. The rounded mass of the young woman in the painting by Jan Vermeer (Plate 3) creates a focal point which ties together the contrasting geometric shapes of the furniture and room. Shape, then, can be either two- or three-dimensional, while mass refers only to three-dimensional forms, either real or illusionary.

By comparing the heavy solidity of the sphinx at Gizeh with the flowing form of Antoine Pevsner's *Developable Column,* we can see how masses can also vary in quality and expressiveness as well as in apparent weight. The cubic mass of the sphinx appears stable, eternal, and static. In contrast, the vertical thrust of Pevsner's mass suggests upward movement and implies that it is light enough to rise into the air.

Similarly, in architecture, mass can be emphasized, as in the pyramids of Egypt which were built to provide for the immortality of the Pharaohs, or the sense of mass may be reduced or denied through the creation of perforations or openings in the structure. The ziggurat of Ur (Figure 8-15) seems lighter than the pyramids. Yet both are in reality heavy and compact. On the other hand, a Gothic cathedral, an expression of man's spiritual reach toward heaven, appears light and fragile. Glass windows fill the spaces between structural supports, and the cathedral's strong vertical lines, like those of Pevsner's *Developable Column,* imply lightness.

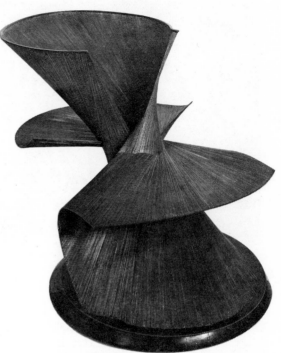

2-9 Antoine Pevsner. *Developable Column.* 1942. Brass and oxidized bronze, 20¾″ high, base 10⅜″ diameter. Collection, The Museum of Modern Art, New York.

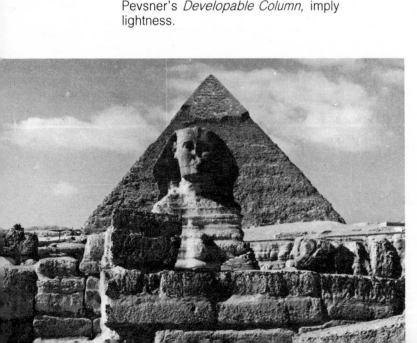

2-8 The Sphinx and the Pyramids of Cheops. Sphinx c. 2530 B.C., 65′ high. Cheops c. 2570 B.C. Giza.

Value, Light, and Shade The degree of lightness or darkness of a visual stimulus is referred to as its *value.* The values used in the visual arts can range from the darkest to the very palest colors or from pure black through shades of gray to pure white. Variations and contrasts in values form an effective tool whether the artist is working with colors or in black and white.

These variations in values can be used, like line, to guide the viewer's eye or to give a sense of movement. For example, an area of sharp contrast in a painting will attract our attention. Three or four such areas, if related in a composition, may cause our eye to travel from one to the other, giving a sense of movement. Values are often used to create an emotional response. Sharply contrasting colors or blacks and whites can express dramatic tension or excitement. The *Self-Portrait* by Rembrandt (Plate 4) produces a dramatic emotional impact not only because the range of values is so wide, but also because the artist has effectively used lighting to focus our eyes on the center of interest. However, the areas of dark shadows in Rembrandt's paintings are equally important. They are never voids of darkness but instead suggest details which our imaginations can enlarge on. On the other hand, light values with few contrasts can give a hazy, unreal, or romantic feeling to a composition.

The use of light and dark in a painting to represent the effect of light and shadow in nature is called *chiaroscuro,* an Italian word meaning light and dark. This method of using highlights and shadows to reveal the modeling of three-dimensional forms was common to Western painting from the Renaissance through the nineteenth century. Leonardo da Vinci used a form of value change called *sfumato,* "like smoke," in which the transitions from light to dark were so gradual as to be imperceptible (Figure 1-3). In this technique, light seems to come from a source within the painting, creating soft contours.

Though Western painters have used value relationships for many effects, until comparatively recently they have been preoccupied with how contrasting values and the pattern of light as it plays over solid objects create the illusion of three-dimensional form on a flat surface. Oriental artists have also made use of value changes, but not for the purpose of creating an illusion of space. Patterns formed by light and dark shapes and the moods and emotions evoked by those patterns are the main concern of the Oriental artist.

Color Color is one of the most effective tools available to the artist. Artists have used color intuitively from the earliest days, but the science of color developed slowly. Though the Greeks, as early as 400 B.C., realized that the apparent color of an object changes with the color of light that falls on it, it was not until the 1600s that Isaac Newton discovered that if white light is passed through a prism, it is broken into a whole spectrum, or scale, of colors. Newton deduced from this that white light is actually a mixture of all colors. The prism fragments the light, breaking it into its component color rays. When we see a

rainbow with violet at one end moving step-by-step through the spectrum to red at the other, we are seeing an example of the same phenomenon. In this case, however, instead of fragmentation by a prism, the sunlight is broken apart as it passes through raindrops. The colors, or *hues,* of the spectrum are produced by light rays, while artist's colors come from *pigment*. These pigments absorb certain light rays and reflect others. Blue pigment, for example, will absorb almost all but the blue rays. It will therefore reflect the blue waves, and we will see blue. No pigment can produce as pure a color as the prism, so no paints have ever achieved the brilliance of light, nor are they standardized. For example, one pure red pigment may reflect more yellow rays than another red pigment.

Each color can also change in value. Color values can range from light to dark, just as noncolor values may range from black through gray to white. A very light blue, for example, is high on the value scale and is called a tint, while a dark, low value of blue is called a shade. *Intensity* refers to the purity of a color. A pure blue, as near the spectrum blue as possible, is said to have a full intensity, or saturation.

The artist can achieve an infinite number of color variations by mixing colored pigments with each other and with black and white. The color wheel is made up of the main colors in the spectrum plus other colors achieved by mixing the main colors. The twelve colors on the wheel (Plate 5) can be divided into three groups: primary, secondary, and tertiary. The three primary hues are blue, yellow, and red. The artist can use mixtures of these three colors as a basis to create all the other colors on the color wheel. By mixing two primary hues equally, the artist can ideally produce a secondary hue, although the proportions may vary depending on the pigment. The three secondary colors are created in this way: blue mixed with yellow yields green, blue mixed with red forms violet, and red plus yellow makes orange. There are six tertiary colors, each the result of mixing a primary color with a nearby secondary color. Thus red and orange make red-orange, yellow and orange make yellow-orange, and blue and violet make blue-violet.

The three major elements of color may be summarized as follows:

1. Hue—An identifiable color on the spectrum and color wheel
 a. Primary hues—red, yellow, blue
 b. Secondary hues—green, orange, violet
 c. Tertiary hues—yellow-green, blue-violet, red-orange

2. Value—The degree of lightness or darkness of a color

3. Intensity—The degree of purity of a hue. Ideally a pure hue reflects no other color rays. This is also called saturation.

Complementary colors are those which appear opposite each other on the color wheel. For example, blue and orange are complementary colors as are red and green. Ideally, complementary colors mixed to equal amounts create a neutral gray, but pigment

differences may make this difficult. Colors which are adjacent on the color wheel, such as blue and blue-green, are called *analogous* colors.

Artists make use of color schemes or arrangements of certain colors for differing effects. In a color scheme where complementary colors are used next to each other, the effect will be one of strong contrast and emotional excitement. An analogous scheme made up of colors close to each other on the wheel has a subdued or quiet physical and emotional effect, and schemes with light colors or tints evoke opposite emotional responses from those with dark colors.

These emotional responses to colors appear to be almost universal—some colors make us feel sad while others lighten our spirits. There is a sense of joy in Matisse's *Red Studio* with its variations of red and touches of other bright colors (Plate 6). Color can be used symbolically as well as emotionally. The Virgin is traditionally shown in a blue cloak because the color symbolizes heaven. However, color symbolism is not as universal as emotional response to color is. For example, in one culture a particular color may signify mourning, while in another the same color may have a joyful symbolism. Impressionist painters tried to duplicate the effect of natural light and shade by placing small brush strokes of contrasting colors next to each other (Plate 7). Vibrations in the eye from these colors heightened the effect of dancing light.

With a quite different purpose in mind, Piet Mondrian simplified his paintings to the primary hues (Plate 8). He used colors at full intensity, and the apparent difference in their positions in space comes from the different sizes of the color areas and their relative warmth and coolness. Warm colors like red, yellow, and orange tend to move forward toward the eye, while cool colors—violets, blues, and greens—recede.

Because of the great number of effects which can be achieved through color and because of its effect on our emotions, it is an expressive tool of endless excitement and visual variety. Although we think of color as the particular concern of the painter, it is essential as well to the work of interior, fashion, and advertising designers.

Texture Texture is the surface quality of an object which can be seen as well as felt. Nature is lavish with surface variations. Think of the bark of a tree, then of the smoothness of a river-polished rock. The microscope discloses the existence of even greater textural variety. A detailed photo of an orange skin reveals hills and valleys which compare with the surface of the moon. In painting the artist may create the illusion of texture on a flat surface. For example, paint is applied in certain ways to suggest the smoothness of satin or the roughness of an old man's wrinkled skin. Rough, smooth, shining, dull, hard, and soft textures are contrasted to increase the expressiveness of the shapes and to avoid monotony. Sometimes painters achieve a desired effect through the use of actual surface texture such as we see in Georges Braque's combination of newspaper cutouts and paint surfaces.

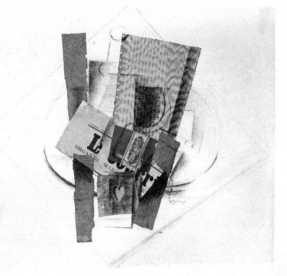

2-10 Georges Braque. *Le Courrier.* 1913. Colored paper, printed paper, and charcoal, 20″ x 22½″. Philadelphia Museum of Art: The A. E. Gallatin Collection.

Architects also use materials of varying textures, such as glass, slate, marble, wood, to break the monotony of large areas in a building. Architectural surfaces can also be broken up with setbacks and applied details that create pockets of shadows and lights or otherwise add textural interest. The alternating setbacks of structural members, the sculpture in niches, and the open stonework on the facade (front) of the Gothic cathedral of Milan combine to produce an overall effect of texture.

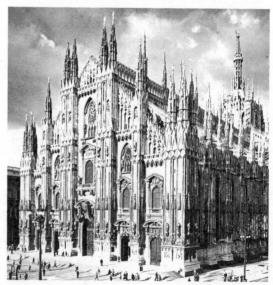

2-11 Cathedral of Milan. Begun 1386. Photo, Italian Government Tourist Office.

2-12

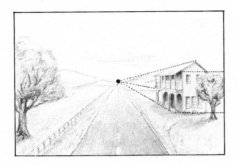

One-point perspective.

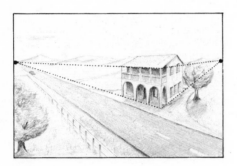

Two-point perspective.

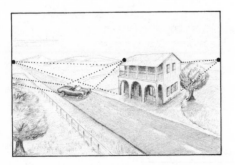

Three-point perspective.

Perspective When we think of the term *perspective*, we usually think of *linear perspective*, an inheritance from the Italian Renaissance that has influenced our way of creating and looking at painting for centuries. In linear perspective the artist uses lines (either actual or implied) to probe space and give the illusion of depth on a flat surface. The Greeks and Romans had some knowledge of linear perspective before the Renaissance, but it was revived and further developed into a science by Renaissance painters, who followed certain rules in order to create the sense of space. *Atmospheric perspective* involves the use of cool colors and light values to make objects appear distant. The main rules of linear perspective are:

1. All objects appear smaller the farther away they are.

2. Parallel lines receding into the distance appear to converge. The point at which they seem to meet is called the vanishing point. Horizontal parallel lines do not converge.

3. In one-point perspective, the viewer is looking at the object head-on and the parallel lines meet at one point. When an object is viewed at a slight angle, the perspective is called oblique and involves two or more vanishing points.

4. Vanishing points are placed along an imaginary line called a horizon line. This may be at the normal horizon—our usual eye level when we stand on level ground. Parallel lines above this line appear to converge down toward it, while lines below it appear to converge up to it. The horizon line may also be placed higher or lower than normal, which will make objects appear below or above the viewer's eyes.

5. Round forms, which have no parallel sides, can be considered as though they had rectangles surrounding them.

During the Renaissance, artists were intrigued by the scientific aspects of perspective and worked out rules which would help them attain the spatial effects they wanted. An engraving like the *Nativity* by Albrecht Dürer, which uses one-point perspective, looks almost like an illustration for a rule book on perspective.

To create an unusual experience of space, usually for purposes of emotional effect, an artist may use two or more eye levels and may adapt these scientific rules to create whatever effect he wishes.

Contemporary artists do not always use linear perspective. They may ignore it completely, or they may combine it with other methods of creating spatial effects.

Pablo Picasso, in *The Three Musicians* (Plate 9), combined several viewpoints with flat overlapping shapes. Like the Egyptian painter, who also used several viewpoints and overlaps, he was not concerned with creating an illusion of three-dimensional reality on the flat surface of the painting. We find a similar lack of interest in deep space in Romanesque sculpture and Egyptian painting where the most important figures were depicted as very large, the minor figures as small. This had nothing to do with their placement in space but was done for expressive purposes—to show their special status. Artists of these cultures were not less skillful, but used spatial relationships and scale to create a particular emotional effect, not to create three-dimensional reality.

2-13 Albrecht Durer. *The Nativity*. 1504. Engraving. The Metropolitan Museum of Art, Fletcher Fund, 1919.

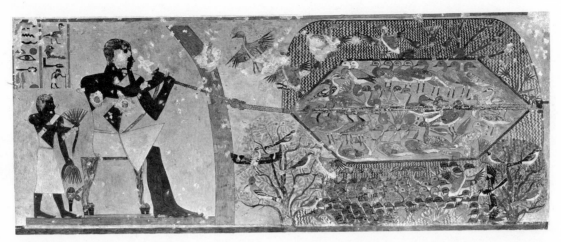

2-14 Wall painting, *Beni Hasan, Tomb of Khum-Hotpe.* c. 1900 B.C. Tempera. The Metropolitan Museum of Art.

The Language of the Artist

We have been talking about technical tools of the artist. Now we will study the language the artist uses to express his ideas and to create a visual composition. This language contains elements which are basic to most art and to most periods of history—unity, balance, rhythm, proportion, and design.

Unity Visual unity occurs through the interrelationship of all parts of an artwork so that the parts fit together in a recognizable order. This order may appear to be simple, or it may be highly complex. Parts of the composition can be related and unified by repeating and echoing certain shapes, masses, colors, or lines, as the vertical and horizontal lines are repeated in the Parthenon (Figure 9-7). A snowflake is an example of simple visual unity derived from converging lines and the repetition of shapes. The sculpture *Full Moon* by Richard Lippold (Figure 18-14) also illustrates how several points of interest can be unified by their convergence toward a center. No part of this wire sculpture is independent of any other. Even the space between the wires is an important part of its visual structure. Sometimes a work of art may appear to the inexperienced eye to have little unity, as in this painting by Joan Miró, *Carnival of Harlequin.* In it the apparent lack of unity adds to its sense of fantasy, yet the repetition of similar shapes, colors, and lines produces a composition which holds together.

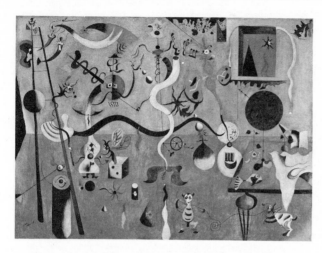

2-15 Joan Miró. *Carnival of Harlequin*. 1924-25. Oil on canvas, 26″ x 36⅝″. Albright-Knox Art Gallery, Buffalo, New York.

Balance Unity which may result from the relationship of two opposite forces is called balance. When a work of art is balanced with almost equal shapes or masses it is said to have formal balance. An example of informal balance can be found in Miró's painting. In Vermeer's *Young Woman with a Water Jug* (Plate 3), one of the unifying factors is the careful balance between the strongly contrasting rectilinear shapes and the roundness of the woman's body. In his paintings Mondrian balances geometric areas of color against white space (Plate 8).

Exhibiting yet another kind of balance, Alexander Calder's mobiles fascinate us with their ever-changing but balanced relationships. His subtle organic shapes move animatedly through space to create a vital rhythm. If you want to experience how difficult it is to attain this visual and physical balance, cut some shapes from colored cardboard, fasten them to strips of wire, and then try to make an interesting but balanced mobile. You'll find that it is not as easy as it sounds.

2-16 Alexander Calder. *Lobster and Fish Tail*. 1939. Hanging mobile: painted steel wire and sheet aluminum, about 8′6″ x 9′6″. Collection, The Museum of Modern Art, New York.

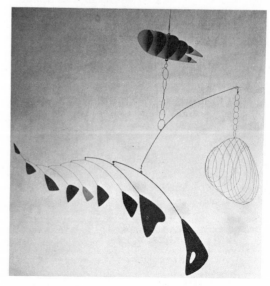

Rhythm Rhythm is a basic element of life. It is created through the regular repetition of events, such as waves pounding on the shore or a regular heartbeat whose rhythmic pattern can be seen in a cardiogram. In the visual arts rhythm is produced by the regular repetition of similar lines, shapes, or colors. Marcel Duchamp created a sense of flowing rhythm in *Nude Descending a Staircase* by repeating shapes of the body as it moves down the stairs. Similarly, the repeated arches of the Roman aqueduct at Pont du Gard please us with their rhythmic repetition (Figure 3-8). These are obvious examples of rhythm in art. A more subtle example appears in Michelangelo's *Creation of Adam* (Figure 1-1), in which the lines of Adam's listless, half-alive body are echoed, but not exactly repeated, in the vital life-giving lines of God's figure. To help you see how artists use rhythm, place a piece of thin paper over this illustration and trace some of the repeated shapes or lines. Your tracings may reveal patterns to you that were not apparent before.

Proportion In art as in mathematics, science, or cooking, proportion refers to the relationships of the parts to each other and to the work as a whole. Greek civilization was particularly concerned with proportion both in human actions and in their art. This attitude shows in the incredibly subtle relationships of each small part of the Parthenon to each other part of the building (Figure 9-7). The Greeks refined the rules of proportion into a system which they called the Golden Section, and applied it to their temples. This rule said that a small part

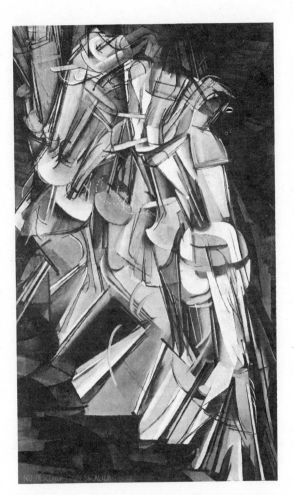

2-17 Marcel Duchamp. *Nude Descending a Staircase, No. 2.* 1912. Oil on canvas, 58″ x 35″. Philadelphia Museum of Art: The Louise and Walter Arensberg Collection.

2-18 The Golden Section.

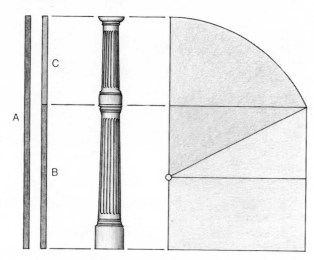

head is larger in relation to the rest of his body than that of an adult. In teaching figure drawing an instructor will sometimes suggest that students measure a figure's proportions in relation to its head. The average adult is usually about eight heads tall. Sometimes artists change human proportions for expressive purposes. The Spanish painter El Greco distorted the bodies in his paintings to accentuate their spiritual quality. In contrast, in classical Greek sculpture the ideal was moderation, and the relationship of all parts of the body were kept to idealized proportions.

2-19 Leonardo da Vinci. *Man, The Unit Measure.* c. 1492. Pen and ink, 13⅛″ x 9⅝″. Academy, Venice. Photo Alinari.

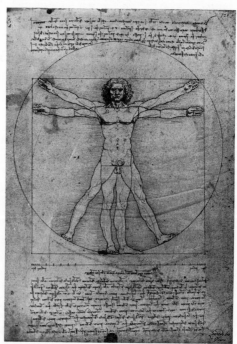

relates to a larger part as the larger part relates to the whole. The Greeks were also interested in the relationship of the parts of the human body to the whole, and they developed idealized concepts of these relationships. These relationships also intrigued Renaissance painter Leonardo da Vinci who said, ''Man is the measure of all things.'' He placed the human figure as a unit of measurement in the center of the most perfect geometric shapes, the circle and the square.

General rules of human proportion can be set with considerable accuracy. A child's

Human proportion also affects architecture and furniture design. In contemporary design, the module, or core unit, has been based on dimensions and ratios derived from the human body. Similarities in human proportions have permitted designers to standardize clothing, furniture, machinery, eating utensils, and so on. Modern mass-produced plywood or plastic furniture is designed for the average human proportion. The scale of a building in relation to the size of the human figure also has a great deal to do with its emotional impact. For example, the immense size of St. Peter's in Rome (Figure 11-15) dwarfs the human's sense of importance.

Thus scale in art is usually developed in relationship to human size. It can be manipulated for visual and emotional impact, but any work of art, whether it is a Gothic cathedral or the decoration on a clay pot, refers in some way to human proportions.

Design

Sensitivity to design is as old as mankind, and early humans took their inspiration from the world around them. The veining of a leaf or the pattern of annual growth of a tree suggest designs of variety and complexity which are the result of the natural laws of growth. Early mankind was inspired by the natural world to carve or paint tools, weapons, and pots with decorations based on spiral, wavelike, and simple animal forms.

These same stylized designs recur in different cultures and geographical areas. Apparently there are basic forms in nature to which all humans respond. If we can judge from the evidence seen in prehistoric cave paintings, many of our responses have not changed significantly from Paleolithic times to the present. The word *design* can also refer to the total composition of a work of art. Whether we use *design* to describe the applied decoration on a clay pot or the complex plan for a building, we are speaking of the same human need to search for visual structure and order.

In our further study of functional and nonfunctional arts, let us remember all these artistic tools which are used by the artist to develop composition and structure.

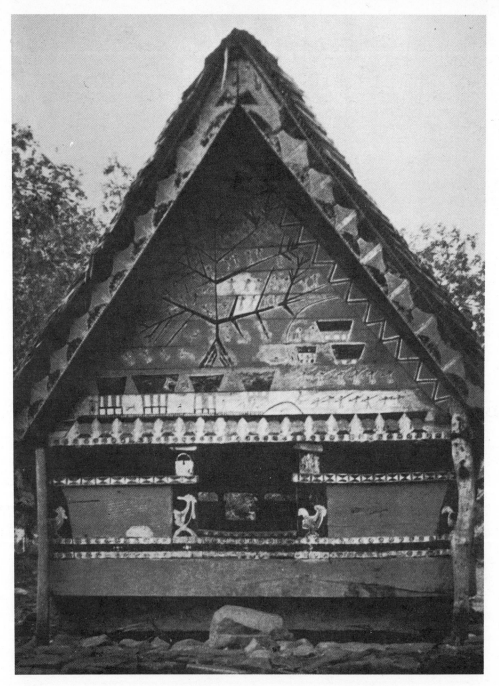

3-1 Sacred Men's House. Oceania. Photo, Collection of Stella Russell.

Changing Techniques, Changing Forms

Introduction

In this section we can come closer to the actual experiences of artists in creation. In studying the materials with which architects, sculptors, painters, weavers, and other craftsmen spend their days and the methods they use to create their final works, we can leave the gallery and museum and look into studios and workshops. Creation involves a constant struggle on the part of the creator to express emotion and visual excitement with materials which may place limitations and restrictions upon that expression.

Throughout history artists have searched for better and more responsive methods to express their visual images. The sense of frustration they often feel is a result not only of dissatisfaction with the images they create, but also of the difficulty in finding the best technical means to express what they have only imagined. There is an interrelationship between materials and techniques and the images and forms of art which we must keep in mind as we study art in the world.

Sometimes the forms and images that artists wish to create influence the discovery of new materials, and at other times techniques, inventions, and discoveries influence the forms of art.

Change is perhaps the only constant factor—change in materials, change in techniques, change in forms.

Architecture

Architecture is the first manifestation of man creating his own universe,
creating it in the image of nature, submitting to the laws of nature,
the laws which govern our own nature, our universe. The laws of gravity, of statics
and of dynamics, impose themselves by a *reductio ad absurdum:*
everything must hold together or it will collapse.

Le Corbusier, *Towards a New Architecture*

Of all the arts we shall study, architecture is the one which probably has the greatest effect on our daily lives. Most of us spend a large proportion of our time in buildings. On the way to work or school we pass more buildings. All around us, space has been enclosed and walled in. Architecture, the art of building, could as well be called the art of enclosing space in a useful and pleasing way.

The Functions of Architecture

What makes humans build? Obviously, the most basic reason is to provide shelter or protection from unpleasant weather, from the sun, or even from animals or unfriendly humans. Imagine yourself living on the earth before there were any buildings. What would you do for shelter? You could crawl under the branches of a tree, or—if you were lucky —maybe you could find a cave to serve as home and shelter. Eventually, however, you would probably try to build a more permanent shelter. You might make a lean-to out of branches or a hut out of bent sticks and bark such as those built by American Indians. Or you might weave saplings into a wall and plaster them with mud. In some parts of the world, such as the Middle East, the soil can be shaped into bricks. When dried in the sun, these bricks can be used for building. Though these may seem like crude or primitive homes to you, you can imagine the amount of time and ingenuity it took to develop even these simple solutions to the needs of early humans for shelter.

Later, having solved the problem of shelter for himself, man built temples to his gods, fortresses for protection, and palaces and tombs for his rulers. The appearance of the structures that he designed and built was directly influenced by the climate, the available materials, the site on which they were built, and the needs of the people who were to use them.

What Problems Must a Builder Solve?

Builders have many concerns when they plan and construct a building. They must determine how to support it during construction and—even more importantly— how to keep it from collapsing after completion. Other structural considerations include how to roof the enclosed space, how to arrange the spaces inside conveniently, how to let in sunlight, how to provide

protection from the weather, and how to control the interior temperature. A builder must also consider how to let people move comfortably through the interior spaces and how to make the building pleasing to the eye inside as well as out. In the following sections we shall see how builders both in the past and today have tried to solve these problems.

Traditional Methods and Forms of Architecture

Some of the materials and building methods in use today date back thousands of years, while other, totally new building materials and techniques have been developed since the Industrial Revolution.

Wood Construction We know little about the earliest wood construction because wood burns and rots, leaving no remains for us to examine. However we can guess at these earlier forms by examining wooden structures built in primitive societies today. For example, in the warm, lush climate of Polynesia, villagers still build houses out of trees and vegetable fibers, probably in much the same way that their ancestors built homes. In northern climates, however, early man probably built huts of logs with mud and grasses stuffed between them to provide protection from the elements.

 Post and beam With the development of tools, upright and horizontal posts made from tree trunks could be cut and fitted together to create a simple form of construction called post and beam. The beams could support roofs of bark or sod or could be positioned to span openings for floors and windows. The size of the space which could be enclosed using this type of construction depended on the strength and length of the beams. As long as the opening was not too wide, the beam and post worked, and a rectangular space could be enclosed. It is likely that the homes in the endless forests of northern Europe looked much like the American log cabin, which was based on post and beam construction. An important design feature of many of these structures was a pitched roof to allow snow and rain to run off. Early in their history the Japanese developed wood construction into complex forms, spanning huge spaces with wooden posts and beams, like a Buddhist temple at Nara built in A.D. 736 which was 284 feet long and 166 feet wide. There was no limit to the space that could be enclosed if you did not mind having posts throughout the interior. A tall pagoda built in Japan in the eighth century shows how complicated early wooden post and beam construction could be.

 Triangular trusses When the builder wishes to span a large space without a lot of interior posts—as in a barn or storehouse—a triangular truss is often used. Just when builders worked out the triangular truss is uncertain, but its crossbracing added great strength and rigidity to the wooden roofs of stone churches at the beginning of the Christian era. Bracing based on the triangle is still used today when a wide area must be roofed and the space below left free of posts. Today's A-frame houses make use of the principle of the braced triangle.

3-2

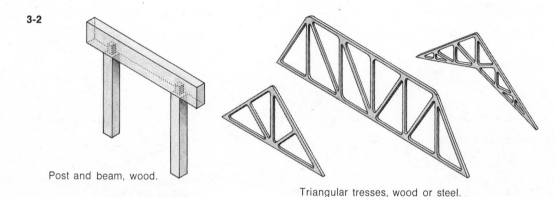

Post and beam, wood.

Triangular tresses, wood or steel.

Balloon framing, wood.

Balloon framing A lighter way of building with wood, balloon framing was developed in the 1800s when metal nails were produced in quantity and sawmills turned out lumber in standard sizes. The frame of light wood was nailed together, replacing the slow process of cutting, fitting, and pegging heavy posts and beams. Each part of the building helps support every other part and nailing the outer wall to the frame increases its strength. Builders still use this form of framing in homes, although now walls are more commonly enclosed with sheets of plywood instead of separate boards.

Stone Construction Stone is one of mankind's earliest and most widely used building materials. It is available in most parts of the world and is strong and durable as proven by the many ancient stone buildings which still stand today. Under the right conditions stone is able to support a great deal of weight. However, because of this weight, a stone structure must be carefully planned and built to avoid collapse. The earliest stone buildings were made by placing one stone on top of another. Stability was achieved through the downward thrust of the weight of the stone. If you remember building a tower out of blocks, you recall that it would stand up only if the blocks were carefully positioned one on top of another. If

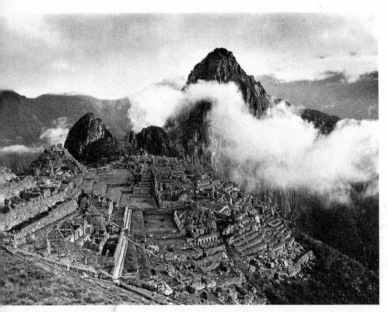

they were not balanced carefully, the tower would collapse. A similar combination of placement and gravity kept the walls of ancient stone buildings together. The earliest were built of unshaped stones, but in this Inca wall at Machu Picchu in Peru the stones are fitted so closely together and with such skill that a knife cannot be pushed between them. With such careful construction no mortar was necessary to hold the stones together. The Indians who built the cliff dwellings in Mesa Verde, Colorado, used the cliff as one wall of the building. They added stone walls, doorways, and wooden ladders to make an early apartment house under the sheltering roof of the cliff.

3-3 Machu Picchu. Photo, William Harris.

3-4 Indian cliff dwellings. Mesa Verde, Colorado. United States Department of Interior, National Park Service.

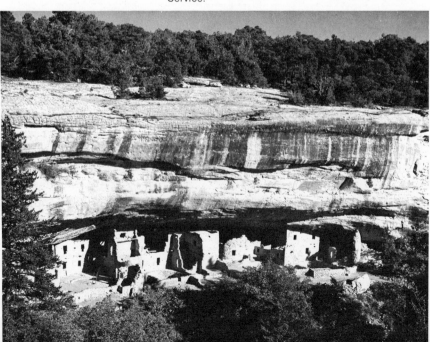

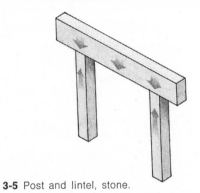

3-5 Post and lintel, stone.

Post and lintel Two stones can be set upright and a third (the lintel) placed over them to create an opening and provide support. This is post and lintel construction and, like wooden beam construction, it is a useful way to form rectangular structures. But you can see that construction based on the post and lintel is limited by the size of the stone available for lintels and the distance the stone could span without breaking of its own weight. Stonehenge, a huge mysterious structure built in prehistoric England, is made up of enormous vertical stones placed in circular arrangements, with horizontal stones on top as lintels (Figure 8-6). How the massive stones were transported miles from the nearest quarry and raised into position is still a source of discussion among archeologists.

The post and lintel was used widely in early Egyptian buildings because of an abundant supply of stone. In addition, the Nile River made it relatively easy to transport large stones on rafts to the building sites. The Temple of the Sun at Karnak was constructed of stone posts and lintels whose shapes were probably based on earlier carved wooden posts. Notice that its immense interior space was filled with a forest of columns. This is because the heavy stone lintels could only reach across a limited space without support.

3-6 Model of Hypostyle Hall, Temple of Karnak. 1350-1205 B.C. The Metropolitan Museum of Art, Purchase, 1890, Levi Hale Willard Bequest.

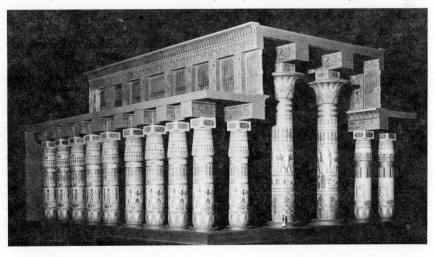

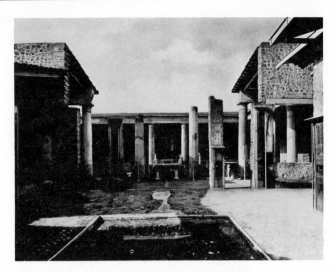

3-7 Villa of the Vettii, Pompeii. A.D. 63-79.
Alinari-Art Reference Bureau.

In Rome, apartment houses of five stories were constructed with stone walls and posts and lintels. Remains of these buildings—with stairways, lightwells, and elaborate room arrangements—can be seen today. When the Roman town of Pompeii was buried by volcanic lava and ashes from an eruption of Mt. Vesuvius, this comfortable home of a well-to-do Roman with its courtyard garden was ruined in moments. Now restored, it shows us how delicate and elegant a post and lintel structure could be.

Arches In countries where wood and stone were scarce, early peoples learned to shape mud into bricks and dry them in the sun. Such bricks were one of the earliest manufactured building materials. Thick-walled huts could be made using these bricks and wooden beams to support the roof. In many ways these huts were probably similar to the adobe houses in the southwestern United States and Mexico. A problem with sun-dried bricks is that they are apt to crumble when exposed to weather. To prevent this, the bricks were fired to harden them.

Though huge towers could be built using bricks, a problem arose when a builder wanted to span gateways, passages, or other openings. A new system had to be worked out using the small units of bricks. By setting each stone or brick out a little from the one below, a corbeled arch can be formed. It takes careful balancing and relies on gravity to keep it in place. The true arch was a significant improvement on the corbeled arch because its wedge-shaped units support each other through mutual pressure. True arches, first made in Mesopotamia with brick, were later built in stone and refined by the Etruscans and Romans.

The arch was an important building method used by Roman engineers in the construction of large buildings, sports arenas, triumphal arches, aqueducts, and other structures. In the Pont du Gard, a Roman aqueduct and bridge still in use today, you can see how each stone wedge was shaped to fit snugly into the curve of the arch. You can sense how the placement of the final stone—the keystone—made the arch into a self-supporting unit. The wedges were squeezed together, and the weight above the arch was sent through it, outward, and down to the ground. During construction the sides, or shoulders. of the arch had to be supported with a wooden structure (called

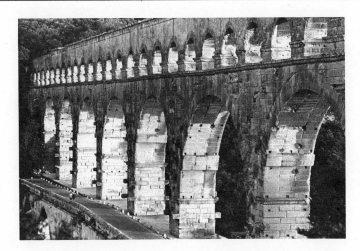

3-8 Le Pont du Gard, Nimes. Early First century A.D. Photo, Helena Kolda.

 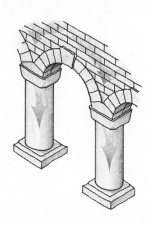 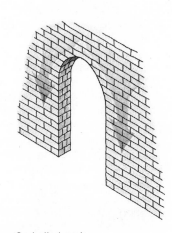

3-9 Pointed arch. Round arch. Corbelled arch.

''centering'') until the keystone was put into place. There is a quality of life in the interrelationship of the stones in an arch which does not exist in the massive stone posts and lintels at Karnak. The solidity of a building constructed with arches depends on how the thrusts of weight are balanced against each other and how they are carried down to the ground. A row of arches placed next to each other, such as we see in the Pont du Gard aqueduct, made it possible to bridge a wide space. The comforts of the wealthy Romans depended on such engineering feats. The aqueducts, for instance, provided water from distant sources for the Romans' luxurious baths and villas.

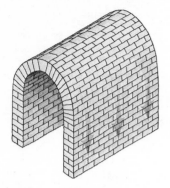

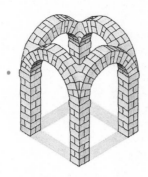

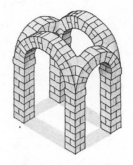

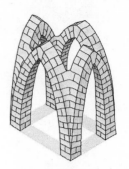

3-10 Barrel vault.

Round arches can vault
a square evenly.

Round arches cannot
vault a rectangle evenly.

Pointed arches can
vault any area.

Vaults A series of arches placed one behind the other produces what is known as a barrel vault. Vaulting provides the builder with another way to roof over large areas and has the advantage of being able to span wider spaces than stone lintels. Roman architects frequently used vaults and arcades to build large complex buildings, like the Baths of Diocletian, of a size never before seen in the West. Precise engineering knowledge was needed to work out the complicated problems of weight and pressure encountered in such large buildings. Early vaults were to set on heavy walls that supported the weight of the building and counteracted the outward

pressures of the vaulted ceiling. The barrel vault better solved the problem of spanning a wide space while avoiding wooden beams that might burn or lintels which could break from their own weight. As you can see in the diagram, the walls of the barrel vault are solid. As engineering skills developed, builders were able to break into these walls with arched openings and still keep the structure sound. Sometimes two intersecting barrel vaults were used over a square compartment to create cross-vaulting.

Ribbed vaults Early Romanesque churches with their heavy massive walls supporting barrel vaults were dark and

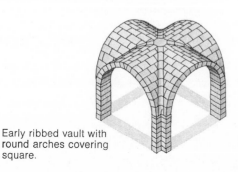

Early ribbed vault with
round arches covering
square.

3-11

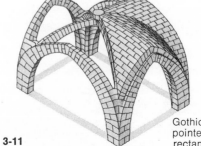

Gothic ribbed vault with
pointed arches covering
rectangle.

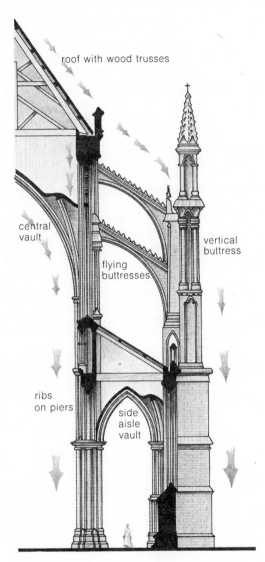

roof with wood trusses

central
vault

vertical
buttress

flying
buttresses

ribs
on piers

side
aisle
vault

3-12
The Gothic system: Cross section of a cathedral.

gloomy. Medieval church builders sought solutions to the problems of how to increase the height of the central nave and bring light into the church. They found that by using a pointed arch and concentrating the thrusts of weight on ribs they could span rectangular and irregular areas and build lighter, airier churches. The pressure and thrust exerted on the ribs was in turn transferred down to piers inside the building and out to buttresses on the outside. Because these stone skeletons carried the weight, the spaces between the ribs could be filled with lighter stone panels and even glass. This change to pointed arches with weight-bearing ribs, piers, and buttresses made the Gothic cathedral possible.

The religious exultation of the Gothic period was expressed in the cathedral at Amiens. The tremendous height of the vaulted nave reaches upward toward heaven, bathed in a twilight pierced at intervals by brilliantly colored stained glass windows. You can feel the organic, living quality of the Gothic cathedral where each part depends on the counterbalancing weight of each other part. The thrust moves from towers and roof down to vaults, through ribs and piers, out to buttresses and flying buttresses, and so down to the ground. These cathedrals took hundreds of years to build, and it is easy to imagine the failures their builders must have experienced while trying to work out these problems of weight and thrust. There were some cathedrals, in fact, like Beauvais in France, that reached too high, collapsed, and were never completed. But most were finished and still stand today as examples of daring and creativity in building design and construction.

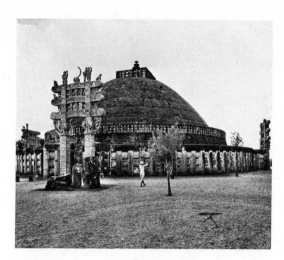

3-13 Stupa No. 1, Sanchī. 70-25 B.C. 120′ in diameter, 54′ high. Eliot Elisofon, Life.

Domes Domes are hemispheres placed on walls that may enclose a circular or square space. Various methods have been contrived to tie in the hemisphere of the dome to the square below it. The Stupa of Sanchi in India, a Buddhist temple built in the first century B.C., illustrates how the stones were placed in diminishing circles to create a dome. The dome has been used by builders in many cultures to create open interior spaces. Large Roman domes represented a tremendous achievement in engineering. The Roman Pantheon, built in the second century A.D., still stands today and is one of the largest domes ever built. Along with the dome of Santa Sophia in Constantinople, it has influenced later architects as has the dome which Michelangelo designed for St. Peter's in Rome (Figure 11-15). Your city hall or state capitol building may have a similar dome. These later domes are often merely copies of Roman and Renaissance domes.

New Materials, New Methods, New Forms

Between the Gothic period and the nineteenth century there were no new structural developments of great importance. Renaissance architects used traditional methods of construction in their palaces and churches. As European towns and cities grew larger, the wealthy merchants built homes of brick, stone, or wood and plaster. The type of house built varied according to climate and materials available. English half-timbered houses with thatched roofs, Dutch brick houses, and wooden homes of colonial New England seem familiar to us even today because many twentieth-century builders have continued to copy them, fitting modern building methods to the outward forms of medieval Europe or colonial America. None of these buildings, nor the vast palaces and country homes of the aristocracy, made use of any daring new structural methods.

However, the Industrial Revolution in the 1800s brought with it totally new techniques and materials. Ever since then there has been a split in the field of building. Some builders have tried to maintain the familiar appearance of buildings while using the new methods; others have created buildings which honestly express the new materials.

Industrially Produced Materials There were enormous changes in our lifestyle with the coming of the Industrial Revolution. The production of everyday articles changed from slow, laborious handwork by craftsmen in their own shops to production by machines in large factories. The invention of machines meant the development of mines to produce the coal to run factories and to make the iron to build more machines. Families left the farms to work in factories and in the mines

and iron works. The populations of towns and cities grew rapidly, and overcrowded conditions became common in urban centers.

These early industrial mills and factories were built with traditional structural materials such as wood, brick, and stone. However, as more open floor space was needed for the operation of large machinery, builders began to use iron trusses for support. The triangular truss was translated into cast iron, and its parts were bolted together. Iron had been used in buildings before but only for fastenings. It was not until the production of iron was industrialized that it achieved importance as a building material. Heavy wooden beams and posts could be replaced with a lighter, stronger iron framework and trusses which could span wide spaces with fewer posts.

The development of the iron skeleton was important because it made possible post-free interiors and lots of windows to light the work space.

With this new method of building, the parts could be cast in iron shops, shipped by the new railroads, and bolted together at the building site. The spaces between the iron frames supported the structural weight. At the same time, with the growth of rail networks, the need for more bridges became apparent. This in turn led to further experimentation with iron as a bridge building material. Some of the most exciting engineering and building advances of the nineteenth century grew out of the creative new ways iron was used in bridges, taking full advantage of shop fabrication methods.

One of the most dramatic uses of iron was in the Crystal Palace built for the Great Exhibition in London in 1851. This was the first completely prefabricated building of modern times. It covered seventeen acres, and all its parts were made in factories, shipped to the site, and assembled there. The weight-bearing iron and wood frame held panels of plate glass in the largest size which could be produced at that time. The glass

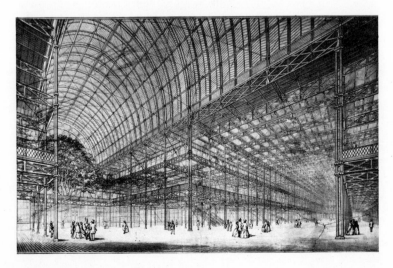

3-14 Crystal Palace. 1851. Royal Institute of British Architects, London.

walls carried no weight and were only used to enclose the space. The enormous open interior of the Crystal Palace with its high curved glass roof stunned the world with its daring new approach to building. Contemporary critics correctly predicted that the Crystal Palace would start a revolution in architecture from which a new style would develop. Its designer, Joseph Paxton, was a gardener who had had experience designing and building greenhouses. To create the Crystal Palace he took newly developed materials and with the great creative vision transformed them into completely new architectural forms. Paxton saw the structural frame as an organic skeleton. He said of his building, "Nature was the engineer. Nature has provided the leaf with longitudinal and transverse girders and supports that I, borrowing from it, have adopted in this building."

You can see in these early iron structures the beginnings of the steel skeleton construction which is now one of our main building methods. Railroad bridges, the

1,000-foot high Eiffel Tower in Paris, and the Crystal Palace provided engineers and architects with experience in metal skeleton building and with evidence of what could be accomplished with new materials and techniques. When iron was first used, it was believed to be fireproof. However, it was soon found that if a fire took hold, the iron would melt.

Steel Construction The development of steel girders which were riveted rather than bolted together allowed stronger and lighter frames to be produced. A further advantage of steel is that it is more resistant to fire than cast iron.

Look around you for examples of steel construction. Perhaps your school gym has steel girders supporting the roof. Steel bridges, high-tension poles, and large buildings under construction show how steel frames are put together.

Buildings using the new steel frame construction were erected all over the world at the end of the nineteenth and beginning of the twentieth century. But the earliest large concentration was in Chicago where the need to conserve space sent buildings higher and higher. The invention of the elevator and the refinement of steel frame construction encouraged the erection of tall urban buildings. The steel frame creates a self-supporting cage, as the stone ribs of the Gothic cathedral created a skeleton. Walls can be attached to this cage, but because they have no structural purpose, they need only be thin panels to keep out the weather and enclose the space. In the Wainwright Building, built in St. Louis, Missouri, in 1891, Louis Sullivan made an honest use of the new construction methods and materials.

3-15
Steel cage construction.

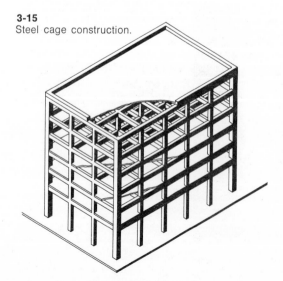

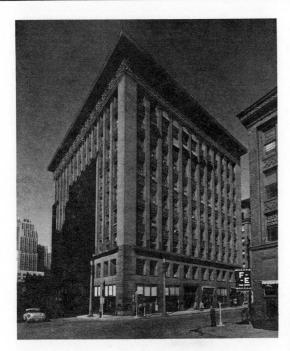

3-16 Louis Sullivan. Wainwright Building. St. Louis, Missouri. 1890-91. Photo, Hedrich-Blessing.

This can be seen particularly in the emphasis on the vertical lines of the building. Structures such as the Wainwright Building are forerunners of today's skyscrapers.

Louis Sullivan, the man most responsible for the development of the skyscraper, was well aware of the problems it would cause. In his *Autobiography of an Idea,* he said, "The tall steelframe structure may have its aspects of beneficence; but as long as many may say, 'I shall do as I please with my own,' it presents opposite aspects of social menace and danger . . . the tall office building loses its validity when the surroundings are uncongenial to its nature; and when such buildings are crowded together upon narrow streets or lanes they become mutually destructive."

Certainly the steel cage can produce overwhelming skyscrapers which dehumanize the urban environment, but in the hands of an architect like Mies van der Rohe it can also create a light, elegant building. Using steel beams, the architect has allowed the cage construction to show on the exterior and has boldly emphasized the vertical thrust of the building.

3-17 Ludwig Mies van der Rohe. Apartment House, 850 Lake Shore Drive, Chicago. 1950-52. Photo, Hedrich-Blessing.

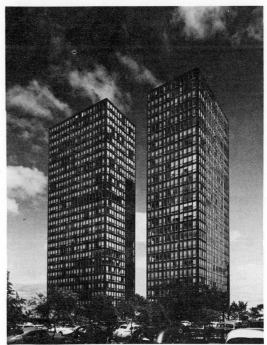

Reinforced Concrete Construction Reinforced concrete is another comparatively new material which influences our everyday environment. It has made possible completely new and exciting building forms. Though concrete had been used in earlier construction, it was not until it was reinforced with metal rods or mesh that its full potential could be achieved. Mills, silos, and other utilitarian buildings were the first to make use of this material, but almost immediately its possibilities were recognized by architects. Now that floors could be made out of self-supporting slabs resting on posts with few or no interior columns for support, Auguste Perret built a rectangular reinforced concrete cage in this apartment house in Paris in 1903. Large areas of its walls are closed in with glass or with thin panels of cast concrete. The material is used honestly, and no attempt is made to cover or hide the concrete because Perret believed that decoration always hides errors in construction. Inside, where the only nonmovable parts are slim columns and stairs, the building is open for flexible room arrangement.

As early as 1905, bridge designers in Europe successfully used curved slabs supported with thin verticals to create graceful arches. Since then, as the technical understanding of concrete has increased, engineers have been able to calculate exactly what stresses and loads the structure can support, and more and more daring experiments in construction have been made. Architects have found that this new material can be used to form arches, soaring vaults, and sculptural shapes like those Le Corbusier designed for a chapel in France. In fact, it sometimes seems that the material can do almost anything an architect wants. For example, Eero Saarinen's TWA Flight Center at New York's Kennedy Airport uses organic shapes cast in concrete to create an open space broken only by curving staircases and balconies (Figure 20-10). This building could be built in a matter of months compared to a Gothic cathedral which sometimes took centuries to complete.

Cantilever construction Cantilevers use the wall or foundation of the building as a fulcrum, and the weight of the cantilevered section is balanced by the weight of the building on the other end, just as your weight on the seesaw is balanced by that of your partner on the other end. Jutting out from the building, the cantilevered section needs no columns under it to support it and is particularly adaptable to self-supporting reinforced concrete slabs. Frank Lloyd Wright cantilevered this house out over the waterfall in a dramatic way, visually tying it in its natural environment and making it appear to float over the stream. Cantilevers can also

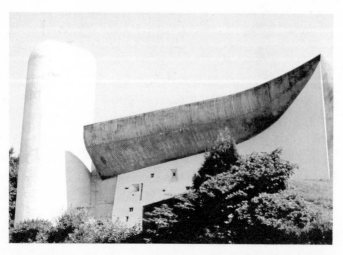

3-18 Le Corbusier. Notre-Dame-du-Haut. Ronchamp, France. 1950-55. Photo, Stella Russell.

support walls hung from them. An example of this can be seen in Wright's Johnson Wax Tower which is built around a central mast with slab floors cantilevered out from it. The entire 156-foot high tower is supported at the base on a unit only 13 feet in diameter, and the glass walls are hung from cantilevered slab floors.

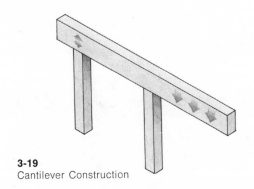

3-19
Cantilever Construction

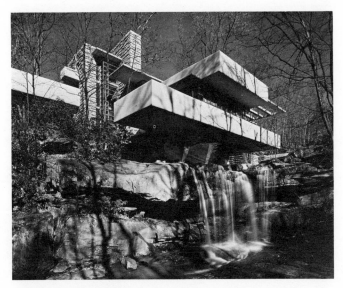

3-20 Frank Lloyd Wright. Kaufman House. Chicago. 1936. Photo, Hedrich-Blessing.

3-21 Frank Lloyd Wright. Johnson Wax Building. (Exterior and Interior.) Racine, Wisconsin. 1936-39.

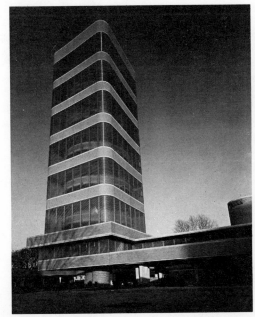

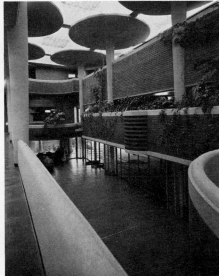

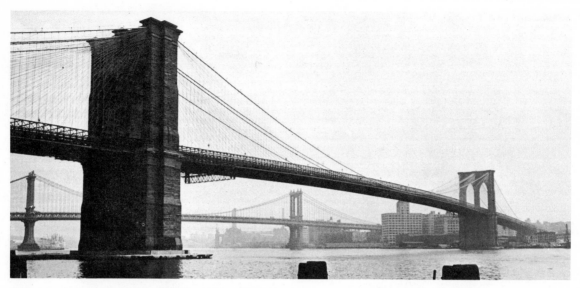

3-22 John Augustus Roebling. Brooklyn Bridge. 1869-83.

Other Construction Methods Steel holds up well under tension, and John Roebling, engineer of the Brooklyn Bridge, understood this quality of the material. He invented the steel cable, which is made up of many parallel wires carrying the stress, and also a machine to put the cable in place on the bridge when it was built between 1869 and 1883. Modern suspension bridges make use of the methods Roebling developed. Many such bridges are marvels of engineering, utilizing the tensile properties of steel. Some of these spans are almost a mile long, and not only do the cables support the weight of the spans, but they also permit fluctuations of several feet between the road and the underlying water, fluctuations which are due to changes in weather and load. Suspension construction has been applied to other structures as well. For example, pavilions for fairs and sports events have been built with roofs and walls hanging on steel cables attached to central posts.

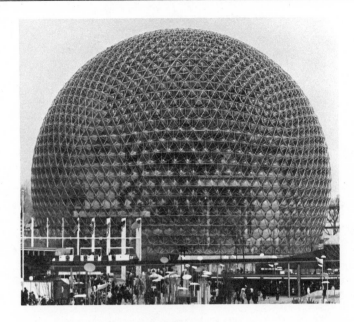

3-23 Buckminster Fuller. Geodesic Dome. U.S. Pavilion, Expo '67. Photo Researchers, Inc.

Buckminster Fuller's geodesic dome is a type of cage construction, based on a combination of trusses which can be made of either steel or wood. The spaces between can be filled with metal, glass, or other light materials. The frame is light in weight, very strong, and can span large areas. The one built for the United States Pavilion at Expo '67 provided a controlled interior climate.

Metal or plywood can be shaped under stress into rounded forms offering another new method of construction in which the outer shell acts as both structure and enclosure. All these new systems change the way buildings look and function.

Later, when we study the architecture of each historical period, try to remember the structural methods and materials that have influenced the forms of buildings. In the meantime, look for buildings around you which demonstrate how the newer methods work. Evaluate the buildings. Do they openly express the methods and materials used in them? Can you find some which copy traditional materials and others that create new and exciting forms through the use of new methods honestly expressed?

Sculpture

Sculpture is such a physical thing
that you must have manipulative ability–
hit a nail with a hammer–cut metal and join metal.
The better you know how to make things,
the better you are as a sculptor.

Richard Stanciewicz

Sculpture is a three-dimensional art form, existing in space. Sculpture penetrates space and, like architecture, draws us into a physical experience with spatial forms. However, while architectural space is large enough to walk through, most sculpture uses space in a more limited way. We are used to looking at statues carved on a building's surface, set into a niche, or standing freely where we can walk around them and enjoy them from every angle. The forms of sculpture, whether seen only from one side or from all sides, change as the light and our angles of vision vary. The spaces between masses can become as important visually as the volumes of sculptural forms themselves. Our eyes follow the dominant lines of the sculpture, and our bodies respond. Often we can even sense the balance and movement of the forms in our muscles. Our tactile response is strong, and our hands long to touch the surface and feel the smooth or rough texture. Even when we cannot touch the sculpture, we can imagine what it would

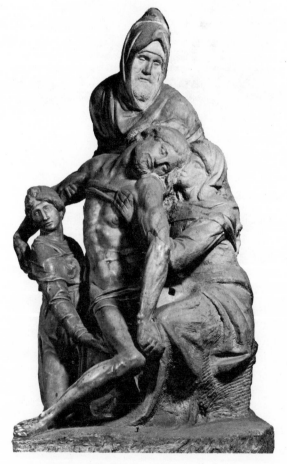

4-1 Michelangelo. *Pietà*. 1548-55. Marble, 7'8'' high. Scala New York/Florence.

feel like to run our hands over it. These are all immediate sensual responses and are separate from any emotional response we may have to the subject matter. Historically, sculpture has fulfilled many other purposes: to teach religious beliefs, to create an emotional atmosphere of veneration, to depict the gods in visual form, to record historical events, to exalt rulers, and to honor the dead. Today's sculpture does not often serve such purposes, but is more concerned with communicating the individual artist's responses either to his own inner world or to the outside world.

In addition, new ways of using traditional materials, new technical methods, and new ideas have changed sculptural forms. In fact, sculpture has changed so radically over the last one hundred years that at times it is difficult to discuss contemporary sculpture in conventional terms or to classify it in the usual way as carved wood, cast metal, or built-up clay. For example, in what category would you place a stuffed vinyl typewriter? You can see that it is sometimes difficult to file present-day sculpture under the old convenient headings.

As we study the processes by which sculpture is made, we will see how the sculptor uses a knowledge of technique to give us aesthetic and emotional experiences. A large part of the process of sculpture is problem solving on a practical level, and there is no doubt that as a sculptor becomes more proficient in his craft, he can concentrate more fully on the expressive aspects of his art.

Traditional Materials and Processes

Stone, wood, clay, and metal have been used by the sculptor for centuries in an infinite variety of ways, reflecting different religious and cultural concepts. Traditionally, stone and wood have been carved in what are called direct processes. That is, the sculptor works with the actual material which

4-2 Arthur Secunda. *Music Machine.* Detail of central portion. 1962. Polyester assemblage. Collection, David Secunda.

forms the piece of sculpture. Before setting to work on this material, the sculptor prepares a small sketch and/or model of the larger work to serve as a guide. He then enlarges it either by eye or with a device which measures the original and marks the increased proportions on the block of wood or stone. Once he has done this, the sculptor chips away the excess material, and gradually the image begins to emerge from the block. Michelangelo used to go to the quarry and pick out the stone he wanted for a particular piece of sculpture. He believed that he could see the sculptural forms trapped inside the stone, waiting to be released by his carving. With a similar sense of identification with his material, the African sculptor (Figure 1-15) beseeched the living tree to give approval to the sculpture he would create from it.

Stone Stone sculpture of the past varied from small prehistoric fertility figures like the Willendorf Venus (Figure 1-14) to the enormous sculptural bulk of the sphinx, which was built out of many blocks of stone (Figure 2-8). Granite, sandstone, marble, onyx, and many other stones have been carved by sculptors who chip away by hand at the hard stone with tools which have changed little over the centuries. Chisels, mallets with heavy heads, rasps, and hand finishing tools used by sculptors today are basically the same as those Michelangelo used to carve the *Pietà* (Figure 4-1). But today a sculptor who works in stone or wood usually employs power tools to cut away the excess material or to add a polish to the finished work, and may only use hand tools

for the final carving and shaping. If you were to try to chip off a few pieces of marble with a hand chisel, you would understand how difficult a task it is and what a help the power tools of the twentieth century have been to the sculptor.

The character of the stone with which the sculptor chooses to work is an important element in the appearance of the finished piece. For example, the texture of a finished piece of sculpture will vary depending on the type of stone used as well as the tool with which the final chiseling is done, and whether it is highly polished or left rough. In addition, the stone's special qualities, such as the veins in marble, must be respected and used expressively by the sculptor. Finally, because stone, for all its hardness, can break as it is being worked, care must be taken to choose blocks without flaws in them.

Wood Like stone carving, wood carving is a direct technique which involves removing material until the desired form emerges from the piece of wood. As with stone, hardness and graining vary, and consequently each kind of wood presents a different technical problem of possible breakage or splitting. Today wood grains are important both from a technical and an aesthetic point of view, for the character of the material chosen by the artist is important to the appearance of the final piece of sculpture. However, in early cultures after a wood sculpture was completed, it was frequently painted or coated with fine sheets of bronze or gold, so the texture or grain of the wood would be masked by the overlying layers. For example, a Japanese temple guardian carved in wood

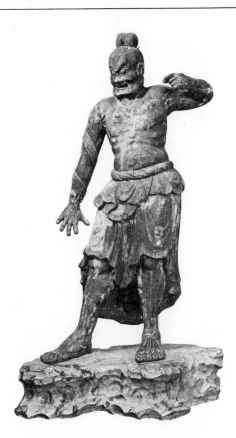

in the twelfth century would be brilliantly painted and its eyes made from semiprecious stones.

Contemporary sculptors often use wood in the traditional manner, carving from solid blocks. But they also use it in new ways. Louise Nevelson, for example, assembles pieces of wood and combines them into compositions which suggest walls or niches taken from architectural settings. Her works are concerned with the play of light and shade over forms and can be looked at as symbolic spaces for retreat and protection from our plastic streamlined world. She started by picking up bits of discarded wood in furniture and pattern shops. After nailing and gluing them together, she painted them flat black or white, creating an overall texture. This technique of assemblage is a

4-3 *Niō.* Twelfth or thirteenth century A.D. Japan. Wood with traces of color, 69¼″ high. Asian Art Museum of San Francisco, The Avery Brundage Collection.

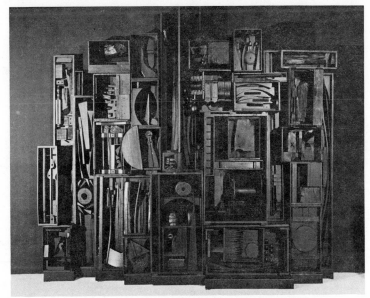

4-4 Louise Nevelson. *Sky Cathedral - Moon Garden & One.* 1957-60. Black painted wood, 109-130″ x 19″. Collection: Arnold and Milly Glimcher, courtesy The Pace Gallery, New York.

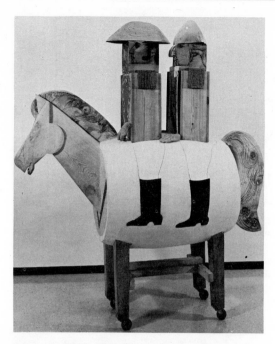

4-5 Marisol (Escobar). *The Generals.* 1961-62. Wood and mixed media, 87″ x 28½ x 76″. Albright-Knox Art Gallery, Buffalo, New York. Gift of Seymour H. Knox.

new development in sculpture, which sculptors have applied to a great variety of materials in addition to wood.

Newly developed techniques have greatly increased the flexibility of wood as a material for sculpture. For example, plywood can be bent and shaped by the use of heat and weight and built up into almost any form, then painted. Tree limbs may be glued together with modern high-strength glues, carved and shaped to create organic mazes reminiscent of tangled jungle undergrowth or huge skeletons.

Clay Clay has been shaped into sculpture as long as human beings have known the material. It is a very plastic substance which is easy to model and allows a great deal of spontaneity when used for small sculptures. Preconquest Indians in Mexico, for example, made lively clay figures of humans and animals for religious purposes (Figure 14-20). Small painted clay figures from Tanagra were popular throughout the Greek

4-6 Haniwa Warrior. Sixth century A.D. Japan. Earthenware, 47⅜″ high. Asian Art Museum of San Francisco, The Avery Brundage Collection.

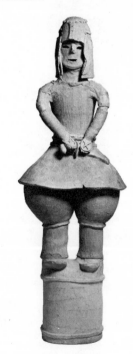

world and had a charm and human quality which was lacking in the larger idealized stone or bronze figures which we normally associate with Greek sculpture. Clay can also be built up into large forms by coil and slab methods, provided that care is taken to prevent the shaped clay from collapsing prior to hardening. The Haniwa tomb figures of seventh-century Japan were shaped of clay and built to a height of several feet.

In order to make more than one copy of a particular piece of sculpture, clay which has been diluted with water until it has a creamy consistency can be poured into plaster molds. When the clay has hardened, the molds, which are made in sections, are removed from the sculpture and can be used over again to produce many replicas of the original. The process of firing clay, which will be discussed in the section on pottery, takes place in kilns heated to high temperatures. Firing causes physical changes to take place in the clay, hardening it and making it nonporous. Fired clay, whether shaped by hand or cast in molds, can be painted or glazed with minerals which, when fired, fuse into a glassy coating. Renaissance sculptors glazed their ceramic sculpture, and there is a revival of interest in the technique today. Contemporary artists are producing sculptural pieces with hand-building, casting, or combined techniques.

In addition to its use as a material for finished sculpture, clay has been used for centuries to form small models of large projected sculptures or to build up the full-size sculpture from which a metal statue is cast.

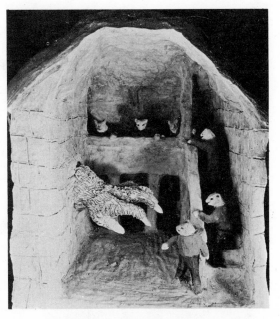

4-7 Louise McGinly. *Panic*. 1973. Courtesy of The William Sawyer Gallery, San Francisco.

Metal Until recently, metal sculpture had always been cast. The same lengthy process of producing a cast bronze sculpture had been used for centuries with few changes. Although it is difficult to visualize the process by reading about it, an explanation will give us an idea of the technical problems a sculptor faces. Sculpture cannot be dashed off in a moment—it takes careful planning and engineering skill to foresee the problems of casting and to prepare for them.

First the sculptor creates a full-size original. This is the creative part. The rest is technical. Usually the sculpture is made of clay built up over a wooden or metal framework, called an armature. The armature is like a skeleton and keeps the clay from collapsing as it is built up, allowing the sculptor to produce slender forms and extended arms and legs which would otherwise be impossible with soft clay. After the sculpture is completed, a sectioned plaster or a flexible gelatin mold is made from it, and melted wax is then poured or

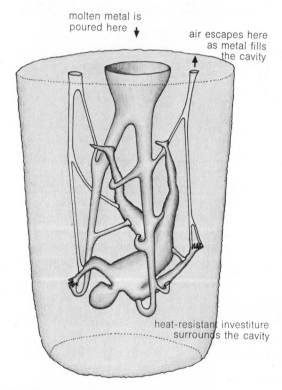

molten metal is poured here ↓

air escapes here as metal fills the cavity ↑

heat-resistant investiture surrounds the cavity

4-8 Bronze casting.

brushed into the mold. Since the sculptor usually wants a hollow bronze cast (obviously cheaper and lighter than solid bronze), the wax model is made as a hollow shell. This is done either by brushing the melted wax onto the mold until a thin shell is built up or by filling the middle of the mold with a solid core and pouring the wax around it. When the mold is removed, the wax appears as a hollow replica of the original sculpture. Wax rods are attached to it to create vents and channels (called *gates*), and it is placed upside down in a container. A mixture of plaster, silica, and clay is poured around it and in the central hole. This hardens into a fireproof mold that is called an *investiture.*

The investiture is heated in a kiln and the wax runs out. For this reason the process is called *lost wax.* What is now left is a hollow investiture which has reproduced the original clay sculpture. Molten bronze is poured into the hot investiture and allowed to harden. When the investiture and core are removed, the emerging bronze looks very odd with the vents and gates sticking out from it. These must be removed and the surface cleaned and finished according to the sculptor's wishes. A finish, called *patina,* is usually applied to the bronze. Depending on the chemicals used, it can range in color from greens to dark brown.

Renaissance sculptors usually cast their own works or at least directed the assistants who did the work, but nowadays most metal sculpture is cast in foundries by highly trained craftsmen who have the technical knowledge to control the process. Sculptors who produce large cast sculpture usually

have assistants to help them with the work involved in building the armature, enlarging the model, and preparing the sculpture for casting. Henry Moore, a contemporary sculptor whose works are often cast in bronze, makes small models of his large figures and turns them over to assistants who build them up to the final size in plaster shaped over armatures. Moore oversees their work throughout the process and works on the final plaster sculpture himself. He also does the final finishing of the bronze when it comes back from the foundry.

Some sculptors today carve the original sculpture from Styrofoam, which also melts away when the investiture is baked in the kiln. Metal sculpture can also be cast with the industrial sand-mold technique. In this method the sculptor's original model is placed in a sectional metal container, and a special fine damp sand is packed tightly around it. This sand holds the impression of the original even when it is removed in the metal sections. These sections are reassembled and clamped firmly together, and liquid metal is poured into the hollow space formed by the sand mold. Relief sculpture can be cast by pouring metal into an impression made in a flat bed of sand.

Through the technique of casting, several metal sculptures can be made from one original clay or wax sculpture, each of them reproducing the original model. Sometimes the sculptor works on the final finishing so that each one can be considered an ''original'' work. However, molds can also be made from any existing sculpture, so that frequently the duplicates you see are actually reproductions, not finished by the artist. Whether the artist casts his own work or

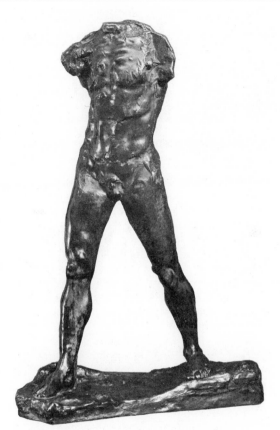

4-9 Auguste Rodin. *The Walking Man.* 1878. Bronze, 33¼'' x 16¾'' x 21⅞''. Gift of Mrs. John W. Simpson. National Gallery of Art, Washington, D.C.

turns it over to a foundry, the final shape in metal exactly reproduces the handwork of the sculptor. This is particularly evident in the work of Auguste Rodin, a French sculptor who sometimes left parts of his works unfinished or with only suggestions of details.

The marks of his fingers or tools in the clay can be seen exactly reproduced in some of his bronze figures. Bronze casts are still made, but today most metal sculptors build up their sculpture, using soldering and welding techniques to join and shape the pieces of metal (Figure 18-13).

Changing Representations of the Human Body

The human body has been the primary subject of sculpture throughout history—at least up until the changes which took place in the arts after World War I—and has been used as a means of expressing emotional, religious, cultural, and aesthetic concepts. A brief sketch of some of the various ways in which the human form has been depicted throughout history provides us with a view of the many changes which have taken place in the art of sculpture.

The Egyptians had a static society which was perpetuated by a rigid caste system, and their absolute rulers believed that immortality could be achieved through the preservation of their bodies. To perpetuate the memories of these rulers and to honor the gods, artists of this society created massive stone statues in the tombs and as monuments. Abstracted and exaggerated in scale, these works are far from exact representations of the body (Figure 8-10).

This Egyptian sculpture contrasts sharply with the subtle elegance of classic Greek statues in which the body is idealized. Though Greek figures often appear at rest, they are never static. As an example, the Greek athlete depicted in this sculpture

seems ready to move into action any minute. The classical Greeks, who worshiped their gods with athletic contests, believed that in the arts, as in all things, moderation should rule. Consequently, the body was always shown in a state of balance between energy and repose. Their philosophical concept of the ideal, of which ordinary existence was considered to be only a more or less corrupted replica, led sculptors to try to perfect what nature had imperfectly copied.

But ideas and cultures change. The Medieval period, for instance, was concerned with man's spiritual battle—the battle between good and evil for the soul of man. In sculpture this led to a more expressive and dramatic depiction of the human body. It was a prophetic vision which interested the sculptor, and his works were an expression of the conflict between man's yearning and striving for the perfection of heaven and the temptations that the evils of life on earth represented. Sculpture was mainly used in the churches to instruct and guide those who came to worship. The human figure was often shown in stress, through an excitement in the pose and through vital but unselfconscious dramatic gestures that mirrored the spiritual intensity of the period. You can see how this dramatic change in sculptural forms reflected the differences between the Greek ideal and the medieval spirit.

In contrast, the sculpture of India reflected the Eastern concept of the all-embracing unity of all cosmic existence. An Indian goddess may appear in a pose which accentuates the sensuality of her curving body. Her sexuality had a religious meaning

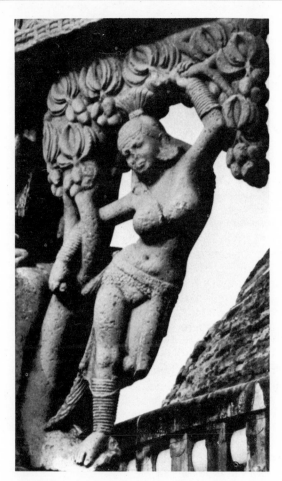

4-10 *Stupa of Sanchī,* detail. Early first century B.C. India. Photo, Eliot Elisofon, Time-Life Picture Agency.

and was intended to arouse those who looked at her to attempt spiritual communion with the gods. As a result, little attention was paid to anatomy, and the proportions of her body were exaggeratedly curved and swelled to express the rhythm that pulses through all living creation. Obviously, the ideal proportions and balance which were fundamental to the Greeks were alien to Indian art. The lavish carvings of human, animal, and floral motifs which intertwine over the surfaces of Indian temples were another expression of this sensual rhythm which the Indians believed was common to all natural life (Figure 4-10).

Responding to changes in social and religious patterns, nineteenth-century European sculptors became concerned with the individual's personal responses to life. Though few shared Rodin's intense psychological interest and his expression of it in dramatic gesture, other sculptors also studied man's search for himself in a world of human suffering. Through their work they expressed the romantic preoccupation with each individual's emotional struggles.

But with the arrival of the twentieth century, the artist's view of the human body changed. In a commentary on the antihuman industrial environment of this century, the body is portrayed as abstracted and almost dehumanized. The partial-figure concept used by Rodin was further developed by Constantin Brancusi. Influenced by the simplification of volumes in African sculpture, Brancusi reduced the human figure to cylindrical shapes. Although he was a master of human anatomy, having created a figure so precise in its anatomical structure that a

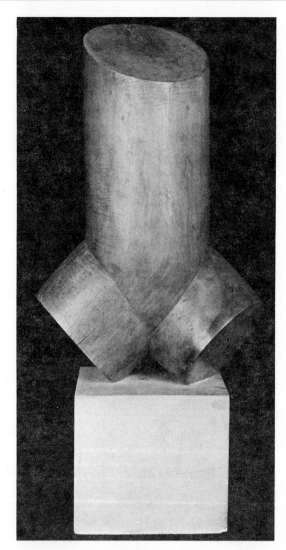

4-11 Constantin Brancusi. *Torso of a Young Man.* 1922. Maple on limestone base, 19″ high, base 7″ high. Philadelphia Museum of Art: The Louise and Walter Arensberg Collection.

Budapest medical school is said to have used it for a teaching device, he abandoned such academic naturalism and said he had no interest in what he called the "beefsteak" of the torso.

Many contemporary sculptors have depicted the body as an actual machine, making constructions of mechanical forms in which human feelings appear ignored, repressed, or alienated. These sculptors have reduced the human body to shapes that are more technological than organic (Figure 15-12).

Others, like Henry Moore, have been interested in the biological structure of the body and the relationships between its shapes and forms and those of the natural world. To express his organic vision, Moore often reduces the head to a relatively unimportant part of the body, concentrating on the terminals and shafts of the bony structure (Figure 17-21). By creating great hollows in the middle of his figures, he rephrases the human body, sculpting strong rhythmic volumes and spaces that suggest the openings of the living body and emphasize sexual associations. These cavities are related as well to caves, holes in trees, and rocks. Through these relationships Moore associates the body with the universal mysteries of life and nature and separates it from the emotions of the individual.

Other contemporary abstractions of the human form represent the artist's response to the alienation of twentieth-century human beings from each other. The attenuated and flattened figures in Giacometti's *City Square* appear almost as shadows that float across the flat plane of the street. In this sculpture

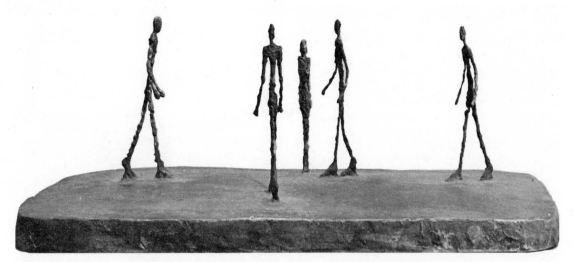

4-12 Alberto Giacometti. *City Square*. 1949. Bronze 9⅜″ high. Photo, Pierre Matisse Gallery.

the artist has captured the momentary encounter of five figures who, though they share a unity of time and space, seem unable to experience any real interchange. Isolation, alienation from other men, separation, and loneliness are all expressed here. Sculptor Castro-Cid also expresses the alienation of man by reducing the figure to a few simple forms—a suggestion of a body and a motorized head that symbolically expresses the mechanization of mankind. Looking at these examples, we can see that throughout the ages the sculptor's preoccupation with the human form has reflected changing ideas of man and that the expression of those ideas has also changed with the sculptor's use of new materials and techniques.

4-13 Enrique Castro-Cid. *Model H*. 1963. Construction, 23¾″ x 16⅛″. Richard Feigen Gallery, Inc.

New Materials, New Methods, New Forms

Many of today's sculptors reject traditional materials. Even when they do use stone, metal, wood, and clay, they frequently use them in new ways.

Industrial techniques, such as metal welding, lamination of wood, and the casting and vacuum-forming of plastic, are explored by contemporary artists as they are developed. The metal sculptor today usually welds steel directly or hand hammers iron, while the wood sculptor builds up his pieces using techniques taken from modern furniture production and carpentry. Sculpture today is generally constructed, built, assembled, or arranged rather than cast or carved.

Constructed Sculpture Picasso was the first artist to fit objects he found around him—handlebars, bones, a feather duster—into sculptural assemblages, and now many sculptors incorporate bits and pieces found in junkyards and auto graveyards into their work. Jason Seley used old auto bumpers to construct *Anatomy Lesson* (Figure 18-13).

Constructions of sheet metal, wire, or translucent plastic often replace the usual sculptural volumes with lighter shapes in which space becomes an important element (Figure 2-16). With these materials the sculptor expresses his concern with shaping and dividing space rather than filling it. Both Alexander Calder and David Smith have used sheet metal to produce flat painted shapes which are welded and riveted together into metallic sculptures (Figure 18-12). Smith's constructions do not move as do Calder's, but nevertheless they have an open quality about them. Wherever possible,

4-14 Pablo Picasso. *Bull's Head.* 1943. Bronze, 41″ high. Galerie Louise Leiris.

he has placed them in natural settings so that the clouds and sky seen through the openings can become an active element of the composition.

Alexander Calder, a dynamic and inventive artist, creates both moving and stable sculptures. Using electrical motors to create movement in some of his works, Calder early became fascinated with the changing relationships between the parts of his sculptures. Some of his later mobiles, which depend on air currents to move them in complex ever-changing patterns, are arranged to clank or ring as they move.

Clearly, twentieth-century sculptors have been fascinated by the machine. Marcel Duchamp, Naum Gabo, and Calder all used motors to move their sculptures, programming their forms to move at varying speeds and through changing patterns which add a new element of time to sculpture. Carrying this idea further, Jean Tinguely produces complicated machines which may require the viewer to participate in the action and which sometimes are programmed to destroy themselves (Figure 19-5).

Mixed Media This new method of assembling sculpture out of found objects and different materials led to what are called mixed media constructions or assemblages. In these constructions sculptors use materials that have never been considered sculptural or artistic before. Sometimes objects are combined with painted canvases, making the line between painting and sculpture difficult to draw at times. For example, is Robert Rauschenberg's *Pantomime* (Figure 19-15) a piece of sculpture or a painting? When he attaches an electric fan to a canvas, in what category do you place the work?

Three-dimensional canvases, constructed on frames and painted in the artist's individual style, are difficult to classify. Are they dimensional paintings or painted sculptures? Lee Bontecou's canvases have a resemblance to primitive masks. Her technique, which involves stretching and gluing fabric over a wire frame skeleton, is similar to early aircraft construction. Using this method, Bontecou creates openings which can be interpreted as eyes, mouths, entrances to caves, or sexual cavities.

4-15 Lee Bontecou. *Untitled*. Welded metal and canvas, 72″ high, 66¼″ wide, 26″ diameter. Collection of Whitney Museum of American Art, New York. Photo, Geoffrey Clements.

The term *soft sculpture* may seem to be a contradiction in terms, but some contemporary sculptors create works that could be classified as soft sculpture. For example, many artists make stuffed forms of one kind or another, and some weavers make free-standing or hanging shapes which are sculptural or environmental in form. A Pop artist like Claes Oldenburg uses many materials to create his soft, larger-than-life-size sculptures of electric fans, typewriters, and other everyday objects.

4-16 Claes Oldenburg. *Giant Soft Fan.* 1966-67. Construction of vinyl with wood, foam, rubber, metal, and plastic tubing. 10′ x 10′4″ x 6′4″. Gift to The Museum of Modern Art, New York.

Among the many industrial materials used in sculpture today is plastic, which is used in a variety of ways. Whether plastic sculpture is cast in solid pieces (Plate 10), constructed out of thermally bonded sheets of plastic, built up of fiberglass and resin, or vacuum-formed with industrial packaging machines; seemingly endless effects can be achieved with this material. Lightweight and colorful, it can be used to make tiny boxes through which light filters, or it can be built up over wire mesh forms, or cast in solid, brilliantly colored, jewellike forms. Sculptors have found fascinating possibilities for expression in plastic materials and in the industrial techniques used to form them. In fact, the creations which have resulted are so varied that there is no single visual characteristic common to all plastic sculpture.

To increase their knowledge of industrial techniques, some contemporary sculptors have spent time in the laboratories and plants of large corporations studying new methods used by engineers and technicians and have collaborated with engineers to apply these techniques to art. Out of this joint experimentation may come aesthetic uses of these techniques which will not only produce great works of art, but which may in turn influence industrial and commercial products.

For example, all sculpture involves light— natural or artificial light playing over its forms and through its spaces. But new lighting techniques have been adapted by sculptors to create spatial environments. Tubing with neon gas inside can be bent and formed into any shape and when lit, such a sculpture makes a visual statement in neon lights.

Certainly more aesthetically satisfying signs could be designed by sculptors. Plastic rods can also be used to carry light from a light source at one end of the rod, or translucent colored resins can be lighted from within to create interesting visual effects in sculptural form. In Stephen Antonakos's *Red Box Over Blue Box* (Plate 39), changing waves of colored light are programmed to play over and through the sculpture. From these examples, you can see that light has been exploited by sculptors in new ways which represent their individual approaches to sculpture—some, highly organic; others, geometric; still others, mechanical.

In further explorations of contemporary technology, some artists have experimented with communications media, building rooms in which you can watch video or film images projected all around you accompanied by electric sound. Others have directed bulldozers to shape huge earthworks (Figure 1-19) or crews of workmen to hang a huge nylon curtain across a valley (Figure 19-17). All of these are new sculptural responses to space, form, and light.

So we find man again relating to his era, using the available artistic, scientific, and industrial techniques to create sculptural forms. These forms grow directly out of the methods and materials of today, just as a Greek marble carving grew out of the materials and methods available then. Sculpture, like architecture, has accepted the challenge of new methods to create totally new concepts within an ancient art.

Drawing, Painting, and Printmaking

It is not enough for a painter to be a
clever craftsman; he must love to
"caress" his canvas too.

Pierre Auguste Renoir

Drawing, painting, and printmaking—each of
these arts has its particular characteristics,
and all share some similarities. What do they
have in common? What similar skills are
required of their creators?

Traditionally, the creation of an image on a
flat surface through the application of some
kind of coloring material or pigment has been
the common element in all these arts.
Whether they are produced by drawing on
parchment or on paper; by painting on
plaster walls, wood, or canvas panels; or
through impressions printed on fabric or
paper from wood or metal plates; these
images have appeared on flat surfaces. Their
creators have translated their personal
visions to the flat surface by using brushes,
pens, or engraving tools. However, new
techniques and materials have changed the
visual forms of these arts. In addition,
changing ideas have led artists to search for
new techniques to express those ideas.

For that reason we cannot separate
completely the study of materials and
techniques from the study of forms. For
instance, the technical development of the
camera has completely changed concepts of
drawing, painting, and printmaking. No
longer does the artist play the role of
recorder of reality as he had generally been
doing since the Renaissance. At the same
time, social changes in the Western world
brought about by twentieth-century
technology have been important factors in
changing the forms of modern painting and
drawing.

We can certainly develop a greater
understanding of the art of the painter and
printmaker if we know something about the
techniques these artists have used in the
past and the great variety of methods
available to them today. When we come to
the contemporary scene, we will discover
that while many painters use familiar
methods and materials, others are
experimenting with industrially developed
techniques and other new methods of
creating images on two-dimensional surfaces.

Still others are rejecting the concept of the flat surface altogether. Thus we will find that the lines between the arts have again broken down. Sculptured forms appear on paintings; paint is used on sculpture as it was in earlier cultures; prints have become three-dimensional. Time and sound are made part of the art experience, and the viewer often becomes a participant in an environment or an event. We will examine these newer concepts of art in greater detail later in the text. Now we will take a brief look at the many technical processes used to create images on flat surfaces.

Drawing

Of all the art skills, drawing has always been the most basic. When walking on the beach, have you ever picked up a stick and drawn with it in the sand? Perhaps lines drawn on sand or in dust were human beings' first drawings. Undoubtedly our ancestors in caves picked up pieces of burnt wood, idly rubbed them on the walls, and discovered a way to make images.

Now artists have a choice of many materials with which to draw. Whatever the material used, drawings fall into three categories: (1) notes or sketches made for the artist's information, (2) drawings which are completed artworks, and (3) drawings that serve as plans or studies for other works. These last drawings may be studies for paintings, prints, sculpture, architecture, the crafts, or industrial arts. Painters, sculptors, and architects make rough sketches as source material for their final works much as writers jot down notes. Artists work out ideas with pencil or chalk—how to

5-1 Michelangelo. *Studies for the Libyan Sibyl.* 1511-12. Red chalk on paper, 11⅜″ x 8⅜″. The Metropolitan Museum of Art, Purchase, 1924, Joseph Pulitzer Bequest.

draw this part of a figure, how that shape looks combined with this one, what line best expresses an emotion. An artist's sketchbooks are full of such notes and visual ideas. Working from these notes and studies, the artist in the past would often create a full-scale drawing, or *cartoon,* of his final work. When this was accepted by the client who commissioned the work, the artist could begin work, being guided by and staying

close to his original drawing. Today, when the artist-client relationship is usually not as close, this method of working from a cartoon is less important, and the early studies an artist makes are apt to be for his own use.

Traditional Drawing Methods The lively images drawn on the walls of caves were dependent on the contour of the outline to express the action of the charging animals. Earth pigments were used to fill in the spaces between the lines with color. Some of the decoration on the walls of Egyptian tombs was drawn, then painted—using heavy outlines filled in with flat color. The same is true of the thousands of pottery jugs and drinking vessels found throughout the Greek world which were covered with fine brush drawings outlining flat areas of white, black, or red. The monks who decorated Medieval manuscripts often used brushes to outline their complex intertwined designs, while the artist drawing on silk used a brush to create the outlined figures, to fill in the solid areas, and also to write the text.

Ink Ink, the artist's basic fluid drawing medium, has been in use for thousands of years. The Egyptians drew on papyrus with carbon ink, the ancient Chinese used it on silk scrolls, and western manuscript illuminators used ink on vellum made from animal skins. Paper is believed to have been developed in China around A.D. 100 and brought to Europe with the spread of Islamic culture. By the fifteenth century, paper was manufactured in Europe, and the artist then had a wider choice of drawing surfaces and techniques. Ink was brushed onto the paper with hair brushes or stroked on with a bamboo or quill pen. Depending on the materials and techniques used, the artist was able to produce a large variety of effects ranging from broad brush strokes to delicate pen lines. By studying their ink drawings, we can see how artists like Rembrandt and Goya worked out the dramatic light and shade which they used in their prints and paintings. With ink, rich solid blacks could be contrasted with thin lines or with pure white paper areas, and an infinite range of grays

5-2 Rembrandt van Rijn. Study for *The Night Watch (The Company of Captain Frans Banning Cocq)*. 1642. Wash drawing, 12′2″ x 14′7″. Rijksmuseum, Amsterdam.

could be obtained with diluted ink. These grays are particularly characteristic of Chinese drawings which are washed onto the silk with the most subtle tone gradations. Here, again, is a case where the distinction between drawing and painting disappears.

To familiarize yourself with one of the artist's basic materials, take some paper, a brush, a pen, and a bottle of ink and experiment to see what a variety of lines and textures you can create. Try drawing with a stick or with the tip of a feather. Wet the paper and see how the brushed ink lines run into the surrounding white paper with a soft fuzzy edge. Dilute the ink and wash a tone over the entire sheet of paper. After it is dry, go back and draw with the pen. Or try drawing over the washed areas with chalk or charcoal.

5-4 Albrecht Dürer. Study for *Praying Hands,* detail from *The Assumption.* 1508. Wash drawing, opaque highlights. Albertina, Vienna.

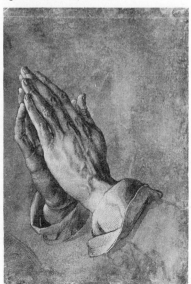

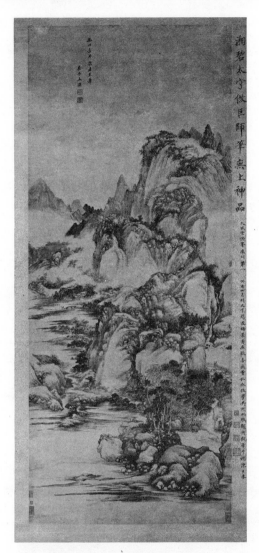

5-3 Wang Chien. Hanging Scroll. 1674. Ink on paper, 71⅝″ high, 29¾″ wide. Asian Art Museum of San Francisco, The Avery Brundage Collection.

Chalk, charcoal, and crayon Chalk, held together with a binder (such as gum arabic) and pressed into sticks, became a popular drawing material in the Renaissance. It was available in black, white, and in shades of red and brown and was a versatile material for it could be sharpened to a reasonably fine point, used bluntly, or rubbed on its side across the paper to cover large areas. Chalk could also be used strongly and vigorously or with a light and delicate line. Many chalk drawings by the greatest artists of the Renaissance still exist, and in them we can see how artists such as Leonardo studied a series of heads, or Michelangelo worked out the twist of a body or the detail of a foot for a figure he planned to paint in the Sistine Chapel (Figure 5-1). We are brought very close to the creative sources of these Renaissance artists when we see the chalk studies they made for paintings or sculpture.

Charcoal was improved from the crumbly pieces our ancestors found in the ashes of a fire to a specially prepared stick made from hard close-grained wood. Artists find charcoal an easy material with which to work and one which can produce many different effects. Because the artists can develop a wide range of light and dark values with charcoal, it is especially useful in drawing large areas of light and shade, or, if sharpened with sandpaper, it can be used for linear drawings. Smudged and rubbed into the paper it can create hazy effects. Traditionally, a popular way to use charcoal was to draw with it on gray textured paper and add white chalk highlights. One drawback to charcoal is that it smudges more easily than other drawing materials do.

Consequently, charcoal drawings need to be sprayed with a fixative to prevent them from smudging.

Wax crayons have an advantage over charcoal in that they do not smudge or rub off the paper as easily. Crayon is useful for drawing large areas of light and shade. With it the artist can create rich shining darks or, if it is handled lightly, soft grays.

5-5 Georges Seurat. *Café Concert.* c. 1887. Conté crayon, 12″ x 9″. Museum of Art, Rhode Island School of Design, Providence, R.I. Gift of Mrs. Murray S. Danforth.

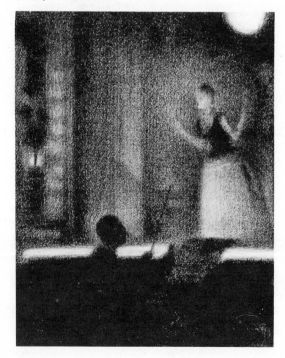

Pencil Before the lead pencil was invented, artists used silver-tipped tools to draw on paper coated with white or tinted pigment. This *silverpoint* technique created very fine, delicate lines, comparable to thin pencil lines and is still used by artists who wish to draw detailed images. The earliest pencils were lead points in a holder, but by

5-6 Jean Auguste Dominique Ingres. *Madame Destouches*. 1816. Pencil drawing. Cabinet des Dessins, Musée du Louvre, Cliché Musées Nationaux.

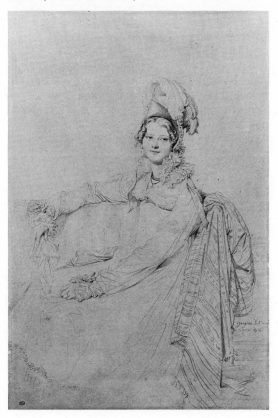

the eighteenth century the graphite pencil was widely used. Its wood-encased point creates lines which can be thin and hard or smudgy and soft. Nowadays pencils are sold in grades ranging from the soft 6B to the hard fine-pointed 9H. Pencil does not smear as much as chalk or charcoal. Though it is particularly good for small sketches and detailed drawings, it is not very useful for larger drawings because it takes a long time to cover large areas with it. However, the pencil stands on its own as an art medium as is demonstrated in this drawing by Ingres.

New Combinations of Materials and Techniques Today many drawing methods are used in unorthodox ways and are combined to produce a multitude of effects and textures. Ink and chalk drawings may have bits of photographs or magazine illustrations pasted on them. Pencil drawings can be combined with commercial overlays of printed dot patterns like the screens used in magazine and newspaper reproduction. Artists sometimes draw with matches dipped in ink or blow fine mists of ink onto paper with airbrushes. Many painters like to draw with the same brushes with which they paint, thereby making it difficult to say at what point drawing ceases and painting begins. These new methods have given artists great freedom to express new changing ideas. Drawing remains a vital skill for all those working in the visual arts.

5-7 Roy Lichtenstein. *Pistol*. 1964. Banner in red, black, and white felt, 82″ x 49″. Collection, The Museum of Modern Art, New York. Gift of Philip Johnson.

Drawing as a Planning Aid Drawing is an important planning aid for artists in many fields. For example, without some skill in drawing the architect or industrial designer would have a difficult time working out his ideas or communicating them to the people who will construct the final works. Plans for buildings, sketches of furniture or utensils, rough layouts for advertisement—all these depend on drawing in one way or another. Thus, skill in drawing is not only necessary to the painter, sculptor, and printmaker, but it is essential to those creating in other materials as well.

Painting

When you think of painting, color is what you usually think of first. Certainly it is the element which is basic to all painting. Drawings sometimes have color, but paintings almost always do. Painting can be defined as the art of spreading pigment on a flat surface using color, shape, and texture to achieve aesthetically satisfying images. As we saw in Chapter 1, a painting need not be pleasing to be aesthetically satisfying. Its subject matter or emotional content may produce sensations of horror, yet the composition may be organized successfully from an aesthetic point of view, and color will play an important part in the successful communication of emotion.

Color in paint is produced by dry pigment suspended in a *vehicle*. Various methods of painting—fresco, oil, tempera, watercolor—differ in the vehicle used and the way it is applied to whatever surface is utilized. Pigments are made both from organic and inorganic substances. Artists in the past used colors derived from pigments that were available in their particular part of the world, so that the colors used in painting were limited by the available pigments. Prehistoric painters mixed charcoal and earth pigments with a binder such as fat and spread them on the walls of caves (Figure 8-1). Egyptian paintings were done on dry plaster with

pigments mixed with limewater in an early attempt to produce durable paintings on the walls of the tombs. The dryness of the Egyptian climate and the sealing of the tombs have combined to keep these paintings fresh through thousands of years (Figure 2-14). Painters have used ground-up beetles, the urine of cows fed on mango leaves, and a variety of plants in their search for coloring materials. Lapis lazuli, a semiprecious stone, was ground and purified in Medieval times to produce a beautiful blue pigment. Because of its expense, this paint was usually reserved for the cloak of the Virgin Mary. Even today, the earth provides pigments like yellow ochre and raw or burnt umber. Minerals such as zinc, cadmium, and cobalt produce a variety

of colors. Coal tars are another important pigment source. In the past the painter's craft included grinding his own pigments and mixing them with whatever vehicle was needed to spread them, but today most artists use commercially prepared paints with the vehicle already mixed in them. However, dry pigments are still used when an artist paints in fresco or tempera.

Fresco Fresco is an Italian term meaning fresh and is used to describe the technique of painting on freshly plastered walls. As far as we know, the earliest true frescos were painted on the walls of the famous Palace of Minos in Crete.

5-8 *Bull Leaping* (reconstruction). Knossos. Fresco. The University Museum, University of Pennsylvania.

To produce a fresco, the artist mixes his pigments with water or limewater and then spreads them on freshly applied wet plaster. The painting of fresco that results is extremely durable because the pigments and plaster combine to create a strong surface. In fact, the painting's colors literally become a part of the wall as it dries. This means that an artist must know exactly what he wants to paint before he begins. In addition, since the pigment has to be brushed on when the plaster is wet, only an area large enough to be painted in one day is plastered at a time.

Usually the artist prepares a full-sized cartoon or sketch before starting work on a fresco, and from this cartoon an outline is drawn on the section of the wall to be painted each day. If you look closely at a frescoed wall, you can often see lines where one day's plastering stopped and the next began. Usually the artist tries to conceal these lines by having them occur along the contours of shapes in the painting. The way in which the wall was prepared and plastered and the paint applied affects a fresco's durability, and as a consequence, some frescoes have lasted better than others.

Fresco was an important painting technique in the Greek, Roman, Medieval and Renaissance periods and was revived in Mexico in the early part of this century. Michelangelo's religious figures (Figure 11-13) and Orozco's revolutionary heroes (Figure 17-15) were painted with the same basic technique, though they differ in the way each individual artist expressed emotion.

5-9 Domenico Ghirlandaio. *Birth of the Virgin.* 1491. Fresco. S. Maria Novella, Florence. Photo, Alinari.

Fresco is still used today for murals, though it is not as common a technique as it once was. Sometimes there is confusion between the terms *fresco* and *mural.* A mural is any painting done on a wall, but a fresco is always painted on fresh plaster.

Tempera When you hear the term *tempera,* you probably think of the jars of poster paint you used in grade school. Actually these paints are not true tempera as the term is used historically. The traditional tempera technique uses egg yolk as the binding material, though gum and casein have also been used. Applied to a properly prepared surface, called a ground, egg tempera is very durable. It became popular for small paintings because the ground could be painted on wooden panels. The wood first was coated with gesso—a mixture of white pigment (chalk, plaster, or white clay) and an animal glue. The correct preparation of the gesso ground was important. Incorrectly mixed gesso could cause cracks to develop all over the painting. After the ground was prepared, dry pigments were mixed with egg yolks and water and painted on the absorbent gesso. Sometimes the egg yolks were mixed to create an emulsion with oil and varnishes. This method of painting with egg tempera was used widely in the Medieval period for altar paintings on wood. Later painters used tempera on canvas. However, this method has proven to be less durable than tempera on wood.

In the early method of painting with tempera, usually dark and light values were built up with an underpainting of umber pigment. Colors were then painted over this undercoat. Brilliance and crispness are characteristic of tempera paintings, and, although this technique fell into general disuse with the development of oil painting, there are some contemporary painters, such as Andrew Wyeth, who still use it because of its precision.

Oil Painting Developed and refined in Flanders in the fifteenth and sixteenth centuries, oil painting was an outgrowth of the commercial developments of that period. Trade with many parts of the world brought new materials to Europe, including those from which oils and varnishes could be extracted. Oil paints consist of a mixture of dry pigments with oils and sometimes varnish. The transition from tempera to oil was slow, with oil paint first being used in transparent glazes over a tempera underpainting. Solid form was modeled with tempera, and the final painting was done with thin oil glazes. Layers of semitransparent glazes of warm and cool colors placed on top of each other imparted a rich glow and depth to the painting.

Canvas generally replaced wooden panels in the sixteenth century, and from then on oil painting became the most widely used technique in Western art. Although oil paint on canvas is not as durable as fresco or tempera on wood, oil techniques offer great advantages and variety to the painter. Oil paint dries slowly and can be worked on for a long time. It can be applied in thin glazes over underpainting, or it can be put on in thick layers with a brush or palette knife. It allows a wide range of tones from light to dark. Thin, transparent dark shadows can be contrasted with thickly applied highlights, a combination which was unobtainable with

5-10 Andrew Wyeth. *Christina's World.* 1948.
Tempera on gesso panel, 32¼″ x 47¾″.
Collection, The Museum of Modern Art,
New York.

5-11 Franz Hals. *The Bohemian. 1628-30.* Oil,
22¾″ x 20½″. The Louvre, Paris. Cliché des
Musées Nationaux.

earlier methods of painting. Rembrandt made full use of this quality of oil paint in his contrast of deep mysterious shadows and brilliant light areas (Plate 4).

Later painters, instead of using underpainting and glazes, applied the paint directly to the canvas with free brush strokes. For example, the Impressionists created an effect of vibrant light by placing small thick strokes of complementary colors next to each other (Plate 7). *Impasto,* or heavily applied paint, became a popular technique with some painters—Van Gogh in particular applied his paint with a palette knife. With this change to direct techniques, painters generally became less concerned with the craft of painting than with the immediate effects produced, and many carelessly painted works from the eighteenth and nineteenth centuries are cracking. Very heavy paint is particularly apt to crack if not applied properly, and some colors will darken and bleed through into each other.

As is apparent even in this brief discussion, oil painting lends itself to a variety of visual effects and surfaces. It is not surprising, then, that this technique has been used so widely since its development.

Watercolor Painting Watercolor paints are made of pigments with a binder which can be diluted with water, such as glue, egg white, or gum arabic. Washed over a white ground which shows through the transparent pigments, these paints produce paintings of distinctive freshness, clarity, and transparency—qualities which can be easily lost if the painting is worked over. Watercolor has been used in the West since classical times, and almost all Medieval manuscript illustrations were done with watercolor (Plate 14). Watercolor paintings using nonfading pigments on good quality papers are remarkably permanent.

5-12 Paul Cézanne. *The Basket of Apples* (detail). 1890-94. Oil on canvas, 25¾″ x 32″. Helen Brich Bartlett Memorial Collection. Courtesy of the Art Institute of Chicago.

In the Orient, watercolor has been the most important painting technique for centuries (Figure 14-29). The basic pigment used is a mixture of lampblack and glue formed into a block, although colored pigments have also been used. Often working on a surface of silk, the artist used a combination of brush drawing and painting. Years of training prepared him to use the brush skillfully to create the expressive lines so characteristic of Oriental painting. Unlike most Western painting, color was not used in an effort to represent reality. Suggestion has always been more important than representation in Oriental painting.

For some time after oils became so popular in Western painting, watercolor was used primarily for sketches. It is a quick, spontaneous technique which lends itself well to the notes an artist might make as studies for an oil painting. In the eighteenth century, however, watercolor was revived as an important art medium. For example, William Turner used watercolors to create misty paintings which were forerunners of later Impressionistic works (Plate 11). Even though the variety of effects possible with transparent watercolor is not as wide as is possible with oils, artists in different periods have used it in divergent styles to serve their

5-13 John Marin. *Echo Lake, Franconia Range, White Mountain Country.*
National Gallery of Art, Washington, D.C., Alfred Stieglitz Collection.

individual purposes of expression.

Watercolor is also used in thinly diluted form in wash drawings to provide a wide range of tones. The term may imply a contradiction, yet a wash may be used to reinforce a line drawing. *Gouache* refers to watercolors mixed with some form of white pigment. Since the paint is opaque, the light is not reflected from the white paper under it. Because of its opaque quality, gouache can be worked over more than transparent watercolors. However, since all the colors are mixed with white to make them opaque, the range of values is limited and the overall effect is rather light and dry. School poster paints, which are sometimes incorrectly called tempera, are usually a form of gouache.

Pastels In their present form pastels date back about two hundred years. Applied with sticks of color, pastel painting depends more on broad areas of color for its effects than it does on drawn outlines. It is a method of painting with pure color or pigment without any vehicle like egg or oil. There is just enough gum binder used in pure pastel to form it into sticks. As a consequence, the colors do not suffer from darkening or from other effects of age. When high-grade paper and nonfading colors are used, pastel is one of the most permanent types of painting from a chemical point of view, but it is not physically very durable unless protected by glass or by a fixative sprayed on the surface. Because of its brilliance of color and freshness of application, pastel appealed to Impressionist painters, to whom it was

important to capture a momentary effect (Plate 12). Some newer chalk crayons are referred to as pastels, but most of these mix wax or oil with the pigment and are not true pastels.

New Materials Artists are constantly looking for new ways to express their responses to inner emotions and to the outer world, and this includes a search for new materials. For example, Jackson Pollock (Plate 2) used house paint and metallic enamels in huge canvases on which he dribbled and flung the paint in complex interweaving rhythms. New synthetic materials have given twentieth-century artists a wide choice of effects—some painters even pour polyester resins colored with dyes onto fiberglass cloth instead of canvas.

The most widely used synthetic paints today are the acrylic and pyroxylin paints. These paints have greater durability than oils and can be used on a wide range of surfaces. In addition, the acrylics, which have brilliant color, can be used either like transparent watercolors to allow the white of the canvas to show through, or they can be built up in thick impasto effects (Plate 13). Thin glazed areas can be contrasted with heavily textured areas. Since the paint dries rapidly, it can be worked over in a matter of minutes, and many layers of paint can be built up. As artists continue to experiment with the synthetics, the range of possible effects is constantly being expanded. Though painting with synthetics has in no way replaced oil painting, these new paints and techniques have greatly expanded the artist's technical means of expression.

Mixed Media As in drawing and sculpture, the freeing of art from its traditional boundaries led to experiments in combinations of materials in painting. In the early years of the twentieth century, Picasso and other painters began to add paper and other materials to their paintings. They called these works *collages,* from the French word for glue. Painters today combine varied materials—metal, fabric, wood, paper—as well as actual objects in assemblages (Figure 19-15). Others use three-dimensional canvases (Figure 4-15) which bring *actual* space into the painting instead of creating the *illusion* of space with paint. Objects are glued, stapled, nailed, or even welded onto paintings. Images are sometimes photo-printed onto paper, canvas, or plastic to become part of an assemblage. What can we call these paintings? The usual term is *mixed media,* which is a convenient way to get around the problem of how to classify many works of art today.

New Ideas, New Images

Changes in twentieth-century painting are not only the result of technical inventions, greater freedom of expression, and new materials, but also of the changing concepts of the role of the artist and of painting. For several centuries artists were concerned with how to paint the illusion of three dimensions on a two-dimensional surface. The Greeks and Romans used a limited form of linear perspective, which Renaissance painters developed to a science. Leonardo da Vinci and Albrecht Dürer wrote treatises on the scientific aspects of painting, and rules for

5-14 Jim Dine. *5 Toothbrushes on Black Ground.* 1962. Oil on canvas and collage, 4″ x 3″. Sidney Janis Gallery, New York. Photo, Eric Pollitzer.

perspective were set down. To Leonardo, "The first requisite of painting is that the bodies which it represents should appear in relief, and that the scenes which surround them with effects of distance should seem to enter into the plane in which the picture is produced by means of the three parts of perspective. Namely, the diminution in the distinctness of the form of bodies, the

diminution in their size, and the diminution in their color. . . .'' Mechanical devices were developed to help the artists work out problems of perspective and proportion.

Alberti, a Renaissance architect who also wrote a treatise on painting, said that painters ''have no other aim but to make the shapes of things seen appear on the surface of the picture not otherwise than if this surface were of transparent glass.'' From the time of the Renaissance the artist held up a mirror to nature and then surrounded the painting with a frame. When you stand in front of a picture painted in the Western world between the Renaissance and the late nineteenth century, you seem to be looking through a window onto the scene in front of you. The painting is a bit of framed space, a window on reality. This window concept of illusionistic painting persisted for five hundred years. Artists even placed painted windows behind a portrait of a patron or a Madonna in order to be able to paint a landscape which could go back miles in depth. Although Impressionist painters were less concerned with solid form than earlier painters had been, they still created a framed window in which the viewer's eye was carried through the wall of a room into a painted illusion of space.

With the invention and widespread use of the camera, Western artists no longer saw themselves as skilled recorders of that real world beyond the window frame.

5-15 Robert Delaunay. *Window on the City, No. 4.* 1910-11. Oil on canvas, 44¾'' x 51½''. Collection, The Solomon R. Guggenheim Museum, New York.

Printmaking

We are exposed to millions of printed images in our daily lives. Cereal boxes, posters, soup cans, and magazines all speak to us through the printed images. Though the dependency of our society on the printed image is a recent phenomenon, the process of printing images on paper or fabric is ancient. Printing, if defined as a method by which we can reproduce the same image over and over again, has existed since the earliest days in Egypt, China, and India. Originally used on textiles, the printing technique was later applied to paper and eventually developed into modern commercial printing methods in which images are repeated millions of times. Early prints on paper in the Western world were made for the purpose of communicating information or opinion, just as our modern high-speed presses are used today to communicate information through newspapers, books, or magazines. Printing was used during the fifteenth century to make playing cards and religious souvenir pictures, and as paper became generally available in Europe, hand-lettered and illustrated manuscripts gave way to books printed with movable type with woodcuts for illustrations.

Commercial printing methods and artistic printmaking have been closely related throughout history. Artists have quickly adapted new techniques developed in commercial printing to their own use. There are many methods by which multiple prints may be made, and each method affects the appearance of the final print. Today many artists use traditional methods of printing which have been discarded by commercial printers as too slow and laborious. Some artists print their own work; others have their work reproduced by master printers trained in the particular technique the artist chooses to use.

Since printmaking makes use of drawing skills, it is sometimes difficult for the beginner to identify whether a particular work is an original drawing or a print. However, a familiarity with printmaking and with some of the most common printing techniques used by artists can be helpful in recognizing prints.

Relief Printing This is the oldest method of printing and includes all forms of block printing. Woodcuts, wood engravings, and linoleum blocks are the most common types of relief printing. In this process artists use sharp gouges to cut into the wood. Ink is then spread on the block, paper laid over it, and the ink transferred to the paper by pressure. It is the wood that has not been cut away that holds the ink and prints it on the paper. As in most printmaking methods, the printed image that results is a reverse of the original. In the fifteenth and sixteenth centuries woodcuts produced in this way were used for book illustrations and for single religious prints in Europe. Some of these were printed in editions of thousands and sold at popular prices. Later, such prints were used to illustrate political handbills, particularly during the French Revolution and in Mexico. Woodcuts were commercially discarded in the Western world when steel engraving was developed, but artists have continued to use the technique.

5-16 Katsushika Hokusai. *Fuji Seen from the Bottom of a Wave.* 1823-29. Woodblock, 9⅞″ x 14⅞″. The Metropolitan Museum of Art, Rogers Fund, 1914.

In the Orient, woodcuts have been a significant artistic technique for centuries. There, these prints have filled the need for inexpensive art for people who could not afford painted scrolls. Some Oriental woodcuts were printed with black outlines to which colors were later added by hand. Others were produced by cutting a block for each color and running the print through several printings, changing blocks and ink colors for each run. When Japanese prints came to the Western world after Japan was opened to world trade in the nineteenth century, Western artists revised woodblock printing as an expressive art technique.

Etching and Engraving In etching and engraving the ink is forced into grooves in metal plates. When damp paper is forced down onto the plate by a press, it picks up the ink from the grooves. Thus in a sense this process is the opposite of the woodcutting process, for in etching and engraving the ink reproduces what is cut *into* the metal plate, while in woodcutting the ink reproduces the wood which has been left standing.

The differences between etching and engraving lie in the different processes used to cut the image into the metal plate. In etching, the metal plate is first coated with a waxy acid-resistant substance, called a *ground.* The artist draws his image on the

5-17 Rembrandt van Rijn. *Three Crosses.* c. 1660. Etching. British Museum, London.

coated plate by removing the ground with a fine needle. As a result, when the plate is placed in an acid bath, the acid can reach the metal and eat into it wherever the artist has drawn lines and removed the ground. Thus the artist's drawing is etched into the metal by the acid. After removal of the remaining ground, the plate is inked and the print made, or pulled, from the plate.

In engraving the grooves in the plate are made by digging directly into the metal plate with special sharp tools.

In both etching and engraving the artist builds up areas of darks by placing many lines close together. Also, in both processes the ink is lifted out of the grooves by the

pressure of the press and stands out on the surface of the paper, giving the image a sharp definition. It can often be felt as a raised line when you run your finger over it. There are also methods, called *mezzotint* and *aquatint,* by which large areas of the plate can be roughened so that the ink adheres to a whole area and is printed as flat tone. In the etching by Rembrandt, the artist has employed both line and aquatint to create dramatic images through the use of intense light and shade.

Engraving was first developed as a popular commercial method and was used for illustrations by artists like Albrecht Dürer, who produced hundreds of religious

5-18 Albrecht Dürer. *The Triumphal Arch of the Emperor Maximilian*. 1515. Woodcut. 11' x 9'7''. National Library of Austria, Vienna.

engravings. Editions of thousands of prints from one plate were not unusual. Much finer detail is possible in the engraving process than with the woodcut. This helps explain why engraving quickly became a popular technique. Later, engravings were used for reproductions of artworks. The steel engraving of a sentimental scene was an important decoration in Victorian homes. However, few artists today are concerned with such fine detail, and most prefer the popular etching process. Artists like Matisse and Picasso have illustrated books with etchings as well as producing limited editions of individual etchings and lithographs.

Lithography Lithography takes advantage of the natural antipathy of oil or grease toward water. Limestone slabs or sensitized metal plates are used as the drawing surface. The artist draws with greasy crayons or a special ink called *tusche*. Then a solution of nitric acid is applied to the stone or plate to make the sections which have not been drawn on resistant to the printing ink. The stone is kept wet with water during the printing process. The greasy ink adheres only to the crayon image and is repelled by the wet areas of the stone. When the stone and paper are run through a press, the paper picks up the ink from the drawn image, reproducing the artist's work. If the stone is not kept wet, it will print solid black, as any printmaker quickly learns.

5-19 Edvard Munch. *The Shriek*. 1896. Lithograph, 20⅝'' x 5 13/16''. Collection, The Museum of Modern Art, New York. Mathew T. Mellon Fund.

5-20 Honoré Daumier. *Rue Transnonain.* 1834. Lithograph, 11¼″ x 17⅜″. Philadelphia Museum of Art: Bequest of Fiske and Marie Kimball.

The direct drawing method of lithography allows the artist a great deal of spontaneity and variety of expression. The drawing crayons are made in varying degrees of hardness, and when stroked onto the grainy surface of the stone, they can create tones ranging from soft grays to rich heavy darks. Crayons can be used on their sides to texture large areas of gray, and details can be drawn in with a pointed crayon or a pen dipped in tusche.

When lithography was invented in the 1800s, it immediately became popular for illustrations in newspapers and magazines and gradually replaced engraving, because it is quicker and easier to draw with crayon on a stone slab than to engrave lines into a metal plate. Daumier, for example, used the lithographic process to comment on the society in which he lived. His prints were usually political or satirical and were often very strong in emotional content. He

exploited the dramatic potential of lithographs to create an atmosphere of horror in this newspaper illustration for April 15, 1834, depicting the murder of a worker and his family by government troops. Another type of expression can be seen in the lithographs of M. C. Escher, who used this technique to create a new world in which staircases lead the eye through optical illusions, and fish turn into birds.

Some artists print their own lithographs, developing and changing the images as the prints are pulled, while others draw the image exactly as they want it to appear and turn the stone over to a master printer for reproduction. Color lithographs are produced in the same way as black and white prints, except that they require a new drawing for each color to be printed.

5-21 M. C. Escher. *Belvedere.* 1958. Lithograph, 18⅛″ x 11⅝″. Courtesy of the Vorpal Galleries, San Francisco and Chicago.

Print Editions Originally used as a means of reaching a mass audience with thousands of copies of an image, these printing methods are now used by artists to print limited editions. Generally, an artist numbers each print to indicate how large an edition was printed and the order in which prints were pulled. Thus 2/50 on a print means that this is the second print in a limited edition of 50. Prints are generally less expensive than paintings since they are produced in multiples, and many people who cannot afford a painting can own a signed and numbered print.

Silk Screen Silk screen is a twentieth-century commercial process which has been adopted by artists. Used commercially, it can print images onto T-shirts, cheese glasses, and all kinds of materials which could not be printed on by any other process. With it artists can create multiple color prints with complex images.

 The screen itself is made of fine silk stretched on a frame. Stencils are cut into a special film which is then fixed to the screen, or they are painted directly onto the silk with glue. The stencil prevents the paint from going through onto the material to be printed. Thus, what prints is the area not covered by the stencil. If the stencil is brushed on with glue, a free-flowing, loose image can be created. With a film stencil, the edges are hard and sharp. The paint, which can be thick and opaque or thin and transparent, is rubbed across the silk with a rubber squeegee and transferred directly to the

5-22 Frank Stella. *Lincoln Center Festival '67*. 1967. Poster, offset lithograph, 44¾" x 29½". Collection, The Museum of Modern Art, New York. Gift of List Art Posters.

paper underneath. To produce multiple-colored prints the artist uses several stencils as well as printing transparent colors over each other.

Silk screen is a particularly popular printing technique for posters because of the ease of printing large, flat color areas. However, it can also be used with a great deal of subtlety, and the prints often appeal to us through the rich colors and varying textures the artist is able to produce with this medium.

Mixed Media Collages of various materials can be glued onto metal or wooden panels, then inked and run through a press to produce unusual textures. A new and freer way of printing, this process is called *collography*. The potential for this technique is limited only by the inventiveness of the designer. Collography can also be combined with other printing methods. Or, prints can be given a raised surface by printing damp paper under strong pressure onto carved wood blocks to which textured materials such as metal scraps, screening, or heavy twine have been glued.

Silk screens and lithographs have been used to print flat cut-outs complete with slots and tabs that can later be assembled into three-dimensional objects. Thus the artist,

instead of trying to produce an illusion of solidity through the flat image of a print, creates a printed image that becomes a three-dimensional object itself.

Other printing techniques, such as photo-printing, are used by artists in ways which make it difficult to classify the artwork that results. For example, photos printed on cloth which is then cut out, sewn, and stuffed, become sculptural forms; prints on Styrofoam produce three-dimensional objects.

As in all the arts today, the materials and techniques available to painters and printmakers are almost unlimited. This produces an atmosphere of experimentation and freedom which makes for great vitality and variety in the images which artists create today.

5-23 Katinka Mann. *Presence*. 1969. Intaglio and mixed media, 23″ x 26″.

Art through a Lens

The medium, or process, of our time—electric technology—is reshaping and restructuring patterns of social interdependence and every aspect of our personal life. It is forcing us to reconsider and re-evaluate practically every thought, every action, and every institution formerly taken for granted. Everything is changing—you, your family, your neighborhood, your education, your job, your government, your relation to "the others." And they're changing dramatically.

Marshall McLuhan, Quentin Fiore

The camera lens, whether used for still photographs, films, or television, probably has shaped our lives in the twentieth century as much as any other single invention. Through the photographic image we have all been exposed to people, places, and ideas that we might never have been exposed to otherwise. Much of our understanding of the world in which we live comes to us through the lens. In fact, we are surrounded by camera images to such an extent in our daily lives that few could question Marshall McLuhan's view that "the medium is the message."

In this chapter we will explore how the camera lens records images on still and motion film as well as how it transmits images to the television tube. The aesthetic considerations which we will discuss in relation to still photography and film apply as well to the electronic medium of television.

Still Photography

Photography is both a complex science and a new art medium. As a science it depends on laws of physics involving the passage of light through a lens. Light transfers the image "seen" by the lens onto sensitized film, and this image is then made visible and permanent by chemical treatment.

The photographic image is a product of scientific laws and experimentation, but it can also be a work of art whose expression is limited only by the creativity and imagination of the individual photographer. Though it is true that a camera more or less accurately records what it is trained on, the same subject can be interpreted in as many ways as the varying visions of each photographer. Like all other artists, he decides what image to portray, what to emphasize or eliminate, and what viewpoint would be most expressive.

In this way, the photographer's creativity transforms the mechanical aspects of photography into a fine art, separating the snapshot from the work of art and the mass of recording pictures which surround us from the truly expressive photo-image.

Photography is also a useful research tool for the scientist engaged in investigating space, the subterranean depths of the seas, or the life of microscopic organisms. In addition, photography acts as a recorder, documenting the events, people, and places of history as it is made.

In still photography the camera immediately promises the photographer some degree of success in the translation of the artistic vision into visible form because part of the process of recording the subject has been assumed by mechanics. The ease with which we can trip a camera shutter may make photography seem like a simple push-button art. It is true that if we are lucky, we can expect some positive results almost from the start, but for a photographer to be able to exploit all the creative potentials of

photography, great technical knowledge and expertise are required. Yet even complete technical knowledge cannot guarantee masterpieces. A work of art in photography, as in other arts, is the result of a combination of its creator's personal vision, ability to express emotion in visual images, and technical skill.

The principle of the camera dates at least as far back as the Renaissance. At that time the artistic preoccupation with the creation of an illusion of depth on a flat surface led to the development of a device called *camera obscura*, literally dark room. By reproducing exactly the scenes they wished to portray, this device helped artists to render three dimensions on a two-dimensional surface. As Leonardo da Vinci described the principle, light entering a tiny opening in one wall of a

AIDS TO DRAWING.—FIG. 8.—THE CAMERA OBSCURA.

6-1 Wood engraving of a camera obscura from *The Science Record for 1874*. International Museum of Photography at George Eastman House.

6-2 Daguerre. *Interior of a Cabinet of Curiosity.* 1837. From the collection of Société Francaise de Photographie.

6-3 Nadar. One of a series of portrait photographs of Sarah Bernhardt. Late nineteenth century. Caisse Nationale des Monuments Historiques.

darkened room forms an inverted image of the outside scene on the opposite wall. This could be traced, and the tracing would give the correct perspective for a painting. Later, artists found that if a lens replaced the pinhole opening, a clearer image could be produced.

However, it was not until the nineteenth century that a way was found to capture an image on a sensitized surface. Though Thomas Wedgewood had earlier been able to create impermanent solar pictures, the first *fixed* camera image was probably produced by Joseph Nicéphore Niepce in 1826, followed shortly thereafter by Louis Jacques Mandé Daguerre. By 1837 Daguerre had made a detailed picture of a corner of his studio using a modification of Niepce's invention. He considered the production of a daguerreotype to be "a chemical process which gives Nature the ability to reproduce herself." Daguerre's pioneer photograph is outstanding in its composition, in its reproduction of depth, and in the range of its textures.

As the technique of photography improved and permanent images of people and places could be made, many painters decided that their traditional function as recorders of reality was no longer valid, since the camera appeared able to replace them. Photographers began to use the new invention to produce work which reflected the traditional art concepts of the period. Early creative photographers worked largely in the area of portraiture, and despite the limitations imposed on them by these artistic traditions, many created portraits of great sensitivity and aesthetic appeal, often revealing the inner character of their subjects through expressive use of pose, lighting, background, and point of view. For example, in Nadar's portrait of Sarah Bernhardt the photographer has shown us much more than Sarah Bernhardt's physical beauty by capturing the pensive and poetic qualities of the famous actress. A broad range of tones, from black through grays to white, appears in the draperies and diverts the viewer's eye. After scanning the draperies, however, our eye returns with renewed interest to the intense personality revealed in the face.

Through the technical experiments made by photographers in the 1850s and 60s a way was found to shorten the time needed for the picture-taking process. No longer did the subject have to sit still for such a long period of time. This technological advance made it possible for photographers like Mathew Brady to record the horrors of the American Civil War, which he did with great expressive power.

By the last part of the nineteenth century, photographers no longer attempted to duplicate older forms of art, and photography emerged as a new type of artistic expression. American photographers like Alfred Stieglitz, Edward Steichen, Paul Strand, and Edward Weston did not view photographs as duplications of realistic paintings. Instead, they felt that photography could present more expressive views of commonplace scenes like *The Terminal* and began to use the camera as a creative tool which did not rely on the past for its images. For example, Ansel Adams brilliantly

6-4 Mathew B. Brady. *Ruins of Richmond, Virginia*. Albumin print from collodion negative. Collection, The Museum of Modern Art, New York.

6-5 Alfred Stieglitz. *The Terminal*. 1893. International Museum of Photography at George Eastman House.

6-6 Ansel Adams. *Half Dome and Moon.*

demonstrated the potential of photography as an art form with prints which appear to extend the range of black and white tones into infinity.

Applying these standards of creativity, photographers have expanded the expressive use of the camera in the documentation of history. During the depression of the 1930s, Dorothea Lange recorded the anguish of a migrant farm worker with a portrait that has since become a classic. Her field notes describe this migrant mother: "Camped on the edge of a pea field where the crop had failed in a freeze, the tires had just been sold from the car to buy food. She was 32 years old with seven children."

Later, Margaret Bourke-White, Bernice Abbott, Frank Duncan, and many others earned international reputations as creative documentary photographers who interpreted the events, people, and places of the world around them with sensitivity and creativity. The news photo has now become an important part of our lives through its ability to capture a moment of history and to express visually what is often inexpressible in words.

6-7 Dorothea Lange. *Migrant Mother, Nipomo, California.* 1936. Photograph, 12½" x 9⅞". Collection, The Museum of Modern Art, New York.

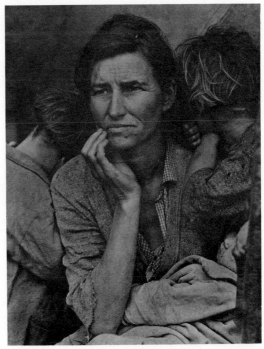

Technical Aspects of Still Photography

Basic photographic equipment consists of a camera with a lens, shutter, and diaphragm openings; films (or plates); filters to control or alter lighting; papers on which the image is printed; and the chemicals needed to process the film.

Still Cameras The camera is surprisingly similar to the human eye. In its simplest form it is a mechanical device based on the same physical principles which enable the human eye to transmit images to the brain.

A simple box camera has a fixed lens and a nonadjustable aperture, or opening, that admits light rays which are then focused on light-sensitized film at the back of the camera. The viewfinder allows the photographer to see what the final image will be. The first photographers had to compose their pictures through large viewfinders that reproduced images the size of the intended photographic prints. Early cameras were bulky, but with the development of more sophisticated portable cameras which allowed pictures to be taken almost anywhere and without heavy equipment, candid photography revolutionized the medium. Many cameras today can be fitted with alternate lenses of different focal lengths for near, far, or detailed subjects. Some are equipped with photoelectric cells that can control the intake of light and change the shutter speed automatically. There are even some cameras capable of processing the film and producing photographs in a matter of seconds. The most complex cameras can be operated by remote control and are designed to probe unknown areas when used in conjunction with instruments of science like the telescope and microscope.

6-8 A comparison between the human eye and the shutter of a camera.

 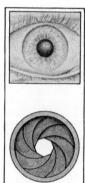

The parts of a camera The lens components are the most valuable feature of a camera. Although even a pinhole will produce an image, a good lens concentrates the light more rapidly, admitting more light in less time so that even dim, moving objects can be photographed. Telephoto lenses permit detailed views of distant objects by magnifying them, while wide-angle lenses enable the photographer to focus on broader subjects in close range than standard lenses do. Fish-eye lenses are an extreme form of wide-angle lenses which distort subjects by magnifying only the central portion of the total image.

Other important parts of a camera are the shutters and diaphragms which control the size and speed of the camera aperture at the moment of exposure. The size of the opening and the length of time the shutter is open regulate the amount of light reflected from the subject onto the unexposed film.

Though inexpensive, nonadjustable cameras have only one aperture size and one shutter speed, most cameras allow considerable choice in lenses, focus, shutter speed, and so on, giving the photographer a great deal of flexibility with which to meet his expressive needs. Depending on the refinement of the camera, shutter speeds can range from 1/1000 to ½ of a second, with additional mechanisms for time exposures. The size of the aperture opening is indicated by the F-stop numbers on the lens control— the larger the F-stop, the smaller the opening.

Film Black and white film is formed from an emulsion of light-sensitized crystals (silver-halide particles) embedded in gelatin and laid upon a transparent film backing. After exposure to light and processing the light-sensitized crystals reverse to form the negative from which prints can be made.

Black and white films vary significantly in their sensitivity to dark and light values. Consequently, certain films will produce stronger contrasts than others. Film also varies in speed, and the photographer must know which film to select for the particular subject and conditions which he faces. Moving objects must be recorded at fast shutter speeds to stop action and avoid blur, therefore they require fast-acting film.

Color films vary according to whether they are to be used under daylight or artificial lighting conditions. Some produce images which are made into color transparencies; others produce color prints. Large photographic prints—whether black and white or color—are desirable for advertising or photojournalism purposes where corrective retouching to clarify detail is often necessary. As in black and white photography, the type of film selected is important to the final image.

Processing and printing Though the processing of black and white film is not nearly as complicated as the processing of color film, it is still not a simple procedure. Invisible chemical changes take place when light rays fall on the emulsions of black and white film. These create visual images when the film is put into an alkaline chemical developing solution. The processed negative that results is next rinsed in an acid stop bath (to stop further developing action) and then is permanently fixed in a hypo-alum solution. The more complex procedure involved in developing color films requires highly controlled conditions for both color transparencies and prints. Because film is sensitive to light, photographic developing processes must take place in the controlled light of the darkroom.

The printing process requires exposure of photosensitive paper to light which is passed through a negative under darkroom conditions. Contact prints are made the same size as the negative by placing negatives and contact paper together with the emulsion side of the negative in contact with the emulsion side of the paper and exposing them both to light. Enlargements of photographs are made by projecting light through the negative into the lens of an enlarger and then onto a sheet of sensitive enlarging paper. The distance from the lens to the printing paper controls the size of the enlargement. As in film developing, the invisible images which are printed on the paper must then undergo the same three baths of developer, stop, and hypo fixative in order to be made visible.

During this enlargement process the original image may be changed and refined. For instance, by using different kinds of papers the texture and value contrasts can be increased or diminished, or the negative may be masked to a smaller size so as to emphasize certain parts of it in the final print. The image may also be darkened or lightened. or individual parts may be blocked out entirely. Portions of negatives may be combined into a montage by exposing sections of them on the same enlargement. The print itself may be trimmed to change its composition. Darkroom changes of this kind permit infinite variation and are often used by photographers to increase the expressiveness of the final print. The great variety of technical procedures available to the photographer, both through the camera and in the darkroom, allow him to experiment and create a wide range of unusual realistic or abstract images. There are, however, purists who believe that the negative should be printed intact with no changes made during processing.

There can be no question that still photography has fundamentally changed our concepts of the world around us. In addition, it has influenced artistic expression in other areas, particularly painting. And perhaps even more important, the invention of still photography led to the development of the motion picture.

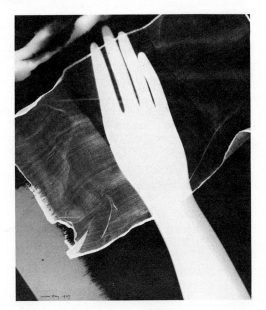

Cinematography

Movement is inherent in all living organisms and has always fascinated humans. It is not surprising, then, that the question of how to express motion has been a continuing concern of artists from the Stone Age to Marcel Duchamp (Figure 2-17) to the most contemporary filmmaker.

The earliest noteworthy experiments in depicting motion through photography were those of Eadweard Muybridge. Setting up twenty-four cameras to capture successive views of a horse in motion, Muybridge in 1878 confirmed the theory that in active movement all four hoofs of a horse leave the

6-9 Man Ray. *Rayograph.* 1927. Collection, The Museum of Modern Art, New York. Gift of James Turall Soby.

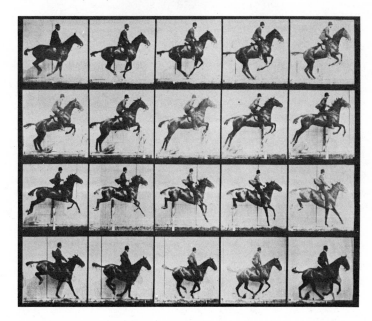

6-10 Eadweard Muybridge. *Daisy Jumping a Hurdle,* Plate No. 640 from series, *Animal Locomotion.* 1883-87. Photolithograph, 19″ x 24″. Collection, The Museum of Modern Art, New York. Gift of Philadelphia Commercial Museum.

ground. More importantly, his sequential photos led, through various experimental steps, to his invention of a piece of equipment capable of photographing a rapid succession of images. Muybridge also invented a device he termed a zoogyroscope whereby these images could be projected onto a screen. In 1893, an amateur photographer named Alexander Black had the idea of telling a story in pictures. He persuaded the president of the United States to be photographed at the White House in a production he called *A Capitol Courtship.* Showing the film with a moving picture projector perfected by Thomas Edison, Black produced the first practical motion picture to win public acceptance as entertainment. With these inventions, the motion picture was born.

Motion pictures are actually made up of thousands of photographic images which produce an illusion of motion when they are projected in rapid succession because the human brain is unable to differentiate between the individual images presented. This apparent merging into a single moving picture occurs because each photograph, called a frame in motion pictures, differs slightly from the one which preceded it. As these images are projected, each one lingers briefly as an afterimage in the brain, and if the frames are shown in timed sequence at a given speed, the brain will be unable to perceive the blank intervals between the frames. Instead, it will perceive the illusion of motion.

With the invention of the movie camera, the artist had been given a tool which enabled him to create actual moving images.

This resulted in the development of a totally new art form, which might be defined as the art of expressing emotion and communicating meaning through the rhythmic motion of illuminated images, usually accompanied by sound.

As soon as the camera was able to record motion believably, artists of the cinema began to experiment with a variety of space-time illusions. The cinematographer soon found that he could suggest rapid movement over great distances or extend or draw out a brief event because the camera could be used to accelerate, slow down, or reverse motion. In this way, with the motion picture camera the filmmaker is able to manipulate our perceptions of events, people, happenings.

Cinematographers found that the motion picture camera can be made to imitate the human eye by scanning the overall scene or by concentrating on significant details in the long (distant) shot, the medium (closer) shot, and the extreme close-up. The close view creates an intense intimacy and can portray unusual views of form and texture which are perhaps reminiscent of the vividness of our childhood sensations when we first began to see, feel, and touch the strange new world. Such extreme close-ups in movies challenged the social conventions which had existed regarding appropriate distances between human beings. When such taboos were broken, the viewer became a participant in the screened events, drawn into the film by the intimacy of the image.

With the conversion from silent films to "talkies" the gap between reality and illusion was further reduced, and another dimension was added to the art of the cinema. The moving film also controls our perceptions of time. Other visual art forms, such as architecture, painting, and sculpture, are restricted to the experience of the here and now. Like theater, the cinema enjoys the benefits of extended visual experiences, but as an art form it has been most successful when it has developed its own forms instead of imitating those of the theater.

Visual narration has been a vital part of cinematography from the early films of D. W. Griffith, who used the close-up brilliantly in films like the *Birth of a Nation* (1915), through Eisenstein's almost surreal shots in *Potemkin* (1925), to Ingmar Bergman's most recent films. Yet unlike the theater, where the art form unfolds through live performance, in cinematography, the cutting, editing, and other techniques make it possible for filmmakers to use events in time creatively and to suggest rather than spell out an explicit narrative.

Paralleling the developments in narrative cinema were developments in the so-called art film. Painters like Salvador Dali and Fernand Léger experimented with surreal and abstract films in the twenties and thirties. Today, when the film is more fully developed as a separate art form, the filmmaker is usually technically trained in that medium, but interaction between cinema and other arts such as painting, sculpture, theater, dance, television, and architecture is important. Both the commercial, narrative film and the art film are influenced by other art forms and in turn influence them.

6-11 Ingmar Bergman. *Wild Strawberries*. 1957. Film. The Museum of Modern Art, Film Stills Archive.

6-13 Fernand Léger. *Ballet Mecanique.* 1924. Film. The Museum of Modern Art, Film Stills Archive.

6-14 Schmitt collects lunar rake samples. December 1972. NASA.

6-12 Sergei Eisenstein. *Potemkin.* 1925. Film. The Museum of Modern Art, Film Stills Archive.

Cameras, Films, and Techniques The motion picture camera is based on many of the same principles as the still camera. The difference between the two lies in the fact that the motion picture camera is capable of photographing a rapid succession of images. The many different specialized needs of cinematography require considerable variation in film sizes, lenses, and modes of operation. Camera sizes include 8mm, 16mm, 35mm, and 70mm. Generally, the cameras which take the smaller, less expensive films are used by amateurs, while the larger films can be projected on bigger screens for theater audiences. Sound on film is made possible with a magnetic sound strip. Lenses control focal length, speed, the depth of field. For example, long focal length lenses bring the subject closer by magnifying only a portion of the scene. The zoom lens is generally used to change focal length within a range between wide-angle and telephoto, providing almost instant variations in the image. A smaller lens opening permits sharp focus of a subject over a great depth of field or distance. This is the reason why both close-up and distant views may appear equally sharp at the same time. Moving the camera permits a panoramic view of an area and is particularly valuable when a moving subject must be photographed. By focusing on the subject, the photographer keeps it centered while the remainder of the scene changes, imitating with the camera what we do with our eyes. The final editing and cutting of the developed film is one of the most important creative steps in the production of a finished film. Editing equipment consists of cutters and splicers for cutting and joining two pieces of film and a machine which permits close control of forward and backward movement of the film while the editor looks at it through a built-in viewer.

Television

Television shares with cinema two early ancestors: the drama and the narrative form of the novel. From these beginnings both television and cinema have developed into important informational, expressive, and entertainment media. Television's unique contribution is its instantaneous transmission of live events to our homes, and this live coverage of news and sports events provides examples of some of television's most successful programming. Such programs give us a sense of participation in what is going on in the world. For instance, the worldwide audience who watched with awe and excitement man's early exploration of the moon was witnessing at the same time one of television's proudest achievements.

Through the imagery and sound of television we are given a chance to relate personally to all the events on the screen. Extreme close-ups eliminate the psychological distance between the TV image and our emotions, while the immediacy of television provides us with a way to enjoy and identify with dramatic presentations or events. In the world of the megalopolis, human beings tend to become cut off from community living and alienated from other humans. Yet in the tragic

6-15 Jean Marsh as Rose in *Upstairs Downstairs.* Courtesy KQED, San Francisco.

assassination of John Kennedy television not only heightened the impact of the event, but it also helped to bring millions of isolated viewers together in a spirit first of mourning and then of national unity and hope.

We all know the wide range of television programs available on our sets: feature length dramas, situation comedies, educational films, old motion pictures, interviews and panel discussions, game shows, animated cartoons, news analyses, soap operas, documentaries, and commercials. Some of these programs are highly creative; others, less so.

Commercial television has been criticized for its lack of originality, its tendency to program according to the lowest common denominator, and an apparent reluctance to experiment with new ideas. This can be largely attributed to the fact that commercial television is supported by the businesses that buy advertising time. They want the largest viewing audience possible for their commercials, so much of commercial television's programming is planned to appeal to the broadest possible market. The TV commercial itself has as a result become a distinctive element of commercial television and in recent years has shown potential as a form of sophisticated expression.

In contrast, noncommercial television has been freer to experiment with new expressive forms and creative approaches. Some of these, having first won acceptance on public-supported television, have filtered into commercial TV. Public or educational television offers creative possibilities in drama, news coverage, public information programs, and children's programs. However, in order to stay alive and continue its creative broadcasting and experimenting, public television depends on grants from corporations and foundations and on the financial support of the viewing public—us.

The technical process of television is also used by artists to create experimental artworks, like this one by Nam June Paik (b. 1932), which are broadcast to limited audiences in museums and galleries. This particular piece has one thousand different images.

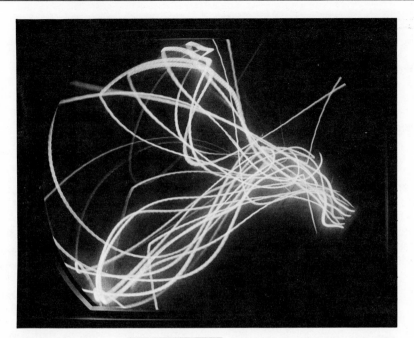

6-16 Nam June Paik. *N̶Rondo Electronique.* 1966-68. Courtesy Bonino Gallery. Photo, Peter Moore.

It is interesting to speculate on the artistic potential of television with the arrival of cable television with its almost endless variety of program selection capability. Specially created video art could be made available to every household provided some method of financing, such as pay TV, were devised. Another exciting innovation is the videotape cassette systems now being developed. With appropriate adapters, tapes of virtually any subject could be viewed in the home.

Television as an art form obviously has yet to reach its full potential.

We need only look around us to see some of the technical and social results of the invention of the camera lens. The new art forms it has produced—photography, cinema, and television—are now part of our everyday lives, and their very familiarity should make it easier for us to evaluate just how aesthetically successful and expressive they are.

Art in Function

A vessel of baked clay: do not put it
in a glass case alongside rare
precious objects. . . . Its beauty is
related to the liquid that it contains
and to the thirst that it quenches.

Octavio Paz, *In Praise of Hands*

Any piece of art or craft which makes
everyday living more efficient and pleasant
can be called functional art. This includes the
handcrafts, mass-produced industrial arts,
and the communication arts. These have
grown out of deep human needs, and
throughout human history the useful arts
have expressed these needs in their structure
and form.

We have only to look around us to
observe that structure is basic to life and that
one of the determining factors in the design
of living growing forms is the basic
arrangement of their cells. This arrangement,
in turn, is influenced by environmental and
functional needs. We can see an example of
nature's structural ingenuity in the snail shell,
which for centuries has fascinated scientists
and mathematicians because of the way its
structure grows to fit the needs of the animal
while revealing a constant logarithmic spiral.
This rule of proportion, existing in numerous
examples of marine and other forms of life,
also appears to be the basis for what is
known as the Golden Section (Figure 2-18).
This rule for achieving pleasing proportion
in ancient buildings was revived by
Renaissance artists who believed that it

corresponded with the laws of the universe
and should apply to all artistic creation as
well as to nature.

Whether or not we accept this rule as the
only way to harmony in all visual creations,
human beings do seem drawn to works of
art which support the Golden Section. At any
rate, it is clear that in nature the final form of
a structure follows the function which it
performs.

Honeycombs, beavers' dams, birds' nests
all express the materials used in them and
the purposes they serve. Seeing this, many
designers and craftsmen believe that any
article which is designed for use must also
honestly express its materials and purposes
as well as be appropriate for the time and
place it is used. They consider this to be true
whether it is a steel and plastic chair, a piece
of power machinery, or the fork with which
we eat. But in addition, the elements of
design which we have already discussed in
earlier chapters are just as important in these
functional arts as they are in the fine arts.
Rhythm, balance, and proportion are basic to
all well-designed objects; and line, mass,
color, and texture are critical concerns if a
functional object is also to be aesthetically

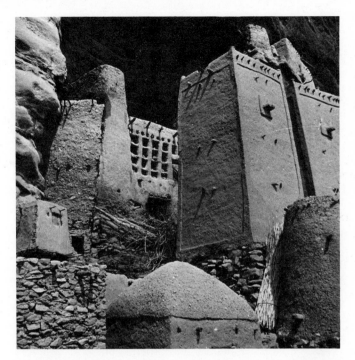

7-1 Granaries of the Dogon people in French Sudan. Collection Musée de l'Homme. Photo, Dr. Palis.

satisfying. From prehistoric times on humans have needed useful objects and have fashioned them from the materials at hand, trying to make them as beautiful as possible. Even when survival absorbed most of man's energies, he found time to shape his weapons and tools to please the eye as well as to fit the hand (Figure 8-4). Handcrafts grew out of societies which antedated the separation of beauty and usefulness that appeared during the Industrial Revolution in the nineteenth century. The tools and utensils of daily living which filled homes before that time were made by craftsmen who were concerned with both function and beauty of design and material.

From Traditional Handcrafts to Industrial Arts

Throughout history craftsmen have created products out of available resources in response to the needs of society. Today's industrial arts have grown out of a long tradition of handcrafts, although the methods of production and many of the materials used are totally new. Ancient flint and ivory tools, baskets, pottery, and weavings developed in response to the same physical human needs as have our twentieth-century plastic bowls, steel tools, and machine-made fabrics. Early in every society, the crafts of pottery and

weaving were developed to meet basic needs for clothing and containers. As each society became more complex and sophisticated, the crafts of metalwork and woodworking were added.

Certainly, handcrafts fulfill human needs in a more personal way than is possible with industrial arts, but despite the significant differences which exist between handmade and machine-made products, the same principles of design are involved in both. The most obvious difference lies in the touch of the creator which is usually visible in handcrafted objects. For example, in this oversized spoon we can sense the handwork of the northwest native American who carved it for a village feast. Also characteristic of handcrafts is the close relationship between the material and the craftsman, which can be seen in the way the

7-2 Ladle. British Columbia. c. 1850-70. Horn, 17¼″ long. Courtesy of the Museum of Primitive Art, New York. Photo, Charles Uht.

object expresses its material. A glass vase is blown from molten material and as a result looks quite different from a clay vase which is shaped on a wheel from wet clay. In addition, a craftsman uses his tools with great care and has a personal concern for the object's durability. His work shifts back and forth between beauty and function, giving us pleasure as well as filling our needs for a useful object.

Traditionally, a handmade object is both planned and executed by the designer, and in this way products are created which could justifiably be called one of a kind. The closeness of the craftsman-consumer relationship demands a two-way responsibility, for the craftsman respects the customer's needs, while the product is valued by the patron who knows and trusts the craftsman who created it.

On the other hand, the integrity of the product of industrial processes depends on the designer's sensitivity to its materials, form, function, and ornamentation as well as on his understanding of and sensitivity to the capabilities and limitations of the machines which manufacture it. Today, for the first time since the machine supplemented the handcraftsman during the Industrial Revolution, industrial designers have come to recognize the importance of this respect for material, for honest expression of function, and for concern with aesthetic values in their designs for mass production. George Nelson's mass-produced furniture is an example of the kind of creative interaction of artist, engineer, and machine which now makes it possible for us to create beautiful furniture, ceramics, glassware, fabrics, and other useful objects in large numbers.

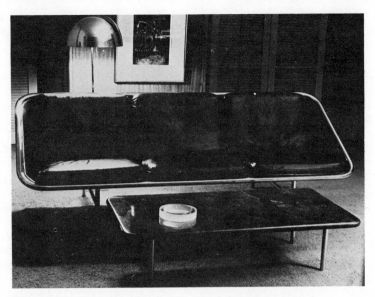

7-3 George Nelson. Sling Sofa. 1963. Herman Miller, Inc.

Pottery Although the first human use of clay precedes recorded history, we do know that very early in our history people shaped clay from the mud of riverbanks into useful containers. The earliest pots were patted and pinched into shape, then dried in the sun. Clay was also shaped into coils or slabs to form the walls of a vessel, then smoothed by hand or with a stone or shell in the same way American Indians still form and smooth their pots. It was soon found that firing the clay pots over hot coals or in a kiln would make them more durable and able to hold water. The subsequent invention of the potter's wheel on which clay is shaped while the wheel is rotated permitted potters to

7-4 Potter's kick wheel. Concrete, steel, and cast iron. Robert Brent Corporation, Healdsburg, California.

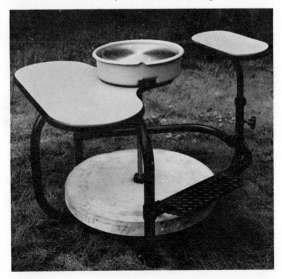

produce more, to achieve greater smoothness and uniformity, and to attempt more ambitious designs. Greek potters, for instance, created beautiful shapes which were designed for specific purposes—for oil and precious perfumes they made narrow-necked bottles to hold the contents safely, while wide-necked jugs made it easy to pour water or wine. Heavy containers were fitted with three handles to make it easy to pour from them or move them (Figure 9-16). Later, when potters wanted to make large numbers of similar pieces, they used molds. In this process, clay is first mixed with water until it has a creamlike consistency (called *slip*), which allows it to be poured into the molds.

Whether ceramics are hand or machine formed, they must be fired to be hardened and made watertight. When the air-dried ceramics, called *greenware,* are ready for firing, they are put through a low *bisque* firing to remove all water from the clay. A second, higher firing hardens or fuses the dried clay and, depending on the type of clay used and the heat of the kiln, determines the kind of pottery or china produced. For example, earthenware, made from coarse clays, is fired at low temperatures (1740°–2130°F) and is suitable for rough pottery and bricks. Stoneware, on the other hand, which is used for most dinnerware and ceramic sculpture, is made from somewhat finer clays and fired at higher temperatures. Porcelain, used for the thinnest china and for some ceramic sculpture, is made primarily from very fine white kaolin clays and is fired at the highest temperatures, close to 3000°F (Figure 14-30). At this temperature the clay becomes completely fused and vitreous (glasslike).

The colors and decorations we see on ceramics are produced by glazes and pigments which are made from powdered mineral substances suspended in water and applied either to the bisque or after the clay has been fired. During the second, higher firing the glaze becomes glassy and hard, making the piece more durable and waterproof. Glazed ceramics can range in color from muted earth tones to brilliant primary colors, while textures may be very rough or shiny.

Each one of these steps in firing ceramics requires great care and knowledge of the process, whether it is done in a small kiln by handcraftsmen or mass-produced in large factories. Any errors in firing can produce drastic and unexpected changes in glazes or can ruin a pot completely.

Pottery developed into a highly sophisticated craft in early Egyptian, Mesopotamian, and Greek civilizations as well as in China and Japan. The Chinese have produced some of the world's greatest ceramics, pieces of exceptional beauty in design, glaze, and ornamentation. On many of their porcelain pieces the Chinese used their famous Celadon glaze, a gray-green glaze which involves precise control of the heat and oxygen supply in the kiln. In addition to producing delicately shaped ceramics, the Japanese are also noted for simpler, rougher pottery, which has greatly influenced Western contemporary craftsmen.

Today the hand potter makes use of traditional methods from many different cultures, some of which were ignored for years because of our emphasis on industrialization. At the same time the industrial designer of integrity who creates

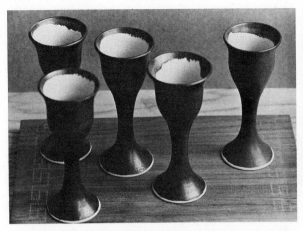

7-5 Left: hand-made ceramics. Right: mass-produced ceramics. Photos, Ruth Bossieux.

for the mass market tries to produce ceramics which honestly express the mass-production methods used to make them while maintaining beauty of form and material.

Glass Glass has been blown since the first century A.D. Composed chiefly of silicates, glass can be blown, cast, pressed, or spun into threads. When it is shaped by hand blowing, a glob of glass is dipped from a hot furnace with a blowpipe, and as air is blown through the pipe, the molten mass forms a bubble which can then be shaped. The hand blower rolls and shapes the bubble, using a wooden tool, calipers, and cutting shears, reheating it when necessary to keep it soft.

Color in glass is produced by mixing various minerals like copper, cobalt, or cadmium into the molten glass. Colored transparent or translucent glass reflects the light and glows luminously like the rich windows in Medieval cathedrals (Plate 20).

Glassware produced by machine is usually made by pouring molten glass into molds and pressing it with a shaped plunger. There are many ways of decorating glass, although much of it needs no ornamentation, depending on its shape, texture and transparency for its attractiveness. If desired, however, decoration can be applied by cutting into the surface, engraving it, etching or sand blasting it to create texture, or by adding colored enamels to the surface. Many contemporary handcraftsmen and sculptors are now exploring glass as a creative material and are using it in new forms.

7-6 Sidney Waugh. Merry-Go-Round Bowl. Steuben Glass.

Textile Arts Another ancient craft which appeared in many different cultures is the process of interlacing horizontal and vertical threads, called weaving. The lengthwise threads are called warp; the crosswise, weft, woof, or filling. Fabric is produced by this basic process whether the weaving is done on a handloom or by machine. Originally, fabrics were made from natural fibers such as animal hair or cotton, linen, or silk. The first weavers soon discovered that the types of weaves and the materials used determined the weight of the cloth produced. Obviously, climate and available materials were both important in the decisions the weaver made about the weight of the fabric to be produced.

Having mastered the production of simple fabrics, weavers found that the manner in which the loom was threaded and the way the threads were interwoven affected the pattern and texture of the cloth they could produce. By combining different threads and weaves, the craftsmen could create an almost infinite variety of fabrics. Later, as weavers became more versatile and the supply of materials more varied, social needs or values, such as the symbolism of luxurious fabrics for the rich and rough fabrics for the workers, influenced the type of textile produced.

There are three basic types of weaves: plain, satin, and twill. In plain weave, the simplest and strongest, the filling yarn passes over one warp thread and under the next, as in cotton broadcloth, burlap, or muslin. In satin, or floating-yarn weave, filling yarns float over and under several warp yarns. In twill weaves, warp and filling yarns are interlaced in broken diagonal patterns.

Pile weaves, such as in velvet and carpeting, are made from loops which are cut. Handmade rugs have been made for centuries by various methods of pile weaving and loop knotting. Persian prayer rugs were famous for their intricate designs and rich colors in the fifteenth century, but fine rugs had been woven in that part of the world for centuries before that (Figure 1-12).

The handweaver today combines some of the earliest techniques with others which have been developed over the centuries. He may use traditional fibers or new synthetic fibers or a combination of both. Nowadays the man-made fibers of rayon, fiberglass, and nylon are used both in machine and handweaving.

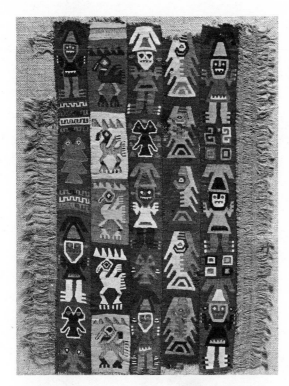

7-7 Peruvian tapestry. Eleventh century. Wool. The Metropolitan Museum of Art, Rogers Fund, 1928.

Europe even to the present day. Working from a "cartoon," or drawing, the same size as the projected tapestry, weavers took years to create intricate pictures using hundreds of colors. These tapestries, which illustrated legends or religious scenes, were often used to cover stone walls and doors in the chilly Medieval castles or later to add richness to royal palaces. Recent years have seen a revival of this ancient art form, and today outstanding artists design tapestries to be woven by professional hand weavers, while others design and weave the tapestries themselves.

7-8 *The Hunt of the Unicorn.* French or Flemish. Late fifteenth century. Tapestry, wool, and silk with metal threads. The Metropolitan Museum of Art, The Cloisters Collection. Gift of John D. Rockefeller, Jr., 1937.

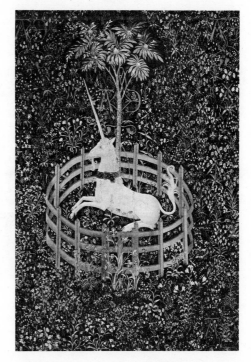

Although some of the effects achieved by handweavers can be attempted on high-speed mechanical looms, the machine-made product is usually more aesthetically satisfying when the designer has used the machine to produce its own effects rather than trying to duplicate handwoven material.

Tapestry weaving, which has used various methods to incorporate many irregular areas of color into a tightly woven hanging, has continued for centuries as a major art. Descendants of Medieval tapestry weavers have kept the craft alive in certain towns in

Application of design to fabric surfaces

Designs may be applied to fabric by embroidery, by printing with a block or stencil, or by the process of batik or tie-dyeing. These are all ancient arts which have persisted to the present day, though new materials and machine methods have changed them somewhat.

Fabrics ornamented with hand-printed designs were known in ancient Egypt and were widely produced in India and the Orient. These fabrics were brought by traders to Europe and became extremely popular in the eighteenth century. Originally, they were laboriously printed from carved wood blocks which were inked by hand, but as machine printing developed, inked rollers were substituted for the blocks. Today's fast presses can now print thousands of yards of the fabrics we use for shirts, dresses, and window curtains in a short period of time.

Some of the ancient hand printing and dyeing methods are still used by handcraftsmen. Both tie-dyeing and batik are old methods that have recently been revived and used to create wall hangings as well as materials for clothing. In batik, wax is used to block out areas of the cloth which are to remain white, or light-colored, while each succeeding dye bath produces deeper colors by dyeing over the lighter colors. Batik dye is also used for painting directly on the fabric as in this wall hanging by Helen Muller.

7-9 Helen B. Muller. *Birds and Fishes.* 1973. Batik, 58″ x 36″.

Other fiber crafts In addition, many kinds of embroidery and stitchery are again being used by craftsmen and artists, often in combination with printing techniques, handweaving and macrame. Originally used for fishermen's nets, macrame is the art of knotting strands of fiber together to produce a variety of open patterns. Now it is used to create colorful belts, handbags, clothing, plant hangers, and wall hangings. Using macrame and weaving techniques, artists have created three-dimensional wall hangings, free-standing sculpture, and environments large enough to walk into. Other old craft methods are now popular and are used with great inventiveness: quilted and stuffed fabric, looped knotted textiles, and grasses and twigs woven into fibers are some of the methods contemporary artists use to produce interesting textures.

7-10 Walter Nottingham. *Skins of Us.* Detail. Crocheted wool, rayon, and horsehair mounted on velvet platform with Plexiglas, 16″ x 66″ x 30″. Photo courtesy of American Crafts Council's Museum of Contemporary Crafts during the "Sculpture in Fiber" exhibition.

Woodcraft Wood has played an important role in nearly every phase of human existence. The tombs of the ancient Egyptians were full of wooden utensils and furniture put there to make life comfortable for the dead in the afterlife. African, Oceanian and native American cultures have used

7-11. Windsor chair. Early eighteenth century. Old Sturbridge Village, Sturbridge, Mass.

wood for boat decorations, masks, sculpture, and furniture (Figure 14-14). The Gothic cathedrals built in the Middle Ages were treasure houses of carved wooden choir screens, stalls, and pews. And throughout history, musical instruments, like the famous Stradivari violins, were often made of wood because of the mellow tones it can produce. The great cabinetmakers of the eighteenth century in Europe created luxurious furniture and floors for the aristocracy in which contrasting wood grains were inlaid in complex designs, known as marquetry and parquetry. Wood was also often combined with metal or inlaid with ivory or shells as decoration, and in wealthy Oriental homes it was painted with colored lacquer. On the other hand, Colonial and early nineteenth-century America expressed its democratic ideals in functionally simple and aesthetically pleasing furniture, such as Windsor chairs and Shaker tables.

Contemporary wood usages Furniture, cabinets, and smaller accessories such as bowls, trays, and serving implements constitute the major use of wood in contemporary handcraft design. At the same time, simplification of wooden shapes to modules allows the mass manufacturer to produce a maximum number of variations in furnishings with minimal effort. When storage units, like these by the late architect Eero Saarinen, are dimensionally coordinated, purchasers can arrange and rearrange them in varied space-saving combinations to suit their individual needs. The simple modular construction means that they can be produced by factory methods. Formed

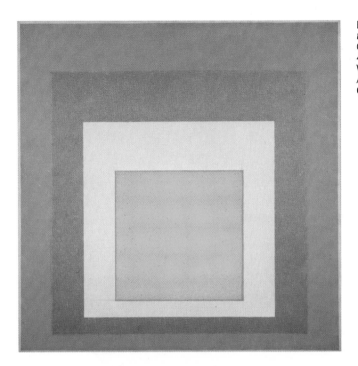

Plate 1 Josef Albers. *Homage to the Square: "Ascending".* 1953. Oil on composition board, 43½″ x 43½″. Collection of The Whitney Museum of American Art, New York. Photo, Geoffrey Clements.

Plate 2 Jackson Pollock. *Number 1.* Oil on canvas, 68″ x 104″. Collection, The Museum of Modern Art, New York.

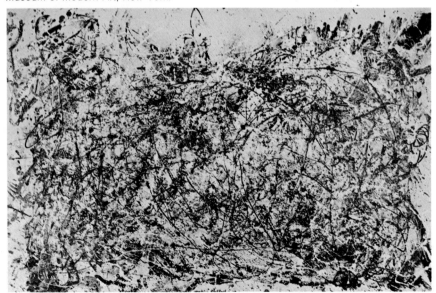

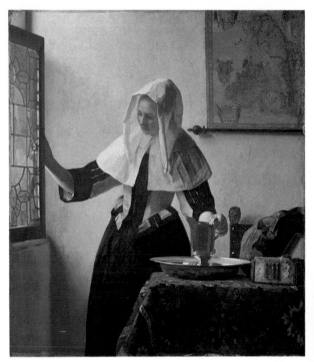

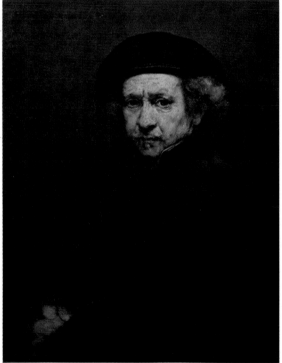

Plate 3 Johannes Vermeer. *Young Woman with a Water Jug.* 1658-60. Oil on canvas, 18″ x 16″. The Metropolitan Museum of Art, Gift of Henry G. Marquand, 1889.

Plate 4 Rembrandt van Rijn. *Self-Portrait.* 1659. Oil on canvas, 33¼″ x 26″. National Gallery of Art, Washington, D.C. Andrew W. Mellon Collection.

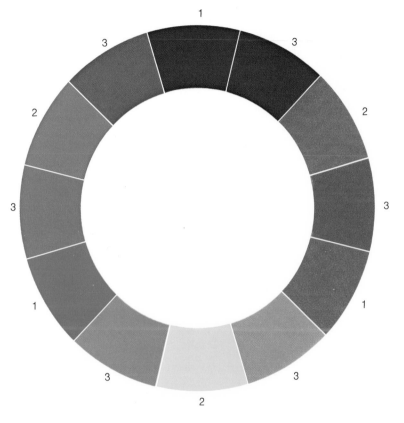

Color wheel 1 Primary hues. 2 Secondary hues. 3 Tertiary hues.

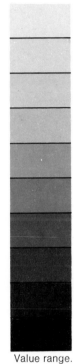

Value range.

Intensity range from red to its complement, green.

Plate 5 Color wheel, value range, and intensity range. Adapted from *Photography* by Charles Swedlund.

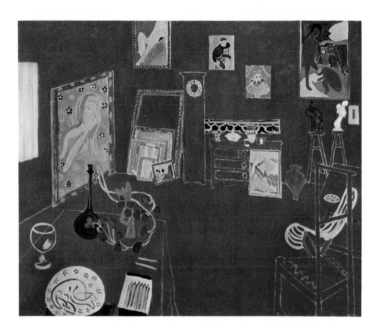

Plate 6 Henri Matisse. *The Red Studio.* 1911. Oil on canvas, 71¼″ x 86¼″. Collection, The Museum of Modern Art, New York. Mrs. Simon Guggenheim Fund.

Plate 7 Claude Monet. *Water Lilies* (detail). c. 1920. Oil on canvas, triptych, each section 6′ 6″ x 14′. Collection, The Museum of Modern Art, New York. Mrs. Simon Guggenheim Fund.

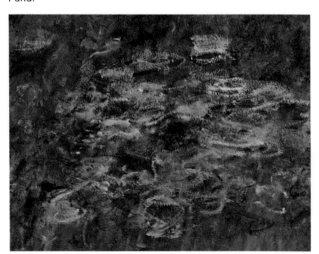

Plate 8 Piet Mondrian. *Broadway Boogie Woogie.* 1942-43. Oil on canvas, 50″ x 50″. Collection, The Museum of Modern Art, New York.

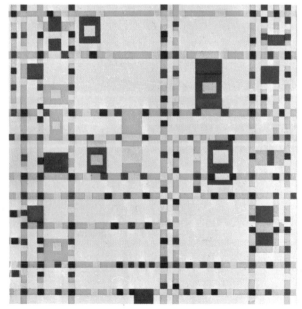

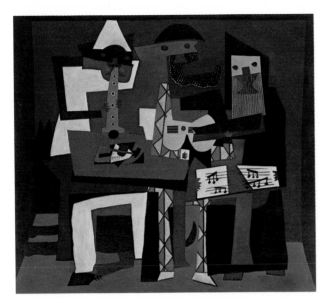

Plate 9 Pablo Picasso. *Three Musicians*. Summer, 1921. Oil on canvas, 6'7" x 7'3¾". Collection, The Museum of Modern Art, New York. Mrs. Simon Guggenheim Fund.

Plate 10 DeWain Valentine. *Dark Mauve Ring*. 1967. Cast polyester resin, 23½" x 11". Courtesy Denise Rene, New York.

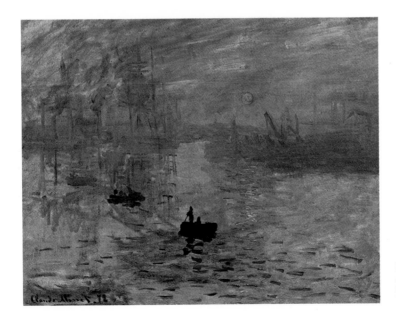

Plate 11 J. M. W. Turner. *Venice: From the Giudecca Looking East, Sunrise*. 1819. Watercolor, 8¾" x 11¼". The Tate Gallery, London.

Plate 13 Morris Louis. *TET*. 1958. Synthetic polymer on canvas, 45″ x 153″. Collection of The Whitney Museum of American Art, New York. Gift of the Friends of the Whitney Museum of American Art. Photo, Geoffrey Clements.

Plate 12 Edgar Degas. *After the Bath.* 1898. Pastel on cardboard, 24⅜″ x 25⅝″. Cliche Musees Nationaux, Paris.

Plate 14 Cross page from the *Lindisfarne Gospels.* c. 700. Reproduced by permission of the Board of the British Library.

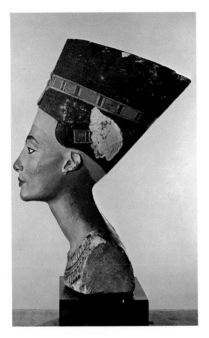

Plate 15 *Queen Nefertiti.* c. 1360 B.C. Limestone, 20″ high. State Museums, Berlin.

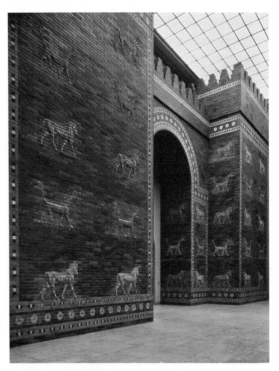

Plate 16 The Ishtar Gate (restored) from Babylon. c. 575 B.C. State Museums, Berlin.

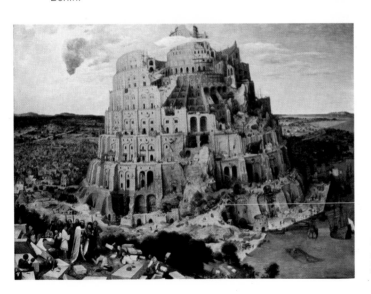

Plate 17 Pieter Bruegel. *Tower of Babel.* 1563. Oil on canvas, 44⅞″ x 61″. Kunsthistorisches Museum, Vienna.

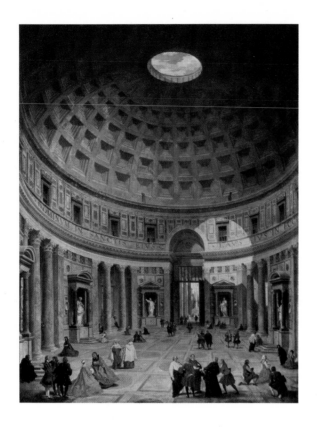

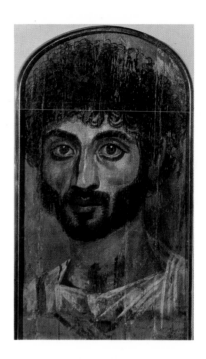

Plate 18 The Pantheon (above). 118-125 A.D. Rome.

Plate 19 Egyptian portrait (right above). Second century A.D. Encaustic on wood. The Metropolitan Museum of Art, Rogers Fund, 1909.

Plate 20 *Notre Dame window* (right) from Chartres Cathedral. Twelfth century.

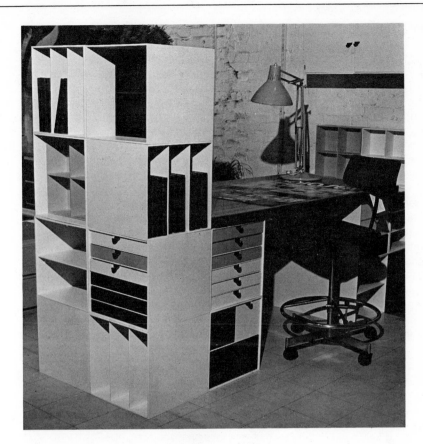

7-12 Stackable furniture.
Design Research,
San Francisco.

laminated plywood and wood bent under
heat and pressure are new industrial
methods of using wood which have been
applied to mass-produced furniture,
accessories, and sculpture. Though the
potential functional uses of wood appear
endless and the demand for wood products
continues to grow, the world's supplies may
not be sufficient to meet those demands in
the years to come.

Metalwork Metal refining and forming was
one of the first manufacturing processes
developed in early cultures. Each metal,
whether rare gold or silver or the alloys and
common metals such as bronze, copper and
iron, was used for a different purpose and
required different handling by the craftsman.
Gold and silver were known and prized early
in history, both for their rarity and for their
color and texture, and were used for jewelry,

for sacred objects, and for ritual vessels. A few of the traditional techniques of working in metal which have been used over the centuries are hammering, raising (or embossing), and casting. The metal craftsman has used each of these techniques to create useful and pleasing objects such as armor, buckles, necklaces, drinking cups, and ritual objects of all kinds (Figure 14-25). Crowns for kings, chalices for religious observances, coins, medals, and jewelry were often decorated with set-in jewels or with powdered glass melted onto the surface to produce colored enameled areas. Benvenuto Cellini created this jeweled gold and silver saltcellar for King Francis I of France. Gold was also rolled into thin sheets and used to plate over less expensive materials, such as the wood on a Pharaoh's throne (Figure 8-13). However, no matter what metal was chosen, the craftsman had to explore all its possibilities in order to achieve his desired effect. In using metal, its weight and support potential must also be considered, and the artist must deal with the possible effects of corrosion as well as with the surface characteristics achieved by molding, hammering, or polishing the metal. All of these factors must be considered in relation to function as well as to the final aesthetic effect.

Aluminum and stainless steel have now been added to the older metals and have been widely used in the twentieth century for furniture, utensils, and sculpture. Both these metals can be worked by hand or by machine and are particularly adaptable to mass-production methods. An example of modern industrial craftsmanship in metal is architect Mies van der Rohe's Barcelona chair which has become a classic through its attractive design and its honest use of materials. It proves that industrially produced objects can be aesthetically pleasing.

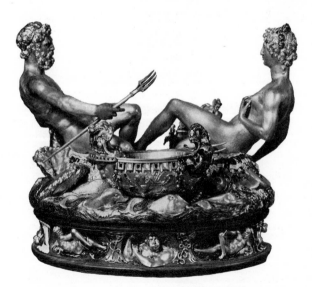

7-13 Benvenuto Cellini. *Saltcellar of Francis I*. 1539-43. Gold, 10¼″ x 13⅛″. Kunsthistorisches Museum, Vienna.

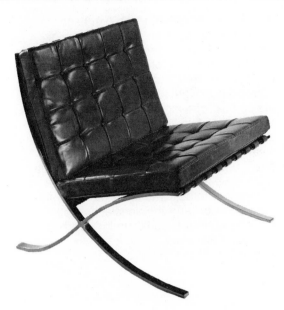

adapted to tools and toys as well as being used for working and walking surfaces in homes and offices. Orlon, used in textiles, is an acrylic derivative; and nylon, originally designed to replace silk during World War II, is made from polyamide resins. All of these synthetic materials are used by designers in the functional arts to replace many older natural materials because they can be molded or cast quickly and economically into almost any shape. With these versatile plastics the industrial designer is able to create aesthetically pleasing designs for mass production, such as this furniture by Eero Saarinen. Artists, too, are continually experimenting with plastic resins in sculpture and painting techniques (Plate 10).

7-14 Ludwig Mies van der Rohe. Lounge chair (Barcelona chair). 1929. Chome-plated steel bars, leather, 29½″ high. Collection, The Museum of Modern Art, New York. Gift of the manufacturer, Knoll Associates, U.S.A.

7-15 Saarinen furniture. Knoll International. Photo, Herbert Matter.

New Materials, New Forms, New Problems

The invention of modern man-made materials and fibers, called *synthetics,* has opened up new avenues of exploration and creation and has provided limitless challenge to the designer. Probably the most important recent synthetic products that have been developed are the plastic resins which resulted from experiments with natural resins. Acrylic resins make up the various types of lucites and Plexiglas that are used in both fine and applied art, while vinyl resins are particularly

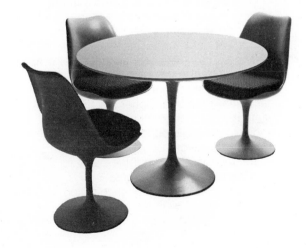

Unfortunately, no way has yet been discovered to recycle plastic, and as a result we are rapidly running out of space to hold our discarded plastic products. With the population pressures the world faces, the craftsman, artist, or designer must consider potential use of a product by the individual and by vast numbers of people, and the ways in which it can be disposed of when abandoned as well as possible depletion of natural resources and power sources needed to produce it. If we are to continue to survive on this earth, we must constantly reevaluate our goals in design and product development in relation to these factors. The alternative is to run out of living space and resources. We should give serious thought to the legacy we will leave to future generations if the industrial products we create today destroy the balance and resources of nature.

Communication Arts

One of the most important needs in any society is to exchange information, and out of this need each culture has developed its own art of communication. Musical notation, numbers, and letters are examples of graphic symbols used to communicate abstractions. Knowledge of the particular code in each case allows us to decipher the message without any other communication. Many ancient cultures produced written symbols of some kind like the Babylonian cuneiform characters which formed the basis for our own written language (Figure 8-17).

Another method of communication was the development of pictorial symbols. For example, the tools with which man worked or the objects associated with him might symbolize his trade or his position in a structured society. The symbols of the royal scepter and crown of the king are common to many cultures and are recognized as representing high social status even out of the context of their particular environment. An artist who is familiar with such symbols can use them effectively for communicating meaning in both the fine and commercial arts. From ancient times to the present day, signs have advertised the seller's wares—the bakery in Pompeii was identified by a sign over the door, and the spectacle shop in a Renaissance town could be located by the painted eyeglasses overhead. In the same way, corporations today often use a trademark or logotype as a symbol which will

7-16 IBM trademark. 1965.

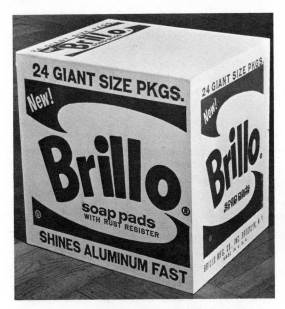

7-17 Andy Warhol. *Brillo*. 1964. Painted wood, 17″ x 17″ x 14″. Photo courtesy of the Leo Castelli Gallery.

be easily recognizable and which will create a desirable image for the company. Most people today can recognize the best-known company trademarks, and Pop artists like Andy Warhol comment on the familiarity of these images in oversized artworks like this painted wooden Brillo box.

Written Copy It is obvious that the communication arts also depend on the actual words, or copy, used. Speech symbols, like the balloons in a comic strip or advertisement, have been used since the Middle Ages. Compare how the words are visually woven into the composition in this altarpiece painted by Grünewald in the

sixteenth century with how these sales promotional pieces link words with graphic devices. You can see that communication techniques have not changed as much as you might have expected, although the content and purpose may be very different.

7-18 Matthias Grünewald. *The Annunciation,* central panel of the *Isenheim Altarpiece.* c. 1510-15. Photo, Lauros-Giraudon.

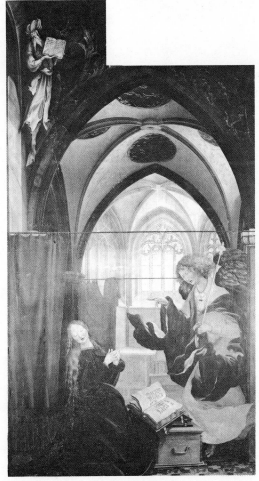

King, 17 mg. "tar," 1.2 mg. nicotine. Extra Long, 18 mg. "tar," 1.3 mg. nicotine av. per cigarette. FTC Report (Aug. '73.)

Warning: The Surgeon General Has Determined That Cigarette Smoking Is Dangerous to Your Health.

Smoothness you can taste.

PACK after PACK

7-19 Lark advertisement. Permission granted by Ligget and Myers, Incorporated. All rights reserved.

Printing Ever since man developed the written word, handwriting has been used in many cultures to communicate ideas and to enhance the look of the written text. China, Japan, and Medieval Europe all developed handwritten script into a highly decorative art (Plate 14). The process of printing type and images on paper evolved slowly. Printing with movable type had been tried in China and Japan hundreds of years before Johann Gutenberg developed his mechanical press in Germany in the fifteenth century. Although the Japanese had used woodblocks to print from around A.D. 700, they were not used in Europe for illustrations until centuries later. These blocks were used along with type in early printed books until the more efficient metal engravings replaced them.

Gutenberg had to coordinate several factors in order to make the important transition from hand-illuminated manuscripts to books printed mechanically. He not only needed a supply of single cast letters which could be put together into words, but also a way of locking the type into a flat form. In addition he needed a surface like paper on which he could print and a way of bringing the paper and type form together under pressure to transfer the ink to the paper. Although these separate elements had been used before in various parts of the world, it was Gutenberg who brought them together into the mechanical process of printing and who foresaw some of the possible commercial and cultural applications of mechanical reproduction of words.

Type Most of our common typefaces are modified from the hand lettering of early manuscripts, which, in turn, were based on roman square capitals. These roman characters might well have been lost had not the early Christian emperor Charlemagne revived ancient learning in the monasteries he founded. The roman calligraphy of his copyists became the model for the rest of

Europe and was the basis for the early typefaces that have greatly influenced the way printed words look today.

Since the first typefaces were created, designers have developed many variations to meet different requirements. All typefaces may be arranged into five groups or families: roman, italic, script, black letter (now obsolete), and sans serif. *Roman* is traditionally used for books, newspapers, and other ordinary reading matter. Roman's companion, *italic,* is used for special emphasis. There are two roman subgroups, old style and modern. Old style letters have graceful, sloping *serifs* (small terminals on the letters), while modern roman faces have straight serifs and a greater distinction between thick and thin parts of the letters.

The next two type groups are not used so widely. *Script* typefaces imitate the letters of handwriting, and just as there are many styles of handwriting, so there are many script typefaces, which are used almost exclusively for announcements and invitations. The *black letter* types have the look of Medieval illuminated manuscripts. Today such exaggerated typefaces are called *decorative.*

Sans serif typefaces are now in wide use. *Sans* is French for "without," and sans serif typefaces are without serifs. Unlike roman letters, which have thick and thin parts, sans serif letters are of uniform thickness throughout.

If you examine books, magazines, and advertising, you will discover many variations of these kinds of type. The differences from one typeface to another often seem very small (and take a practiced eye to recognize), but they greatly affect readability as well as the appearance of the page as a

whole. For instance, a page of this book has a gray tone, while pages of other books, set in heavier typefaces, appear much darker. Designers of printed matter, especially advertisements, must choose type very carefully to give the material the desired appearance and mood. As you read, study the type that has been used and pay special attention to advertisements, where often you will see unique variations of the basic type groups.

The general appearance of type has not changed radically since the earliest days. For more than four hundred years after its invention, type was set by hand. In the nineteenth century, however, numerous machines were invented to replace laborious hand composition of type. Only two kinds of metal composing machines are still in use—the Linotype machines which cast *slugs,* or one-piece fully spaced lines, and the Monotype machines which cast individual pieces of type set in spaced lines.

Old Style Roman

Modern Roman

Modern Italic

Script

𝕯𝖊𝖈𝖔𝖗𝖆𝖙𝖎𝖛𝖊

Sans Serif

7-20 Sample typefaces.

Printing processes If the appearance of type itself has not changed radically since the fifteenth century, the method of transferring the impression to paper has changed enormously. Gutenberg and other early printers used a hand-operated torsion screw to apply the pressure on a flat wooden press and were able to turn out a few hundred sheets a day. Today these presses have been replaced with power-driven machines which can produce the same number of impressions in a few minutes or even seconds. There are three major types of printing processes: *letterpress,* which is printed from a raised surface; *offset lithography,* which prints from a level or plane surface; *gravure,* or printing from a depressed surface.

Letterpress is the oldest and most commonly used method of printing in which the ink is applied to a raised surface and transferred directly to the paper through pressure. The ink rollers touch only the raised areas and do not ink the lower surrounding spaces. There are several different types of presses used, but basically the principle is the same.

Offset printing is the newest of the major printing processes and the fastest growing. In it, the image is printed from a flat surface, level with the nonprinting areas which surround it. The two main differences between it and other methods are the use of the lithographic principle that grease and water do not mix and the way in which the ink is placed on the paper. It is first transferred from the inked plate to a rubber blanket and then from the blanket to the paper. One of the big advantages of offset printing is that the softer rubber surface can produce a clearer impression on many different surfaces.

In gravure, a sunken surface is used to transfer the image to the paper by means of an etched copper plate or cylinder. The etched plate is inked and the excess ink wiped off the surface. The ink remains in the depressed areas and is directly transferred to the paper by pressure. Gravure is considered to be the best method of reproducing illustrations, but since the plates are expensive to make it is only used when a large number of impressions are to be printed.

7-21 Printing processes.

Letterpress

Offset

Gravure

Photoengraving New methods have supplanted the hand-made wood or steel engravings which formerly were used to print illustrations. The images which are to be printed are transferred to the printing plates by a method called photoengraving, first used in the late nineteenth century. The cheapest and simplest type of photoengraving is the *line plate,* or line cut. It is used to reproduce images which are made up of solid black and white lines or areas with no middle tones or grays. Examples of this include some diagrams in this book and pen and ink drawings. The copy is photographed, and the resulting image on the negative is transferred to the sensitized plate by a photographic process. The plate is then etched in acid to eat away the areas which are to remain white. An effect of intermediate tones can be produced by placing the lines close together or by using prepared screens with dots or cross-hatchings (Figure 5-7).

Halftone plates are used to reproduce photographs, wash drawings, or paintings which require intermediate or continuous tones. To photograph halftones, a screen is placed between the camera lens and the film to break the tones into dots of varying sizes. The dots are large in the dark tones and small in the lighter areas. Like line cuts, the halftone plates are also etched in acid, and the dots remain in relief to pick up the ink. The tiny dots of fine reproductions can hardly be seen, but if you look at the pictures in a newspaper, you can see the dot patterns easily.

The colored illustrations you see in books and magazines are made by printing several colors one on top of another. This is done by making a separate plate for each color to be printed. The plates are obtained by photographing a subject through special filters which separate the colors of the original. Each color—red, yellow, blue, and black—is printed individually, using a separate plate. Alignment is crucial for each printing, otherwise the dot patterns will not match up, and the illustration will appear fuzzy. In addition, because there are deficiencies in the way the pigments in the ink reflect the color, the color separations must compensate and print less of some colors in certain areas in order to obtain good results.

There are many variations within the three major printing methods and many different types of presses too numerous and complex to discuss here. Modern printing has become a highly scientific art. Specialized presses, inks, papers, and methods can meet a wide variety of needs from printing metallic inks on drinking glasses to reproducing the most detailed colored painting with every nuance of brush stokes. In addition there are many new developments which may change printing completely. For example, electronic engraving machines, computers which decide on the exact degree of color correction needed, and new plastics, metals, and other products of research are all making for faster and more accurate printing.

Advertising and Packaging In our consumer-oriented society, advertising and packaging account for a large part of the printed material in our lives. Since the purpose of both advertising and packaging art is to focus attention on a product or service so that interest is aroused in potential customers, the artwork must be designed to capture their attention long enough to make an impression and induce them to buy. For this reason, most advertising and packaging designs use easily understood symbols and simple bold colors and type. But the process

of research, evaluation, and design necessary to produce a sophisticated advertisement like this one for Olivetti is a demanding one requiring highly developed skills. Once the theme of the advertisement is decided by the client, the artist creates the layout by starting with rough thumbnail sketches and ending with the final carefully prepared copy which will be photographed for printing.

It can be seen from this discussion that whether working in the field of magazine, book, or advertising design, the graphic artist

7-22 G. Pintori. Corporate advertisement. 1947. Courtesy of Olivetti Corporation of America.

7-23 CBS radio network advertisement by Andy Warhol. *Living Off the Main Line.*

must have a knowledge of layout, reproduction methods, lettering, typography, and printing techniques. Even more important, however, he must be a skilled craftsman who is creative and imaginative in approach. In fact, many fine artists, like Frank Stella (Figure 5-22), have moved into the commercial field with satisfying results. The same elements of design—balance, unity, line, color, and shape—are as important in advertising as they are in painting or sculpture. In the hands of a good designer, the commercial graphic processes can be used creatively and expressively to create visually exciting and satisfying pages.

Clothing Design

The impulse toward personal adornment has been a vital human concern throughout history, and people today, just as in other cultures in the past, want to be distinguished from (or look exactly like) their fellow humans through some form of dress. In addition, present-day affluence has made it possible for millions to indulge this impulse, while in the past only the very wealthy or members of the ruling or priestly classes were able to use self-adornment for personal or ritualistic reasons.

We usually assume that the first body coverings were worn as a protection against the elements. However, the earliest wardrobes consisted of body paint, tattoos, animal skins, headdresses, masks, and jewelry which were worn to enhance the wearer's appearance or to produce magical or religious effects (Figure 14-7). Greek athletes wore nothing more than a coating of oil, and the victorious prehistoric hunter probably considered bloodstains and scars the most fashionable decoration of all. Body scarification had social significance for the African and was as meaningful to him as make-up for the Egyptian or a laurel wreath for the victorious Greek. Adornment, then, was frequently linked with the wearer's status. One of the oldest and most constant marks of status through human history has been the head cover. Even if he wore nothing else, the primitive king was distinguished by his crown or headdress. The Bible speaks of covering our heads before God, and clergy in all cultures have been distinguished by headdress and ecclesiastical vestments. Other examples of status-giving clothing are the long robes and hoods worn by academics and the wigs worn by some judges to mark their office. Uniforms provide instant identification for the nurse, mailman, policeman, or Girl Scout, and the modern athlete wears a number and his team colors on the field.

Design in Fashion and Costume Since the purpose of costume is essentially social, fashion in dress has been subject to as many changes as society itself, and clothing styles seem to move in cycles and express the social concerns of each period. Trends usually develop from the tastes of a society's elite, whether from the British upper crust or the popular figures in today's world of entertainment. Traditionally Paris has been the center of high fashion, or "haute couture" since the time of Louis XIV, and the semiannual showings of the latest Parisian designs continue to stimulate the fashion

7-24 Thomas Gainsborough. *Mrs. Richard Brinsley Sheridan*. c. 1785. Canvas, 86½″ x 60½″. National Gallery of Art, Washington, D.C. Andrew Mellon Collection, 1937.

informal styles. A common element in contemporary clothing design—whether of European or American derivation—is that it maintains the integrity of the human body. The hooped skirts of baroque court life find few counterparts in today's comfortable clothing (Figure 12-12).

The same considerations of color, balance, line, and texture apply to dress as to any other good design. But, in addition, since clothing is seen in action, drapery, folds, and gathers of cloth are used to emphasize the rhythmic flow of the design. In clothing as in sculpture, form and line are seen from all sides, a fact which must be considered by the designer.

It is interesting that there is no form of clothing worn by modern man which could not be found a thousand years ago, with the possible exception of underwear. We know that cloaks and tunics were worn in earliest times, sandals appeared by the time of the Greeks, trousers were worn by Biblical peoples as well as by the barbarians of Northern Europe, and gloves and trunk hose were medieval creations. For this reason, background knowledge of the evolution of costume is essential to every fashion designer and can often provide inspiration for contemporary dress.

Because fashion has become a mass product, the latest creations of top fashion designers are usually adapted and modified by less exclusive fashion houses and then are finally produced in quantity according to standardized patterns in factories. The ready-to-wear fashion industry is a multimillion-dollar enterprise in the United States which depends on constant changes in styles to provide a market for its products.

world. However, the European influence is not as dominant an element in American fashion today as it was before the last thirty years. Now such outstanding American designers as Norman Norell, Pauline Trigère, and Oleg Cassini have done much to replace the American dependence on the elegance of Parisian fashion with a delight in our own

Costume design Like the fashion designer, the designer of costumes for the stage must also have a basic knowledge of the history of costume. Theater design calls for both costume and set designers, each with a specialized function to perform. The costume designer helps to establish the mood and character of individual players, as well as the whole production, through the clothing he designs and chooses for them. The designer of costumes for the theater or film knows that the style of a garment must not only emphasize the individual characterization of each player, but must also fit in with the total experience of the group spectacle as well. In addition, in the theater, designs must be stylized and slightly exaggerated to carry across the footlights to the last row in the house. Often the costume designer has to find ways to produce historical costumes with contemporary fabrics and accessories which are quite different from those used during the original period, and also must deal with budget restrictions. The costumes created by the designer must satisfy the director, the physical needs of the actors, the mood of the play and must interact successfully with the lighting. Finally, the designer must be ready to make last minute changes as rehearsals proceed.

We have seen in this chapter that the functions, materials, and social needs have greatly influenced the design of the useful arts. Now we move on to a study of all the arts throughout history. As we read about each period or culture, the techniques which have been discussed in this section will be seen in historical context. Certainly some understanding of the materials and techniques that have influenced architects, artists, craftsmen, and industrial designers is helpful in placing art in the context of its era. For that reason, it may help to refer back to this section at times when you read about the painting, architecture, sculpture, or functional arts of a particular period.

8-1 Cave paintings. c. 15,000-10,000 B.C. Lascaux, France.

Changing Ideas, Changing Art

Introduction

We cannot, of course, be certain of the human needs and environmental forces which motivated early mankind to create, but we can say that art truly began when humans first created visual forms which expressed their deepest feelings about the world around them.

We can also attempt to project ourselves into the lives of early humans and try to understand some of their feelings. Surrounded as they were by a hostile natural environment of rain, snow, floods, lightning, blazing desert heat, or deep forests or jungles, what responses would they probably have? Certainly survival must have preoccupied most of their time and energy for thousands of years. These basic human needs of survival—food and reproduction—have not changed. We can also assume that our ancestors had human feelings and that they must have known fear and awe at the forces of nature, joy in the warmth of fire and in the taste of food, and pleasure in sexual union. Not only do these emotions run as a constant thread through human life, but the need to express them seems to be common to all human beings as well.

The human animal is creative, and the source of creativity lies in the imagination.

As an example of the drive toward creative expression in our early ancestors, consider the prehistoric paintings which fill the caves in Lascaux, France (Figure 8-1). We can certainly appreciate the skill and sensitivity that enabled the prehistoric artist to express so vividly such feeling and action. Though we can never know exactly what went on in the minds of these early painters, through their art we can see them as humans who were in close touch with the instinctive forces which pervade all life. Very early, humans were able to symbolize those life forces brilliantly with rough materials of earth pigments and charcoal painted on the walls of caves or with clay shaped into figures. To see that creativity was as highly developed in early humans as in the artists of later centuries, we have only to compare this Minoan idol shaped around 1700 B.C. with Picasso's twentieth-century ceramic figure. It is not difficult to see that they share a common human vitality and expressiveness.

In this way, by examining examples of artistic expression throughout history, perhaps we can move closer to the wellsprings of human feelings which have given rise to these creations. And by

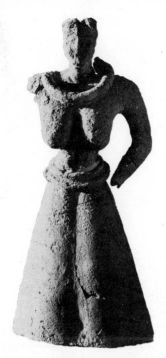

8-2 Clay statuette. 2000-1500 B.C. Kea. Department of Classics, University of Cincinnati.

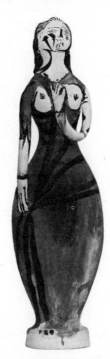

8-3 Picasso, Pablo. *Woman Standing*. 1953. Ceramic figurine. Service de Documentation Photographique de la Réunion des Musées Nationaux.

developing a sensitivity to the varying visual images used by artists we can share some of the emotions, needs, and experiences which are common to all humans no matter when or where they lived.

In this section we will look at art in different periods of history, in as much detail as possible in its limited space. Throughout this historical presentation, emphasis will be placed on Western art because of its direct influence on our lives and art today. Consequently, we will only skim over the richness of artistic expression in other cultures—the Orient, Africa, and Latin America. Although we will certainly find great differences in cultural attitudes and in the images produced in different periods, we will also find running through those changing images and forms a basic spirit of humanity shared by human beings no matter where they lived.

Prehistoric and Ancient Art

To the ancients, the movement of
the sun and stars was the image of
perfection: to see the celestial
harmony was to hear it, and to hear it
was to understand it.

Octavio Paz, *In Praise of Hands*

As we try to understand the lives and feelings of our prehistoric ancestors who first carved or painted images, we can assume that they must have lived in an uneasy relationship with a baffling and confusing world, without any understanding of the natural forces affecting their lives. Floods and forest fires, the migrations of the animals and birds on which they depended for food, hurricanes, and tornadoes were all inexplicable events to them, and they must have seen these natural phenomena as the expression of frightening unknown forces over which they had no control. Their huts may have sheltered them from the wind or rain, but what could they do about the rest of the natural forces and events which so intimately affected their lives? For example, how could they ensure that they would always have food, or guarantee that life would go on?

Stone Age Art

Prehistoric humans apparently saw no split between objects of utility and of beauty, for their world was not specialized as ours is today. The tools and utensils they made to help them hunt, cook, scrape, sew, carve, and later to build were all a part of their struggle with the overwhelming forces of nature and were not separated from their everyday lives.

The oldest hand-fashioned objects were the simplest tools and arrowheads, which were made by flaking stones or by carving bones. Certainly these tools were created for use, but the animals and symbols carved into some of them indicate that the need to create an image was also strong. Although the reindeer and other animals which cover them were probably an attempt to control the outcome of the hunt through symbolic power over the animal, we can surmise that the carver also was expressing a basic artistic need in shaping the forms so creatively and with such feeling and vitality. The later, more complex weapons had barbed tips which lodged in the animal's body, becoming more deeply embedded as he struggled for freedom. As you study these tools, you can see how human technical knowledge advanced.

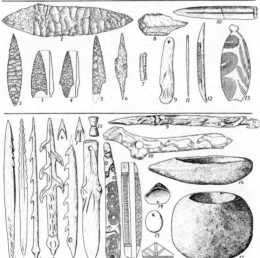

8-4 Neolithic tools. Bone. France. Courtesy of the American Museum of Natural History.

Stone Fertility Sculpture Sculptured stone figures have been found on the floors of painted caves and apparently date from about the same time as these tools. Although the majority of the statues were female, a few were male, and a very few were bisexual, like this rare hermaphroditic image which appears like three different sculptures when it is seen from the front, side, and rear. They are generally considered to be fertility symbols and are believed to have been used ritually in early attempts to control the human life cycle.

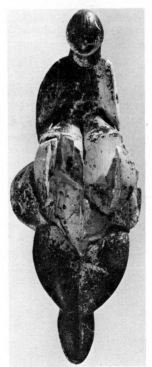

8-5 *Venus of Lespugue.* Late Paleolithic. Mammoth tusk. France. Collection Musée de l'Homme. Photo, J. Oster.

Cave Paintings The huge boulders overlooking the caves in Lascaux, France, must have seemed immense and overwhelming to prehistoric humans, emphasizing their helplessness in a frightening world. Trying desperately to come to terms with this world, they may have believed that carved and painted images would help them gain control over it.

It is probable that the paintings of animals which covered the walls of caves in Spain, France, and Africa were painted in an attempt to control another important survival need—food (Figure 8-1). When these paintings were first discovered in the late nineteenth century, most of the art world believed that they had been recently painted and found it difficult to believe that such vivid and accurate impressions of animals could have been made by Ice Age artists, working more than 20,000 years ago. But it is now generally agreed that these paintings of bison, mammoth, and deer were made by prehistoric hunters who had an intimate knowledge of the game they stalked and who used that knowledge to record with great sensitivity the essential features and movements of the animals. Working by light from flickering torches, deep in the recesses of the caves, and depending on their recollection of living models seen only during the hunt, the prehistoric artists must have experienced many difficulties. A visit to these caves today, now lit with electricity or strong flashlights, is an eerie and awe-inspiring experience which gives us some idea of the strong motivation the painters must have felt.

Hundreds of animals that the hunters wished to capture or kill were painted on the walls in realistic action scenes—often depicted pierced with arrows or spears. In the same way, some tribes in Australia today still make drawings of animals which they intend to hunt because the symbolic killing of the animals with painted arrows is believed to assure success in the hunt. Probably the same kind of ritual took place in the caves of the Stone Age, although scholars still debate the purpose of the images. Do they represent prehistoric scorecards used after the hunt to record success, or were they worshiped before the hunt with arrows added during each ritual? We may never know the answer.

Some parts of the caves are more fully covered with paintings than others. Possibly this is because new generations felt that the pictures painted by the people who came before were sacred, and if more paintings were added in these areas, it might assure greater success for the ritual. In the Lascaux caves, images of horses were added 8,000 years later to a forty-foot painting of a cow. Perhaps the addition of the horses made the whole wall more sacred than it had been. Certainly we do not know all there is to know about the meaning of these paintings.

Stone Age Monuments There are few remains of Stone Age homes, but there are many impressive monuments which are still standing. Some of these are made of huge stones dragged from distant places and set up in careful arrangements and combinations which must have served some ritualistic purpose. Brittany has thousands of these menhirs and dolmens, as they are called, set in rows.

The most famous of all Stone Age monuments is Stonehenge in England, built around 1800 B.C., long after the Egyptian and Mesopotamian civilizations had developed their sophisticated art (Figure 8-7).

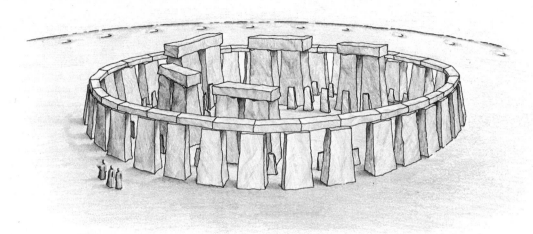

8-6 Reconstruction of Stonehenge.

8-7 Stonehenge. c. 1800-1400 B.C. Diameter of circle, 97′; height of stones above ground, 13½′. Salisbury Plain, England.

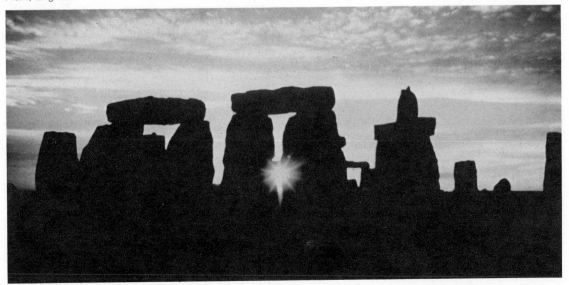

The people living in Britain at this time were still in the Stone Age, and though we might consider them primitive, the evidence of Stonehenge indicates that they had precise knowledge of the movements of the sun and stars. The placement of the enormous stones was so mathematically accurate that according to a computer it is only one tenth of a degree off at the summer solstice, the longest day of the year. At dawn on that day, the first rays of the sun pass through the rings of stones to strike the altar in the center—an impressive event which is enhanced by the fact that each of the stones is about twelve feet tall, dwarfing the human observers. This photograph recreates the religious mood which probably surrounded Stonehenge when it was in actual use. How these enormous rocks were transported from distant quarries and set up into position is still in doubt, though it has been suggested that they were dragged over log rollers by hundreds of people working together.

These Stone Age ritual caves and monuments apparently were abandoned as society became more complex. In fact, it is now believed that most Stone Age art, particularly the cave paintings and stone tools, was not even seen by humans again until it was recovered in the nineteenth century. Certainly, then, such art cannot be considered as a continuing influence in the cultural development of Europe. Since the unfolding story of Western art did not begin with the cave paintings and other creations of the European Stone Age, then we must look elsewhere for those beginnings.

The Fertile Ribbon and Fertile Crescent

We will find the beginnings of settled civilization and complex art and architecture near several great rivers in what is now called the Middle East.

The Fertile Ribbon of Egypt hugs both sides of the Nile River and can be seen on the left of this map. Though it is just 16 miles across, it is nearly 500 miles in length, ending in a wide delta where the river joins the Mediterranean Sea. Quite different in shape, the shaded portion in the center of the map between the Tigris and Euphrates Rivers is called the Fertile Crescent. Complex and sophisticated civilizations grew, flowered, and died in this part of the world long before civilization began in Europe. Archaeological evidence indicates that both areas had active prehistoric cultures from around 4000 B.C. and that about 3000 B.C. the peoples living in them began to make written records. We are not always certain of the exact dates in these early civilizations. In addition, it is often difficult to keep track of the dates when reading the text, for many of the cultures overlap. Egyptian history is usually broken down into three main periods:

Old Kingdom, circa 2800–2000 B.C.
Middle Kingdom, circa 2000–1600 B.C.
New Kingdom, circa 1600–500 B.C.

Within these there were many dynasties, but these do not concern us in this brief discussion.

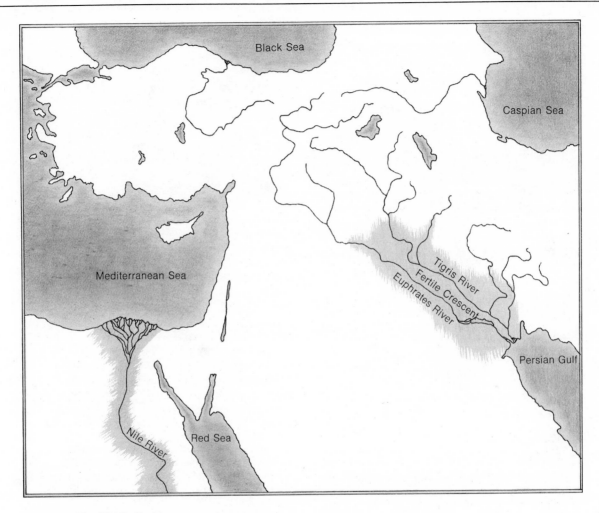

8-8 Map of the Middle East.

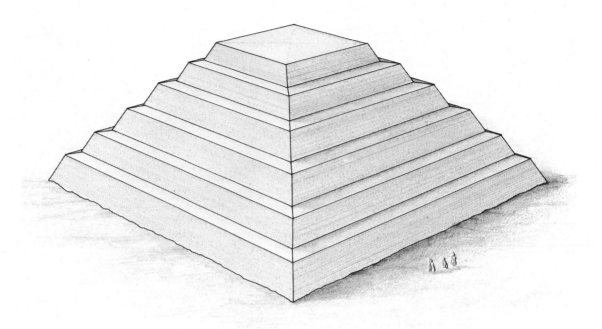

8-9 Reconstruction of the Pyramid of Zoser.

Egypt

Ninety-seven percent of Egypt is arid desert land, and the remaining three percent is fertile only because of the water supplied by the Nile River. This meant that early life was restricted to those areas bordering the river, which could easily be nourished by the annual flooding and ebbing of its waters. Because of this, the Greek historian Herodotus called Egypt's culture ''the gift of the Nile.'' In addition to providing water for agriculture, the Nile has also provided a means of communication, transportation, and sanitation to the peoples living along its banks.

The cultivation of the soil even along the Nile itself required irrigation, necessitating a communal effort on the part of the people. It was out of such cooperative efforts, in which individuals and whole villages had to work with one another, that the complex Egyptian

civilization developed, making possible large-scale building. The earliest major architectural structural form developed in Egypt was the mastaba, or step pyramid. One of these, made for King Zoser, actually consisted of several mastabas of diminishing size set on top of one another. The spaces between the walls were filled with rubble, and at one time the whole surface was covered smoothly with bricks. King Zoser's tomb was deep inside this structure.

Pyramids The most famous pyramids of Egypt were created for a father, son, and grandson during the Old Kingdom period (between about 2800 and 2000 B.C.) (Figure 2-8). The power structure of Egypt centered on the king, or pharaoh, and on the priests who could command thousands of men to work in the construction of the huge pyramids and temples. Pharaoh Kafre's tomb is the largest and most famous of the pyramids which were originally covered by the blocks of limestone still to be seen on the top. It was believed that Kafre's immortality would be guaranteed by the pyramid tomb, a gigantic sphinx sculpture, and a temple, all dedicated to him and all connected underground by passageways. The sphinx represents a king wearing a linen headdress, which signified royalty; and before it was worn down by weathering, it probably portrayed the features of Kafre. His smaller portrait is made from basalt, a rock so tough that a modern steel tool would quickly dull in an attempt to carve it. We can only assume that the Egyptians shaped this material, which is harder than our modern tools can carve, by using stone tools still harder than basalt—a very slow process.

Tombs Inside the pyramids, beneath the solid mounds of earth and rubble, were rooms full of the rich belongings of the pharaohs. These were left there to provide him with what his subjects believed he would need in his life after death. Another replica of the pharaoh was set up in front of the burial chamber to hold his spirit when his body no longer contained it. The wall paintings in the burial chambers give us a vivid view of ancient Egyptian life and customs, as do the many objects found in the tombs. Jewelry, cosmetics, toys, furniture, models of houses, pieces of clothing, sculptures depicting such daily events as slaves baking bread— thousands of these have survived to tell us what life was like in a well-to-do Egyptian home.

Since the images in the tombs were meant to last for eternity, they were carved and painted as clearly as possible according to a set of strict artistic and ritualistic guidelines. People, scenery, animals, and furnishings were always shown from an angle or point of view which gave the least dimension in depth and the most characteristic contour. For example, a pond or a lake might be painted as if seen from above or from the side. An underwater scene might show fish swimming through the reeds, while birds and trees were drawn in profile. A table might be shown from one side or from the top. The figures of people in Egyptian paintings usually seem to stand in poses which even the most supple of us could never achieve. This was because the Egyptians represented details of the human body as a composite of its most characteristic shapes. They believed that since the head was most easily seen in profile, it should be painted that way. For the

8-10 Portrait of King Kafre, Giza. c. 2530 B.C. Diorite. 66″ high. Egyptian Museum, Cairo.

8-11 *Offering Bearers* from the Tomb of Sebek-hotpe. Dynasty XVIII. Thebes. Tempera on mud plaster. The Metropolitan Museum of Art, Rogers Fund, 1930.

same reason the eye was shown from the front, as were both shoulders; but arms, legs, and feet were presented in profile. Egyptian art is not based on what the artists saw but on what they knew about their subjects, in somewhat the same way a twentieth-century Cubist painter showed many facets of a human figure (Figure 1-4).

The decorations in these tombs were highly specific because of the belief that the king could only enjoy in afterlife what was provided for him in reality or in replica in his tomb (Figure 8-12). For example, the birds in Egyptian paintings are reproduced so accurately that they can still be identified as varieties living in Egypt today. Pious Egyptians believed that the pharaoh would starve if paintings of food were not there to guarantee that he could eat as he was accustomed. Originally his descendants had brought the dead king real food, but they quickly found that such piety was short-lived and that paintings were more durable.

The architects of these buildings tried to hide their entrances to prevent the valuables inside the tomb from being stolen. The sparse simplicity of the exterior surface of the pyramid made concealment of the entrance to the interior difficult and no matter how carefully they tried, the doorways were almost always located and the pharaoh's belongings stolen. Apparently, even for those who believed that the essence of God rested in the pharaoh, the lust for worldly treasure could be stronger than the fear of the divine.

New burial places had to be devised to protect the king's remains, so hidden tombs were constructed in cliffs. By the time of the Middle Kingdom (about 2000 to 1600 B.C.),

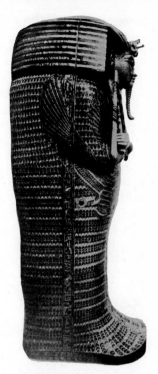

8-12 Sarcophagus of King Tutankhamen. Egyptian Museum, Cairo.

the tomb entrances were made as inconspicuous as possible, with no large monuments to mark the burial spot. The cliffs in Thebes, the Valley of the Dead, contain most of the tombs from that period. But despite the fact that it is difficult to see the entrances to the tomb in the cliff, all were broken into by robbers. This meant more than the loss of valuable art objects; it also meant that the pharaoh was deprived of what he needed to exist in his afterlife.

Over a period of nearly 3,000 years, from around 3000 to 600 B.C., Egyptian customs and the art which reflected them changed very little. For us, living in a time of constant change, it is difficult to imagine such a static society, but dynasty followed dynasty through the Old, Middle, and New Kingdoms with little change in art forms. Only one king appeared who altered the static repetition of religious ideas and images, and his changes did not last long.

It was the remarkable Pharaoh Akhenaten, who reigned in the New Kingdom (around 1600–500 B.C.), who broke with the traditions of the past. As a monotheist and heretic, he tried to simplify rituals and cut down the long list of Egyptian gods, confining worship to only one—the sun-god Aton. And for a short time under his rule art was realistic, full of movement and individuality. Akhenaten's queen, Nefertiti, was a partner in the reforms and is known to us by her portrait as an individual human and not as an abstracted symbol (Plate 15).

However, tradition dies slowly, and when his nephew Tutankhamen became pharaoh at the age of twelve years, in about 1360 B.C., the old beliefs were restored. He only reigned a few years, for he died as a very young man. No other pharaoh has been found buried with such elaborate preparations or such a wealth of tomb furnishings. When Tutankhamen's tomb was discovered, almost intact, in 1924, the archaeologists found in it a throne inlaid with gold, a beautifully decorated golden dagger, and a great deal of jewelry inlaid with glass and semiprecious stones. This included golden amulets of the gods, rings, bracelets, necklaces, and even golden guards to protect the mummy's toes. Small sculptures,

deep blue glazed pottery, clothing, alabaster boxes and vases, and many ritual objects found in the tomb attested to the delicate and advanced craftsmanship of the ancient Egyptians. The royal mummy was found in a nest of several stone, wood, and gold sarcophagi, each one smaller than the last, with the innermost one just fitting his body.

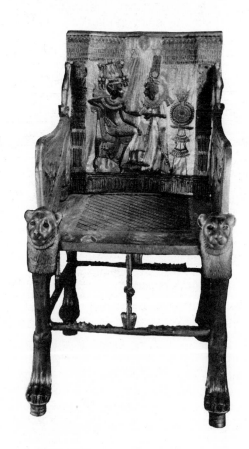

8-13 Throne of King Tutankhamen. Egyptian Museum, Cairo.

Temples The temples of the New Kingdom rose almost as high as the ancient pyramids. Built of stone post and lintel construction, their immense columns were often shaped like a bundle of papyrus stems bound together. These bundles are believed to have been used instead of scarce wood in earlier small buildings and may have been the source of the column design. Other columns in the large stone buildings were topped with capitals which were inspired by the lotus flowers of the Nile (Figure 3-6).

This Temple of Rameses was unique. As worshipers proceeded between the statues in the entry hall to the innermost sanctuary, they found a small confined area reserved for sculptures of Rameses and the sun-god. The building was designed so that twice a year, at the equinox, a ray of sunlight would pierce the mammoth stone temple and reach this shrine. The scientific skill of these ancient Egyptian builders, as evidenced in the Temple of Rameses as well as in other buildings, is staggering even when compared with today's engineering. When recent construction of the Aswan Dam raised the level of the Nile, the entire temple was moved to the top of a mountain to preserve it.

Delicate glassware, jewelry, richly glazed pottery, alabaster vases and boxes, as well as the paintings and sculpture preserved in the tombs, combine to give us a picture of ancient Egypt as an aesthetically sophisticated civilization. It was, however, an art that required a wealthy ruling class to maintain, so when internal power struggles within the structured society led to the collapse of the government, Egyptian art declined as well.

Mesopotamia

Like the Fertile Ribbon along Egypt's Nile, the Fertile Crescent, between the Tigris and the Euphrates, was flooded when the rivers overflowed in spring, and in summer it was parched by the sun. Here, also, irrigation was necessary for agriculture to develop. Because it did not have natural barriers which kept invaders out, the whole area of Mesopotamia, the land between rivers, became over a period of thousands of years, the home of a series of civilizations. One culture would develop, decline, and fall before invaders, and another would grow to take its place. Existing at the same time, but as far as we know independent from Egypt, Mesopotamian culture was in constant flux and change. There, society was not static like that of Egypt, where the sandy deserts isolated the civilization from outside influence. We only have space here to touch briefly on the most important of the cultures which developed in this fertile land over more than 3,000 years. The story is a confusing one, with constant alternation of power between the empires of Babylon and Assyria. The approximate dates of the four main early cultures in this area are:

Sumer, circa 4000–2300 B.C.
Assyria, circa 1400–600 B.C.
Babylon, circa 2000–550 B.C.
Persia, circa 550–325 B.C.

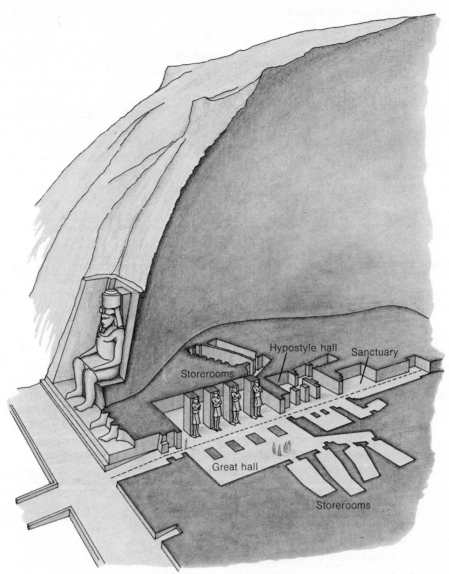

8-14 Reconstruction of the Temple of Ramses.

Sumerian Art The Sumerians were the first people known to have developed a written language. They were also engineers who, despite poor local materials, built large cities and palaces and developed the arch. Even today we follow the Sumerians' division of the hour into 60 minutes and the circle into 360 degrees.

Sumerian religious thought stressed the nature gods of water, sky, and storm. The mountains were considered to be the home of the gods, and Sumerian temples were placed on artificial mountains made of sun-dried bricks which the worshiper could ascend by wide ramps. All that is left today of these ziggurats, as the man-made mountains are called, are mounds of clay, but an artist's drawing shows us how they may have appeared, with ramps that led upward on all sides through archways and past trees and gardens. Like the pyramids of Egypt, the ziggurats were built with solid walls, and the interiors were filled with earth. What has been called the hanging garden of Babylon was actually a ziggurat with trees and flowers planted on its platforms.

8-15 Ziggurat of Ur.

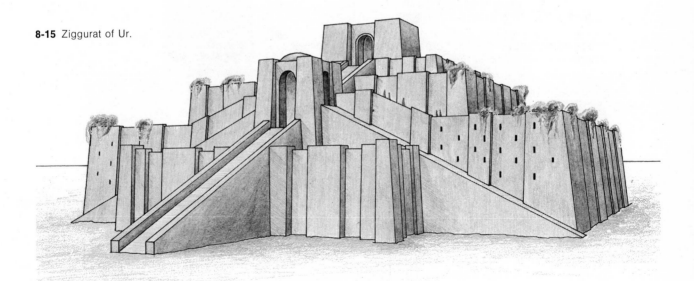

The first arches The extremely limited building materials available in Mesopotamia forced builders to invent new forms. Without wood or large stones, the Sumerians had to use bricks to span openings, and this led to the revolutionary concept of the arch. It was an important building feature never developed by the Egyptians or by the later Greeks. The use of arches permitted the building of major architectural structures without the limitations of the huge slabs of stone needed for post and lintel construction, which could collapse from their own weight. Eventually, the sun-dried bricks were fired with a glazed surface to make them more weatherproof, and the exteriors of buildings were often surfaced with them.

Much of what we know of Mesopotamia is derived from the Old Testament of the Bible. There we learn of Hammurabi, King of Babylon from around 1727 to 1686 B.C., who established an empire and created a famous code of laws which is inscribed on this basalt *stele,* one of the rare stone monuments in Mesopotamia.

The land of Mesopotamia as a whole was poor. When humans tried to imagine a more desirable existence, they called their image ''the garden of Eden,'' or Paradise. But on their earth was clay and lots of it.

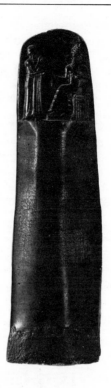

8-16 Stele inscribed with the Law Code of Hammurabi. c. 1760 B.C. Diorite, 7' high. Cliché des Musées Nationaux.

Cuneiform script That clay was used to make tablets on which human beings' first written words could be recorded. In the Sumerian period, inscriptions were scratched or pressed into the clay tablets in what is called cuneiform script. This script enabled people to put ideas into written language; and because the symbols were phonetic, they could be read as spoken language. In contrast, Egyptian writing was pictographic, made up of images of objects. As a result, its potential for communication was limited, for unlike sounds, images are not easily recombined into new words. In order to express thought successfully in writing, people must be able to combine symbols of sounds. Although far removed from it in actual words, our modern written language is a development from Mesocuneiform script.

8-17 Cuneiform tablet from ancient Sumer containing titles of literary composition. c. 2050 B.C. 80 x 132 mm. Yale Babylonian Collection.

Assyrian Art The beginnings of Assyrian art date from the fourteenth century B.C. when the Kingdom of Babylon was forced to acknowledge the independence of this area of Mesopotamia. Though Assyria developed an empire, it could never overcome the dominant position held by Babylon; and when Assur, its capital, was destroyed in the seventh century B.C., the Assyrian empire collapsed.

The Assyrians were primarily warriors and hunters, who commissioned their sculptors to depict military camps, expeditions, hunting scenes, and the life of the kings and the military caste in their reliefs. Some of the carvings were realistic, like this relief decorating the Palace of Asurbanipal at Nineveh, which portrays the death of a wounded lioness, showing a strong sense of action and knowledge of animal anatomy. It

8-18 *Dying Lioness.* c. 650 B.C. Nineveh. Limestone, 13¾″ high. British Museum, London.

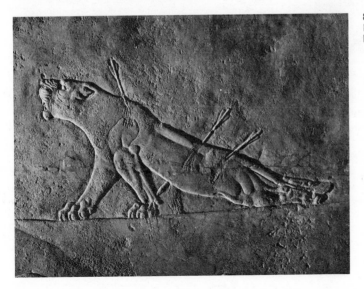

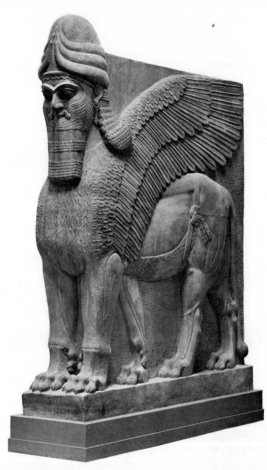

8-19 *Winged Lion* (guardian of the Palace Gate from the Palace of Ashur-nasir-apal II). Eleventh century B.C. Assyrian. The Metropolitan Museum of Art. Gift of John D. Rockefeller, Jr., 1932.

even expresses some sensitivity to the death throes of the animal, a sensitivity not commonly found in Assyrian art. Other animal sculptures were nonrealistic—for example, this stone guardian which stood at one of the entrances to the palace of Sargon II at Khorsabad. It has a human head, the headdress of a god, the wings of a bird, and the body of a lion. It also was made with five legs so that when it was seen from the front, it would appear to have four legs, and as one walked past it into the palace, it would still seem to have four legs. This represents an effort to make the animal appear as complete as possible, in the same way the Egyptians drew the human figure from several points of view in an attempt to present a total image.

The Assyrians did not introduce any new construction methods, and palaces decorated with great stone slabs carved in relief were their most characteristic form of architecture. Some of these palace structures of the Assyrians were highly elaborate, like the 200-room palace-temple complex of Sargon II at Khorsabad, enclosing twenty-five acres and including a ziggurat with a spiral ramp.

Babylonian Art From the New Babylonian period (about 626–538 B.C.), which the Bible describes, very little remains. The palace of Nebuchadnezzar II, the sanctuary of the universal god Marduk, and the hanging gardens of Babylon are all gone. But the arch, the main contribution of Mesopotamia to the architecture of the Western world, can be seen in this gate dedicated to the

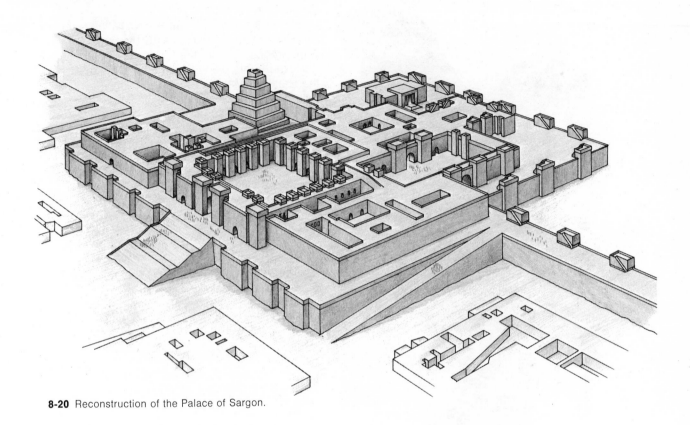

8-20 Reconstruction of the Palace of Sargon.

goddess Ishtar (Plate 16). The gate, which is still standing, is faced with glazed brick, decorated with fanciful two-headed animals, some as long as twenty feet. Similar glazed brick reliefs in brilliant colors were also used on the Processional Way of Babylon which led to the Ishtar Gate. This technique of firing the bricks with a vitreous glaze to make them more durable helped to preserve this

archway and its nearby reliefs, but nothing remains of the famous Tower of Babel. Artists throughout history have tried to imagine what it must have looked like, but without any drawings or plans of it, no one can be quite sure. Brueghel's imaginary painting of it sets it in a Flemish landscape, near a Medieval town peopled by artisans in sixteenth-century dress (Plate 17).

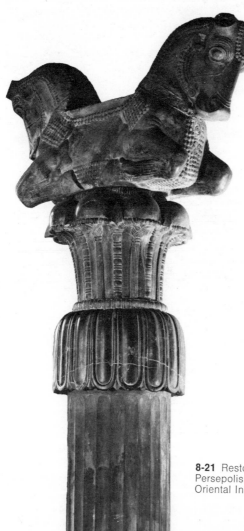

Persian Art The final period of Mesopotamian art overlaps Greek civilization, and its architecture was stimulated by contact with Greece. Darius, the emperor who was defeated in his plans to conquer Greece at the Battle of Marathon, built a massive palace in the city of Persepolis, whose great halls, with roofs supported on slender sixty-foot pillars, shows the influence of Greek architectural forms. No longer did Mesopotamian palaces look like fortresses; instead they were open and inviting in plan with many stairways and columned waiting rooms. Perhaps this huge capital with two animal heads placed back-to-back is symbolic of the role played by the Persian empire—one head looks back to the cultures of the Fertile Crescent upon which much of the Judeo-Christian tradition is based, while the other head looks toward the Mediterranean and the civilization of Greece, whose philosophy and art also strongly influenced Western culture.

8-21 Restored double bull capital and column from Persepolis. First century. Stone. Courtesy of the Oriental Institute, University of Chicago.

The Classic Past

Leaving the waters of the splendid
East, the sun leapt up into the
firmament to bring light to the
immortals and to men who plough the
earth and perish.

Homer, *The Odyssey*

We have been brought up to think of the Greeks and Romans as the wise ancients who developed complex and sophisticated civilizations, when in fact they had the good fortune to be alive when the world was young. They had a chance to create a new world, to develop new philosophies, governmental systems, and styles of art. In contrast, perhaps we are actually the ancients, grappling with the problems of a weary world which has made many mistakes.

Our legacy from Greece is incalculable. Greek dramatic literature, the poetry of Homer, experiments in democracy, philosophical concepts, the Greek scientific approach to the mysteries of nature, the artistic expressions of the Greek civilization— the list of their cultural achievements which continue to influence Western man is almost endless. There is hardly a facet of our lives which is not still affected in some way by Greek thought.

Actually much of what we consider to be characteristic of this ancient civilization was originally derived from other peoples and absorbed into the Greek culture. For example, the Greeks incorporated into their art and religion ideas from the Ionic peoples of Asia Minor, through whom they received

elements of the Mesopotamian culture. The Dorians, who invaded the Greek mainland and the Aegean Islands from the north around 1000 B.C. disrupted the earlier sophisticated cultures of Crete and Mycenae, but they absorbed their technical skills of metallurgy, pottery, weaving, building, and farming. All of these influences were incorporated into the later Greek civilization.

Like other areas of the world where land bordered a sea, there was constant trading and traveling during prehistoric and early historic times among the lands bordering the Aegean Sea. Such contact and exchanging of ideas with other peoples stimulated the development of the Aegean civilization. For example, largely because of its island location. Crete became an extremely sophisticated civilization, between around 2000 B.C. and 1400 B.C. carrying on trade with Asia Minor and Egypt and incorporating influences from these areas into its art. Egyptian post and lintel construction probably influenced the building of the enormous palace built at Knossos on Crete which gave rise to the Greek legend of the labyrinth. In this myth the Greek hero Theseus found his way through a complex maze, similar to the many rooms of the palace, to slay the

Minotaur who had been demanding a yearly sacrifice of young Greek men and women. The myth of the Minotaur, half man and half bull, probably grew out of a memory of the Cretan cult of the bull, which is so vividly expressed in the palace frescoes of young men and women leaping over the bull's back (Figure 5-8).

The Aegean Sea is full of islands which provided stopping places for sailing ships, and early Greek sailors used the strong winds of Homer's "wine dark sea" to take them on long expeditions for both trade and war. In the epic poem of *The Odyssey* Homer describes some of the legendary inhabitants of these islands such as the frightening one-eyed cyclops and the alluring sirens.

By the mid-fifteenth century B.C. Mycenae on the Greek Peloponnesus (the southern peninsula of Greece) had become a rival of Crete. The golden treasures which have been discovered there bring to life the warlike and lusty days of the ten-year war between the Mycenaean dynasty and the Trojans. Some of the royal inhabitants of the hilltop citadel at Mycenae, such as King Agamemnon, Clytemnestra, and Aegisthus, later became the main characters in Greek tragedies. In addition, many Greek myths are to a great extent based on folktales handed down from the stories told by bards by the royal fireside in Mycenae.

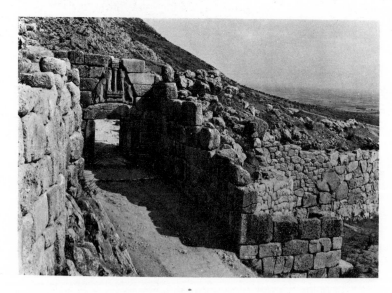

9-1 The Lion Gate, Mycenae. c. 1250 B.C. Tap Service.

Gods and Mortals

The inheritance of oral poetry from Homeric days was of great importance in the growth of Greek art—inspiring artists to create images of the mortals and immortals who tangled with each other throughout the *Odyssey*. Natural events like storms, earthquakes, bolts of lightning were all explained by the early Greeks as expressions of the anger of the gods. Although these gods, who played such an important part in the lives of the Greeks, were powerful and frightening, they were also extremely human, and their emotions, weaknesses, and virtues were largely exaggerations of the foibles of mortal men. But the gods were also immortal, and although they could suffer and be wounded, they could never be overcome except perhaps by trickery. The Greeks were in awe of their gods, but they also felt close to them, and artists depicted them in human form. By around 700 B.C. the political and economic base of the Greek civilization was shifting from an agricultural organization to urban centers. With the resulting growth of trade, some towns or families became wealthy enough to pay craftsmen to create images of these immortals and heros which were then dedicated to shrines honoring the gods.

Also dedicated to the gods were the first ritual Olympic games, held in 776 B.C. This gathering of athletes gave impetus to a creative process which culminated in classic Greek sculpture. Rigidly posed Egyptian statues must have been the original models for this early male figure known as a *kouros,* but apparently the Greeks were not content

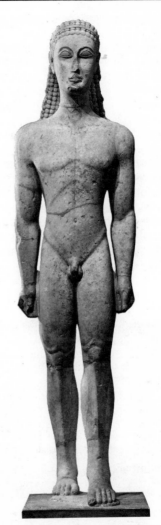

9-2 *Standing Youth (Kouros).* 615-600 B.C. Marble, 6'1½'' high. The Metropolitan Museum of Art, Fletcher Fund, 1932.

with static poses which could not convey the spirit of the gods and heroes they wished to portray. Thus, although the kouros is stiff and severe, it is also full of vitality—both physical and mental—already illustrating the Greek ideal of a healthy mind in a healthy body. Standing rigidly with one foot advanced, fists clenched, and muscles taut, the figure seems to be waiting to burst out of its bonds of stone. A companion statue of a young maiden, or *kore,* with a rigid compact figure stares at us with an artificial archaic smile which may not have been so much the result of artistic design as of the sculptor's difficulty in carving the mouth. In these early memorial figures of mythical heroes, gods, and mortals we can already begin to see that quality of balance between the emotions, sensations, and intellect which became so typical of later classic Greece. Like most Greek sculpture, the kouros and kore statues were colored, and we can see traces of the original paint on them still. Though today we think of the pure white marble of Greek statues and temples, we must remember that they were once covered with brilliant colors.

Like the kouros, the bronze charioteer from Delphi, which was cast in the fifth century B.C., is also stiff in the way he stands and holds the reins, but there is a more human quality in his head with its curled hair held by a headband and his inlaid stone eyes. These, too, were originally painted. Probably the statue was commissioned to celebrate the victory of a city in the ritual athletic contests, but whether it was a portrait of an actual winner or an idealized expression of all healthy minds and bodies is not known. At any rate, in it we see the beginnings of the idealization and refinement of proportion which characterizes classic Greek art.

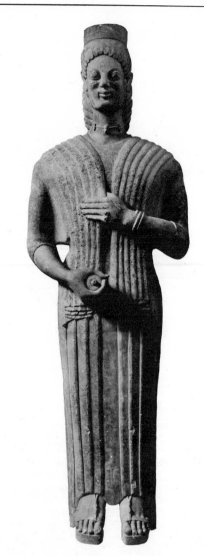

9-3 *Young Maiden (Kore).* Staatliche Museum, Berlin.

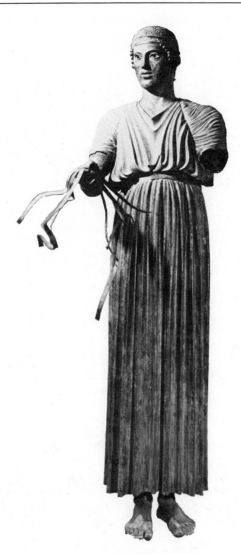

9-4 Charioteer from the Sanctuary of Apollo at Delphi. c. 470 B.C. Bronze, 71″ high. Museum, Delphi.

The Golden Age

The Golden Age of Greece, or the Classical period, refers to a comparatively short time during the fifth and fourth centuries B.C. when Athens was the center of a rich flowering of art, literature, and philosophy. This moderately sized city produced in three generations such dramatists as Aeschylus, Euripides, and Sophocles; philosophers like Socrates, Aristotle, and Plato; sculptors like Phidias; and leaders of the high quality of Pericles and Themistocles. During this period, many temples were built as shrines dedicated to the patron gods and goddesses of each city-state.

These marble temples, which were such a crowning achievement of Greek architecture, clearly show their origins in the temples of Egypt and in the wooden columns, rafters, and gabled roofs of earlier Greek buildings. For example, the later stone columns were placed at what were originally the meeting points of the wooden beams, with a square plate interposed between the capital and the beams in order to strengthen the joining point. Even the heads of earlier wooden pegs show as decorative elements in later stone construction. In earlier wooden buildings the ends of the beams were covered with clay tablets to protect them from the weather, and the grooves in these tablets were later copied in stone, probably to drain off rainwater. In stone construction the spaces between these beam ends were called *metopes* and were decorated with carving. So we can trace all the details of the famous Greek orders of architecture to the original wood construction and see how they were translated into stone. The Greeks maintained

the same general plan for all their temples, subtly relating each part to the whole composition. The main variations existed in the details of the columns.

Greek Orders The different types of columns are called the *Greek orders,* which Western architects have borrowed, copied, and adapted for centuries. They can still be seen around us in buildings today—look for them copied in marble and even cast cement on libraries, courthouses, and banks. They were, like all classic Greek architectural details, refined to create as satisfying and harmonious a relationship between all the parts as possible. The simple early Doric order, with its unadorned capital, was named for the northern peoples, although it probably originated in Crete. The Ionic order can be traced back through Ionia to earlier forms used in Asia Minor whose spiral decoration is believed to be derived from sheaves of rushes which were native to Mesopotamia but not known in Greece. However, some people consider them to be simplified ram's horns. This Ionic column, with its slender *shaft* and delicate *fluting* (grooves and ridges carved in the shaft to emphasize its height) was lighter than the earlier and more solid Doric. The Doric order gave an air of massive grandeur to the early temples, while the Ionic temple was lighter and more open and inviting. The most ornate order, the later Corinthian, has a capital shaped like an inverted bell decorated with overlapping rows of acanthus leaves. This style was adopted by the Romans for their religious and secular buildings and eventually influenced later Romanesque, Gothic, and Renaissance

builders in their use of naturalistic plant forms. Unlike the Greeks, who rarely used more than one order in a building, later architects, particularly during the Renaissance, often mixed the orders.

The most famous Doric monument, although not necessarily the most refined, was the Parthenon, built on the Acropolis overlooking Athens and the Aegean Sea. An *acropolis* is simply a fortified hill. In Athens it was covered with sacred shrines, and this artist's reconstruction of the Acropolis shows it during the Golden Age of Pericles (480–420 B.C.) when it was at its height as a religious center. Temples, treasures, commemorative statues, and *votive statues* were reached through a ceremonial gateway at the head of a long flight of steps. Up this pathway and through the gate came the procession honoring Athens's patron goddess Athena, whose towering statue by Phidias was visible from the sea several miles away.

The richly decorated Doric Parthenon was dedicated during the Panhellenic celebration of 437 B.C. and shows in its sturdy form the subtle Greek architectural proportions which have influenced so many architects throughout history. The precise way in which the proportions were worked out, the interplay of vertical and horizontal forms, the contrast of the solid *cella* against the many columns, all combine to create a harmonious composition which appears simple but which is actually extremely complex. The architects Ictinus and Callicrates designed the columns to bulge slightly outward in the center. This distortion, called *entasis,* was used to counteract the optical illusion which causes

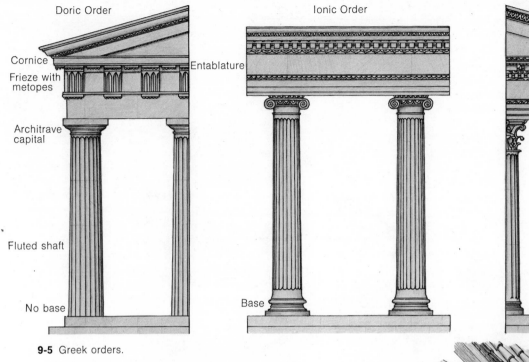

Doric Order

Cornice
Frieze with metopes
Architrave capital
Fluted shaft
No base

Ionic Order

Entablature

Base

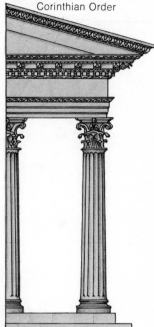

Corinthian Order

9-5 Greek orders.

straight lines to appear to curve inward. In
addition, the horizontal line of the top step on
the porch, which formed a base for the
columns, and the line of the *architrave*
between the columns and the roof were also
swelled slightly upward to avoid the
appearance of sagging. In the space formed
by the columns and roof at the end we can
see the shape of an inverted vase. Was the
beauty of that space created by chance, or
was it the result of careful planning? Perhaps
it had a symbolic meaning which is now lost.
The triangular space between the columns
and the roof, known as the *pediment,* held

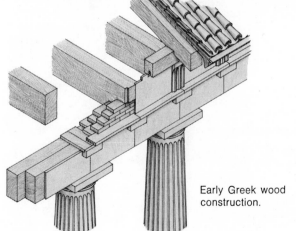

Early Greek wood
construction.

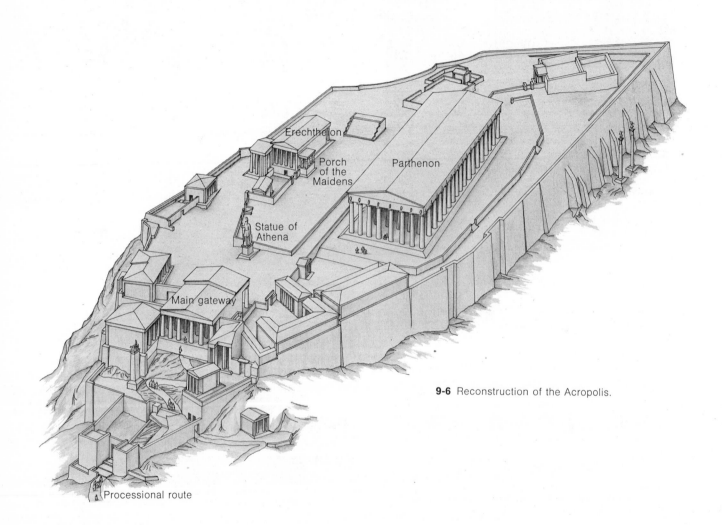

9-6 Reconstruction of the Acropolis.

Erechtheion

Porch of the Maidens

Parthenon

Statue of Athena

Main gateway

Processional route

9-7 South porch of the Parthenon. 448-432 B.C. Photo, Greek National Tourist Office.

ourselves as part of a ceremonial procession of Athenians winding their way up the rock of the Acropolis toward the Parthenon, we will first pass through the propylaea, or ceremonial gateway. Instead of entering the temple here, the sacred processional would wind around the side and approach the temple at its other end. Walking along the side of the Parthenon, we can look up and see the lively horses and riders carved on the metopes. And as we climb the steps, above us is the sculptured *frieze* surrounding the cella depicting the panathenaic procession which took place every four years. We might look for fellow citizens represented in the frieze, but the idealized faces have a dignity appropriate to the occasion which makes them difficult to recognize. Next we would pass through the colonnade and stand at the entrance to the temple, for only the priests could enter the sacred sanctuary. But in front of us inside the cella we might be able to catch a glimpse of the magnificent gold and ivory statue of Athena Parthenos by Phidias.

Unfortunately, today the temple is stripped of most of its sculpture, the gold and ivory has gone, and only bits and pieces remain of the rich religious shrine which once existed.

Another temple on the Acropolis is the Erechtheum, which covered one of the most ancient of shrines—sacred to the snake-god Erechtheus, to Athena, and also to Poseidon. This multiple dedication explains the complicated and unusual multilevel plan of the temple which was built beside the sacred spring and olive tree. Its four levels contain three differently proportioned sets of Ionic columns as well as these unusual *caryatids* of the Porch of Maidens.

sculpture depicting the birth of Athena and the quarrel between Athena and Poseidon. The middle figures have enough space to stand erect, but as the roof slopes down, the awkward space dictated their crouched and stretched-out poses.

The Parthenon, like all Greek temples, was built to be visually satisfying from all sides, and its carefully proportioned rectangular form presents an impressive silhouette which dominates the Acropolis. If we imagine

9-8 Three goddesses from the east pediment of the Parthenon. c. 438-432 B.C. Marble, larger than life size. British Museum, London.

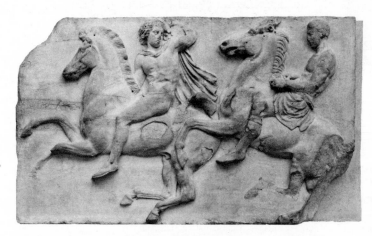

9-9 Horsemen from the west frieze of the Parthenon. c. 440 B.C. Marble, 43″ high. British Museum, London.

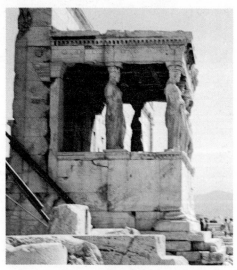

9-10 Caryatid porch from the Erechtheum. 421-405 B.C. Acropolis, Athens.

Sculpture of the Golden Age Classic Greek sculptors learned to distill the essence of beauty from the realistic world around them, idealizing the body, but at the same time making their statues human enough to allow us to identify with them. No particular living individual is portrayed during the Classic period, yet with all that has been left out, enough humanity remains to show the Greek people as serene and at peace with the world and with themselves.

Myron's *Discus Thrower,* which exists now only in a later Roman copy, shows how far

Greek sculptors had moved from the stiff frontal pose of the kouros. Myron had successfully solved the sculptural problem of rendering movement in space. This statue of the Classic period was carved around 450 B.C. and shows the athlete poised at the critical moment just before his forward swing. We see him just as he has bent down and swung his arm backward to throw the discus with all his force. From whichever angle we look at the statue, a rhythm develops which draws us into the sculpture and encourages us to examine it from all sides. Our eyes move from the discus to the arm, to the head, down to the knee, and back out to the heavy discus to begin the cycle again.

The *Aphrodite* from Melos, while perhaps not the most beautiful sculptured feminine figure of her day, has captured the imagination of the public ever since her rediscovery in 1820. Part of the popularity of this figure may be the result of the debate over the original pose of her missing arms. Some historians say she was holding a shield and gazing at a reflection of her beautiful body in it. Or perhaps she was deciding whether to rearrange the folds of her dress, which is carved as if the cloth were wet, revealing more than it conceals. Whatever the meaning of her pose, Greek sculpture like this, which was rediscovered during the Renaissance, had a lasting influence on Western art. When you say someone has the body of a Greek god, you are probably thinking of the idealized human bodies carved by Praxiteles. This sculpture of

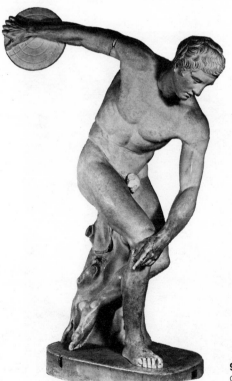

9-11 *Discus Thrower.* Roman copy of bronze by Myron. c. 50 B.C. Photo, Vatican Museums.

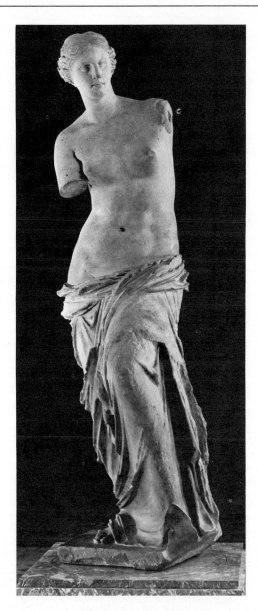

9-12 *Aphrodite.* Second century B.C. Marble, larger than life size. The Louvre, Paris. Cliché des Musées Nationaux.

Hermes is noted for the soft sensuous appearance of the skin and the graceful pose, which contrasts so sharply with the stiff kouros figure of 200 years before. Hermes, the messenger of the gods, stands relaxed, his weight flowing from his torso to the reversed direction of his hips in a gentle S curve. In one arm he holds the infant

9-13 Praxiteles. *Hermes and the Infant Dionysus.* c. 340 B.C. Marble. 7'1" high. Museum Olympia. Hirmer Photograph.

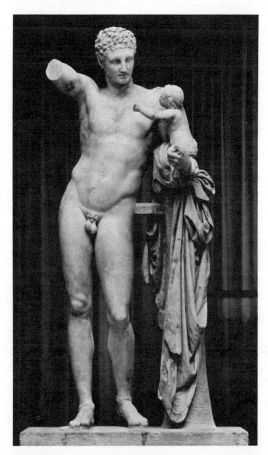

Dionysus, god of wine, and his missing arm probably held a bunch of grapes toward which the child is reaching. The Hermes and the Aphrodite represent the height of the Golden Age of Greek art.

Hellenistic Art Following the Classic period when Greece produced most of its best-known art, sculptors became more interested in recording the faces of actual humans than in creating idealized portraits. After the death of Alexander the Great in 323 B.C. his empire broke up into small states with wealthy rulers who competed with each other in commissioning extravagant and showy art. Hellenistic is the term applied to this art of the Mediterranean area which was conquered, colonized, or influenced by the Greeks.

The taste of this period leaned toward detail and emotional content instead of abstract beauty, and even mythological subjects, like Laocoön and his sons, were treated with an emphasis on individual human emotion. Legend has it that the Trojan priest Laocoön and his sons were punished by the gods and strangled by snakes because they revealed the true purpose of the Greek wooden horse which was designed to defeat Troy by a trick. The agony of their death shown in this work is typical of Hellenistic sculpture in which all emotions were exaggerated.

Painting Unfortunately the great wall paintings of Greece have disappeared, and we know of them only through references in literature. But the creativity of Greek painters has been preserved for us in the refined and expressive paintings on their decorated pottery. We can enjoy the full vitality of the

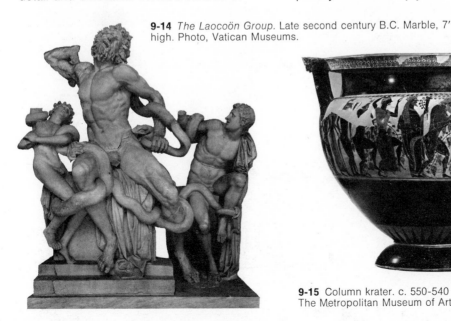

9-14 *The Laocoön Group.* Late second century B.C. Marble, 7′ high. Photo, Vatican Museums.

9-15 Column krater. c. 550-540 B.C. 22″ x 23 3/16″. The Metropolitan Museum of Art, Fletcher Fund, 1931.

Greek imagination applied to myths of gods and heroes, everyday life, comedy, drinking parties, or grief for the death of a loved one in these paintings on vases or jars. Just as classic Greek sculpture evolved from early simple forms, so pottery painting developed from simple but lively black figured jars (Figure 2-3) to the more sophisticated figures in this scene of a Dionysiac feast. Immortal gods and mortal humans remained the main concern of the artist just as they were in sculpture, and graceful figures with fluid draperies are typical of the classic painting style. Greek pottery was famous throughout the classic world because of the diversity of its shapes and the skill of the paintings on them. Pottery became a major item of export and an important part of ancient Greek economy. Some pieces have been found by skin divers on sunken ships as far away from

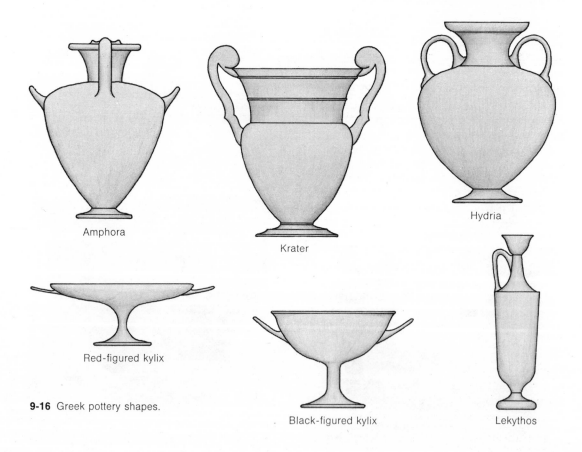

Amphora

Krater

Hydria

Red-figured kylix

Black-figured kylix

Lekythos

9-16 Greek pottery shapes.

Greece as southern France. The Greek potter designed every piece to serve a specific function, creating shapes to fill every possible need from large storage jars to delicate drinking cups, just as potters today create shapes to fit different functions.

The Rise of Rome

As Rome developed as a power in the western Mediterranean, the Greek colonies there were threatened. Greek power declined, and finally the Greeks were defeated by the Romans at Corinth in their own homeland in 146 B.C. Their influence continued, however, and Roman scholars went to Athens to study under Greek teachers.

Like the Greeks before them, the Romans borrowed and incorporated ideas from other peoples into their art. Greek culture was a particularly strong influence on the Romans, coming to them first by way of the Greek colonists who settled in southern Italy and Sicily in the eighth century B.C. and later by direct contact when Rome conquered Greece.

The Romans combined this strong Greek influence with that of the Etruscans who originally ruled over western central Italy as far south as the Tiber. Many concepts of Roman religion and government originated in the Etruscan culture, while Etruscan civilization in turn had incorporated elements from various other civilizations—Greek, Mesopotamian, ancient Central European, and Indo-European. The Etruscans used the arch, cast sculpture in bronze, and carved in stone, but are particularly noted for their vigorous clay portraits and the lively frescoes of banquets and festivals with which they decorated their tombs.

The term *Greco-Roman art* describes the early art which developed in Italy after the Romans overwhelmed the Etruscans in the third century B.C. and conquered the Greeks. The Roman town of Pompeii was filled with examples of art in the late Greek Hellenistic style (Figure 9-14). In addition, many of the

9-17 Flutist (detail) from the Tomb of the Leopards. c. 470 B.C. Etruscan fresco. Alinari-Scala.

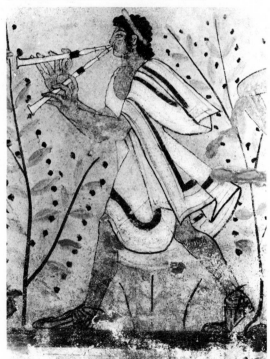

artists in Italy were Greek or Etruscan, working on commission for wealthy Roman patrons. The Romans added their own genius to the artistic accomplishments of the Greeks and Etruscans, making important contributions in engineering and in building techniques such as the refinement of the arch and vault. They spread their knowledge of construction and skill in government further than any other civilization had previously succeeded in doing or has done since then. Roman walls and roads can still be found in the northern areas of England, in Jordan in the east, and in remote areas to the south in Africa. The precisely carved Corinthian columns of this temple of Jupiter at Baalbek in Lebanon still stand as an example of Roman imperial expansion.

This far-flung Roman Empire was based in part on skill in government and in part on engineering skills.

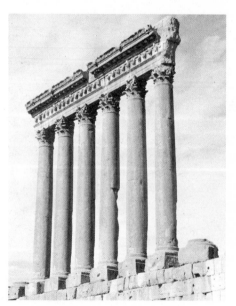

9-18 Temple of Jupiter at Baalbec. First to second century A.D.

Pax Romanum

The Roman conqueror wisely allowed those he defeated to continue to worship local gods, as long as the Roman gods were recognized as the central authority. At the same time, Roman amenities like aqueducts, roads, arenas, bridges, basilicas (meeting halls), temples, public baths, and forums were provided for every city under Roman jurisdiction. The Pont du Gard (Figure 3-8), which carried water twenty-five miles to the city of Nimes, was an example of Roman engineering skill with the arch, which made life more comfortable for all its citizens. In addition, the *Pax Romanum,* or Roman Peace, assured the defeated peoples of security from other invaders, since Roman militia were left to maintain law and order.

Architecture The Romans had a taste for lavish decoration which appeared in their adoption of the Greek Corinthian order and in the frequent combination of all three orders (Doric, Ionic, and Corinthian) in one building, as in the Colosseum in Rome. The largest assembly area built up to this time, the Colosseum seated 50,000 spectators, protected by canvas awnings from the sun and rain as they watched the bloody battles between men and wild beasts.

Another large, richly decorated building, the Pantheon, is the only temple of classic antiquity which has always remained a house of worship. Originally designed to hold statues of the major Roman gods under one roof, it is now a Christian church (Plate 18). In its dome we see the skill with which the Romans used concrete in building. The huge

dome of the Pantheon, which was the largest of antiquity, has a diameter of nearly 140 feet and is constructed of brick and concrete with a thin covering of marble. The walls of the Pantheon are twenty feet thick at some places in order to support the heavy weight of the dome, whose center was left open to admit light into the building's interior. As the sun moved across the sky it spotlighted in turn each niche with its statue of a god. Concrete faced with stone was also used to build the famous Roman baths in which spacious halls and gathering areas as well as outdoor swimming pools, cold and hot rooms, gymnasiums, and libraries were all heated by furnaces. Lead pipes which carried the hot water can still be seen in the ruins of the Roman baths.

The Romans took the plan of the Greek temple and transformed it into large structures called basilicas which usually had cross-vaulted roofs. The influence of these daringly vaulted basilicas on later European church architecture was immense. The arches and vaults based on Roman experiments were gradually transformed in the Middle Ages into the Gothic system of building. The Basilica of Constantine, which is even larger than the Pantheon, rose 114 feet high and glowed inside with rich marble

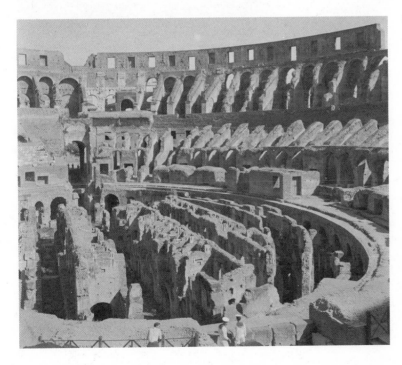

9-19 The Colosseum. A.D. 72-80. Rome.

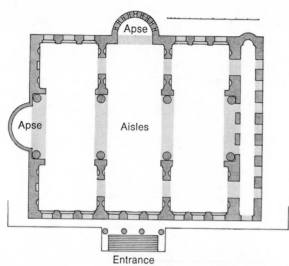

9-20 Floor plan of the Basilica of Constantine.

9-21 The Arch of Constantine. A.D. 117-38. Rome.

veneer. The rounded area at one end, borrowed later by Christian churches as a sanctuary for the altar, contained a seated statue of the Emperor Constantine.

Another typically Roman design was the triumphal arch, erected by successful Roman generals to celebrate their victories. These ornate monuments were constructed in the countries conquered by Rome and came to symbolize Roman glory. They have been copied in later periods all over Europe and even in New York's Washington Square.

The Roman emperors, senators, and other wealthy and important citizens lived in luxurious palaces and country villas with elaborate fountains and gardens depending on water carried for miles by aqueducts. Well-to-do city dwellers had a pleasant life in townhouses with central courtyard gardens,

hot water, and comfortable furniture, while the ordinary citizen in Rome might have to climb five stories to his small crowded apartment (Figure 3-7).

Painting The larger villas and houses were decorated with colorful wall paintings, which we can still see preserved in the villas in Pompeii. These murals give us some idea of what ancient Greek painting must have been like, for most of them were done by Greek artists. Landscapes, intimate scenes, ceremonies such as weddings, and mythological figures were favored subjects. In them, the shapes of the figures were blocked out in areas of simple color, with brush strokes which were often free and lively.

Mosaics were also popular for wall and floor decoration. These extremely detailed mosaics were made of small pieces of marble set in mortar and show battle and hunting scenes alive with exotic wild animals and birds from as far away as Egypt. One mosaic shows the Nile River with crocodiles, lotus buds, and a hippopotamus.

Roman Portraits Perhaps the most typically Roman contribution to art was in portraiture. In contrast to the Greek idealization of the human face, these portraits were exact duplications of real people with all their warts, wrinkles, and other natural disfigurements. Realistic busts of stern-looking Roman generals and rulers were placed in local forums to represent Roman authority to the conquered peoples. These, along with the faces depicted on Roman coins, spread the image of that authority throughout the Latin-speaking world. Perhaps the use of this ancient form of mass media accounted in part for Roman success in government.

 This typical Roman ability for realistic portraiture appeared in a group of paintings of Roman colonists who had died while away from their homeland. In the Roman district of the Faiyum cemetery in Egypt, their bodies were wrapped as mummies in Egyptian fashion, and a portrait of each deceased person was inserted in the linen wrappings over the head (Plate 19). Painted in a lively informal style on wood with wax as the vehicle for the pigments, the colors were made permanent by the application of heat, in a method called *encaustic*. These portraits capture the individuality of each person and

9-22 Bust of Brutus. c. 260-220 B.C. Bronze. Alinari-Scala.

are so full of life that it seems they must have been painted while the subjects were still alive to pose for them. The encaustic technique used on these paintings preserved for all time a vitality in portraiture which was not to be seen again for a thousand years. In the same way, the massive stone and concrete buildings of Rome lasted for centuries. And the Roman life-style, which spread throughout the Empire from Damascus to northern Britain, influenced law, engineering, literature, and architecture down through centuries in time to the present day.

The Middle Ages

Between the city in which it is promised that we shall reign
and the earthly city there is a wide gulf—
as wide as the distance between heaven
and earth. Yet . . . there is a faint shadowy resemblance between
the Roman Empire and the heavenly city.

St. Augustine, *City of God*

By the fourth and fifth centuries A.D. darkness seemed to be descending on the Western world as the light of "Eternal Rome" died out. But in its place, all over Europe and the Mediterranean world, altar lights glowed softly, as the new faith of Christianity attracted converts. The power of Rome gradually faded, but many of the images of Greek and Roman times lingered on in early Christian religious art.

The Roman Emperor Constantine became a Christian in A.D. 303, and ten years later he established the new religion throughout the Roman Empire. Practicing Christians before that time had gathered for worship in their homes, or, during periods of persecution, they had carried on their religious services in underground tunnels, called *catacombs,* which honeycombed the soft volcanic rock underlying most of Rome. They also buried their dead in *niches* which they carved into the walls of the catacombs.

10-1 Coemiterium Maius. Rome. Scala/New York.

Symbols of a New Religion

Although we think of Rome as the center of early Christianity, in reality the converts to the faith came from all over the ancient world. Some were Jews, some Romans, some were northerners like the Gauls, Goths, and Visigoths, and still others came from the Middle East, then called Byzantium. Many peoples and languages were represented, and the only way they could communicate with each other and express their common religious beliefs was through visual symbols which were meaningful to them all. These symbolic images were also a safe way to avoid persecution. For example, the Romans might recognize a cross as a Christian symbol unless it was disguised, but they did not know that the fish stood for Christ. No pagan could object to paintings or sculpture of the Good Shepherd, for this was a popular classic subject; but in Christianity the Shepherd surrounded by his flock symbolized Christ with his devout Christian followers. So these early Christian frescoes painted on the walls and ceilings of the catacombs are full of images of grapes, flowers, animals, birds, and fish, most of which, though copied from ancient art, had symbolic significance to the Christians. For example, grapes, which had represented Bacchus, the Roman god of wine, now stood for the promise of everlasting life represented by Christ. The peacock, originally meaning wisdom, became a symbol of Christ and the life eternal because its flesh was believed to be incorruptible, and the fish also represented Christ. Just as pagan festivals became Christian holy days, familiar pagan images were used by the faithful to represent

their new faith. The result was that no sharp line can be drawn between the images of Classic art and the new art of the Christian Church in its earliest days.

In a catacomb fresco of Christ the Shepherd, he is seen as a clean-shaven Roman lad, not as the older bearded Middle Eastern figure by which he was later represented. The circle which surrounds the figure signifies eternity. The same image of Christ as a good shepherd also appears in early Christian sculpture. Again, in a niche in

10-2 *The Good Shepherd,* Catacomb of Domitilla. Early third century A.D. Rome. Alinari-Scala.

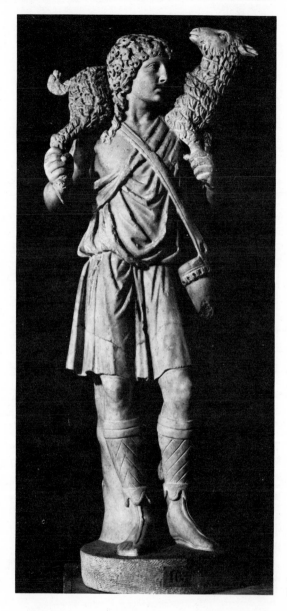

the wall of a third-century *mausoleum* a mosaic depicts Christ as a shepherd with a flock of sheep. Wall decorations such as these were created to tell the story of the martyrdom of Christ and to preach sermons to the worshipers. The mosaic artists were not as concerned with realistic representations of human forms as they were with the expression of the new religion, and as a result the images were abstracted and spiritualized. In addition, the way in which mosaics are made calls for simple areas of color. Many small pieces of glass were laboriously set into cement to create these images and were carefully placed to reflect the light that filtered through the small windows and flickered from the altar candles. The walls seemed to lose their solidity in the almost supernatural glow, and for this reason mosaic was especially well suited to expressing the spiritual messages of early Christianity. The shimmering gold and colored glass pictures suggested a heavenly world, and as the congregation entered the mysteriously lit interior of these early houses of worship they must have felt as if they were transported to another life.

10-3 *The Good Shepherd*. Early third century A.D. Museo Christiano Lateranense. Rome. Alinafi-Scala.

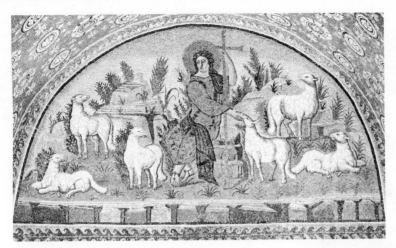

10-4 *The Good Shepherd.*
c. A.D. 547. Mosaic. Galla
Palcidia, Ravenna. Scala/New
York-Florence.

New Religion; New Architecture

Once the Christian Church replaced the power of the Roman Empire, new architectural needs arose and new solutions had to be found. Places of worship could not be modeled on ancient temples, for the ritual of the Christian Church differed from that of ancient religions. In the pagan temple the inner sanctuary was restricted to the gods and their priests. The faithful, as they proceeded around the outside of the temple, could only catch a glimpse of the inner sanctuary through the doors. Since the temple exterior was more important to the worshipers than the sanctuary, the sacrificial altars were placed outside, and the exterior itself was decorated with statuary. In contrast, in the Christian church the congregation actually took part in the religious ceremonies, so space had to be provided for people to enter and participate in the mass and later to move forward to receive communion.

When Emperor Constantine declared Christianity the new state religion, Christians left the catacombs and began to build new churches based on the secular Roman basilicas. These basilicas were assembly halls which were built with a tall central nave and lower side aisles, which sometimes had barrel-vaulted galleries placed over them (Figure 9-20). This same plan was followed in many of the Christian churches. In the basilica the Roman judge was seated on a raised platform at the end of the hall, usually in a semicircular apse. Seats for the lower officials were arranged to the left and right of him, and this seating arrangement influenced the placement of the bishop and clergy in later Christian churches. The Roman altar—where sacrifices were offered in front of the judge before justice was dispensed—was replaced by the Christian altar table. Although in the Roman basilicas the entrance was usually located on the long side of the hall, in the early churches it was always at the opposite end from the sanctuary and

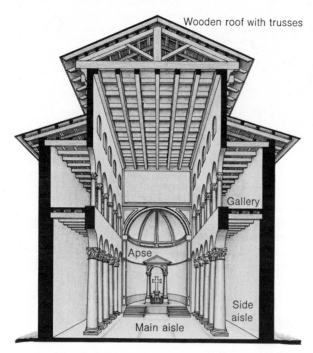

Wooden roof with trusses

Gallery

Apse

Side aisle

Main aisle

10-5 Cross section of an early Christian basilica.

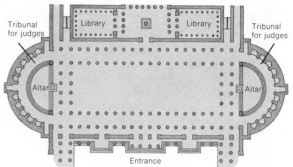

Tribunal for judges

Library

Library

Tribunal for judges

Altar

Altar

Entrance

Floor plan of the Basilica of Trajan.

altar. These early Christian churches were entered through a gateway into a walled courtyard where the faithful washed off the sins of the world in a fountain before entering the church itself. The oblong hall of the church was divided by rows of columns into aisles leading to the altar. Thus the basic plan of the Christian church developed from earlier Roman architecture. Of course, changes were made, but essentially the same plan was used for the next thousand years. In addition, some of these early churches even used marble columns and

Corinthian capitals which had been removed intact from Roman buildings.

Since Christ had preached that the afterlife was more important than material riches on earth, the churches symbolized this belief with their plain exteriors. But the interior was richly decorated with mosaics or paintings to symbolize the richness of the spiritual life in the kingdom of Heaven.

San Vitale in Ravenna, a church built about A.D. 540, is octagonal in shape, with interior surfaces covered with marble and rich mosaics that repeat many of the images in the catacomb paintings. Justinian, Emperor of the Holy Roman Empire, is pictured standing with soldiers and clergy around him in the eastern *apse* end of the church which is decorated with wall mosaics surrounding the altar. The figures are placed high above the congregation, adding to the sense of awe and mystery the simple worshipers must have felt when they stood before these colorful glowing images.

Long before the birth of Christ, domes had been used as symbols of the heavens, and in A.D. 532 Justinian commissioned a domed

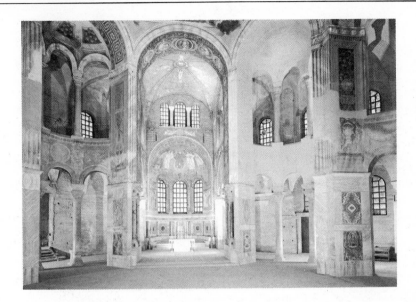

10-6 San Vitale (interior).
A.D. 526-47. Ravenna.
Scala/New York-Florence.

10-7 Santa Sophia. A.D. 532. Constantinople. Photo,
Fritz Henle, Photo Researchers, Inc.

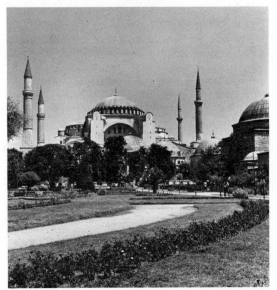

church, Santa Sophia, to be built in
Constantinople. Experiments in using domes
to roof square or cross-shaped churches had
been going on in the Middle East for many
years, but none could equal the great central
dome which seemed to float over Santa
Sophia. Here, in the eastern part of the Holy
Roman Empire, the dome reached new
heights, and from that time on it became an
almost constant element in Byzantine
architecture. Procopius, who saw it being
built, said it hung "as if suspended by a
golden chain from heaven." The ribbon of
windows at the base of the dome creates a
stream of light which must have been
dazzling when it played over the original
brilliant mosaics. Only a few recently restored
mosaics remain in place.

Early churches were often built over the tombs of martyrs because the Christians considered the graves to be sacred. In them were golden gem-studded and enameled altar furnishings—chalices, screens, candle holders, and *reliquaries* which held the relics of the martyrs. This one, called the crucifix of Justinian, is believed to contain a fragment of the cross on which Jesus Christ suffered and died and reflects a mixture of influences. The Greek letters *chi rho,* the first two letters of Christ's name, were combined into the Christian cross symbol, which also symbolized the crucifixion of Christ. The

10-8 *Cross of Justinian.* A.D. 527-65. Vatican, Rome. Alinari-Scala.

heavy square and oblong jewels set into it are reminiscent of northern art, while the gold and precious gems were common in Byzantium and the East.

As you can see from this example, by the sixth century A.D. Christian art had become a mixture of styles from many sources, and in these first centuries following the collapse of the Roman Empire in A.D. 313 no uniform style of art emerged. Thus the art of the early Christian world was as diverse as its origins. Among the Teutonic peoples who swept across Europe on the vast network of Roman roads were craftsmen skilled in working metal and wood. The Romans called these northern people barbarians. However, though their art was not as ornate or sophisticated as that of southern cultures, it was far from unskilled. Their style of carving animals—both real and mythological—came from across the steppes with Asiatic nomads, perhaps from as far away as China, and eventually found its way into Christian art. The dragons on this metal helmet protect the wearer's eyes with magic powers, while on the top of the head another dragon reaches down toward the nose, thereby protecting the skull. The demons from whom protection was needed were very real to the northern invaders who wore such helmets, but the helmets were also clearly designed to ward off real sword blows as well.

During this chaotic period, monasteries were quiet retreats which became the centers of learning in Europe. It was here that monks laboriously copied by hand many of the literary works of the past that otherwise might have been completely lost. These manuscripts were richly decorated over every

10-9 Ostrogothic helmet. Seventh century A.D. Iron. State Historical Museum, Stockholm.

Islam

Early in the seventh century A.D. another religious figure was born—Mohammed, the founder of Islam. The new religion spread throughout the Mediterranean world and in its first forty years drew more converts to it than had been attracted to Christianity in the previous 400. This rapidly growing religion soon became a threat to the Christian world, which responded by sending the Crusaders to recapture the Holy Land from the Moslems. The resulting contact with other peoples and other cultures greatly enriched European art and learning, although it was not successful in stopping the spread of Islam.

available bit of space with swirling, intricate designs in which plants, animals, birds, and humans entwine around each other and change from one image to another (Plate 14). A snake may turn into a bird, which in turn may become a fish, and the whole design may make a letter *M.* It seems that to these illustrators nothing could exist without being transformed into something else.

Islamic Art The Moslems built mosques in which to worship throughout the Islamic world. In the great mosque at Mutawakkil, the largest ever built, you may recognize in the tower, or *minaret,* the influence of the ancient Mesopotamian ziggurat. The top of this tower, as in the ancient buildings, was reached by ramps.

10-10 Mosque of Mutawakkil. A.D. 848-52. 45,000 square feet. Samarra, Iraq.

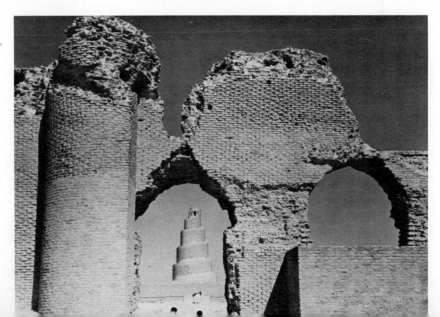

Because images of humans were forbidden by their religion, the Moslems created elaborate nonrepresentational designs to decorate both their religious and secular buildings. Many of these were based on Arabic lettering of sayings from the Koran, while others were abstractions of flowers and plants. Glazed clay tiles decorated with these designs brightened the walls of palaces and mosques. These houses of worship, from whose towers or minarets the faithful were called to prayer five times a day, were usually built with a courtyard and fountain where the worshipers could perform the necessary ritual washings. Inside the spacious buildings a forest of columns separated the men who knelt alone on their rugs in private prayer.

Moslems from Africa invaded and conquered Spain in the eighth century, establishing a rich culture there. In the southern city of Granada, the Moorish rulers built a vast palace which was known as the Alhambra, or red castle. All the most lavish elements of Moslem architecture were included in its design—courtyards with fountains were surrounded by delicate columns carved with intricate geometric and calligraphic patterns, and brilliantly colored tiles covered the walls. The Alhambra set a style of decoration which was copied by builders throughout the Islamic world.

One of these buildings, and probably the best known Islamic structure, is the Taj Mahal in Agra, India, built around A.D. 1500 by the Shah Jahan as a loving memorial to his favorite wife Membaz Mahal. This lavishly decorated monument appears to float above its reflecting pool, which mirrors its glowing white marble dome and slender towers covered with delicate carving.

Carolingian Europe

In the eighth century the Catholic Pope in Rome became concerned about the increasing spread of Mohammedanism and decided that the former dominance of the Holy Roman Empire might be restored by selecting a vigorous Barbaric leader like the Christian convert Charlemagne to become Emperor. Charlemagne chose the city of

10-11 Suleimaniyeh Mosque. A.D. 155-56. Istanbul. Turkish Tourism and Information Office, N.Y.

10-12 Taj Mahal. 1630-48. India. Government of India Tourist Office.

10-13 Chapel of Charlemagne. A.D. 792-805. Aachen, Germany. Photo, Ann Munchow.

Aachen in his native Germany for his capital and made it into a cultural as well as governmental center. At this court, classical traditions in art were revived, and classical learning was encouraged, leading to a revival of Roman architectural forms. These, combined with Byzantine and the newly developing Medieval forms, produced what is known as the Carolingian style.

As part of his building program, Charlemagne had a chapel constructed at Aachen in which he worshiped and was buried. This chapel, which was based on the floor plan of San Vitale in Ravenna (Figure 10-6), embodied the new Carolingian style and was an important influence on most later European church architecture. The central space of Charlemagne's chapel was octagonal and covered with a dome inspired by earlier Byzantine buildings. Designed with three levels, the chapel had Roman arches, marble columns with Corinthian capitals, barrel-vaulted galleries, and *pilasters* (flat Roman columns) used against the walls for decoration. The upper galleries opened into the central portion of the church with bays divided into three sections by marble columns brought from Ravenna. The

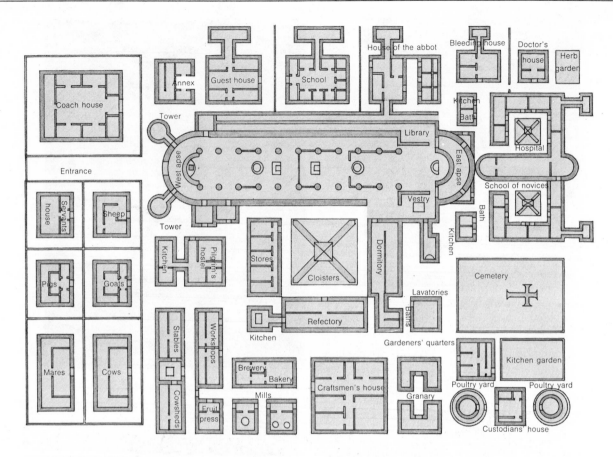

Coach house

Annex

Guest house

School

House of the abbot

Bleeding house

Doctor's house

Herb garden

Entrance

Tower

West apse

East apse

Library

Kitchen
Bath

Hospital

School of novices

Tower

Servants house

Sheep

Pilgrim's hostel

Stores

Cloisters

Dormitory

Vestry

Bath

Kitchen

Pigs

Goats

Kitchen

Lavatories

Cemetery

Baths

Mares

Cows

Stables

Workshops

Refectory

Kitchen

Gardeners' quarters

Kitchen garden

Cowsheds

Brewery
Bakery

Mills

Craftsmen's house

Granary

Poultry yard

Poultry yard

Fruit press

Custodians' house

10-14 Floor plan of St. Gallen (above). Cloister of St. Gallen (reconstruction) (left). A.D. 820.

Emperor's throne was placed in one of the galleries, and seated there on his throne, Charlemagne appeared to the congregation as a representative of God on earth. But in this position he also came face-to-face with his own Lord, for opposite the throne was a large image of Christ and below it was the altar.

In addition to Roman influences on the architecture, the contrasting colors of the stones in the arches were typical of Islamic art, while the richly decorated surfaces echoed Byzantine influences. But the church also displayed its northern origins in its massive, severe stone walls.

Charlemagne carried on an active building program to help restore the power and prestige of the church and the Empire, as the Romanized monarch revived ancient learning, built monasteries, and set up *scriptoria,* or writing rooms, where manuscripts were copied to preserve the store of ancient knowledge. As a result, the monastic movement, which had begun as a withdrawal from the world, ended by creating bustling, active cultural centers. With their protective fortresses, their churches, hospitals, workshops, and farms these centers were large and self-sufficient communities. One of the most complex of these monastic communities developed at St. Gall in Switzerland where every aspect of religious life and learning was provided for. Charlemagne's building activities encouraged a common style in art, drawing together the many varying influences from Italy, Byzantium, and Asia Minor. Thus the Carolingian style brought together many of the elements which were later used in Romanesque churches.

Romanesque into Gothic

Romanesque architecture, as the name implies, was influenced by the revival of classical styles during Charlemagne's reign. It blossomed quite suddenly into an important building style partly as the result of a prophecy which was unfulfilled.

It had been prophesied that the world would come to an end in A.D. 1000. When this failed to happen, Christians emerged from the caves in which they had hidden and, as one early historian put it, showed their gratitude by covering Europe with "a white mantle of churches." These churches varied in detail according to local styles and influences, but whether they were built in Italy, Spain, Germany, or France, they shared similar floor plans and adapted Roman elements to Christian ritual needs. The style is called Romanesque because the plan of churches with a central nave and side aisles was reminiscent of the Roman basilica. The Roman style of arches, barrel vaults, as well as the Roman craft of stone masonry were all widely used by the builders. The vaults helped to solve the problem of fire damage to wooden roofs and could be used to span large spaces safely. But they required heavy walls to support them, and as a result the churches were generally dark because too many windows would have weakened the walls. In some, the walls and vaults were brightened by paintings, and the columns and elaborately sculptured capitals were also often painted. These capitals, developed from the foliage-decorated Roman ones, often told the congregation Christian stories through sculpture. The constant battle between good Christians and evil demons which

10-15 Tympanum of the central doorway depicting *The Last Judgment.* Twelfth century. Vezelay. French Government Tourist Office.

represented worldly sins was a favorite subject, as were tales from the Bible. Over the entrance doorways, sculpture often depicted the Last Judgment in which a large figure of Christ dominated the smaller figures of good Christians rising to heaven and the sinners who were falling to horrible tortures in hell. Eventually the entire church became a sermon in stone, in which each part had a symbolism and a parable or story to tell.

Churches Reach Upward The pious Medieval builders wished to express the upward reach of the devout Christian toward the kingdom of Heaven. They also wanted to bathe the interiors of their churches with the unearthly light which filters through the colored glass of Gothic windows. In order to do this, the walls of the nave had to be transformed into screens of glass. These

10-16 San Ambrogio (interior). Eighth to ninth century. Milan.

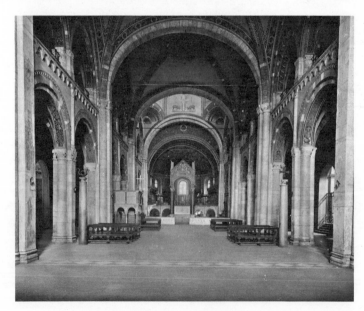

needs led them to experiment with higher vaults whose weight could be carried without such heavy walls. Cross-groined vaults led to the development of *ribs* which carried the weight down to the ground. San Ambrogio, built in Milan in the eleventh and twelfth centuries, has long been considered to be the earliest church with weight-bearing ribs, but now it is believed that Norman churches were the pioneers. Whichever was earlier, the important point is that the groined vault was developed into a ribbed structure which supported the weight of the roof without heavy walls. Exterior *buttresses* also helped to hold back the outward thrust on the ribs. About this time, the pointed arch was also used with ribs, making it possible to vault irregular spaces (Figure 3-9). Each of these elements—pointed arches, ribbed vaults, and buttresses—had been used separately in Romanesque churches, but now, for the first time, they were brought together to form an integrated system. In the church of St. Denis, near Paris, built under the direction of the Abbot Suger (1137–1151), the cross-vaulting over the irregular spaces in the *ambulatory* behind the altar became an organic system using ribbed vaults supported by exterior piers. The pointed arches transferred the weight to the ribs, which allowed the spaces between the ribs to be filled in with thin nonsupporting walls or with glass. So the Gothic style was born. It would spread throughout Europe during the next 200 years with many local variations in details and design. But despite these differences, all Gothic churches and cathedrals used the same self-supporting system of ribs and buttresses, allowing the miracle of light filtering through the glass to become a

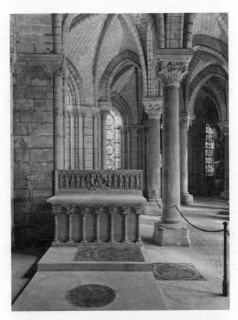

10-17 Ambulatory of St. Denis. France. Caisse Nationale des Monuments Historiques.

feature of all the structures. These windows were made of *stained glass,* in which the glass is not painted but colored with minerals which become part of the glass itself. They are set piece by piece and held together by lead strips. The window illustrated (Plate 20) from the cathedral of Chartres dates from the twelfth century A.D.,

Later, *flying buttresses* were developed to counteract the immense thrusts and allow the vaults of the central nave to rise higher and higher. On the outside of the cathedrals the doorways and facades were decorated with sculptured figures. Romanesque interiors had been simple and dark, but in the new Gothic cathedrals the windows shone like jewels,

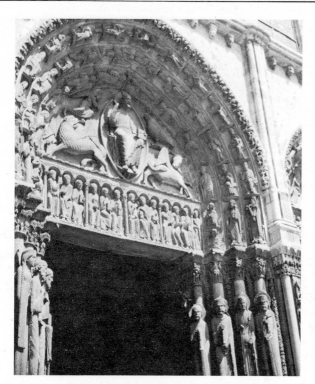

10-18 West portal of Chartres Cathedral. 1150.

and the screens, chalices, and candlesticks used on the altars were often made of gleaming gold studded with gems. The glow of hundreds of candles reflecting from the gold and jewels, the rich vestments of the priests, the vaults soaring into a blue twilight representing Heaven, and the music from choruses of singers must have lifted worshipers out of the harsh realities of their daily lives.

These new cathedrals were communal efforts in which all the devout participated in whatever way they could—carrying stones, cutting them into shape, hauling them up to the craftsmen working on the high scaffolds. This laborious hand-setting of each stone meant that the cathedrals were built slowly and that few were completed in the style in which they were begun. For this reason, one part may be built in early Gothic style and other parts in the more ornate late Gothic style. Skilled craftsmen who could make the rich reliquaries, wooden choir stalls, and carve the stone sculpture decorating the stone facades were in great demand. In the great portals through which the congregation entered, the Romanesque preoccupation with heaven and hell gave way to a broader range of subjects like the coronation of the Virgin. This worship of the Virgin Mary created new and gentler images, and the drapery and poses of the figures became softer.

During this period, Europe's population was increasing, and many people were moving from the sparsely populated rural areas, which had been dominated by local barons and monasteries, into towns. This increased urbanization resulted in a new commercial activity which led to a lively exchange of goods and ideas. Travel became easier, the Crusaders brought back new ideas from a world outside Europe, Latin became a universal language used in both

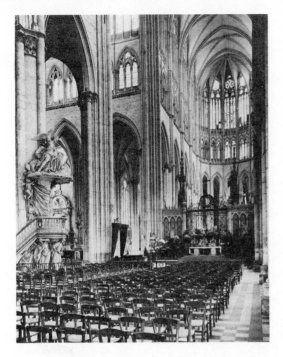

10-19 Basilica of St. Mary Magdalene. Ninth century A.D. Vezelay, France.

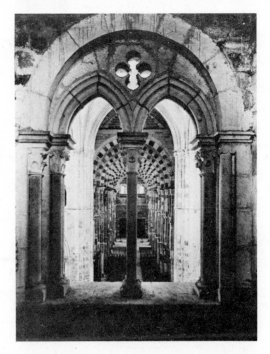

10-20 Nave of Amiens Cathedral. 1220-69.

the church and by scholars, and universities like those in Bologna and Padua attracted students from all over Europe. On their way to visit religious shrines, pilgrims moved freely from town to town, while the burghers competed to attract their patronage. At the same time, ambitious bishops planned impressive cathedrals whose vaults rose to incredible heights. As the later Gothic style developed over the centuries, the stones of the churches were carved into curving forms, decorating the churches with flamelike tracery which appeared to tear apart the simple synthesis of the Gothic structural system. So it seemed that at the very moment when the Church dominated almost every phase of life, the forces which led to a totally new spirit and new era were at work.

The Renaissance

Thy will is free and whole and upright
and now it would be wrong to rein it
in. Be thine own Emperor and thine
own Pope.

Dante, *Divine Comedy*

History does not unfold conveniently in chapters, and the Gothic spirit did not dramatically disappear with the development of the new social and cultural attitudes foreshadowed by Dante's poem.

The term *Renaissance* means rebirth and refers to the renewed interest in classical learning, philosophy, and art which developed in Italy in the fourteenth century. During the time of the ancient Roman Empire, the city of Rome was the center of power in the Western world, but its defeat by the Germanic tribes resulted in a transfer of that power to other centers. To Italy, the Middle Ages which followed the collapse of Rome seemed like a barbaric interlude.

At the time of the building of the great cathedrals in the thirteenth and fourteenth centuries, France, and particularly the University of Paris, was the spiritual and intellectual heart of Europe. But Italy, remembering its classic past, resisted the northern mystical religious thinking and the Gothic art style which expressed it. Italian Gothic architecture, for example, never totally lost its emphasis on classic proportion and balance. The humanism of Greece lingered in Italy even through the religious intensity of the Medieval period, and as that religious

spirit died out, the humanistic attitude began to flower and bear fruit. Consequently, Italy became the center of the new thinking which emphasized the importance of the individual and acceptance of life here on earth. We see the beginnings of the new ideas in the work of the Sienese painter Simone Martini (1284–1344), who expresses the religious faith of the Medieval period in his *Annunciation,* using a traditional gold background, sinuous lines in the figures, and decorative Gothic detail. But at the same time, the Virgin is a real woman, startled and frightened by the appearance of the archangel bearing the fateful message.

Another new force influenced art—the increased trade throughout Europe and the Orient. Its two main centers at this time were Italy and Flanders. With the rise of commercialism, princes, merchants and bankers threatened the power of the Pope and the bishops. As a well-to-do middle class began to develop, political and economic concerns dominated where once religious ideas had been all-important. And as the central power of the Empire declined, the families which ruled over cities and small states became more powerful. Competition developed among the towns and between

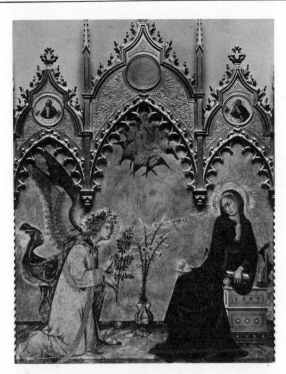

11-1 Martini di Simone and Memmi Lippo. *The Annunciation* (central panel). 1333. Alinari-Scala.

the princes and the wealthy powerful church. At the same time, intellectuals began to abandon Medieval scholasticism, which had disputed such questions as how many angels could stand on the head of a pin. In its place they studied the world around them with a scientific attitude based on the readings of Aristotle, using their senses to observe and their reason to explain what they observed. As humans became less concerned with the afterlife, their interest in the here and now

increased. Thus the thinking of the Middle Ages slowly disintegrated, and the Gothic style in art declined. Flanders, with no classical tradition to turn to, continued to devote herself to expressing the dying Medieval faith in a new realistic style, but Italy turned to the heritage of Rome to fill the space left by the death of the Gothic spirit.

Humanism in Art

Italian Renaissance scholars rediscovered ancient Rome, and artists, even princes, dug excitedly in Roman ruins to find precious lost statues. Along with this interest in the classic came a return of concern with individual humans which was reflected in painting and sculpture. No longer was art the communal expression of anonymous artists motivated only by religion. The harbinger of this new era in art was Giotto (ca 1266–1337) (Plate 21), hailed by the poet Boccaccio (1313–1375) as the artist who "restored to light this art which has been buried for many centuries." His brush brought the warmth of humanity into Christian religious painting, and although his frescoes illustrated traditional religious subjects, such as the life of Christ or the life of St. Francis, Giotto expressed individual human emotions in a new and startling manner. He was also concerned with making figures in his paintings appear real. This is readily apparent in a comparison of the solid realistic figures in Giotto's *Deposition* (Plate 21) with those in a Byzantine altarpiece (Plate 22). Notice how Giotto's faces realistically mirror human feelings and how the drapery suggests the solid shape of the body beneath it. No wonder Petrarch, the great fourteenth-century

poet, accustomed to traditional Byzantine art, claimed that Giotto painted nature so faithfully that his paintings could be mistaken for reality. Nevertheless, there is still a Medieval aura about Giotto's figures, who appear withdrawn into a personal spiritual experience, unaware of the world around them.

Like Giotto, other artists ushered in the early Renaissance while at the same time looking backward at their Gothic past. One of these was the northern sculptor Claus Sluter (1380–1406), who left his native Holland to travel to France to work at the court of the Duke of Burgundy. One of Sluter's most famous works is the *Well of Moses* at Dijon in which the biblical prophets are depicted as real human beings, whose faces express their individual personalities. The striking illusion of life in this sculpture, combined with Sluter's expression of deep religious emotion, represents a transition from the Middle Ages to the Renaissance. Sluter was also one of the first Renaissance sculptors to remove his sculpture from the architectural setting of the church, where it had been confined in niches and portals. As the first important sculptor to produce free-standing statues, Sluter was innovative and ahead of his contemporaries; and although the Gothic spirit was still strong in his work, his new ideas had an important influence on later Renaissance artists.

The new individualistic and competitive spirit of the time was exemplified by the contest for a design for the north doors of the Baptistery of Florence held in 1402. Lorenzo Ghiberti described his victory triumphantly: "To me was the honor

11-2 Claus Sluter. Detail of *The Well of Moses*. 1395-1406. Height of figures c. 6'. Chartreuse de Champmol, Dijon. Caisse Nationale des Monuments Historiques.

11-3 Lorenzo Ghiberti. *The Annunciation,* detail of the *Gates of Paradise.* c. 1435. Gilt bronze, 31¼″ x 31¼″. Baptistery, Florence. Alinari-Scala.

conceded universally and without exception. To all it seemed that I had at that time surpassed the others." For an artist to have expressed this kind of self-congratulation would have been unthinkable in the days of Christian humility, when cathedrals were built and carved by devout unknown craftsmen.

The Early Renaissance in Florence Since Florence was a mercantile city where banking became an important activity, it is not surprising that the first arithmetic textbook, published there in 1478, dealt with commercial calculations. Money was power. The rich Medici family, whose fortune came from banking, gained control of the city and founded a powerful dynasty of princes who ruled it and the surrounding territory. These Medici princes were great patrons of the arts, setting up a lavish court where artists, goldsmiths, furniture makers, tapestry weavers, poets, and musicians found employment. Benozzo Gozzoli (c. 1420–1497), for example, decorated the Medici family chapel with frescoes of the *Journey of the Magi* in which portraits of the Medici appeared in magnificent costumes. Other rival families who wished to gain status also became art patrons, competing with the Medicis in commissioning artists to glorify them. Bankers and merchants also built ostentatious palaces and gave money to the church to construct buildings decorated with paintings and statuary.

11-4 Benozzo Gozzoli. *Journey of the Magi* (detail). 1459-61. Alinari-Scala.

11-5 Cathedral and Tower, Florence. Cathedral begun by Arnolfo di Cambio in 1296. Dome by Filippo Brunelleschi, 1420-36. Tower by Giotto, 1334-57. Photo, Dr. Stella Russell.

Architecture Renaissance architecture, like Greek and Roman architecture before it, was more concerned with the aesthetic questions of proportion, balance, and unity than with developing innovative construction methods. Preoccupied with the harmonious relationship of all parts of the building, the architects also placed an emphasis on the horizontal line and on human scale.

The Florentine architect Filippo Brunelleschi (1377–1446) and his young contemporary, Donatello, were fascinated by ancient art and traveled to Rome where they dug up buried temples, looking for statues or pieces of Roman columns. On his return to Florence, the gifted young Brunelleschi was chosen to complete the Gothic cathedral of Florence. Inspired by Rome's Pantheon (Plate 18), he awed the city with the design

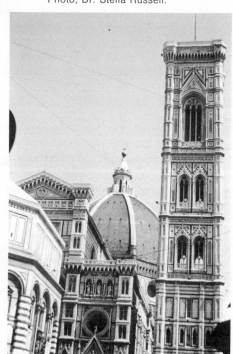

and construction of a giant dome over an area so large that no one in Florence had been able to span it. Bringing back from his Roman excavations a vivid memory of classical architectural forms, he accelerated the early Renaissance rejection of Gothic architecture. He freely incorporated such classical elements as Roman columns, pediments, and pilasters into his new designs, adapting them to the needs of fourteenth-century Florence.

11-6 Leone Battista Alberti. Palazzo Rucellai. 1446-51. Alinari-Scala.

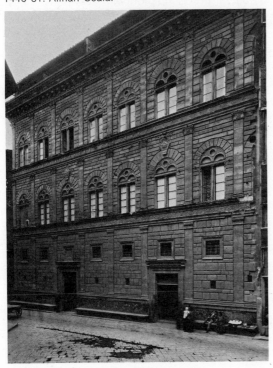

Another Florentine architect, Leone Battista Alberti (1407–1472), came from a family of wool merchants and bankers and had studied law at the University of Bologna. Perhaps because of this background he believed that laws regulated beauty and that harmony could be achieved by following certain rules of proportion. Alberti was the first Renaissance architect to study Roman architecture in great depth, and his *Ten Books on Architecture* were the most important and influential theoretical architectural work of the early Renaissance. As a practicing architect, his own style represented a scholarly, but free, application of classical designs to churches and palaces. For example, taking the Colosseum in Rome as inspiration, Alberti designed a facade for the Palazzo Ruccellai that was divided into three horizontal bands decorated with nonfunctional columns adapted freely from the classic Doric, Ionic, and Corinthian orders (Figure 9-5).

Sculpture The Florentine master sculptor Donatello (1386–1466) made a complete break with the old Medieval traditions. Through him the art of sculpture found a new aesthetic rationale in the creation of harmony and balanced relationships of volumes in space. Following the lead of the Greeks and Romans he so admired, Donatello studied the human body carefully and sculpted from models in his studio. Working in this way, Donatello created the bronze *David,* perhaps his most revolutionary achievement. It was the first life-sized nude statue since antiquity, and Donatello chose to represent David as an adolescent Italian rather than as a Greek

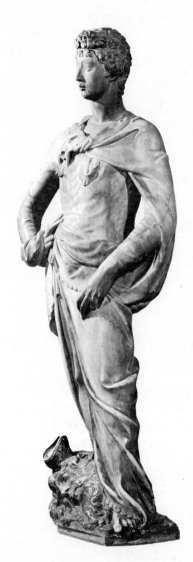

athlete. Looking enviously at a crucifix sculpted by the more intellectual Brunelleschi, Donatello is said to have remarked, "To you it is given to make Christs, to me peasants." Perhaps this explains the shepherd's hat and boots worn by *David.* At any rate, Donatello was constantly searching and experimenting to improve his sculptural techniques so he could better express his philosophical and moral beliefs. In this he was typical of the Renaissance scientific spirit which constantly searched for scientific knowledge and for new methods to express its new ideas.

Painting Breaking away from the Medieval preoccupation with spiritual expression, artists following Giotto were fascinated with rendering objects in space. Renaissance sculptors, painters, and architects were all interested in new discoveries in perspective. Architect Brunelleschi, for example, attempted to explain the world in a scientific manner, and his studies of the laws of linear perspective influenced his contemporaries. One of the first painters to apply these rules was Masaccio (1401–1428). His fellow Florentines were startled by Masaccio's representation of space in frescoes like *The Holy Trinity,* where the religious figures were painted realistically as if they were in one of Brunelleschi's chapels. Shown kneeling outside the chapel, the wealthy donors are as prominent as the religious figures. They appear in an illusion of space so real that we feel we can almost touch them. In the fresco,

11-7 Donatello. *David.* 1408-09. Marble. Scala/New York-Florence.

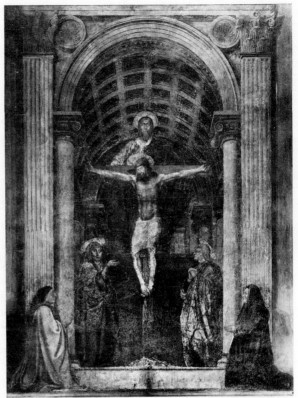

11-8 Massacio. *The Holy Trinity with the Virgin and St. John.* 1425. Fresco. Sta. Maria Novella, Florence. Alinari-Scala.

the grandeur of scale, the solid mass and simple draping of the figures show the influence of Roman architecture and sculpture on Masaccio. His vision was of the new Renaissance human being—not the frightened Medieval figure, but an individual who saw himself as an important part of the universe. The three-dimensional solidity of his painted figures reminds us both of Giotto and of early Renaissance sculpture. This close visual relationship between sculpture and

painting was important in the early days of the Renaissance, and, in fact, sculpture was to influence painting throughout the entire period.

The early Renaissance painters were entranced with the real world and the atmospheric space in it. In addition, they learned how to show bodies as if seen head on in space with a method called *foreshortening,* and they studied anatomy in their search for knowledge of the real world

11-9 Andrea Mantegna. *Dead Christ.* 1480. Alinari-Scala.

around them. All of this new knowledge enabled painters to depict figures in more natural and dramatic poses, and their paintings of saints and other religious figures show them as real human beings rather than as the stylized and symbolic figures of the Middle Ages.

The new art of Donatello and Masaccio inspired other artists like Andrea Mantegna (ca 1431–1506) who worked in Padua near the Arena Chapel which Giotto decorated. Like Giotto, Mantegna retold religious stories in his murals. His series of wall paintings illustrating the story of St. James shows the influence of the ancient sculptures Mantegna must have studied, while his violently foreshortened figures influenced later Renaissance painters.

New Realism in the North

Although the painters of the Italian Renaissance developed the mathematical laws of perspective, they turned to the north to learn the techniques of oil painting, how to paint with its rich color, and how to use atmospheric perspective. Because artists traveled frequently at this time and brought back sketches of each other's work, knowledge of the new techniques spread rapidly from Flanders to Italy.

Born in Flanders, Jan van Eyck (1370–1440) was a northern artist who went to work at the court of the Duke of Burgundy. Van Eyck made revolutionary technical discoveries, using the new method of oil painting to render the elaborate detail of rich northern interiors and the soft blue depth of Burgundian and Flemish landscapes. In this method, the pigments were suspended in oil and some other unknown ingredient, possibly the newly discovered turpentine. The tempera underpainting in black and white or earth brown was covered with layers of transparent oil glazes, one on top of the other, until the final glowing color was achieved. Details were drawn in white and the color glazed over them. The result was a painting technique which allowed the precision of tempera with a great depth of color made possible by a succession of oil glazes.

It was a technique which lent itself to paintings of the comfortable, materialistic life in Flanders and Burgundy with its rich fabrics and carved furnishings.

Flanders at this time was developing a thriving commercial middle class, and van Eyck painted the wealthy burghers of the Flemish towns in all the luxury and material

comforts of their everyday surroundings. Some of these paintings, however, had an additional symbolic meaning. For instance, this painting of Italian silk merchant Giovanni Arnolfini and his Flemish bride shows them surrounded by symbols of the religious aspects of marriage (Plate 23). The single candle in the chandelier is symbolic of the presence of God and was placed there to remind the couple that their vows had been made in his presence. Dour-looking Arnolfini and his shy bride stand on hallowed ground, their slippers discarded. The fruit on the windowsill represents the delights of man's lost paradise, while the dog symbolizes fidelity and fertility. So we can see that this Flemish room, with every object and texture lovingly painted, also had a deeper mystical meaning to those who understood its symbolism. The artist himself can be seen in the clear mirror, which repeats the uncompromising reality of the scene. He also inscribed in Latin above the mirror, "Jan van Eyck was present."

Italy was preeminent in gold and silver crafts, but the northern craftsmen excelled in tapestry weaving and wood carving. Rich tapestries had been a feature of Medieval castles, and the art continued without interruption throughout the Renaissance, and even to the present day, in Flanders and France. Carved wooden furniture and paneling enriched the comfortable homes of the burghers. The wooden altar screens and stalls in Medieval churches had been carved with elaborate biblical scenes, flowers, and animals. This tradition of craftsmanship was now applied to both secular and religious sculpture. Colored sculpture was traditional—

11-10 Michael Pacher. *St. Augustine and St. Gregory,* center panel of the *Altarpiece of the Four Latin Fathers.* c. 1483. 81″ x 77″. Munich, Alte Pinakothek.

Sluter's *Well of Moses* had been elaborately painted down to the last detail (Figure 11-2). Now some artists, like the German Michael Pacher (1435–1498), used their virtuosity in painting and carving to create incredibly complicated altarpieces which were Medieval in feeling but were innovative in their use of space. Austria, where Pacher worked, was the natural geographical gateway for Italian influences on northern Europe, and certainly Pacher, like other northern artists, was influenced by Italian art in his sculptural forms and his use of perspective to depict depth. Pacher produced actual carved

sculptures which were painted in detail and set in elaborate architectural settings as well as paintings which *look* like painted sculpture in architectural settings. Sometimes it is difficult to tell which is which. But there is no question that this combination of color and actual solid form in sculpture had an influence on the way later painters depicted dimensional volume in Renaissance painting.

The High Renaissance

The Renaissance had begun as a rebirth of the Roman past, but it quickly progressed from mere imitation of past glories to the expression of its own enlightened interest in exploration, science, nature, and man the individual. Aristotle's teachings that nature should be observed with both the senses and reason were an important guide in the development of Renaissance thinking:

The Italians were indeed obsessed with the problems of rendering space on a flat surface, and they used the rules of perspective and new knowledge of painting methods in a more intellectual manner than did the painters of the north. At the same time, the Italians were more concerned with creating formal compositions which were worked out with almost mathematical precision, for they found beauty in the classic relationships of each part to the whole. It is not surprising that they were so intrigued with the Greek Golden Section (Figure 2-18).

In 1452, a gifted boy named Leonardo was born in the Tuscan village of Vinci and grew up to be an artist and scientist who symbolized the Renaissance ideal of the "universal man." Filling countless notebooks

with his scientific findings, Leonardo da Vinci (1452–1519) learned anatomy of the human body by dissecting it, became an accomplished musician, a brilliant engineer who invented mechanical devices of all kinds, and a student of every scientific subject from hydraulics to war machines to botany (Figure 2-1). In fact, his last years were spent working on drainage and hydraulic problems for the King of France.

In addition to his scientific interest which led him to explore every facet of the natural world, Leonardo was also concerned with human beings and their place in that world. His drawing of man at the heart of the universe is typical of the new humanism of the Renaissance (Figure 2-19). Man as the measure of all things is enclosed in a formal square and circle in a work that expresses both the glorious potential of human beings and the intellectual formalistic thinking of the High Renaissance.

Leonardo's most famous painting recreated a life-size *Last Supper* on the walls of a monastery in Milan. Commissioned by a patron who wished to be in the company of the Lord while joining the monks at dinner, the painting makes dramatic use of one-point perspective to draw our attention to the figure of Christ. The figures in the painting form four groups which are both visually and psychologically linked to one another by their gestures and movements. At the same time the painting shows us the individual personality of each of the disciples as seen through Leonardo's searching eye. The painter chose the exact moment when Christ, isolated from the worldly group of disciples, said, "One of you shall betray me." Although

11-11 Leonardo da Vinci. *The Last Supper.* c. 1495-98. Mural.
Sta. Maria delle Grazie, Milan. Alinari-Scala.

it is full of tension and drama, the composition nevertheless exemplifies the Renaissance ideal of harmony, balance, and beauty arrived at through carefully calculated intellectual and technical means. Even in its ruined condition, which is the result of Leonardo's experiments in painting techniques, *The Last Supper* remains a summation of much of Renaissance thinking.

If *The Last Supper* is Leonardo's most famous religious work, the *Mona Lisa,* or *La Gioconda,* is probably the world's most famous portrait (Figure 1-3). La Gioconda, wife of a Florentine banker, sits with her hands quietly folded and looks at us with an ambiguous expression. In this work,

Leonardo, the intellectual scientist who claimed that there is no science which cannot be translated into mathematical symbols, painted one of the world's most intriguingly poetic paintings. Some say that the soft play of light and shade which models the forms of the woman's face may have been responsible for her cryptic smile. But since Leonardo was a master of his craft and a similar smile appears in other portraits, it is probable that he intended to paint the mysterious expression. At any rate, the painting has always fascinated viewers and was one of the artist's own favorites.

Another Florentine, Sandro Botticelli (1444–1510), painted the *Birth of Venus* for

a Medici patron in a delicate decorative style (Figure 2-6). Botticelli was typical of the Renaissance in his interest in both pagan classical myths and Christian religious subjects. At the same time, he was also strongly influenced in traditional Gothic and Byzantine painting. This can be seen in his use of restless line, in the exaggerated elongated shapes, and in the stylizations which distort the bodies and increase their ethereal qualities. In his paintings, Botticelli expressed the Greek platonic view of beauty that everything on earth has an ideal counterpart. The *Birth of Venus* interprets the myth of the goddess's birth as the entry of divine beauty into the world—she steps from a huge shell blown to the shore by wind gods amidst a shower of roses, in a conception far removed from the scientific explorations of men like Leonardo. It was more important to Botticelli to create this other-worldly quality than to give an illusion of reality. In this, he was closer to the Medieval period than to the Renaissance.

Florence was the center of creative activity at this time, and many sculptors, painters and craftsmen gathered around the Medici family. One of these was Domenico Ghirlandaio (1449–1494). He was an accomplished mural painter whose paintings told sacred stories as though they were a part of Florentine life (Figure 5-9). In his fresco depicting *The Birth of the Virgin* the scenes take place in a wealthy Florentine home. While family guests in Renaissance dress view Mary, St. Anne, and the infant Christ, another group is being greeted at the head of the stairs, while a group of cherubs dances overhead. Such storytelling pictures

delighted wealthy patrons whose portraits were often seen in these religious paintings showing off their fine clothing and jewels. Another reason for painting religious incidents with such familiar details of daily life was that everyone could identify with them and would thus be drawn into the story.

Twenty-three years younger than Leonardo, Michelangelo Buonarroti had a long life (1475-1564) which spanned the Renaissance and the beginnings of the Baroque era which followed. In his eighty-nine years Michelangelo both witnessed, and was responsible for, great changes in the appearance of the city of Florence. Apprenticed at thirteen, as was the tradition, he learned from his master Ghirlandaio the necessary skills of drawing, human anatomy, and painting techniques like fresco.

By the time Michelangelo was thirty, his reputation as an architect, sculptor, and painter had attracted the attention of the Pope in Rome. The young artist was thus selected to carry out the ambitious plans for a tomb for Pope Julius II, to be executed in the finest marbles from Carrara's quarries. When the sculpture was scarcely begun, however, Pope Julius, a worldly prince of the church, persuaded Michelangelo to undertake an even more exacting commission.

The vaulted ceilings of the chapel built by Pope Sixtus IV in the Vatican had remained unpainted, although the surrounding walls of the building held murals by many famous painters. So in 1509 Pope Julius asked Michelangelo to paint the ceiling of the Sistine Chapel with religious frescoes.

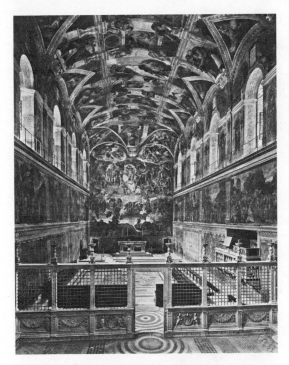

11-12 Sistine Chapel (interior) showing Michelangelo's ceiling fresco and the *Last Judgment.* 1508-12. The Vatican, Rome. Scala/New York.

Reluctantly agreeing to the assignment, Michelangelo, who had up to then been more a sculptor than a painter, refused any help and spent the next four years almost in solitude on his back on a scaffold creating hundreds of biblical figures sixty feet above the floor. In this huge painting, figures of Old Testament prophets alternate with the oracles of classic mythology in the spaces above the windows (Figure 5-1). On the ceiling itself, the hundreds of Old Testament scenes range

from the book of Genesis to the Flood. As a practicing sculptor all his life, Michelangelo believed that the more painting resembled sculpture, the better it was. Therefore, he accentuated the volume and mass of his figures, creating the effect of a relief on the ceiling.

To see the evolution which had taken place in Renaissance thinking, compare the detail from the ceiling, the *Creation of Adam,* with this marble relief of the *Creation* carved about 1430 by Jacopo della Quercia (1378–1438). Instead of depicting God at Adam's side as della Quercia did, Michelangelo, in the new Renaissance spirit of humanism, placed the figures so that they are almost facing each other as if they are on equal terms. As God the Father is wafted through the heavens by attendant angels, Adam awakens as if from a deep sleep and gazes directly at his Maker. You can sense the life force which seems to vibrate between the almost-touching outstretched finger of God and Adam.

As a result of his paintings in the Vatican, worldly recognition came to Michelangelo, and commissions followed for marble tombs for princes and popes as well as religious statues for churches (Figure 4-1). His figures, which were carved with some parts highly polished and other parts left rough-hewn, seem to struggle with stretching contorted muscles to release themselves from the stone. At the same time the sense of tension which exists between these opposing forces and the larger-than-life scale of the sculptures intensifies their sense of power and movement. These characteristics of Michelangelo's sculptures influenced later Baroque artists who often overstated and

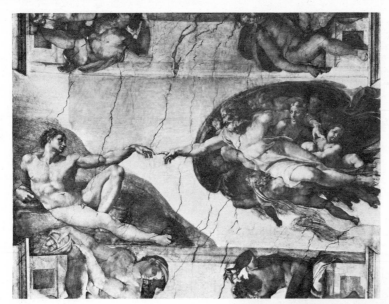

11-13 Michelangelo. *The Creation of Adam,* detail from the Sistine Ceiling. 1508-12. Fresco. Alinari/Florence.

11-14 Jacopo della Querica. *The Creation of Woman.* c. 1430. Marble, 34½" x 27½". S. Petronio, Bologna. Scala/New York.

exaggerated the scale and movement of their figures.

Michelangelo's last great work, which occupied him during the final years of his life, was the continuation of work on the principal Renaissance church of the Christian world, St. Peter's in Rome. Succeeding in completing the dome, where other architects had failed, Michelangelo drew many plans for the enormous structure whose construction was not finished until after his death. Based on a Greek-cross floor plan, the church is roofed with a dome which soars over the city of Rome. Supported on four massive arches, it is not a hemisphere like other Renaissance domes but is elongated. The upward lines of the pilasters below and the curving ribs on the dome reach toward its center in a restless climax. The church is so large that it

is impossible to experience the whole from any one point in the interior. Its overpowering scale and the strong contrasts which exist between its conflicting architectural elements mark it as one of the most significant monuments of the High Renaissance, heralding the approaching Baroque era.

Another Renaissance artist who worked briefly on St. Peter's, Raphael Sanzio (1483–1520), was a young rival of Michelangelo's and Leonardo's. Popular with later generations mainly for his many beautiful painted Madonnas, Raphael was also famous during his short lifetime for his more formal, intellectual paintings. This sketch for his circular painting called the *Alba Madonna* shows how Raphael worked out the compositional problem of fitting the figures to a round space.

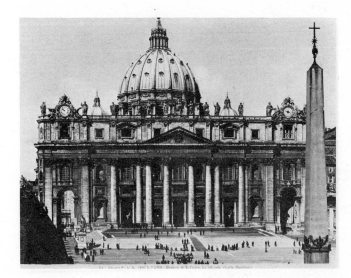

11-15 St. Peter's. 1546-64. Rome.

11-16 Raphael. Sketch for the *Alba Madonna*. 1511. Museum of Fine Arts, Lille.

The rivalry between Michelangelo and Raphael was intensified by the fact that at the same time Michelangelo was painting the Sistine ceiling, Raphael was decorating the walls of other rooms in the Vatican. Raphael was deeply concerned with the universality of human experiences and strove to find some kind of balance between the religious and profane aspects of the High Renaissance. This appeared visually in the way he used architectural settings and balanced formal composition to frame his figures in an attempt to unify his paintings. In his frescoes in the Vatican, themes of classical philosophy contrast with teachings of Old Testament prophets. In the section called *The School of Athens,* a deep three-dimensional space was created as a setting for the figures who appear to move in groups through the formal

11-17 Raphael. *The School of Athens.* 1510-11. Fresco. Vatican Palace, Rome. Alinari/Florence.

architectural surrounding. Famous classical teachers with their pupils are grouped around symbols by which we can recognize them, while Plato and Aristotle are silhouetted against the sky in the middle of the arch. The formal, one-point perspective lines lead our eyes to their figures, while the assembly of philosophers and pupils is split into the two divergent schools of Renaissance thinking represented by those two philosophers.

Northern Art and the High Renaissance

The new spirit of the Renaissance was not confined to Florence and Rome or even to Italy. Art in Germany remained Medieval in many ways and was an art in transition and conflict. But it was freed from some aspects of the Gothic style, partly as a result of Johann Gutenberg's development of printing methods which helped to spread classical learning. In Germany, painters were never able to combine religion with humanism as harmoniously as Italian artists did. As a result, the conflict which existed between these two ways of thinking, as well as the influence of new Reformation teachings, produced a dramatic intensity of emotion in such German painters as Matthias Grünewald (1470–1528).

Grünewald's great Isenheim altarpiece was Gothic in spirit, and like most Medieval religious art, it preached a visual sermon (Figure 7-18). But while it was still Gothic in its religious expression, this painting brought a fullness of form and a new boldness of spatial organization to German painting, which was representative of the new times.

In the central panel, showing a stark scene of suffering, Grünewald effectively used a Medieval device to describe the relative importance of figures through differences in their size. Christ's dying body, painted with sickly pallor, is distorted by the torture of his wounds, and his pain is echoed in Mary's face as she falls back onto John. Mary Magdalene, with her vessel of ointments, wrings her hands in despair, while John the Baptist points toward Christ, uttering the words from the Gospel of John, "He must increase, but I must decrease." In contrast to this scene of suffering, the panel, which recreates the Resurrection, is filled with mystical beauty, and the risen Christ leaves behind him a trail of radiant light. In paintings like these Grünewald stepped out of the limits of his Medieval tradition, and through his use of solid forms and dramatic expression of personal emotions, influenced all the German Renaissance painters who followed him.

Prints The development of the new printing methods increased the demand for wood-block prints and for the new metal engravings. As the art of printing spread, books were illustrated with woodcuts, and printed playing cards and souvenir religious pictures became popular.

A painter who became a master printmaker, Albrecht Dürer (1471–1528), started his artistic life as an apprentice to his goldsmith father and to a painter and engraver. From these teachers Dürer learned the meticulous draftsmanship which characterizes all his work and which is so

11-18 Albrecht Dürer. *The Crucifixion*. 1508. Engraving. 5¼″ x 3¾″. The Metropolitan Museum of Art, Mr. and Mrs. Isaac D. Fletcher Fund, 1917.

important to a graphic artist. Dürer was influenced by Flemish and Italian art which he saw on journeys to Flanders and Italy. On these trips he saw sculpture by Michelangelo and the oil paintings of Jan van Eyck (Plate 23), while in Venice he was exposed to the influence of Mantegna and other Italian painters. When he returned to his native Germany he brought with him the Renaissance concern for science and produced many treatises on perspective and anatomy. He studied nature constantly, and his understanding of the natural world fills his graphic work. Although he painted portraits and religious scenes, it was in the graphic arts that Dürer truly excelled. In his woodcuts and engravings he showed his mastery of light and shade and the effects of his studies of perspective and the natural world (Figure 2-13). He applied his brilliant craftsmanship to many series of woodcuts and engravings which expressed both the faith of the Medieval period and the restless scientific spirit of the Renaissance. *The Triumphal Arch of the Emperor Maximilian,* in which he assembles a mass of detail, shows how strong the Renaissance interest in Rome had become even in Germany (Figure 5-18). The Emperor Maximilian, convinced of the value of art in the service of the crown, entrusted Dürer with many ambitious projects. Too poor to build real arches of stone, he commissioned engravers like Dürer to celebrate his royal deeds.

Dürer influenced other northern painters with his new approach to landscape painting and by showing them that it was possible to use the ideas of the Italian Renaissance without denying their northern Medieval traditions. But none of them was very happy with the new ideas. For example, in slick fashionable court paintings, Lucas Cranach (1472–1553) illustrated pagan myths with nude figures of German beauties

self-consciously acting the parts of classical goddesses. But Cranach, for all his new Renaissance spirit, reflected the spiritual conflict of his country at that time. A friend and follower of the Protestant religious leader Martin Luther, Cranach showed the conflict between the pagan Roman and Greek attitudes of morality and the religious teachings of the Reformation. This conflict showed in the exaggerated forms and awkward poses of his figures.

We can see that the northern artists were always a step behind Italy in their acceptance of the new humanistic spirit of the Renaissance, and it was not until the next generation of artists that these ideas were assimilated into northern art. But by that time Italy had moved on into the Baroque style.

11-19 Lucas Cranach. *Venus and Cupid.* 1531. Art Gallery of the National Museum of Prussian Culture, West Berlin.

The Age of Baroque

By opposing the abstract and general
rules of classicism with the
immediacy of life itself, Baroque art
became one of the great liberating
forces of . . . individual expression.

Marcel Brion

The art of the Baroque reflected a period of transition, inner contradictions, and great stress in European history. In the sixteenth century, Europe was entering the modern world, and, although we may not think that Baroque art seems very modern, the architecture, painting, sculpture, and applied arts of this period reflected social forces which would shape the future of Europe and the New World, intimately affecting our lives. Like other periods of transition, the Baroque was one of unrest, and its dramatic, restless art mirrored the anxieties of the time.

European unity, never very strong because of local rivalries, broke down with the collapse of the Holy Roman Empire. The split between Catholicism and Protestantism in the Christian Church, and the rise of commercial activities and banking which led to modern capitalism, further disrupted the old order. At the same time, a new spirit of nationalism led to fierce competition between the newly emerging nations. Not only were kings and dukes competing with each other for land and power, but religious officials competed for souls, merchants and bankers competed for money, and individuals competed for status and power. There was no longer one cohesive religious or cultural

goal to unite the continent of Europe.

As a result, you will find as you read this chapter that localized Venetian, French, Spanish, or Low Country styles in art emerge. Each of these was a separate and distinct style, and within them individual artists also developed their own personal styles. Thus the fragmentation and competitive spirit which heralded the modern world affected the art of the Baroque period. From this time on it will be more difficult to see any overall pattern in the art of each historical period. But some social and cultural patterns do exist, and if we can see the individual artists as a part of those patterns, it will help us to place their art in context.

Clarity and order—the Renaissance ideal —had distinguished the art of the fifteenth century, and artists like Leonardo da Vinci, Michelangelo, and Raphael had solved many aesthetic and technical problems. Their ideals of classical beauty and harmony were attained. But even Michelangelo and Leonardo, typical as they were of the High Renaissance, had held within their work seeds of the new Baroque style to come. For example, Leonardo's preoccupation with light almost disturbed the balance of his compositions, and Michelangelo twisted his

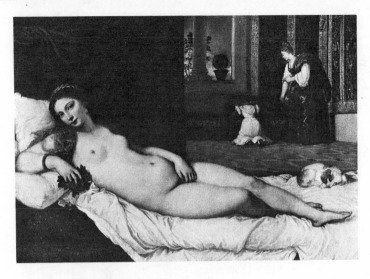

12-1 Titian. *Venus of Urbino.* 1538. Canvas. 5'6" x 5'11". Alinari/ Florence.

painted and carved figures in order to express his religious ideas (Figure 4-1). We will see that the generation which followed broke down the formal boundaries which had restrained Leonardo and Michelangelo, and expressed the spiritual unrest of the day by distorting Renaissance ideals to an exaggerated degree.

Baroque Begins in Italy

During this period of unrest in Italy, the power of the Catholic church and the Pope declined, and art became much less religious. Artists had the freedom to choose subjects like this worldly *Venus.* Although Italy was a battlefield, invaded by both Spain and France, Venice remained a wealthy maritime power, whose ships traded with distant lands and brought back rich fabrics and jewels from the Orient. Their dazzling colors and sensuous textures appealed to the inhabitants of this floating city, a rich trading center since Medieval times. The classic ideals of form and proportion had never been fully accepted in Venice. In addition, glowing mosaics and ornately decorated late Gothic palaces surrounded them with color and visual excitement. As a result, Venice became the center of the new style.

Venetian Painting Typically Venetian in his use of color and texture, Tiziano Vecellio, known as Titian (1477–1576), showed the new secular spirit in his *Venus.* Creating his own personal painting style, he broke away from the formal organization of artists like Raphael (Figure 11-16), often using strong diagonals in his compositions. In such paintings as *The Madonna with Members of the Pesaro Family,* Titian made use of

12-2 Ca d'Oro. c. 1440. Grand Canal, Venice.

12-3 Titian. *Madonna with Members of the Pesaro Family.* 1526. 16′ x 8′10″. Alinari/Florence.

restless forms in strongly contrasting values, placing the Madonna off to the side and balancing her with the coat of arms of the Pesaro family. There was little religious emotion left in such a painting. At the same time, his gods and goddesses were distinctly mortal, painted realistically with glowing skin tones.

The painters who came after Titian, called Mannerists, carried these new ideas still further. The logic of real space was denied; and Michelangelo's twisting figures, Botticelli's elongated proportions, and Titian's unbalanced compositions became

fashionable. The new style of Mannerism was known for its inventive effects and probably appeared as startling to the people of that time as some of the works of experimental artists do today.

One of these Mannerists, Parmigianino (1503–1540), totally disrupted the harmony of the Renaissance. In his *Madonna with the Long Neck,* he crowded the exaggerated elegant Madonna, squirming baby, and attendant angels into one corner of the

12-4 Parmigianino. *The Madonna with the Long Neck.* c. 1535. Panel. 7'1" x 4'4". Scala/New York.

painting, leaving a tall row of unfinished columns to fill the space on the other side. The sinuous grace and sophistication of this Madonna shocked the painter's religious contemporaries, yet Parmigianino and other Mannerists, in reaching for such theatrical effects, were actually expressing the anxieties of their age.

Another Venetian, influenced by Titian, discarded the laws of classical structure. Tintoretto (1518–1594) gradually increased the sense of movement and contrast in his compositions, which almost became floating masses lit by flickering light. He devoted an elaborate series of paintings to St. Mark, patron saint of both Venice and of the great Byzantine cathedral which still dominates the city. But Tintoretto's most famous work remains *The Last Supper,* which provides a striking contrast with the mural of the same subject by Leonardo da Vinci (Figure 11-11).

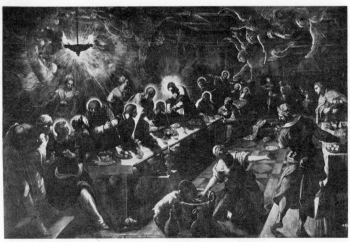

12-5 Tintoretto. *The Last Supper.* 1592-94. Oil on canvas. 12" x 18'8". Alinari/Florence.

Gone is the classic ideal and the balance expressed by Leonardo's one-point perspective and symmetrical composition. It is replaced in Tintoretto's painting by tension and drama. Judas has been set apart in the shadows, but the remainder of the painting is filled with lights, half lights, and active figures. This dramatic interpretation of the familiar theme embodies all the characteristics of the Baroque.

Coming to Venice from the Greek island of Crete, where Middle Eastern influence was strong, Domenico Teotocopulo, known as El Greco (ca 1548–1614), became a pupil of Titian. In spite of exposure to the Venetian Baroque master's work, the Byzantine figures of saints in the mosaics and icons he had seen as a child continued to influence El Greco's painting. Although he learned about light and shade and rich color in Venice, his use of exaggerated elongated figures and strong color contrasts suggest an unreal mystical world quite different from that of other Venetian painters. When El Greco left Venice to live in Spain, where the still-powerful Medieval spirit was directly opposed to Renaissance humanistic ideas, the mannerisms he had learned in Venice became a personal expression of his religious aspirations. His sacred figures, painted in rich Venetian colors, reveal the characteristic turmoil and agitation of the Baroque style, while at the same time they maintain a strong link with Byzantine art. He painted the city of Toledo as if a storm were about to break. The dark sky is threatening and casts an eerie light; the landscape is charged with emotion. In his vision of the

town, acrid green contrasts with the dramatic clouds, and jagged hills and deep river valleys add to the other-worldly feeling. The Renaissance ideals of balance and formal composition are totally forgotten.

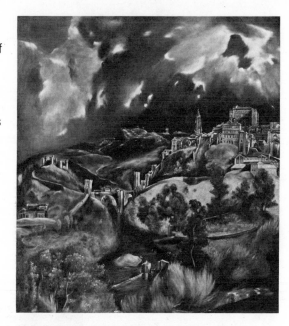

12-6 El Greco. *View of Toledo*. 1604-14. Oil on canvas. 47¾″ x 42¾″. The Metropolitan Museum of Art. Bequest of Mrs. H. O. Havemeyer, 1929.

Sculpture and Architecture Mannerism's concern with effect, rather than with deep emotion or intellectual content, was typical of the work of Florentine sculptor Benvenuto Cellini (1500–1571), whose attempts to prove himself by tackling more and more difficult technical problems are described in his lively autobiography. An expert craftsman, but a supreme egotist, Cellini was delighted with his own technical versatility. The gold and ebony saltcellar which Cellini created for King Francis I of France (Figure 7-13) displayed his remarkable craftsmanship. He wrote of this feat:

> The Sea, fashioned as a man, held a finely wrought ship which could hold enough salt, beneath I had put four sea horses and I had given the figure a trident. The Earth I fashioned as a fair woman, as graceful as I could do it. Beside her I placed a richly decorated temple to hold the pepper.

This kind of novelty appealed to rich princes and kings and led other artists to still greater flights of fancy and more elaborate decoration to satisfy their competitive royal patrons.

At the same time, architects like Andrea Palladio (1518–1580) were also determined to display their skill and their classical knowledge. His Villa Rotunda near Vicenza was supposed to duplicate ancient structures in style and decoration, but no classical monument ever existed like this round villa with four identical porches and portals grouped around a central hall with a dome reminiscent of the Roman Pantheon. Thus the search for novelty had become a goal which superseded the Renaissance interest in accurate classical structure. Palladio's decorative details, influenced by the delicate Venetian architecture, were to have a continuing influence on later architecture (Figure 13-17). Even in eighteenth-century New England—a long way from wealthy Venice—so-called Palladian windows became a feature of wooden houses.

12-7 Andrea Palladio. Villa Rotunda. Begun 1550. Vincenza, Italy.

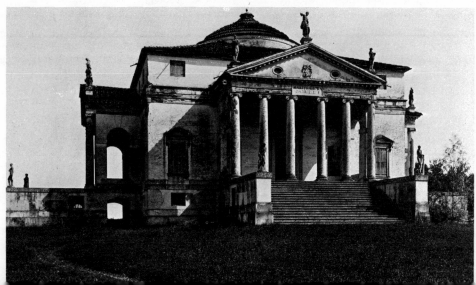

Art in the Protestant North

While the Venetians were expressing their delight in color and texture, northern Europe was in the grip of the Reformation. Because the Protestant church objected to pictures of Catholic religious themes, art became more and more secular in subject matter. The stolid middle-class burghers demanded pictures of themselves and their complacent families to show off their wealth. For this reason, painters like the German Hans Holbein (1497–1543), who traveled to England to become court painter to King Henry VIII, found that portraits were his chief assignment, both in England and in Germany. In *Sir Brian Tuke,* Holbein displays a skill in capturing human expression and great technical skill in rendering details of clothing and the textures of fabrics. These are painstakingly painted with oil glazes which make the surface glow like enamel. Like the painting of Arnolfini and his bride by van Eyck (Plate 23), the objects surrounding the figures have a symbolic meaning. Even the long bony form in the background becomes a skull when viewed from the proper angle.

These portraits, made to be hung in private homes, were partly responsible for the increasing popularity of easel paintings. Before this, paintings had largely been created on commission for churches or palaces and were of mural dimensions whether they were free-standing altarpieces, frescoes, or panels fitted into architectural settings. Now we begin to see smaller works, which could be painted on an artist's easel and could hang on the walls of a patron's home. Although the first easel paintings were primarily portraits of allegorical subjects, it was not long before landscapes expressing the individual painter's response to the natural world around him became common.

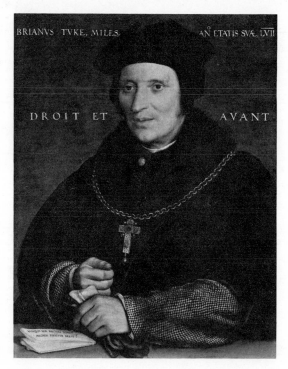

12-8 Hans Holbein the Younger. *Sir Brian Tuke.* 1528-33. Wood. 19⅜″ x 15¼″. National Gallery of Art, Washington, D.C. Andrew Mellon Collection.

Paintings of Everyday Life In the rich Netherlands, painting had flourished for a long time, first as Medieval religious paintings in tempera, then as oil and tempera painting. The Dutch had made a specialty of representing the surface aspects of objects, and pictures of real life were favorites. Even biblical scenes were placed in Low Country landscapes. For instance, Pieter Brueghel painted the *Tower of Babel* (Plate 17) as if it were in a small Netherlands town. Art was no longer created only for the church, and it reflected the life of ordinary people.

The greatest Low Country painter of everyday scenes, Pieter Brueghel the Elder (1524–1569), shows us peasants in ordinary surroundings engaged in work and play. But many of these pictures of rustic peasants, whose human foibles are so apparent, were in reality illustrations of Bible stories. So we see the crucifixion surrounded by peasants in sixteenth-century European dress, the birth of Christ in a cold northern barn, and the death of Mary in a Flemish house. A feast following *The Peasant Wedding* (Plate 24) takes place in a barn where tables are improvised from rough planks. Under a makeshift crown, the bride sits dully, while the groom, shoveling in the food, is scarcely visible. The lively poses of the crowd of peasants carry our eyes again and again to the stolid bride. However, Brueghel, for all his country-bumpkin humor, was a sophisticated man who had traveled in Italy, and his well-composed paintings are not concerned only with surface reality. In his landscape backgrounds, humans are tiny figures in the wide open spaces of Flanders, preaching a lesson about man's lack of importance in the scheme of the universe. Most of Brueghel's landscapes had an allegorical meaning, but the joy he felt in painting nature for its own sake is very apparent. We see workers taking lunch in the hot sun in hay fields, solid Flemish citizens skating on frozen canals, and hunters returning home across snow-covered fields at twilight.

The Counter-Reformation and Baroque

In order to reduce the numbers of people who were leaving the Catholic church to become Protestants, the Pope in Rome changed many of the practices condemned by Luther and began building and decorating projects designed to make Rome once again the religious center of the world. Thus, Baroque art became dedicated to the service of religion, and the Church of Rome spared no expense to make its places of worship more magnificent than ever in an attempt to lure its flock back to the fold. The architecture of this period was dramatic, and the exteriors of buildings were richly decorated. Under the influence of the Counter-Reformation, the Baroque period also saw the start of organized urban planning. New civic spaces were designed by great architects, and plazas, fountains, and private gardens were laid out on a grand scale. Although most of this planning was intended for the aristocracy, some of it, like the plaza in front of St. Peter's (Figure 12-11), added a new dimension to the life of the ordinary citizen and greatly enriched his urban life.

In the Baroque painting and architecture which centered in Rome, light and dark contrasts were emphasized, and painted compositions were turbulent with complex rhythms moving in and out of the flat picture surface. Mysterious effects were fashionable, and theatrical expressions of emotion were admired. Italian painters, for example, used highly exaggerated lighting to dramatize Bible stories in ordinary settings. Caravaggio (1573–1610) was one such artist who used this technique, which can be seen in his *Conversion of St. Paul.* It is painted in a startling and dramatic way, and all the traditional accessory figures have been eliminated. Saint Paul is shown as an armored man flat on his back, almost trampled under the feet of a horse. The painting draws us into the event with its striking perspective and exaggerated unrealistic use of light and shade. It will be obvious why many contemporaries of Caravaggio were appalled by the painting, which they felt showed disrespect toward the saint, if you compare it with Ghirlandaio's *Birth of the Virgin* (Figure 5-9), which also tells a religious story.

The most typical sculptor-architect of the Baroque was Giovanni Lorenzo Bernini (1598–1680), who is best known for an extraordinary sculpture of *The Ecstacy of St. Theresa.* In this work, whose exaggerated expression of emotion shows the influence of such Hellenistic sculpture as the *Laocoön* (Figure 9-14), Bernini represented the Saint's moment of religious ecstacy. In her own words, she felt such a great love of God that:

> The pain was so great that I cried out, but at the same time the sweetness which that violent pain gave me was so excessive that I could not wish to be rid of it.

Bernini's sculpture combined both religious mysticism and an appeal to the senses, and this work epitomized the restless and unstable spirit of the Baroque. The drapery falling in a cascade of agitated folds denies the solidity of the stone from which it

12-9 Caravaggio. *Conversion of Saint Paul.* 1600-01. Oil on canvas. 7'8'' x 5'10''. Alinari/Florence.

12-10 Gianlorenzo Bernini. *The Ecstasy of St. Theresa.* 1645-52. Marble, lifesize. Sta. Maria della Vittoria, Rome. Alinari/Florence.

was carved, showing off Bernini's technical skill, but at the same time demonstrating his preoccupation with detail at the expense of expression. Bernini's religious intensity also led him to create a spectacular design for the piazza of St. Peter's in Rome. This piazza was planned for crowds of Easter and Christmas worshipers and is said to be able to enclose two million people. He compared the curving colonnade to the arms of the Church which "embrace Catholics to reinforce their belief, heretics to reunite them with the Church, and agnostics to enlighten them with the true faith." Thus the dramatic architecture of the Baroque was used as a tool of the Counter-Reformation to draw people into the Church again.

About this time, Annibale Carracci and the other members of his artistic family established an art academy, the first school of its kind in history. In it, students no longer followed the time-honored practice of working as apprentices to a master painter, but studied the work of the artists of the past, absorbing some elements from each. These new academies gained a great deal of power and later dominated and controlled the official art world.

12-11 St. Peter's Piazza, Rome. Alinari/Florence.

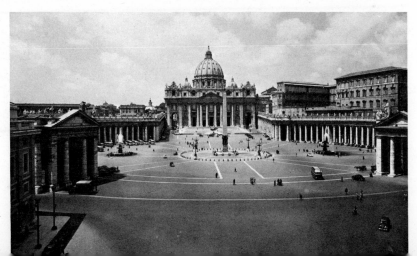

The Baroque Style Spreads

In Spain where royal wealth was immense, largely as a result of her discoveries and plunderings in the New World, the royal court of Spain was ostentatious, ruled by monarchs who saw themselves as both the secular and religious leaders of mankind. They built elaborate palaces and brought Italian and Flemish artists like El Greco (Figure 12-6) to Spain to embellish them. But a native talent, Diego de Velázquez (1599–1660), became the best-known Spanish court painter, producing many royal portraits and grandiose historical scenes.

Velázquez, who was influenced by El Greco's grouping of figures, strong light and shade, and heavy brush strokes, gradually developed a radical personal style of his own. His canvases are Baroque in their use of sensuous color, depth of space, and light and dark contrasts, but he applied his paint in separate brush strokes in a method which came close to later Impressionism. Using this technique of building up forms with many strokes, Velázquez could recreate the play of light over the velvet and satin of his royal sitters's clothing and the luxurious furnishings of their palaces. In *The Maids of Honor,* Velázquez painted his own portrait standing next to the tiny Infanta surrounded by her maids of honor. Portraits of the king and queen, who came to watch the artist at work, appear in the mirror behind him. Velázquez must have felt very secure in his position as court artist to paint himself more prominently than his royal employers.

As the exaggerated style of the Baroque spread throughout Europe, artists in all media came under its influence. Furniture, tapestry,

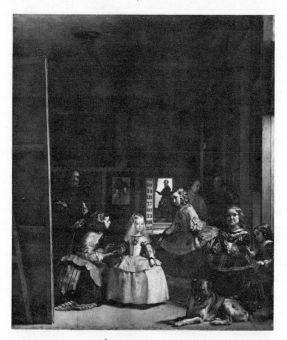

12-12 Diego de Velázquez. *The Maids of Honor.* 1656. 10'5'' x 9'. The Prado, Madrid.

ceramics, glass, and gold glittered with elaborate applied decoration. Every surface was broken with some form of curving arabesque to lend splendor to even the most useful object. Royalty collected rare and valuable objects, competed to fill their private museums, and lavishly decorated their palace walls with paintings by famous artists.

One of the most prolific and worldly artists of this time was the Flemish Peter Paul Rubens (1577–1640). A world traveler and ambassador-without-portfolio, Rubens was a

painter for several courts, had many wealthy patrons, and was actually given the assignment of negotiating the peace between Spain and England. Rubens spent many years in Italy where he learned all there was to know about the use of light and color. He used this knowledge in huge compositions like *The Garden of Love* which express his delight in full-figured nudes with glowing skin colors. Rubens's work was tremendously popular, bringing him great wealth, and he maintained a studio full of assistants to help him fill his many commissions. The best artistic talents were attracted to this workshop, where the master artist kept such a tight control over the work that when a painting was almost complete, Rubens had only to take a brush to touch a detail here or there to make the work characteristically his own. In only four years, Rubens painted twenty-one enormous decorations for the Luxembourg Palace in Paris. These show the history of Marie de Médicis in a mixture of myths, reality, and allegory—a combination which was extremely popular with the aristocracy.

Another palace built in France in the seventeenth century with typical Baroque magnificence and huge scale was the Palace of Versailles. With its vast gardens, it was built to glorify the kings of France. The palace was a city in itself, and we must try to imagine it full of thousands of courtiers and attendants in brilliant costume. The gardens, designed by Le Notre, covered acres and were full of marble statuary in a classic style and ornate, splashing fountains. Although Versailles was built on the same enormous scale as Bernini's piazza, its style, which exemplifies French Baroque, is more

12-13 Peter Paul Rubens. *The Garden of Love.* c. 1632-34. Canvas. 6′6″ x 9′3½″. The Prado, Madrid.

12-14 Palace of Versailles. 1669-85. Courtesy of the French Government Tourist Office, Beverly Hills, Calif.

restrained and more intellectual than that found in Italy or Germany. Its design was, however, revolutionary for its time in the relationship of the interior of the building to the exterior space of the gardens. Italian Renaissance palaces had generally looked inward to courtyards. In contrast, Versailles had broad terraces which opened off large galleries which faced onto the gardens.

A New Spirit of Equality

At the same time that the aristocracy and royalty of France were building huge palaces, the Low Countries, freed of the domination of Spain, were developing a less artificial art. The Reformation had triumphed, and with the success of Protestantism, the influence of the philosophical attitude of rationalism, and the growth of scientific knowledge, art there became more secular. A nation of successful merchants, Holland developed a middle class who supported the new art in which the individual played an important role. Here the Baroque style gave way to the material everyday life of the puritan north.

The Low Countries Frans Hals (1580–1666) was a popular portraitist of the newly independent Holland. He painted Dutch burghers in official portraits in such paintings as *The Governors of the Old Men's Almshouse;* but despite his official popularity, Hals was innovative in his free and bold method of applying paint. In *The Bohemian*

(Figure 5-11), he catches a momentary expression and fixes it permanently on the canvas. Compare the naturalism of Hals's painting with the contrived, dramatic, and theatrical effect of Caravaggio's *Conversion of St. Paul* (Figure 12-9).

While Hals painted his subjects as if they were caught in a passing moment, Rembrandt van Rijn (1609–1669) looked at his with a psychological penetration which seemed to reach the essential core of each human being, subordinating all detail to the character of his subject. His great technical skill is transcended by his understanding of human character, and his portraits reveal such psychological probing that at times we feel we must turn away from the embarrassing intimacy of his insight. Rembrandt used strong contrasts of light and shade and dramatic lighting in a more restrained manner that the Italian painters. Less interested in effect than in emotional expression, he always subordinated the Baroque devices to his message. This is particularly true of his self-portraits, which show us the melancholy of his later life (Plate 4). No longer a popular portraitist, Rembrandt died poor and lonely, after having known great riches and acclaim.

Rembrandt was also a talented graphic artist who preferred etching to engraving for the freedom it gave him. With only a few strokes he could express the essence of a scene, a gesture, or a pose (Figure 5-17). To find models to draw for his religious etchings, he frequented the Jewish quarter of Amsterdam and used the ordinary people he knew there as subjects for many of his graphic works.

Rembrandt's unconventional approach bothered the wealthy civic officials, and his best-known group portrait was rejected by the people who had commissioned it. Called *The Night Watch* because layers of darkening varnish eventually concealed the real event, making it appear like a night scene, *The Company of Captain Frans Banning Cocq* actually represents a volunteer company which had been called together to honor the visiting queen. The group refused to accept the painting, because the members felt Rembrandt had

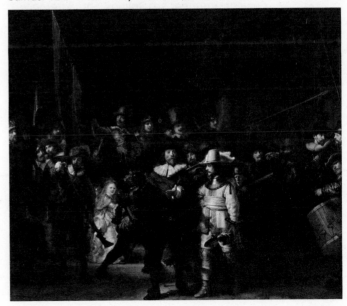

12-15 Rembrandt van Rijn. *The Night Watch (The Company of Captain Frans Banning Cocq).* 1642. Canvas. 12'2'' x 14'7''. Rijksmuseum, Amsterdam.

showed disrespect toward their official positions by showing them in various stages of undress.

Rembrandt's paintings appear so uncluttered with their glowing light and deep shadows, in which nonessential details are lost that, in contrast, Jan Vermeer's (1632–1675) paintings, full of the furnishings of a Dutch household, may seem somewhat overdetailed to us. Vermeer painted the textural details of his interior scenes with loving, meticulous concern for accuracy, using colors which are mellow reflections of Dutch Baroque taste. But the strong composition, which ties together the sensuous color and texture of everyday objects, lifts the paintings above a mere cataloging of material possessions. However lacking they are in deep psychological content, Vermeer's paintings are extremely sophisticated both in color and composition and in the way the masses and contrasts of light and dark are balanced against each other (Plate 3). If the paintings were reduced to abstract shapes and flat colors in the style of the twentieth-century Dutch painter Mondrian (Plate 8), we could see how carefully the composition is worked out. Vermeer's skill in framing his scenes with draperies or furnishings, combined with his innovative device of cutting off his figures at unusual levels, foresaw a new way of looking at the world.

In rebellion against the confines and limitations of the classic Renaissance rules, the Baroque era set the stage for later innovations in all the arts. Individual artists searched for new ways to express their ideas and feelings, and as time went on the variations within each period and style became greater. As these local variations and personal styles increased, it became harder to fit each artist into a convenient category. But this confusion is itself expressive of the times.

Rococo

As Europe entered the eighteenth century, absolute monarchs ruled in most nations. They gathered around them aristocratic courts of genteel hangers-on who schemed for royal favor. Courtly behavior counted more than ability, and aristocrats retreated from the real world, where people lived in terrible poverty, into an artificial world of theatrical performances, masques, and pageants. At the same time, outside the frivolous courts there were some writers and scientists, like Voltaire and Isaac Newton, who expressed ideas that led to a rising skepticism about the social order. So we should remember that although the art of this period was dominated by the aristocracy, the facade of ostentatious decoration was as shaky as the monarchies which supported it. The further the ruling classes retreated into their palaces and gardens, unresponsive to the needs and problems of their subjects, the stronger the revolutionary spirit became throughout Europe and the New World.

The emotional, dramatic Baroque merged into a more graceful style which became known as Rococo. It was popular with the powerful and wealthy upper class, and soon the walls of palaces and country estates were covered with decorations of delicate plants, flowers, shells, and fruit; and furniture,

tapestries, china, and silverware were intricately decorated in the new style.

Whereas the Baroque era had favored theatrical paintings and a monumental style in architecture; in contrast, the Rococo was a style of frivolity and relaxation, and gay paintings of landscapes and cupids were popular, reviving subject matter which had been considered inappropriate for art since the time of the Romans. The rich sensuous colors of the Baroque were gradually exchanged for light tones of the most subtle delicacy.

Court Painting The painter Antoine Watteau (1684–1721), who was also an interior designer, shows us the Rococo at its best. Watteau became so successful in depicting the shimmering silks and satins of the aristocracy gaiety that he was made an official court painter. He was assigned to record the open-air spectacles so popular with the court, painting these events from quick sketches made at the scene. *The Embarcation for Cythera* is a dreamy landscape, peopled by courtiers who are about to sail for the legendary island of love. Adapting painting techniques from Rubens's more robust paintings, Watteau was extremely skillful in rendering luxurious fabrics in rich silvery tones. Watteau often borrowed ideas from the theater, and his subjects seem to act out their parts in a stage setting, almost as if they realize the artificiality of their lives.

The pleasant carefree life of the aristocracy, so soon to end in a blood bath, was also expressed in paintings by François

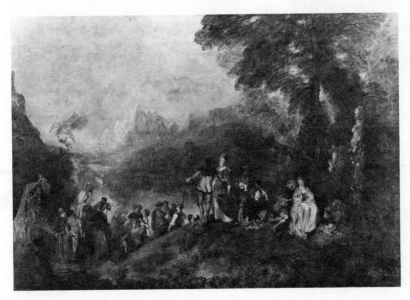

12-16 Antoine Watteau. *The Embarcation for Cythera.* 1717. Canvas. 4′3″ x 6′4½″. Cliché des Musées Nationaux.

Boucher (1703–1770) and Jean Fragonard (1732–1806). Boucher was painter to Madame de Pompadour, and although an accomplished portraitist, he became more famous for his allegories. His gay fantasies used the Baroque diagonals to create lively compositions. Boucher's student, Fragonard, was equally adept at decorative paintings; and pretty faces, delicate colors, supple bodies, and coy poses are typical of the work of both artists (Figure 1-13). In their paintings, gods and goddesses are depicted naked or draped with silk and surrounded by cherubs. Titles like *The Toilet of Venus, The Stolen Kiss, The Bathers,* and *The Fountain of Love* give us an idea of the type of paintings aristocratic patrons liked to have hanging on the walls of their boudoirs and salons. With these painters, the grandiose art of the Baroque was transformed into the intimate, gay Rococo.

The Academies Typical of this period were academies, which controlled literature, art, and science for many years throughout Europe, handing out honors and commissions to scholars and artists who followed their dictates. Other artists, who refused to follow their arbitrary rulings, had a difficult time getting assignments. This conservative official art is called *academic,* and we will see how later artists often rebelled against its restrictive influence.

Baroque in England The Baroque reached England late and there became much more restrained than in the rest of Europe. You can see this restraint in the cathedral designed for London by Christopher Wren (1632–1723). The double row of paired columns in Wren's Cathedral of St. Paul reflects the classic French taste rather than the exuberant Italian, although the central dome was undoubtedly influenced by that of St. Peter's in Rome (Figure 11-15). The facade of the huge church shows similar relationships of structural parts, but the towers come closer to the Rococo in their

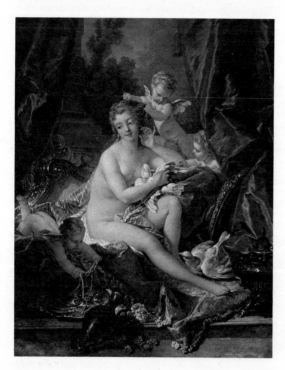

12-17 François Boucher. *The Toilet of Venus.* 1751. Oil on canvas. 42⅝″ x 33½″. The Metropolitan Museum of Art. Bequest of William K. Vanderbilt, 1920.

12-18 Sir Christopher Wren. St. Paul's Cathedral. 1675-1710. National Monuments Record, London.

undulating forms. Wren built many churches in London after the Great Fire in 1666, and the variety in the decoration of their steeples attests to his rich imagination.

Separated from Europe by taste as well as the English Channel, England never fully accepted the Rococo, retaining longer the Baroque. Never as ornate or luxurious in England as in France or Germany, English Baroque revived classical Greek art, and a new style of interior design appeared in the work of Robert Adam (1728–1792), who decorated houses with his own interpretations of classical motifs. These, along with Wren's domes and steeples, later had a strong impact on buildings in North America. The British also excelled in building large comfortable country homes.

12-19 Sir Joshua Reynolds. *The Marchioness of Townsend.* c. 1780. Oil on canvas. 7'11" x 4'10" The M. H. de Young Memorial Museum, San Francisco. Gift of the Roscoe and Margaret Oakes Foundation.

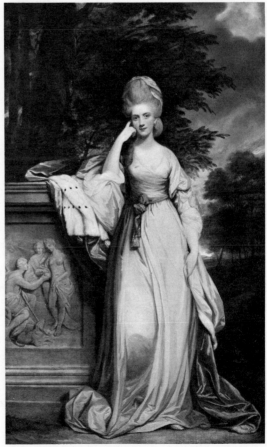

Surrounded by parks and gardens, these homes served as the elegant background for Britain's upper class, which was portrayed in the paintings of Sir Joshua Reynolds (1723–1792). As the head of the Royal Academy of Arts in London, Reynolds laid down specific rules governing the creation of art in accordance with French and Italian academic principles. But despite the fact that his writings on art were pompous, his own paintings have a certain grace and charm. Flattering to their subjects and lacking the psychological penetration of Rembrandt's portraits, these paintings appealed to the aristocracy, who were more concerned with surface effects than with reality. They set the style for fashionable portraits for many years to come.

Contrasting with Reynolds's contrived compositions are the freer paintings of Thomas Gainsborough (1727–1788), who had a talent for posing his subjects in graceful positions (Figure 7-24). His colors are airy, and his paintings sparkle with an elegance which expresses the gracious life of his wealthy subjects in their luxurious country homes. In them we see the life of the more fortunate citizens of Britain. As the eighteenth century progresses, this complacent life will be challenged, and artists will reflect the newer, more democratic outlook.

The Age of Revolution

Revolution is the larva of civilization.

Victor Hugo

During the eighteenth and nineteenth centuries, Europe moved into an age of political and social revolutions. Monarchies, and the luxurious courts which surrounded them, were doomed. Increased commercial activity and the new industrialism led to an uncontrolled system of capitalism which depended on the exploitation of workers and the development of new markets. With this came a shift in power from the aristocracy to the new middle class. As a result, the artificial art, which depended on the kings and nobility as patrons, was also doomed. The social and political unrest caused by the power shift was reflected by artists in varying ways. Some painted political protests, others escaped to a romantic world of exotic scenes. Some put their energies into discovering new ways to represent the world, and still others painted the ordinary life of the growing middle class. The development of this wealthy middle class had a profound effect on art. Like the aristocracy, they wanted to enrich their surroundings with art. Engraved copies of paintings by Boucher, Watteau, and similar painters were popular, but the middle class also had their own favorites who reflected their everyday world. These paintings illustrated tables laden with food, drinking parties, and comfortable household scenes.

This bourgeois taste for ordinary subjects appeared also in the more refined work of the French painter Jean Baptiste Chardin (1699–1779). His arrangements of food and cooking implements, known as *still lifes,* are outstanding in their subtle color harmonies and textures, and despite their simple themes, they satisfied even the most conservative patrons. In his ability to give a quiet dignity to domestic scenes he resembled the Dutch painter Vermeer (Plate 3). His paintings were also enjoyed by the aristocracy, who like to play at living a simple life. Indeed, the demand for his work was so great that he copied some of his most popular paintings in order to satisfy collectors who clamored for them.

But life in the eighteenth century had its unpleasant side as well, even among the privileged. The other side of the story was told by an English artist, William Hogarth (1697–1764), in works like *The Harlot's Progress* and *The Rake's Progress,* a moralizing series of engravings telling of the downfall of a young woman and a young man. His biting portrayal of the dissolution of the young man was aimed at the

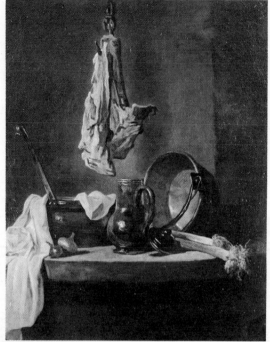

13-1 Jean Baptiste Chardin. *Still Life with Side of Beef*. Eighteenth century. Oil on canvas. 36¾" x 53½". The Norton Simon Foundation, Los Angeles.

weaknesses of British society and sometimes at mankind in general. The rake comes to a pathetic end as a raving maniac in Bedlam, London's insane asylum, where his demented companions include a grimacing fiddler and a schizophrenic wearing an impromptu crown. Engravings had become a popular and inexpensive form of art which ordinary people could afford, and series like these reached large audiences. With Hogarth, the graphic arts had become an important propaganda tool for arousing indignation against social injustices and the vices of the rich.

New Ideas in Art

As the century progressed, the skeptical intellectuals, who had questioned the abuses of the monarchs and aristocrats, joined with the revolutionaries in France and North America to overthrow the royal governments. The impact of these revolutions was felt even in those countries which still retained a monarchy. Many artists were followers of the new democratic ideals, and two quite different painters, Francisco Goya of Spain and the Neoclassicist Jacques David of France, both expressed revolutionary ideas.

13-2 William Hogarth. *In Bedlam* from *The Rake's Progress*. c. 1734. 24½" x 29½". The Metropolitan Museum of Art. Harris Brisbane Dick Fund, 1932.

13-3 Francisco Goya. *The Third of May, 1808.* 1814-15. Canvas. 8'9" x 13'4". The Prado, Madrid.

Francisco Goya y Lucientes (1746–1828) witnessed Napoleon's invasions of Spain in 1809 and 1814. Violence, pain, and the human capacity for evil are depicted by him in a series of prints, *The Disasters of War,* in which there is no romantic illusion about the slaughter, rape, and destruction. Some of his paintings were also concerned with war, and *The Third of May* marks an event which took place after Napoleon's imperial troops had been attacked by an unruly mob. In punishment for this impromptu revolt, a group of hostages, picked at random, were dragged before a firing squad and methodically murdered.

Goya was also skilled in portrait painting and was clever at rendering the rich textures of royal costumes. As a result, he became an extremely popular painter with the aristocracy, who apparently did not realize that beneath the surface elegance of his paintings, Goya was also commenting on the corruption of the royal family and the greed, vanity, and cruelty of the members of the court.

Completely disillusioned and melancholy in his last years, Goya lived in seclusion and painted dark threatening images of horror and despair.

Neoclassicism By the mid-eighteenth century there was a revival of interest in classic art. Archaeology developed into a science, and Pompeii and Herculaneum were unearthed. This rediscovery of Greek and Roman architecture led to a style, called Neoclassicism, which appealed to intellectuals, who believed that the use of reason would solve mankind's problems. Thomas Jefferson's home, Monticello, and

13-4 Francisco Goya. *Saturn Devouring Child.* 1819-23. Fresco transferred to canvas. 57½″ x 32⅝″. The Prado, Madrid.

most of the buildings in Washington, D. C., reflect this style. (Figure 13-17), which also appeared in the academic painting of the day.

Jacques Louis David (1748–1825), a painter who lived during the most violent period in French history, rebelled against the Rococo as an artificial taste. David reworked the classical and academic traditions into a personal style to express his republican ideas. He had an intellectual purpose—to emphasize the moral strengths of ancient Greece and Rome. Taking his inspiration from Greece and Rome, he retold the story of *The Death of Socrates* as a moral of self-sacrifice in a formal composition which shows Socrates giving his famous speech to his followers. In his final statement, the Greek philosopher says that he would rather die than give up the freedom to teach what he believed. Vertical and horizontal shapes dominate the rigidly composed painting, giving it a static quality that does not seem very revolutionary by our standards. David, however, felt that classical forms and composition were the best way to express the revolutionary ideals of liberty, equality, and fraternity.

Landscapes England was not torn by revolution, as were other countries in Europe, and art there was not used for propaganda. Nevertheless, painters like John Constable (1776–1837) expressed the new democratic idea in paintings of the surroundings of ordinary working people. These quiet English landscapes, painted in rich earth tones, were startling to people used to pretentious academic art. Constable said he wanted to

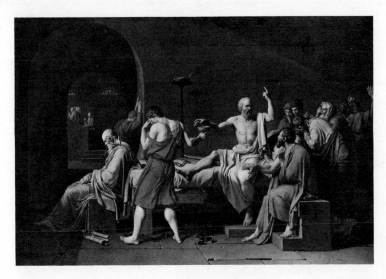

13-5 Jacques Louis David. *The Death of Socrates*. 1787. Oil on canvas. 51″ x 77¼″. The Metropolitan Museum of Art. Wolfe Fund, 1931.

paint what he saw with his own eyes and to capture the "light—dews—breezes—bloom—and freshness" of the English countryside. Constable sketched outdoors, and his quick studies are bolder than the paintings which he later composed from them in his studio. Nevertheless he always tried to keep the freshness of the outdoors in his work and to portray honestly what he saw, without making the composition fit academic rules. His earthy style, with its loose brushwork, outraged critics, although it became extremely popular with the general public. *The Haywain,* which is typical of Constable's simple subject matter, was painted with a real love of the countryside and an ability to show atmospheric effects with a free brush stroke, a technique which paved the way for the Impressionists who painted half a century later.

Another landscape painter, William Turner (1775–1851), had visions of painting the "unpaintable" and was almost possessed with a determination to record all of nature's atmosphere. In many ways, Turner was far ahead of his age, reducing air, water, and even fire to abstractions. Turner painted clouds, waves, and mist as billowing shadowy forms, lit with dramatic light. When Turner watched the fire which destroyed the houses of Parliament in 1834, he was inspired to paint a series of remarkable pictures of the event. Brilliant flames, ominous smoke, reflections in the river, and crowds of people watching all dissolve into each other. Occasionally applying the paint with a palette knife, Turner suggests turbulence with spontaneous bold streaks and dabs (Plate 25). He was a forerunner of the Impressionist painters and was

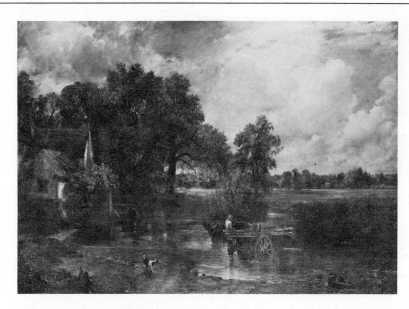

13-6 John Constable. *The Haywain*. 1821. Canvas, 51¼" x 73". Reproduced by courtesy of the Trustees, The National Gallery, London.

rediscovered by two of them, Pissarro and Monet, after his death. But Turner was concerned with the poetic quality of light and was more interested in abstract patterns than were the later Impressionists, who merely wanted to paint the effects of light on objects. A poem by Turner about Switzerland, where it was fashionable for English artists and lords and ladies to contemplate the Alps and the grandeur of nature, tells us a good deal about his attitude toward nature:

> . . . its pine clad forests
> And towering glaciers fall,
> the work of ages
> Crashing through all: . . .

Romanticism and Protest Here we have the beginnings of the Romantic attitude which led painters like Théodore Géricault (1791–1824) and Eugène Delacroix to choose faraway and exotic settings for their paintings. But Géricault's *Raft of the Medusa* was also a protest painting about the lack of proper lifesaving equipment on French ships. It tells the story of drowning, starvation, and cannibalism on a makeshift raft onto which over 100 desperate shipwrecked passengers tried to crowd. However, the protest went unheeded. Instead, the public was outraged by the artist who used naked figures in unclassical poses to tell his story. This was a revolutionary painting in its championing of a current cause in a dramatic way and in the manner in which Géricault used color and composition to intensify emotion. Compare its

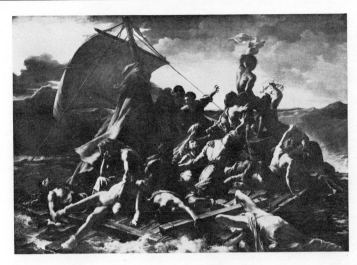

13-7 Théodore Géricault. *The Raft of the "Medusa."* 1818-19. Oil on canvas. 16'1" x 23'6". Cliché des Musées Nationaux.

violent diagonal composition and turbulent forms with David's classic painting (Figure 13-5) to see how strongly Géricault was rebelling against academic painting.

Like painting, the graphic arts in France were also used to protest existing conditions. A political commentator and satirist, Honoré Daumier (1808–1879) earned his living as a cartoonist and illustrator. His lithographs often expressed sympathy with the poor and exploited and presented brutal caricatures of the ruling classes (Figure 5-20). Biting criticisms of the French political, judicial, and police systems, these prints appeared in newspapers where they influenced political cartooning for many years. In addition to his graphics, Daumier painted the slum dwellers of Paris in their squalid, desperate lives. His *Third-Class Carriage,* and its companion *First-Class Carriage,* make strong statements about the gulf between the rich and the poor.

At the same time, the three generations in the third-class coach also reflect Daumier's belief in the self-perpetuating strength of the proletariat.

By this time, the Industrial Revolution was in full swing, and with it came new alignments of power and new areas of competition. Nations fought with each other over territories, boundaries, and economic spheres of influence; and wealthy capitalists founded new dynasties which competed with each other. At the same time, wars were fought over slavery, and the slave trade was abolished. But this did not end the exploitation of workers, and even children had to work long hours in factories and mines. Families crowded into industrial towns and slums to be near the factories, which now produced most household articles as well as the ornate furnishings demanded by the newly wealthy middle class. This led to a

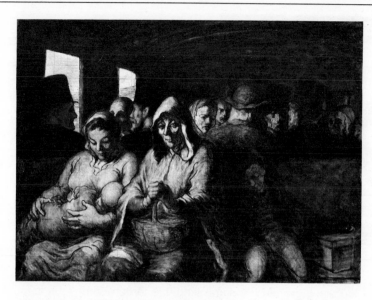

13-8 Honoré Daumier. *The Third-Class Carriage.* c. 1862. Oil on canvas. 25¾″ x 35½″. The Metropolitan Museum of Art. Bequest of Mrs. H. O. Havemeyer, 1929.

separation of art from everyday life—a separation which has continued into our own time. Most of the wealthy factory owners were more interested in material possessions than they were in art, and when they did buy art, their tastes leaned toward the type of academic paintings exemplified by David rather than by Daumier's and Géricault's social protests.

Another rebellious painter, who gave a name to the continuing struggle for artistic independence, was Gustave Courbet (1819–1877). In 1855 Courbet presented a one-man show called *Réalisme, G. Courbet,*

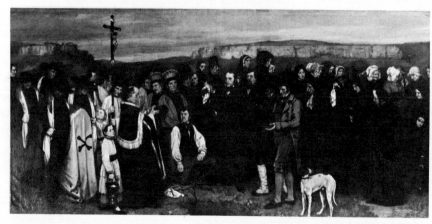

13-9 Gustave Courbet. *Enterrement à Ornans.* Louvre. Cliché des Musées Nationaux.

which marked a revolutionary change in art. Courbet's painting does not depend on graceful poses, rich textures, or impressive colors but rather on a realistic portrayal of ordinary scenes. Courbet gathered around him students to whom he taught his theories of realistic painting. He even brought a bull into the studio once and posed it on the model stand for his students to draw!

Courbet was forced to leave France because of political activities, but his independent spirit continued to influence young artists and helped to set the stage for the artistic upheaval which would soon overthrow the rigid control of the Academy.

New Views of Reality

The Romantic artists had opened the eyes of Europe to unfamiliar cultures. Later, when Japan was forced by the American navy to open her doors to Western trade in 1868, Europeans excitedly bought the newly discovered art of Japan. From these Oriental art objects and from the Japanese woodcuts which were used like newspapers to wrap them for shipping, artists in the Western world discovered a new way of representing space and form. In a woodcut showing an unusual view of Mt. Fuji, Katsushika Hokusai (1760–1849) created an exciting composition in which a huge wave curls up and breaks in the foreground, dwarfing the mountain in the distance (Figure 5-16). A traditional Western landscape artist painting the same scene would probably have emphasized the mountain rather than the off-center wave and would have been concerned with showing the distant mountain in realistic perspective. The Japanese approach to portraiture also

13-10 Tawaraya Sotatsu. *Kasen.* Seventeenth century. Ink and color on paper. 7⅜″ x 8″. Asian Art Museum of San Francisco, The Avery Brundage Collection.

appeared strange, though fascinating. For example, to us, this Japanese woodcut appears flat as a playing card. Obviously, Renaissance obsession with realistic three-dimensional forms did not interest the Oriental, who was more concerned with suggesting rather than recreating reality.

At the same time, the development of photography had a strong effect on how artists saw the world. As a result of the invention of the camera, the nineteenth-century Western painter, brought up to believe that the purpose of art was the reproduction of reality, faced a new dilemma. Because the camera could capture a sitter,

an event, or a scene quicker and more realistically than the painter and his brush, the artist no longer needed to fill the role of transcriber of reality. Relieved of having to transpose solid forms onto a flat surface, painters were forced to rethink traditional concepts of art and to find new outlets for artistic expression.

A painter who faced this dilemma creatively, Édouard Manet (1832–1883) brought together many influences and transformed them into a new style of his own. Trained in the European academic tradition, he was also influenced by the Romantic style's exotic subjects and rich use of color and texture. Manet often chose Spanish subject matter in paintings that show

the influence of Velázquez (Figure 12-12), and he was fascinated by the flat areas of color in Japanese art. His use of broad areas of paint, with occasional spots of brilliant color, was shocking to the nineteenth-century public used to the academic style in painting. Manet was also attacked as a heretic because he did not follow the traditional method of painting dark areas first and then later building up the lights. Instead, with his deep concern for light and color, Manet tried to duplicate sunlight by using the natural brilliance of the white canvas, building up the darker tones.

His large painting, *Le Déjeuner sur l'Herbe,* or *Luncheon on the Grass,* is set in a woodland glade, and its portrayal of naked

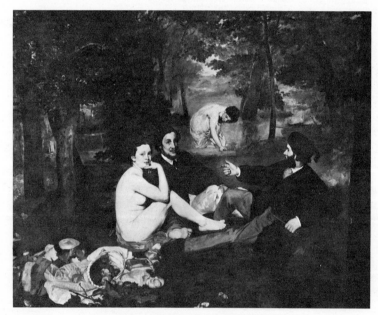

13-11 Édouard Manet. *Luncheon on the Grass.* 1863. Canvas. 84¼″ x 106¼″. Cliché des Musées Nationaux.

women with fully clothed men scandalized the public. Not only was the subject startling, but the use of strong natural light on the skin was not considered sound academic practice. A figure bathing in a pool in the backgound was Manet's way of justifying his portrayal of nudes outdoors, but the world was shocked, and the Academy refused to exhibit his painting in the official Salon of 1863. This led to the formation of a Salon of Rejected Painters, whose rebellion eventually revolutionized art, despite the Academy's continued efforts to control it. In 1865, Manet's masterpiece, *Olympia,* now a favorite in the Louvre Museum, created an even worse scandal than *Le Déjeuner,* and it was even considered pornographic by some

of the artist's contemporaries. Actually, Manet based his painting on the *Venus of Urbino* by Titian (Figure 12-1), but *Olympia* makes no attempt to appear goddesslike. Obviously one of the courtesans of the Parisian demimonde, she lies on her rumpled bed, showing no signs of modesty as her maid brings her an admirer's flowers. Although figures of goddesses were traditional subjects, Manet's suggestion in *Olympia* that Venus was an ordinary woman was badly received by the public, and the flat silhouette of her body further shocked traditionalists. Manet never hesitated to paint as he believed, but he disliked the criticism which came his way as the reluctant leader of the new style of Impressionism.

13-12 Édouard Manet. *Olympia.* 1863. 51¼″ x 74¾″. Cliché des Musées Nationaux.

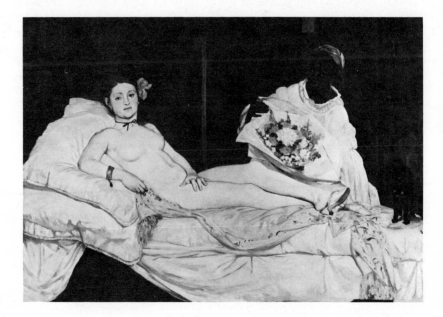

Impressionism

Several young artists were influenced by Manet's attempts to capture the immediacy of a moment, his use of flat simple areas of color and his efforts to depict natural light. Out of this group of rebellious painters came new ideas about the use of color and an out-of-doors method of painting which attempted to catch the fleeting movements of light across the landscape.

In 1874 these young artists, who were rejected by the official Salon, organized their own exhibit in a photographer's studio. Since they believed that photography would soon replace conventional realistic painting, they wished to paint in a new way and chose the photography studio as an appropriate symbol. Among the members of this group were many artists destined to become famous, but their teacher Manet refused to join them in the exhibit. The name Impressionists was provided by a critic who laughed at a painting exhibited by Claude Monet entitled *Impression: Sunrise* (Plate 26). The critic's statement that "these are not artists at all; they are impressionists" seemed to describe the common feature in their work, and, although it was meant as an insult, the painters adopted the label as a name for their new style.

Wanting to capture the momentary impression of light playing over landscape, figures, and objects, Claude Monet and the other painters who belonged to the group—Pissarro, Degas, Morisot, Renoir, Cassatt, Cézanne, and others—painted in the open air instead of in the traditional north-lighted studio. Monet, for example, studied the changing effects of light playing over a haystack or a cathedral at different times of day.

Impressionist Color Theories The light and color reflected from an object in a fleeting moment were more important to the Impressionists than the form of that object. Trying to capture this impression of light, they painted with small strokes and dabs of pure color, taken directly from the tube. This method is called broken color (Plate 7). Instead of mixing blue and yellow on their palettes to make green, or yellow and red to make orange, they placed small brush strokes of these colors next to each other and left it to the eye to mix them. When viewed from a distance, these painted areas became images of trees, figures, flowers, and buildings. This method of painting, as well as the use of flat shapes and unusual perspective borrowed from the Japanese, were common characteristics of a group of painters who varied considerably in their individual styles. Some of them, like Cézanne, Gauguin, Degas, and van Gogh, painted with these methods at first, but later developed their own ways of representing form and even rejected the Impressionistic credos. On the other hand, others remained dedicated Impressionists throughout their artistic careers.

A few years younger than Éduoard Manet, Edgar Degas (1834–1917) carried the idea of painting figures in momentary poses even further. Like other Impressionists, movement intrigued him, and horses and dancers were among his favorite subjects. He liked to catch ballet dancers in moments of action on stage in the bright footlights, intrigued by the unusual positions assumed by the dancers. Inspired by Japanese prints, he also depicted his subjects in unusual perspectives. However, although his paintings appear to capture movement like the action shots of candid photography, Degas was deeply

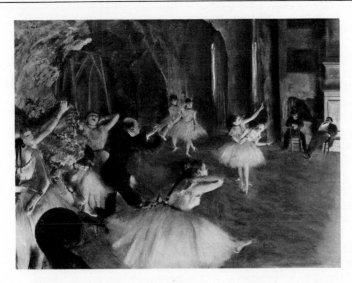

13-13 Edgar Degas. *The Rehearsal on the Stage.* 1878-79. Pastel over brush and ink drawing on paper. 21″ x 28½″. The Metropolitan Museum of Art. Bequest of Mrs. H. O. Havemeyer, 1929.

concerned with composition, and he worked out his paintings very carefully first in sketches and studies. Degas exhibited with the Impressionists, but he never really considered himself one of them because of his interest in composition. He supported their efforts to change the rules of the Academy primarily because he believed in their questioning attitude. He could afford to give them his support, for he was a wealthy aristocrat by birth, had been trained in the tradition of the Academy, and had been accepted to exhibit in the Salon. Set apart from the Impressionists because of his interest in composition and his faithful concern for draftsmanship, Degas might have become one of the greatest portraitists of his day except that he only wanted to paint his close friends with whom he felt empathy.

The painter who was most typical of the whole Impressionist movement, and whose work provided its name, was Claude Monet (1840–1926). Monet was totally absorbed with the changes he saw taking place in the world around him as a result of changing light. In fact, he once painted a series of fifteen views of the same haystack in different lights and at different times of the day. Following his enthusiasm for light, he watched the dancing patterns of sunlight on the water at dawn and created the controversial painting *Impression: Sunrise* (Plate 26), using broken color techniques. The brilliant light of the rising sun through the mist is painted with loose brush strokes which create vague forms, leaving it to the viewer's eye to blend the colors. As Monet continued to refine this technique, his work

became more and more absorbed with the effects of light, until he painted solid objects as if they were made up of only light and air. Saying he wished he had been born blind so that he could regain his sight and paint objects without knowing what they were, he painted forms which became hazy and disappeared into mists of color. Monet painted hundreds of studies of the water and water lilies in a pool in the garden of his home, for he was fascinated by the shimmering surface of the water and the light on the shiny leaves and delicate blossoms of the plants (Plate 27). In his last paintings of water lilies, which he worked on not long before his death, the shapes have become almost completely abstract, and indeed, these paintings were later greatly admired by the Abstract Expressionist painters of the 1950s like Jackson Pollock (Plate 2).

A typically Impressionist painting, *Boulevard des Italiens* (Figure 1-18) by Camille Pissarro (1830–1903), illustrates a busy Paris scene permanently captured on canvas. Because the traditional academic style of the Salon was based on an orderly, rational ''real'' world in which the accidental was eliminated, they rejected this painting. Reality, according to the Academy, was achieved in a painting through the careful rearrangement and simplification of nature. But Pissarro, who was influenced by the unusual perspectives in Japanese prints, saw reality in a bird's-eye view of the boulevard from his rooftop room. And because he had made no attempt to add, subtract, or to organize that view, his painting was rejected.

The critics condemned *Boulevard des Italiens* as having no center of interest, no foreground, no middleground, no

background, no preordained path through which the eye travels. Instead they saw the painting as a glimpse of life without organization, in which one could actually see the strokes of color applied by the artist. Looking at this painting today, we find it difficult to imagine that people once found it shocking, but we must remember that we have become used to the Impressionist way of looking at the world.

Like the other Impressionists, Pissarro took his canvas outdoors and painted in natural light rather than in the artificial light of the studio. Before this time it had been the traditional practice to make only sketches and notes outdoors and to finish the painting inside on a canvas that had been carefully prepared with colored undercoating. Painting outdoors was considered iconoclastic and outrageous, certainly not the method of well-trained and dedicated academic artists.

A consistent exhibitor in the official Salon, Berthe Morisot (1841–1895) was also an important figure in the Impressionist group. She began early to experiment with the technique of capturing fleeting impressions, and her portrait of a young woman, with its sketchy spontaneous brush strokes, shows many characteristics of Monet's later paintings. Dedicated to the Impressionist style, Morisot continued to paint in it after many of the original group had abandoned it and worked hard to keep the group functioning.

Another painter who worked outdoors, Auguste Renoir (1841–1919) was first apprenticed as a china painter, copying Rococo paintings and decorative flowers onto plates and tea cups. All through his life he loved color, flowers, beautiful women, and

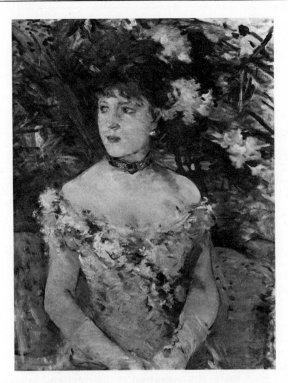

13-14 Berthe Morisot. *Young Woman with a Ball Dress.* Cliché des Musées Nationaux.

charming children, and he sincerely wished to make himself and his fellow humans happy with his paintings. His paintings of women and children are all rather similar, as if he would not undertake a portrait commission from anyone he found unattractive. His commissioned portraits do show some variations in the sitters' characteristics, but the paintings show them all as beautiful.

All the main characteristics of Impressionism can be seen in Renoir's *Le Moulin de la Galette,* a painting of a Parisian outdoor dance hall (Plate 28). It shows us an informal scene rather than a stilted posed composition, breaking up the color and light and emphasizing the vertical and horizontal shapes so that our eyes stay on the surface of the painting. Although some distance has been represented in the canvas, great depth in space was not important to Renoir, and our eye is stopped by the horizontal lines of the pavilion in the background. Compare this shallow space with the deep effects of space in a Renaissance painting like *The Last Supper* (Figure 11-11). In spite of his dedication to Impressionism, Renior, like Degas, was concerned with composition in his paintings, and his later canvases, especially the ones of bathers, were influenced by Venetian painters like Titian (Figure 12-1).

The youngest of the Impressionists, Mary Cassatt (1845–1926) had gone to study in Europe after a comfortable childhood in a rich Philadelphia family and an academic art training at the Pennsylvania Academy. Along with Degas, whom she greatly admired, she was influenced by Japanese prints, and many of her etchings reveal that influence which she absorbed into her own style. Although she is best known for her sensitive paintings of mothers and children, it is in her etchings and aquatints that she is most original and free.

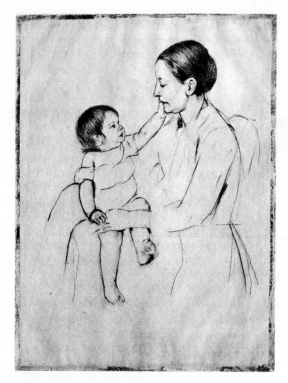

13-15 Mary Cassatt. *The Caress.* 1891. Dry-point. The Metropolitan Museum of Art. Gift of Arthur Sachs, 1916.

The Spread of Impressionist Ideas As we have seen, Impressionism began modestly with a group of painters who took their canvases outdoors to the woods outside Paris to paint natural light effects. This new style of painting, however, soon spread to many parts of the world and greatly influenced future painters as well as artists working in other media.

The newly discovered Japanese art also continued to influence painters throughout the nineteenth century. For example, the expatriate American James McNeill Whistler (1834–1903) used Japanese simplification of shapes and subtle colors in his own way. Rather than paint in the brilliant colors used by his Impressionist friends, Whistler used muted grays and subtle harmonies with only touches of gold and red. He called his paintings "nocturnes," "symphonies," and "arrangements" to emphasize his belief in the importance of the abstract qualities of painting. As compared with painters like Pissarro and Monet, who painted the momentary light effects they saw before them, Whistler believed that "Nature contains the elements, in colour and form, of all pictures, as the keyboard contains the notes of all music. But the artist is born to pick, and choose, and group with science, these elements, that the result may be beautiful." Form and color rather than subject matter were what he considered important, and he called his famous portrait of his mother *Arrangement in Black and Gray* because he saw no reason why the public should be interested in the identity of the sitter. This concept of Whistler's of a painting as an arrangement of color, value, and shape was to have an important influence on later painters and on the development of abstract painting in the twentieth century.

Applied Arts

Following the Industrial Revolution, men like critic John Ruskin and painter and designer William Morris campaigned for a new attitude toward art and the crafts. Attempting to

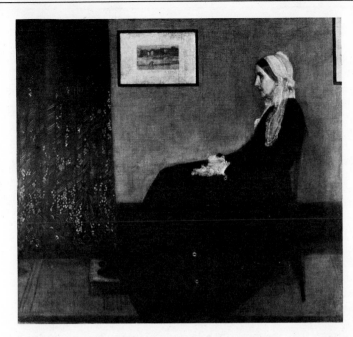

13-16 James Whistler. *Arrangement in Black and Gray: The Artist's Mother.* 1871. Canvas. 57″ x 64½″. Cliché des Musées Nationaux.

restore the traditional skills of the Medieval guilds, they turned with renewed interest to stained glass, decorative wall paintings, and handcrafts. The group called themselves Pre-Raphaelites because of their return to the art created before the Italian Renaissance. William Morris, a writer and social reformer as well as a designer, was a Romantic in his desire to return to the Medieval, but with a competent knowledge of craft, he started an important revival of interest in handmade ceramics, jewelry, weaving, and book printing. Genuinely appalled at the ugliness of the pompous furniture and household implements exhibited at the Crystal Palace in 1851, Morris designed simple furniture, like his famous Morris chair, in an attempt to

simplify furniture and make it more functional. Although his designs for wallpaper, fabrics, and glassware were modeled on earlier art, Morris was forward looking in his idea that the useful object should respect the material from which it is made and be designed for use. In fact, his campaign for better industrial design and more respect for material bore fruit later in the twentieth century when designers at Germany's Bauhaus school applied the principles of simple, functional design to industrial art.

Architecture

In the eighteenth and nineteenth century, architecture, like furniture, was based on older styles. After a classic revival which produced buildings like Thomas Jefferson's home, Monticello, came a Gothic revival. After another period, called Eclectic, in which every conceivable type of architecture from Romanesque to Assyrian was imitated, architects at the end of the nineteenth century finally began to follow the lead of Joseph Paxton's innovative Crystal Palace (Figure 3-14) and make use of the structural knowledge developed by engineers in bridges, railway stations, lighthouses, and monuments like the Eiffel Tower in Paris. Indeed, these engineers had expressed the real architectural strength of the period as opposed to the copyists who built banks, stock exchanges, and government buildings patterned on Greek temples. The pioneer American architect, Louis Sullivan (Figure 3-16), after an early period of designing buildings in historical styles, used the new industrial structural methods in his architectural designs, leading the way to the completely new forms in building which would appear in the early twentieth century.

Sculpture

The accepted academic sculpture at this time consisted of static Neoclassic copies, and Auguste Rodin (1840–1917) was one of the few sculptors with any new creative ideas (Figure 4-9). Born in a working-class quarter of Paris, Rodin earned his living as a young man as a goldsmith and made plaster decorations for buildings, but he visited Italy and was influenced by the sculpture of Donatello and Michelangelo (Figure 4-1). Fascinated by the human body in action, he made quick drawings and clay sketches of dancers to catch their momentary poses with a minimum of lines. In his studio he kept several models constantly moving around, and if he saw a pose he liked, he quickly modeled it in clay. In this way he became completely familiar with movements of the nude human body, using natural poses instead of the stiff poses of the Academy. Rodin's rather Romantic figures are often carved or modeled with rough surfaces in such a way that the solid stone or bronze appears like living flesh. The influence of Impressionism on his sculpture can be seen in the way the light plays over his material, catching the texture so that the surface seems to vibrate. He himself called sculpture "quite simply the art of depression and protuberance."

13-17 Thomas Jefferson. Monticello. 1770-84; 1796-1806. Charlottesville, Virginia. Thomas Jefferson Memorial Foundation.

Postimpressionism

The term *Postimpressionism* is a convenient label used to describe the work of several painters who left their Impressionist beginnings to explore new and revolutionary ways of painting. Their individual styles are so different from each other that all they have in common is this shared attitude of exploration. They lived at the same time as did the Impressionists and were friends with them, but their work gradually developed along different lines. The fact that many of the Postimpressionist artists died before Degas, Monet, or Renoir makes the name confusing, but, like all labels, this one is merely a convenience.

One of the most important Postimpressionists was Paul Cézanne (1839–1906), who exhibited in early Impressionist shows. But he did not agree completely with the aesthetic theories of his friends. He felt their paintings were brilliant in rendering of natural light and color, but lacked clarity and order, and said he wished "to make of Impressionism something solid and durable like the art of the museums." To accomplish this, he brought formal order to his paintings through the use of triangular, horizontal, and vertical shapes and other classic devices of composition. To further his knowledge, he studied the painting of the past, stating that a museum is "the book in which we learn to read." Cézanne very early discarded the idea of capturing transient light effects, and his paintings, although colorful, are made up of forms which exist in a quiet, timeless light rather than in the glancing sunlight of Monet or Renoir. In order to develop solidity in his paintings, Cézanne modeled his masses in a series of planes of color. This revolutionary new method made him one of the most innovative painters of the nineteenth century and led directly to the art of the twentieth-century Cubists. "Treat Nature by the cylinder, the sphere, the cone," he wrote, applying this to his painting by breaking down the most complex objects into almost geometric forms. In his later paintings Cézanne broke masses down into even smaller planes of color, using warm colors like yellow and orange to bring planes forward and cool blues, violets, and greens to push them away from the viewer. He also distorted perspective and shapes to achieve the composition he wanted, not bothering about realistic appearances. Deliberate and careful, he painted the Mountain of St. Victoire near his home in the south of France over and over, gradually abstracting the familiar view. The forms of mountain, valley, trees, and houses in his later paintings of the mountain are no longer treated as recognizable objects but become simply planes of color.

Thus Cézanne, although he lived and worked in the nineteenth century, was one of the first painters of the modern period, and from him we can move easily into the twentieth century and the iconoclastic art of its early years. We have only to compare the *Mt. St. Victoire* with an earlier landscape by Constable (Figure 13-6) and with a later painting by Cubist Georges Braque (Figure 15-4) to see how important Cézanne was as a bridge between the old and new ways of looking at the world. Without the influence of Cézanne's experiments, the early twentieth-century revolution in art could not have taken place.

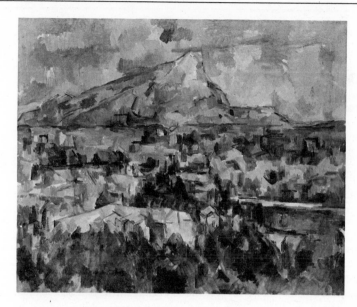

13-18 Paul Cézanne. *Mont Sainte Victoire*. 1904-06. Oil on canvas. 27⅞″ x 36⅛″. Philadelphia Museum of Art, The George W. Elkins Collection.

While Cézanne searched for new ways of painting, another artist, Georges Seurat (1851–1891), was also trying to develop more ordered compositions than those of the Impressionists. Seurat extended their idea of broken color, painting with meticulously placed dots of complementary color (Plate 29). He followed scientific theories of light and color to separate the colors, trying to analyze the exact amounts of each complementary color needed to make up a new secondary color, then dabbed the colors side by side on the canvas letting the eye blend them. But Seurat was also concerned with the silhouettes of objects, simplifying them into simple geometric shapes. He assembled his figures into large compositions which, despite the vibrations of the color, appear static because of the quiet shapes and poses. It was this simplification of form and his strong composition, even more than his use of broken color, that makes Seurat historically important.

A young, enthusiastic Dutchman, painting in the blazing sunlight of southern France, also searched for new color techniques. But, unlike Cézanne and Seurat, who used color to define planes in space and silhouettes of shapes, Vincent van Gogh (1853–1890) used color to express his very personal emotional response to the world. Van Gogh was deeply emotional and religious, concerned about his fellow man. Indeed, at the beginning of his painting career he had lived with coal miners and had painted their poverty in dark depressing colors. He had also hoped, with the help of his brother, to establish a community of artists dedicated to spiritual

values in a rebellion against the commercialism and materialism of the Industrial Revolution. However, his first adherent, painter Paul Gauguin, found their friendship disastrous and departed shortly thereafter for the South Seas.

In a frenzy of creation, van Gogh painted the grandeur of nature (Figure 1-5) and the simple objects which surrounded him. Primarily concerned with his personal response to these objects and with the expression of his emotions about them, he used color to intensify the mood. Van Gogh's painting of his bedroom (Plate 30) shows how strongly color can affect us. He wrote about this bedroom:

> I had a new idea in my head and here is the sketch to it . . . this time it's just simply my bedroom, only here colour is everything.

Like so many nineteenth-century painters influenced by the Japanese prints, van Gogh, like Cézanne, was unconcerned with traditional perspective. However, his interest was not so much portraying the eternal form of objects like Cézanne, but rather in expressing his own emotional responses to objects. While Cézanne, despite his new use of color and perspective, painted form in a classic manner, van Gogh, on the other hand, saw the outer world in deeply personal terms which he expressed with strong slashing brush strokes and brilliant color. In this he was a forerunner of the twentieth-century style called *Expressionism*.

Distrustful of conventions in art and impatient with academic technical skills, Paul Gauguin (1848–1903) was just as romantic as van Gogh and escaped from the harsh realities of the industrial society to an island in the South Seas. There Gauguin sought the

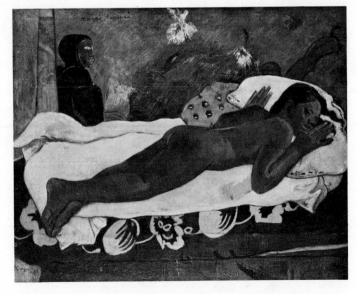

13-19 Paul Gauguin. *The Spirit of the Dead Watching.* 1892. Oil on canvas. 28¾″ x 36¼″. Albright-Knox Art Gallery, Buffalo, New York; A. Conger Goodyear Collection.

simplification of reality which he believed could only exist where life was stripped to its essentials. Artists like Gauguin were often attracted to such remote cultures, where they could lose themselves and avoid their problems. We, as viewers of their work, are also momentarily taken out of our daily lives. In *Spirit of the Dead Watching,* we can vicariously experience a simple life-style in an exotic setting. The drama is heightened for us by a juxtaposition of tropical flowers with the dark figure from the spirit world. Like many of his contemporaries, Gauguin was influenced by Japanese prints, and he also studied the art of native craftsmen of the islands where he went to live. He developed a decorative way of painting which made use of flat areas of pure, often unrealistic, color. Gauguin believed that the Impressionists used color without freedom, shackled by the needs of reality and probability. The outlines of figures and objects are simplified in Gauguin's works, making them appear decorative and symbolic. He believed that a painter should study the silhouette of every object—as he saw it—for distinctness of outline comes from knowledge and lack of hesitation. Aside from their own merit, Gauguin's paintings are important for their influence on later Expressionists and a group of painters who called themselves the Fauves.

We have seen that following the rebellions and innovations of the eighteenth and early nineteenth century, artists rejected the Renaissance concepts of deep space and formal composition, and Cézanne's experiments at the end of the nineteenth century led directly to the Cubist method of depicting form. So, also, the emotional expressiveness of van Gogh developed into Expressionism, while Gauguin's color influenced the Fauves. In this way, the end of the nineteenth century marked a turning point in the direction which art would take in the modern Western world.

Art in the Non-Western World

The society of the masks is the
whole world; and when it bursts out in
some public place it dances the march
of the world, it dances the
system of the world.

Ogotommête

Today we live in a world in which instant communication between places thousands of miles apart is an accepted fact. The peoples of other cultures are not as remote as before —we can touch their lives and let them touch ours. One way of touching is by experiencing the art of cultures other than our own. Through photographs, films, television, and museums we can see and enjoy art from all ages and from all over the world.

Although this book primarily is concerned with the direct heritage and development of Western art, we will also take a brief look at what can roughly be called non-Western art. Although many differences exist in images of different cultures because of varying geographical, social, and religious backgrounds, the visual arts of all humans— whether Western or non-Western—speak to us across time and space. A familiarity with non-Western art is important to us because from the late nineteenth century onward, Western artists have been influenced by many cultures.

We could study each of these cultures for years, but in our limited space we can only glimpse a faint suggestion of the excitement of their arts. Other books listed in the bibliography, together with reproductions of

artworks, will help you explore further.

Human life may well have begun in Africa, for the oldest human skeletal remains that have ever been found came from Southern Rhodesia. Three times the size of the United States, with more than 700 sublanguages, Africa has produced numerous art styles. Centuries before Europeans invaded the African continent, art was a vital part of every phase of living. Useful objects were enriched with decoration, and sculpture was an important aspect of rituals and ceremonies.

African societies similar to those of the historical past still can be found today. They are based on family units, which in turn are part of clans united by blood ties through the female. These clans combine to form villages and are bound together into nations, with heads of government at the top. Thus, villagers are united by family ties, and all join together in devotion to their ancestors.

Some of these ancestors painted animated murals on rocks in the Tassili region of the Sahara around 10,000 B.C. These paintings include lively scenes of hunters and their game, as well as illustrations of African myths. One painting shows a creation myth, in which the first man mates with the morning

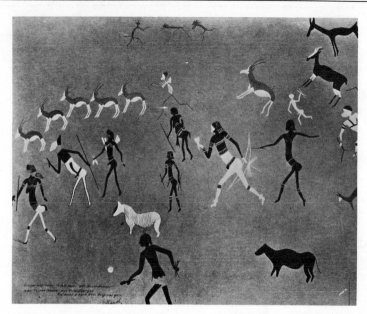

14-1 *The White Lady of Brandberg.* Cave painting. South African Information Service.

and evening stars to produce all the creatures of the earth.

Today, nonurban Africans still live much as did these early painters in agricultural or hunting communities, cultivating their crops for the common welfare and believing in an animistic religion. They think of the world around them as inhabited by souls and spirits whose forces must be approached and, hopefully, mastered. The natural forces of life —the sun, rain, abundant crops, and human fertility—and of death are very real, and African art expresses human responses to these forces with great emotion and vitality. Some of the art objects, such as masks, costumes, wands, and headpieces like this antelope, were used in ceremonies held by secret organizations, so our knowledge of their ritual use is scanty. The split between art and day-to-day life, which developed in Europe with the Industrial Revolution, did not exist in traditional Africa. There, art permeated all of life. Utensils, houses, and furnishings have always been decorated with color and carving; even the human body is enhanced with color.

In African art the expression of an emotional response to the world is more important than the duplication of nature. In fact, these artists always considered reality in art an infringement on the powers that belong to the gods. Instead, the characteristic shapes of humans, animals, or imagined spirits are emphasized and

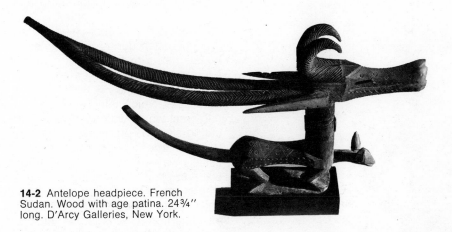

14-2 Antelope headpiece. French Sudan. Wood with age patina. 24¾" long. D'Arcy Galleries, New York.

exaggerated, sometimes so strongly as to be startling to our eyes. This explains why African art appealed to the Western artists who rebelled against realistic art at the beginning of the twentieth century. But, whereas Western artists used distortion and exaggeration to express their personal emotions, the traditional Africans were concerned with the ritual use of the art object and the passing on of ritual from one generation to another.

Sculpture The human figure has been a constant source of inspiration in African art. Sculptured figures, usually carved from wood, range in size from six feet tall to three inches tall. These figures are usually left uncolored or are painted solid red or black, although some contemporary Yoruban art from Nigeria and some Congo sculptures are painted with many colors. These male and

female figures were carved for use in ancestor rites, as commemorative statues, or as mendicant figures (Figure 1-16). In the last use, the bowl was designed to hold contributions to be given to a family deprived of some of its working members. Carved from tree trunks, most of these sculptured figures were status symbols which were commissioned by the well-to-do in each community. In some areas, in addition to wooden figures, wealthy rulers commissioned metal sculpture, which was cast in bronze or brass as early as the fifth century A.D.

Some of the sculptures are fetish figures which were designed both to contact the powers of the gods for help and to ward off evil spirits. For example, in this fetish each nail represents an attempt to reach a god. If there had been no rain for weeks, a priest might drive a nail into the figure to attract the power of the rain. Or if someone were ill, a fetish would be used to contact a spirit's help

shells. Stools were important to Africans, and in some regions the people believed that each person's soul occupied the stool he had cherished during his lifetime. The Ashanti people had a myth about a golden stool that fell miraculously from heaven and brought them good fortune.

Another typical African art object is this neck rest which was used as a head support during sleep to protect the user's elaborate hairstyle. The decoration on these rests usually was geometric and differed from place to place. Communities varied widely in their styles of decoration, and often certain objects were unique to a certain area. An example from Ghana is the unusual disklike head of the Ashanti fertility figure, which was worn by young girls as a charm to insure a good marriage and many children.

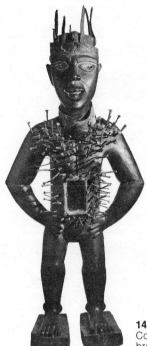

14-3 Nail fetish. Belgian Congo. Wood with dark brown patina. 32¼″ high. D'Arcy Galleries, New York.

in effecting a cure. An unsuccessful fetish would not be used often; consequently it would have few nails and would soon be discarded.

Generally, African sculpture, masks, ceremonial stools, neck rests, costumes, and guardian figures were ornamented with paint, carving, or materials such as feathers, shells, beads, hair, fiber, and stones. Typically, this wooden stool from the Cameroon was decorated with glass beads and cowrie

14-4 Stool. Twentieth century. Cameroon, Africa. Wood, glass beads, cowrie shells, burlap, cotton cloth. 19⅛″ high. Courtesy of The Museum of Primitive Art, New York. Photo by Charles Uht.

14-5 Headrest. Ethiopia. Wood. 7″ high. Segy Gallery for African Art, New York.

usually was decorated with paint or with costumes of feathers or animal skins, or was covered with robes or suits of woven vegetable fibers. Symbolically representing a particular god or spirit, these masked ritual dancers often felt themselves to be psychologically identified with the power of

Masks In Africa, dance was a ceremonial art, and the elaborate masks, costumes, and wands used during the dances were designed to heighten the emotional effect on the spectator, as well as to draw power from the spirits. Many of these masks also emphasized the strong emotional ties that existed between human beings and the world of animals and natural forces. Some masks were made to fit on top of the head, others to cover only the face, and still others to fit entirely over the head and shoulders. In addition, the body of the masked dancer

14-6 Akua'ba statue. Ghana. Wood. 11″ high. Segy Gallery for African Art, New York.

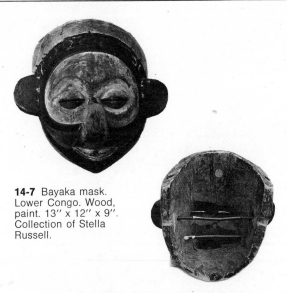

14-7 Bayaka mask. Lower Congo. Wood, paint. 13″ x 12″ x 9″. Collection of Stella Russell.

the spirit. And, in turn, they were identified as that spirit by the community. This use of masks for identification was common in Greek drama and also in the dances of the North American Indians.

To make it easier for the dancers to keep the masks on, often they were made with a bar across the back which the wearer could hold in his teeth. Some of these dance masks were designed to celebrate the human rites of passage through life—particularly birth, marriage, and death. Since ancestor worship was strong in African cultures, death was a constant preoccupation, and the masks reflected its importance. Thus, a white mask might be worn in a dance to attract the power of the ancestral spirits, because the color white symbolized dead flesh.

Realistic Art In Nigeria, the ancient Benin tradition favored realistic art, and cast metal sculpture was common. This Benin ivory miniature, dating from around A.D. 1400, was found during tin-mining activities there. If you look closely, you will see tiny heads of Portuguese soldiers in the scalloped beard and headdress. Thus, with typical wit and inventiveness, the African artist used the Portuguese invasion of the fifteenth century as a source for art, expressing his feelings about the European invasion of his homeland.

14-8 Belt mask. c. 1400. Nigeria. Ivory. 9⅜″ high. Courtesy of The Museum of Primitive Art, New York. Photo by Charles Uht.

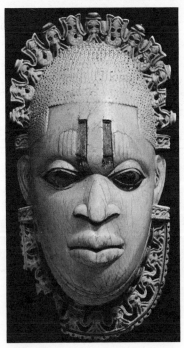

African Influences on Twentieth-Century Art　African sculpture and masks were brought to Europe by traders and were discovered around 1900 by artists like Picasso, Braque, and Léger who found the expressive abstraction of human and natural forms exciting and inspiring. This exaggeration of forms, which was such an important element of African art, has continued for decades to be a significant influence on both European and Afro-American art (Figure 4-14).

Also influenced by African sculpture, the Italian artist Modigliani in the 1920s deliberately abstracted and elongated the shapes in his stone sculpture. The first

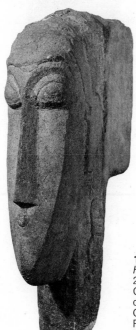

14-9 Amedeo Modigliani. *Head*. c. 1915. Limestone. 22¼″ x 5″ x 14¾″. Collection, The Museum of Modern Art, New York. Gift of Abby Aldrich Rockefeller in memory of Mrs. Cornelius J. Sullivan.

phases of Cubism and other twentieth-century styles were also influenced by the simplified forms of African art. For example, some of the distortions and abstractions in Picasso's famous and influential painting *Demoiselles d'Avignon* (Plate 31) certainly were inspired by African sculpture. Compare the face of the mendicant figure (Figure 1-16) with some of the faces in the Picasso painting.

Oceania

We now move to another group of cultures that developed on the Pacific islands of Melanesia, Polynesia, Micronesia, and Australia. This whole region is called Oceania. Although each island has a distinctly separate culture, some customs, myths, and physical characteristics are common to all. Similarities in races, economic conditions, and the cult of ancestor worship can be found throughout. Most of the Oceanic races appear to have come originally from the mainland of Asia, with the constant travel by early humans from island to island blending their racial and cultural inheritances. Agriculture and fishing traditionally were the main means of livelihood. Wood was plentiful and therefore was the most common building material. Most tools and war implements were also made of wood, often with blades of shell or stone.

Many of the art objects of Oceania reflect the frequent wars that occurred between the different island communities. For example, this Marquesan club, whose top suggests a human head, was standard equipment in a culture where many tribes were cannibalistic.

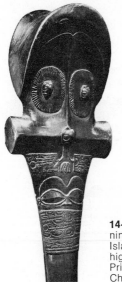

14-10 Staff club (detail). Early nineteenth century. Marquesas Islands, Polynesia. Wood. 60¼″ high. Courtesy of The Museum of Primitive Art, New York. Photo by Charles Uht.

In these islands, cannibalism had ritual purposes and was practiced as a symbolic means of assuming the enemy's power. War shields with carved spiral patterns and animal and human images also were common in Oceania. Expressive carving of the kind seen on this shield from New Guinea, and on the Marquesan club, was typical of the area.

A significant part of Oceanic culture was involved with the elaborate religious ceremonies which stimulated creativity in all areas of artistic expression. For example, ornate houses were built to serve as ceremonial centers for the rituals that

surrounded the cult of ancestor worship, as well as for the rituals for the dead (Figure 3-1). These houses, also used as council houses and as social centers for the men of the community, usually were constructed through group effort. The traditional men's house, with its carved exterior and ceremonial carvings and religious objects inside, was a memorial to ancestors in the same way that a Gothic cathedral was totally dedicated to God. Combining architecture

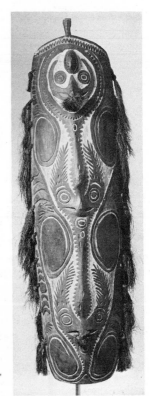

14-11 Shield. Early twentieth century. Sepik River, New Guinea. Wood, paint, dried leaves. 5′4″ high. Courtesy of The Museum of Primitive Art, New York. Photo by Charles Uht.

and painting in one artwork, these houses required months of planning and labor to build, much of which was carried on in secret, sometimes within a walled enclosure. Decorative images representing mythological ancestors were carved on the exterior and interior of the building. Important ritual objects used in the ceremonies for the dead were kept inside where they could be viewed only by the initiated. Because women and children were uninitiated, they were not allowed in or near a man's house. If this law were violated, the house had to be destroyed.

Much of Oceanic art was made to be used in action, so we must try to visualize the art in use—masks moving with the rhythms of ceremonial dancers or weapons and boats in action. The Oceanic artists were influenced in their creative expression by their natural surroundings, and their art echoed the waves of the sea and the tangles of jungle vegetation.

Because of the important ritual function of these objects, the Oceanic artist enjoyed a special professional status in the community. In fact, in Polynesia there is a single word, *tahunga,* which is used for both priest and craftsman.

The well-known heads on Easter Island, made from volcanic tufa stone brought from another part of Oceania, are an exception to the liveliness of expression found in most Oceanic art. These sculptures, whose monotonous and brooding style is unique, apparently are the remains of a vanished and forgotten culture. Indeed, when the island was discovered on Easter Sunday by nineteenth-century missionaries, the island community could reveal little about the heads or why they were there.

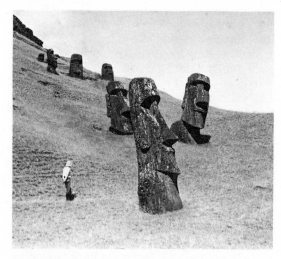

14-12 Images outside the crater of Rano Raraku, Easter Island. Courtesy of the American Museum of Natural History.

America—North and South

Although our indigenous American cultures have existed for thousands of years, it is believed that in prehistoric times nomads from Asia crossed the Bering Strait into what is now Alaska and spread from there throughout most of North, Central, and South America. Although they apparently had a common ancestry, the separate culture of the New World Indians developed different community organizations, religions, and art. Undoubtedly climate and natural surroundings were the most significant influences on these cultures, causing differing life-styles to develop.

For example, the Eskimos of the northwest part of North America lived by hunting and

fishing, moving from one area to another with the seasons or with the movement of game. Their lives were dominated by the harsh climate and by the animals and fish on which they depended for survival. Because of this, their utensils and masks were carved from driftwood, while bone, ivory, and stone were used for sculpture and other art objects.

In contrast to the Eskimo culture, the Northwest Coast Indians who lived on the mainland and the coastal islands lived more settled lives. Generally they lived along inlets or rivers and because of this developed an elaborate fishing technology, with wild plants and berries supplementing their diet. The fish and vegetation, which were dried and smoked to preserve them for the upcoming winter, provided the Indians with an abundant supply of food. Thus they had leisure time in which to carve boats, furnishings, and masks —time which doesn't exist when life is a constant battle for survival.

Many groups of peoples lived along the Pacific Northwest coast, and each group was divided into clans and families. Each family had a set of songs, myths, legends, and names. When a particular animal—such as a shark, a killer whale, or a hawk—became associated with a family, that family owned the animal and only they were allowed to display it on their possessions. Tree trunks were carved in the shapes of these family animal crests, and the resulting tall sculpture told the story of a family in visual form— somewhat like a family tree that described the lineage of its members.

Although the images on the carved poles, weapons, and furnishings might be simplified or abstracted, they never lost the vitality of

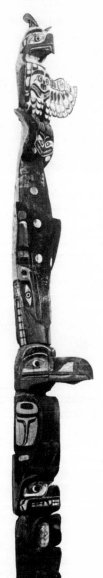

14-13 Totem pole. Early twentieth century. Vancouver Island, British Columbia. Photo courtesy of The Museum of the American Indian, Heye Foundation.

the original animal, be it beaver, raven, or bear. Advanced woodworking skill was also displayed in the dugout canoes, so important to the whaling and fishing economy. These canoes, made from tall straight trees which were felled and shaped with stone tools, sometimes were decorated with carved figures. These figures might be protective effigies like this Tlingit canoe prow, which represents the Land Otter Man who rescues drowning people and transforms them into land otters. The sculpture is decorated with human hair and shells. Today a few Northwest Indians still carve sculpture and utensils, but most of these woodworking arts are dying out.

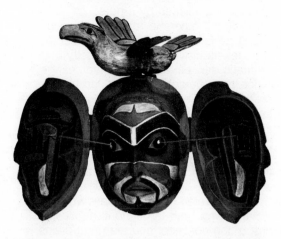

14-15 Double mechanical mask with sea gull on top. 1850-75. Vancouver Island, British Columbia. 21½″ high. Photo courtesy of The Museum of the American Indian, Heye Foundation.

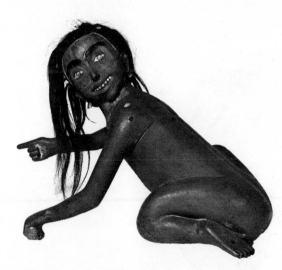

14-14 Canoe prow effigy. 1825-75. Alaska. Human hair, abalone shell inlay, opercula teeth. 14″ x 21″. Photo courtesy The Museum of the American Indian, Heye Foundation.

The carved and painted masks that were used for ceremonial performances and dances often illustrated the legends that were being enacted in the dance. Some were elaborate contraptions of masks within masks; others had moving parts that made noises. During a dance, the wearer could expose several images one after the other by pulling the strings that operated the hinges. Most of these costumes and masks were designed to be seen at night by the light of a flickering fire, which heightened their effectiveness and the drama of the ceremony.

One ceremony, which was distinctive to this area, was the potlatch ceremony. In it, food, drink, and gifts of woven blankets, tools, and utensils were offered to

neighboring villages by a person of rank, who wanted others to recognize his status. The large ladle (Figure 7-2) was used for such feasts. It was a time for poetry, dramatic dances, and social interchange. Since each person tried to outdo his predecessors by giving more and better gifts, the economy of the whole village was affected, and eventually the ceremony was discontinued for this reason. However, potlatch poetry and myth are preserved in the writings of some contemporary Indian writers.

Other diverse groups of New World Indians, who lived throughout the western part of the continent and the great plains, relied mainly on hunting, fishing, berry and seed gathering, and some cultivation of maize for their livelihood. These Indians wove baskets with delicate craftsmanship. Intricate

geometric patterns using straight and diagonal lines were typical of the decoration of these woven objects. This kind of decoration developed in basketry because the interlacing of the fibers makes it difficult to produce curved designs.

In the southwestern parts of the United States, settled agricultural communities that depended on irrigation for the cultivation of maize were established close to 2,000 years ago. These communities, called *pueblos* by the Spanish colonists, housed large numbers of people in cliff dwellings or in free-standing adobe buildings (Figure 3-4). These houses were built on mesas, against cliffs, or near the fertile riverside fields farmed by the inhabitants. Many of the people living in this region today continue the communal life-style of their ancestors. An important part of their

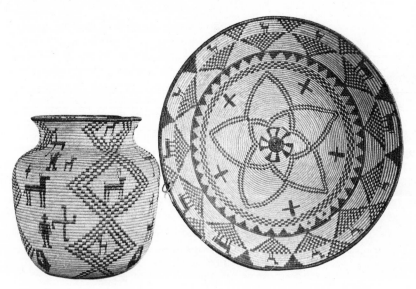

14-16 Apache baskets. Courtesy of the American Museum of Natural History.

culture centers around underground *kivas,* or sacred rooms. Used by the men for ritual purposes, the kivas symbolize the underworld, from which legend says their ancestors once came and to which they believe they will return. Part of the ritual performed in a kiva includes the creation of sacred designs in sand paintings on the floor. These intricate symbolic designs are formed by pouring different colors of sand onto the ground until the image is formed; when the ceremony is concluded, the painting is destroyed.

In these communities the women still weave on simple looms, incorporating intricate traditional designs into rugs and blankets, using wool which is hand-dyed with vegetable colors. Each community produces its own distinctive style of pottery, such as the black polished pots made by Maria of San Ildefonso. Their smooth surface is produced by painstaking polishing of the slightly moist clay with a smooth stone. The black color is achieved by the ancient method of firing in an outdoor kiln whose fire is smothered with cow manure to reduce the oxygen. Other communities in the Southwest create distinctive red pottery with intricate black and white geometric designs painted on it.

When we think of the art forms of the Indians of the American Southwest, probably their silver and turquoise jewelry first comes to mind. Today there are many Indian craftsmen who create jewelry which retains the traditional forms, while others use their artistry to create new designs based on the natural environment around them.

14-17 Navajo blanket. 1840-60. Raveled bayeta and native, handspun wool. 52″ x 71″. The Southwest Museum.

Mesoamerica Moving south into Mexico and Central America, we find that many complex cultures with certain shared similarities developed there between the sixth century B.C. and the sixteenth century A.D. This entire area usually is referred to as Mesoamerica. The similarities of these cultures suggest that they derived from a common racial stock with shared social and religious traditions. Although definite proof has not been found, it is probable that their ancestors also came to the continent with the migrations that took place across the Bering Strait.

In all of these Mesoamerican cultures, religion controlled and directed the social, artistic, and economic life; religious architecture was monumental in scale. Ritual human sacrifice was practiced everywhere, and the legend of Quetzalcoatl was diffused throughout the area. This feathered serpent was a symbol of the life force in Meso-american cultures. Called Kukulcan by the Mayans, Quetzalcoatl was represented by an image that combined the beautiful quetzal bird and the coatl serpent.

Other cultural similarities existed among the Mesoamerican societies. For example, most of these societies viewed the ball as a symbol for the sun and therefore built walled playing fields for ritual ball games. The Aztec and Mayan calendars also show a significant relationship in their methods of recording time.

In Mexico, fertility figures with details similar to those on Oriental artifacts have been found dating from as early as 1000 B.C., but the complex civilizations that developed throughout Mexico were most active from 500 B.C. to the Spanish conquest in 1520. Although they are all called pre-Columbian, these cultures vary in details from era to era and from place to place.

Since the climatic conditions in all of these regions were extreme, often the inhabitants must have been overwhelmed by the forces of nature. Because they believed these forces to be powerful gods, their religion was involved with appeasing them. For example, to encourage the sun to make his journey across the heavens, priests in some regions made a daily sacrifice of human blood. Similarly, they believed that the god of rain, whose waters were needed for crops, could be attracted by the tears of sacrificed children.

Architecture Mesoamerican architecture was not as concerned with enclosing space as it was with building monumental masses of masonry suitable for religious rituals. These huge pyramids, with temples on the top, were covered with ornate stone carvings and painted stucco ornaments. Animal figures—symbols of the gods—were common, but narrative paintings also existed showing processions of warriors and religious scenes.

Ruins of many of these elaborate religious centers have been discovered and restored. For example, not far from the present Mexico City, in the fertile Central Valley of Mexico, an ancient Indian people constructed a city covering more than twenty acres. This city, called Teotihuacán, was dedicated to the gods, and, as a center of religion for at least 600 years, it attracted the best craftsmen in sculpture, painting, and pottery. Even

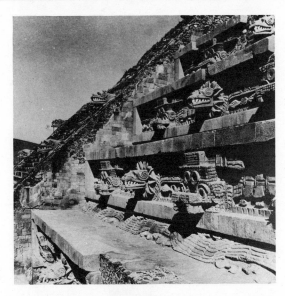

14-18 Temple of Quetzalcoatl. A.D. 300-700. Mexico. OAS.

bookmaking was an important craft, and much of the history of the Mexican cultures was chronicled in illustrated accordian-folded books called *codices.* Much of Teotihuacán still stands, with spacious plazas, tall pyramids, and decorated temples built primarily for the gods. The largest and most imposing building is this 250-foot-high Pyramid of the Sun. Although the priests and rulers may have lived inside this city, the ordinary people probably lived in simple houses surrounding it.

Many vigorous civilizations developed throughout Mesoamerica, all of which had similar maize-growing agricultural systems. The Toltec in the north, the Zapotec and Mixtec in the southwest, the Olmec in the east, and the Maya in the south all produced complex cultures and art. All of these Mesoamerican cultures had calendars based on cycles of 52 years, and complex time markers were set up on the pyramid steps to mark the time of their dedication, much as the cornerstones of buildings are dated today. Scholars have correlated the Mexican-Mayan calendar with ours, so that we are able to date their art and architecture within our own time sequence.

Many of these Mesoamerican cultures constructed temples and pyramids on the sites of previous buildings, and the history of their architecture can be followed by digging into successive layers of construction. As in many cultures throughout history, certain sites were believed to be sacred to a god or gods, and new generations did not wish to abandon the sacred sites. In fact, the Spanish conquerors took advantage of this tradition by building their churches over the ancient sites and by planning the Christian holy day celebrations to coincide with the ancient Indian festivals.

Sculpture and applied arts In addition to the carvings on buildings, small stone and clay figures of gods, animals, and humans abounded throughout the Mesoamerican cultures. These reflect a vivid sense of life which contrasts sharply with the cold, awesome gods and animal symbols on the temples and pyramids. Through them we can sense the ordinary life of the people—their joys and sorrows—and can come close to the human beings who shaped them. Beautifully designed jewelry of gold and ritual implements of stone inlaid with turquoise also

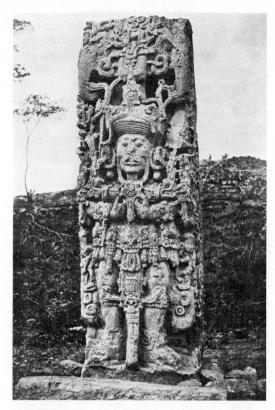

14-19 Stela. Honduras. Courtesy of the American Museum of Natural History.

14-20 Figurine. 800-300 B.C. Mexico. Clay. 3¾" high. Dumbarton Oaks, Washington, D.C.; The Robert Woods Bliss Collection of Pre-Columbian Art.

attest to the high standards of craftsmanship in all these cultures. In addition, elaborate costumes were important for the religious rituals. The priests usually wore elaborate headdresses and cloaks made of feathers during religious ceremonies.

The Aztec civilization is perhaps the best known of these Mesoamerican cultures because of the dramatic tale of its conquest by the Spaniards. The Aztecs were a warlike people who were in constant battle with the civilizations surrounding them. Their art

14-21 Coatlicue (goddess of earth and death). Fifteenth century. Aztec. Basalt. 8′3″ high. National Museum, Mexico City.

reflects their belief in the perpetuation of human life through human sacrifice. Ritualistic skull-shaped masks inlaid with turquoise, images of eagles carrying human hearts, and symbols of blood all are recurrent in Aztec art. Typical of the preoccupation with sacrificial death, the skirt of this Aztec earth goddess is made up of intertwined hearts and skulls. Her head consists of two confronting serpents, her skirt is a series of serpent shapes, and just below her head hangs a necklace of hands and hearts, with a skull as a pendant.

South America

Further south in pre-Columbian South America, the Inca, Tiahuanaco, Chimu, and Mochica cultures built complex cities with buildings that were constructed of sun-dried brick or stone. One such city was Macchu Picchu, located high in the Andes, where the people constructed elaborate structures out of massive stones and surrounded them with large plazas and ritual ball courts (Figure 3-3). In these cultures the crafts were highly developed, and pottery, weaving, and gold and silver work set with semiprecious stones reached a highly sophisticated level. The potters made clay jars shaped like lively and humorous human and animal figures and decorated others with painted birds, animals, or fish. At the same time, their intricately woven and embroidered fabrics were colorful, with geometric patterns and designs of mythological demons and animals (Figure 7-7).

When the Spaniards arrived in the sixteenth century, the numerous Indian civilizations in Central and South America

14-22 Bottle effigies. c. 400 B.C. Peru. Clay. 7½″, 9¼″ high. Lowie Museum of Anthropology, University of California, Berkeley.

were disrupted and despoiled. However, after a period of domination by European traditions, later artists of Central and South America have become aware of the rich traditions and arts of their ancient cultures and have been influenced by them. Many of these artists now work close to the artistic mainstream of their ancestors, creating new interpretations of their ancient heritage.

India

We have seen in the art of other parts of the world that there has been constant intermingling and sharing of cultures as a result of migrations of peoples. India, China,

and Japan provide excellent examples of the changes that result from migration and invasion and the resulting spread of cultural and religious influences. Although we may be inclined to think that strict boundaries in time or place exist in styles of art, this is far from true. Throughout history people have been surprisingly mobile, even in prehistoric times. And as they have moved from place to place, ideas, religious beliefs, cultures, and artistic styles have changed and spread.

Although civilization existed in India as early as 3000 B.C., what we think of as typical Indian civilization began when northern Aryans invaded the area about 100 B.C. These Aryan invaders brought with them their own Vedic religion, with its worship of many gods believed to control all natural forces. There was Agni, the god of fire, and Indra, the god of lightning, and many more. Belief in these new gods spread and played an important part in the development of later Indian art and religion. Early Indian art drew its direct creative inspiration from this religion, as did the later religions— Brahmanism, Jainism, Hinduism, and Buddhism—that developed in India. One important element in all later Indian religions, which can be traced back to the Aryan influence, is the belief that all human beings are a part of nature and that all of nature is related. This belief in the unity of nature is seen in the Brahman concept of the reincarnation of the human soul. Both Brahmanism and Hinduism accept the physical life of humans as part of the life of the universe, reflecting the joys of the senses in the arts.

Buddhist Influences on Indian Art Around 560 B.C., when Prince Siddhartha, called the Enlightened One or the Buddha, left his family and possessions to live in poverty, he inspired the religion of Buddhism, which grew up around the worship of his saintly character. Perhaps for the first time in the history of the world religion was founded on saintliness rather than on fear. Buddhism rejected the physical nature of the earlier Brahman gods, preaching instead the renunciation of worldly pleasures as the way to reach Nirvana. These religious beliefs spread, causing monks throughout India to become beggars in symbolic identification with the saintly Buddha.

The early Buddhists developed a characteristic temple structure, called the *stupa* (Figure 3-13). These domed temples stand on square platforms, often with fences or walls around them. The design of these stone fences was obviously based on earlier wooden posts and beams, and gates were lavishly carved with scenes from the life of Buddha, as well as with animals, plants, and lesser deities all entwined in the ornate decoration.

Sculpture The earliest relief carvings depicting scenes from the Buddha's life never showed his figure, although occasionally his footsteps were carved. Large sculptured figures of the Buddha appeared only after his death. These Buddhist sculptures express the moral greatness of the man in various ways. Usually he is seen in meditation, his gentle smile suggesting saintliness. Symbolically his long ear lobes show how attentively he

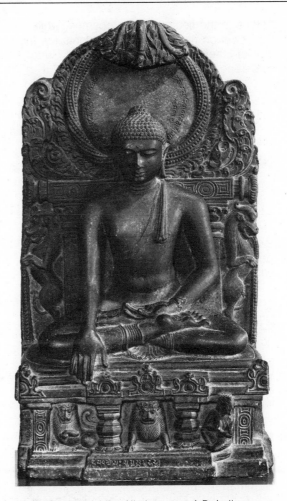

14-23 Seated Buddha. Ninth century A.D. India. Chlorite. 33″ high, 17½″ wide. Asian Art Museum of San Francisco, The Avery Brundage Collection.

listens to the secrets of the cosmos, while the jewel on his forehead represents the third eye of inner vision. The figure of the Buddha is serene and has a nobility which lifts it above the world of sensual pleasure. When Buddhism later spread to Tibet, China, Japan, and Indonesia, artists everywhere followed this same highly spiritual concept of the Buddha in their painted and sculpted images.

Although Buddhism became one of the world's most important religions—spreading into southern Asia, China, Tibet, Korea, and Japan—it did not maintain its dominance for long in India. This is partly because Brahmanism never died out among the people of India and because Hinduism, which developed later, appealed to the people as representing a return to the world from the more ascetic and unworldly Buddhism. Both Hinduism's acceptance of and delight in the physical world were expressed in the exuberant art which it produced. Although some features of Buddhism were incorporated into Hinduism, and even Buddha was considered to be an incarnation of Vishnu, the sensual life shown in Hindu art was far from the saintly renunciation of worldly pleasures found in the Buddha's teachings.

Brahman and Hindu Art Hindu and Brahman temple complexes, with elaborate assembly halls, baths, loggias, and towers, often were completely covered with miles of relief sculpture. Leaving no surface undecorated, the sculptors created in these carvings a testament to their belief in the unity of all living forms—animal, floral, and human. Siva, the destroyer; Trimurtic, the

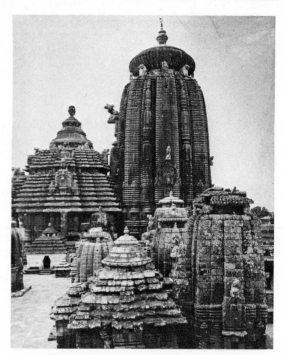

14-24 Hindu Temple. Ninth century. Eliot Elisofon, Time-Life Picture Agency.

three-headed trinity who represents the unity of all life; and other gods and goddesses were carved in interweaving narrative reliefs which showed a joyful love of life (Figure 4-10). Because sexual desire was a revered part of life to the Hindus and because they believed that physical union was one way to attain unity with the gods, erotic subjects were an accepted part of the panorama of life which unfolded on the temple walls.

China and Japan

Buddhism spread to China through Tibet and eventually to Japan. Even before this, however, China was an important influence on the art of Japan; therefore we will study the two civilizations side by side. Many of the same concepts of the human being's place in society were common to both cultures. For example, social classes in both were rigid, the family and ancestors ruling most daily activities. Customs were controlled by ancestral traditions, and, as a result, images and styles in art remained much the same over longer periods of time than in Western cultures. This influence lent a homogeneous quality to Far Eastern art, but it also kept it static. In addition, the expression of the individual artists was much less important than in the West. In both China and Japan, art has been more concerned with expressing ideas than with depicting outer reality.

In China, the ethical system of Confucius regulated the customs of everyday life down to the last detail. In addition, Taoism, whose leader, Lao-tzu, taught devotion to the entire universe—birds, animals, sky, wind, and trees—was aimed toward developing humility. The teachings of these two men, who lived around the fourth century B.C., prepared the way for the acceptance of Buddhism, which came to China through Tibet in the first centuries after the birth of Christ and eventually spread to Japan.

The earliest Chinese art we know of dates from around 1700 B.C. As in other early cultures, the priests in these dynasties were entrusted with pacifying the powerful gods who inhabited the natural world. Elaborately

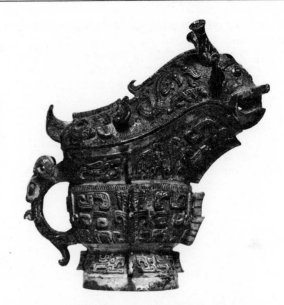

14-25 Ceremonial wine vessel. Twelfth to eleventh century B.C. China. Bronze. 9″ x 9″. Asian Art Museum of San Francisco, The Avery Brundage Collection.

decorated bronze ritual vessels from that period are alive with monsters who represent the powerful spirits. These monsters crawl entwined over bronze elephant and tiger jars on which the lei-wen, a sign for clouds and thunder, may be shown curling around a stylized bird or animal. Demons peer out from the tops and handles of the jars. The spiral decorations give us a sense of prolific life, both real and imagined, and bring us close to the fears which must have haunted the early Chinese.

As time went on, under the influence of the more serene philosophies and religions of Confucianism and Taoism, the fury and force of these images were tamed. In their place, traditional Chinese art expressed a more philosophical attitude.

Architecture in the Orient Most of the early Far Eastern buildings were constructed of wood, so not many ancient ones are still standing. The oldest, at Nara in Japan, dates from the seventh and eighth centuries A.D. and shows how complex the wooden construction became. The traditional structural forms of these temples came originally from China, where we know they had remained unchanged for centuries, because clay models found in tombs dating from 200 B.C. show similar construction. Building probably was the most conservative of the arts in the conservative Far East, and the basic building methods have remained

14-26 Japanese temple. 1053. Kyoto. Japan Information Service.

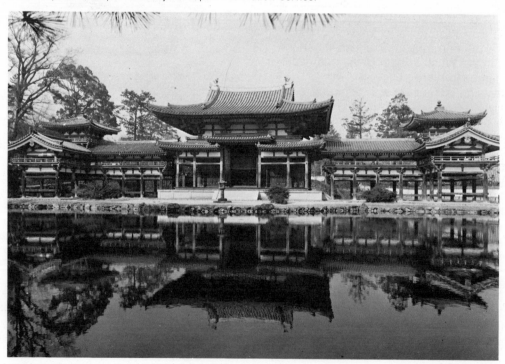

essentially the same throughout the history of both China and Japan.

Certainly, Japanese craftsmen developed the art of making wooden buildings to its most refined expression. The elaborate temples and palaces were built on a stone base with wooden posts and rafters which were fitted together in beautifully crafted joints. The pagoda form, with its wide curved roof, became popular and may have derived from the umbrellalike forms which often capped the stupas in India. There were gates leading into temple enclosures just as there were around the stupas, and the wooden Oriental gates are similar in design to the stone gates of the stupas.

In Japan, the traditional form of domestic architecture was a wooden house or palace with sliding screens. Scroll paintings from the twelfth century show wooden buildings whose style still looks familiar to us today. This style of building has had a strong influence on modern home architecture in the West. In particular, Frank Lloyd Wright, who went to Tokyo in the early 1920s to build the Imperial Hotel, was so impressed with Japanese domestic architecture that he applied many of its concepts to his designs for houses.

Sculpture The fashioning of sculpture began early in the history of China. Clay figures were common in prehistoric times, and great stone animals were carved to line the avenue to the tomb of general Huo Kiu Ping in Shansi province around 200 B.C. In addition, relief sculpture was often used to decorate the tombs of princes and other important persons. Animals, hunters, dragons, Confucian sages, and other human figures were carved on the walls of the tombs so finely that the lines almost appear to have been drawn with ink and brush.

As in so many other cultures, in early Japan, religion was a mixture of ancestor and nature worship, in which the whole of nature was believed to be full of spirits who bestowed on humans the favors of food, children, wealth, safety, and survival. The prehistoric clay figures which have been found in Japan are a vivid expression of this spirit-filled world. Later, around the fifth or sixth century A.D., large tombs were built which were filled with clay, bronze, stone, iron, and glass objects and sculpture. Lively clay statues, called Haniwa figures, which were implanted in the ground around the tombs in order to retain the earth, were representations of houses, animals, and people. Full of life, they give an idea of the daily lives of the inhabitants of Japan at that time (Figure 4-6). Although later art in Japan was profoundly influenced by the contemplative philosophical art of China, this element of delight in all aspects of ordinary human life continued to be characteristic of Japanese art.

Large, free-standing statues of the human figure were introduced into Chinese art with the arrival of Buddhism in the fourth century A.D. Traditional Indian mythology was also transplanted to China, and in some of the statues the Buddha is seen surrounded by Indian Boddhisattvas (Buddhas to be). Sometimes Hindu gods can also be seen. But the Chinese idealized the Buddha, and his figure appears more detached and less human than in Indian sculpture. These

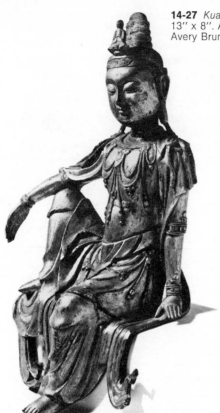

14-27 *Kuan Yin*. Fourteenth century. China. Bronze. 13″ x 8″. Asian Art Museum of San Francisco, The Avery Brundage Collection.

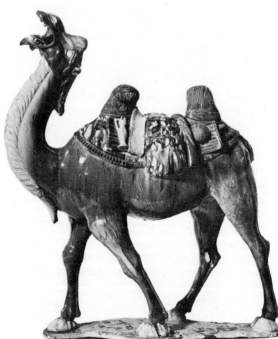

14-28 Walking Bactrian camel. A.D. 680-750. China. Ceramic. 35″ x 31″ Asian Art Museum of San Francisco The Avery Brundage Collection.

enormous images, with impersonal, austere attitudes that emphasized the otherworldly qualities of the Buddha, sometimes were seventy feet tall. Later, smaller gilded bronze images, which were used on temple altars, appear softer and not as cold in appearance. One of the Indian Boddhisattvas became transformed into the Chinese goddess Kuan Yin. Warm and human, this goddess shares many of the characteristics of the Christian Madonna and is also the goddess of mercy. To emphasize this aspect, she is sometimes shown with a child in her lap.

In the Tang period, around A.D. 600–900, a new naturalism entered Chinese sculpture. Instead of the spiritualized portraits of gods, sculptors began to create likenesses of living humans. Small ceramic statues represented court dancers, horses, and even camels. In Japan, the new realism in sculpture produced dramatic temple guardians (Figure 4-3) and painted wood figures like the very human Kichi jo-tn, the goddess of good fortune. As sculpture became more realistic, portraits emphasizing the human characteristics and gestures of priests and court officials became popular as well.

Painting in China and Japan Painting grew to be an extremely important method of artistic expression in both China and Japan. It was natural that this should be so, for the written characters of both languages demanded extreme skill with the brush. It took years of training to learn to be a *calligrapher,* and the quality of brush strokes and the beauty of the characters themselves became as important as the content of the story or poem.

Chinese painting The earliest Chinese painter of whom there is a record lived in the fourth century, and painting flourished from that time on. Except for a few murals, the paintings which have survived are of two types—hanging scrolls and horizontal, or hand, scrolls. These were kept rolled up except when being shown; then they were unrolled a little at a time, allowing the viewer to travel through the painting as if he were moving from scene to scene. Since painting and poetry were considered to be of equal importance, most painters also were poets. Scholars, emperors, and princesses were also accomplished artists. As a result, elegant scenes of life in the court were popular subject matter for Chinese scrolls. But at the same time, the search for unity with nature which drove the Taoist hermits to retire to the mountains, was expressed by the court painters in poetic landscapes of mountains, trees, and waterfalls, often with tiny meditating figures (Figure 5-3). To be one with nature was important to the contemplative Chinese, and the Zen sect of Buddhism, which developed in China in the sixth century A.D., encouraged this love of the natural world. Because of these influences, Chinese painting was not so much concerned with the landscape itself, but with showing its inner essence in order to arouse a poetic response in the viewer. "The branch drooping in the fog, the butterfly on a blossom, the beggar in the filth of the courtyard—they are all Buddha," said the painter Hsia Kuei. This appreciation of landscape, common to both Chinese and Japanese painting and poetry, surpasses even the love of nature found in Western Romantic landscape painters of the nineteenth century.

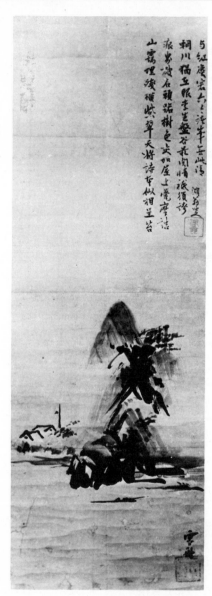

Japanese painting Just as Japanese architecture and sculpture developed certain typical elements, traditional painting in Japan reflects the differences and similarities in outlook between the peoples of the two countries. In Japan, the calm philosophical discipline of China is replaced by an animation and vitality. Until the tenth century A.D., Japanese painting was close to Chinese in style, but after that a typically Japanese style of painting religious subjects developed, in which the Buddha was surrounded by lovely Boddhisattvas playing musical instruments and dancing in a delightful but quite worldly paradise. The secular scrolls which were painted from the twelfth century on were filled with humor, satire, drama, and the mundane events of life—quite different from the meditative Chinese painting. Later, Zen Buddhism influenced Japanese painting, and the colorful style of the storytelling scrolls was replaced by paintings in which insignificant humans were shown serenely contemplating the grandeur of nature. But even here, the Japanese brush technique had a different quality from that of the Chinese and was full of vitality. The Zen painters used a few quickly splashed lines and washes of ink to express their responses to the natural world, reflecting the flashes of sudden enlightenment after meditation which were characteristic of Zen experience.

14-29 Sesshu. Hanging scroll. c. 1500. Ink on paper. 30⅜″ high, 10′⅝″ wide. Seattle Art Museum, Eugene Fuller Memorial Collection.

After years of close association with China, Japan, in the early 1600s, finally cut herself off from China as well as from the rest of the world. No foreigners were allowed to enter the Japanese islands, and no Japanese could leave until 1868. During that period Chinese influence waned because of the lack of contact, and Japan was able to develop a national style of her own.

Woodcuts Another art which developed as an important form of expression in the Orient was that of printing from wooden blocks. In China, where this method was common as early as A.D. 700, it was used to print inexpensive images of the Buddha for popular distribution.

Eventually the Japanese took over the technique and transformed it into an expression of their own particular culture. It is the Japanese prints which we now think of as traditional Oriental wood-block prints. Wood-block printing was a popular art, a mass media that poorer people could afford to purchase. Indeed, from the seventeenth century on, illustrations of folktales, popular actors, and courtesans appeared in inexpensive editions much as centerfold pictures today are printed by the millions. The typical Japanese interest in everyday subjects, their delight in humor, and their love of the national landscape are clearly expressed in these prints.

Artists such as Harunobu, Hokusai, and Hiroshige developed the woodcut to a high level of artistic expression while turning out hundreds of new prints to keep up with the public demand for the latest novelty (Figure 5-16). Utamuro, for example, depicted the courtesans in a romanticized manner, as unreal as today's fashion models. The popularity of the woodcut depended largely on the styles of the moment, and a new hairstyle could suddenly outdate a whole edition of prints. When these prints reached Europe they had a profound effect on late nineteenth-century painters and have influenced Western painting ever since. Japanese calligraphy and brushwork with its free, expressive strokes also influenced Western twentieth-century painters like Mark Tobey and Franz Kline (Figure 18-5).

Handcrafts In addition to its painting, sculpture, and architecture, the Far East has a long tradition of craftsmanship throughout its thousands of years of history. The delicate Oriental pottery and porcelain, silk brocades, ivory and jade carvings, laquer work, and metal crafts have been known and treasured by people in the Far East for centuries, and, since Marco Polo's famous journey of exploration, by people all over the world.

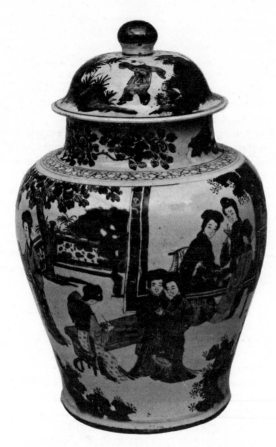

14-30 Jar with cover. 1573-1620. China. Porcelain. 19⅞″ x 7⅝″. The Metropolitan Museum of Art. Gift of Edgar Worch, 1950.

Ceramics From the moment clay was first used in China as a material for making utensils in prehistoric times, it became associated with religion. The bowl or jar which was made from the "divine earth" and hardened by the "divine fire" became a religious expression in itself. From the neolithic earthenware pot decorated with rhythmic spiral designs to the elegant porcelain bowl of the fourteenth-century Ming dynasty, the same sensitivity to the relationships of shape, line, and color have been obvious in Chinese ceramics. The early ceramic techniques were crude, consisting primarily of low firing in outdoor kilns. However, over thousands of years the techniques and methods of making ceramics became highly refined.

The ceramic arts in Japan, although influenced by China and based on Chinese techniques, developed their own distinctive styles. We are all familiar with the detailed floral designs painted on white glazed backgrounds which influenced Western china design, but the rougher simpler pottery of Japan has also influenced twentieth-century potters to a great degree. This pottery has a variety and liveliness in its spontaneous shapes, earth-colored glazes, and quickly brushed-on decoration which appeals to our contemporary eyes. The Japanese followers of Zen Buddhism considered the ordinary things of life to be as important as the spiritual, and they took delight in the process of making pots. Zen also stressed that

uniformity and repetition were fatal to imagination, so these simple pottery bowls show great variety. Like the Japanese landscape paintings, they are expressions of a religious belief and are used in the Zen tea ceremony. This ceremony traditionally takes place in a simple teahouse designed to recreate the quality of serenity and purity one might feel in a hut by a mountain waterfall. Everything used in the ceremony itself is intended to increase this feeling of serenity. The subtle response of the tea drinker to the shape of a bowl, the sound of the whisk stirring the tea, or the color of a flower in a vase characterizes for us the essential difference between the art of the Far East and the art of Western cultures.

14-31 Water jar. 1573-1614. Japan. Stone. 12″ x 25½″. Asian Art Museum of San Francisco, The Avery Brundage Collection.

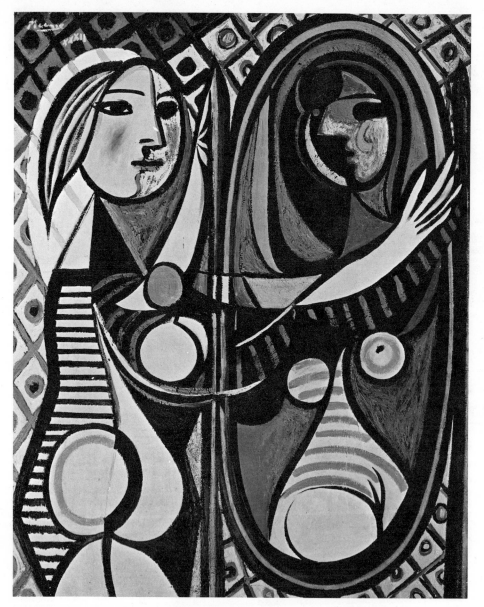

15-1 Pablo Picasso. *Girl before a Mirror*. March 14, 1932. Oil on canvas. 64″ x 51¼″.
Collection, The Museum of Modern Art, New York. Gift of Mrs. Simon Guggenheim.

PART FOUR

Rushing toward the Future: Art in the Twentieth Century

Introduction

Believing that the world could reach perfection by the application of the scientific method to all problems—whether material, spiritual, or political—the nineteenth century had put its energies into industrialization.

And indeed, as the twentieth century arrived, it seemed to many that the human race was still on its way to this perfection. The industrialists and the growing middle class lived in comfort; Europe had been at peace for forty years; the United States had survived a civil war; and marvelous new inventions—the electric light, the telephone, the automobile—promised new material comforts and the end of hard physical labor. For many, a new faith in science and material progress replaced faith in old religions.

However, the Industrial Revolution and years of economic expansion had not created a perfect world in which everyone was well fed and happy. Side by side with the comfortable rich, millions lived in poverty in crowded slums and worked long hours in unsafe and unsanitary factories. Although machines, the supposed saviors of the human race, had made life easier for some, they also had brought economic exploitation and dehumanizing labor to thousands who crowded into smoky towns.

These workers, who formerly had lived in villages or on farms, often felt uprooted and lost when they moved into urban areas to work in the factories. The marvels of science had destroyed much of their faith in old patterns, traditions, and religions and often had failed to replace that faith with the promised material comforts. As a result, social unrest, strikes and riots, radical political movements, and assassinations were an indication that not everyone was satisfied with the industrial progress hailed by the leaders.

As the twentieth century replaced the nineteenth, it brought with it depressions, wars, dictatorships, and the disintegration of old traditions. However, even the twentieth century retained some of the illusions of the earlier age, and yet today many people continue to believe that if we make a few more miraculous discoveries, invent additional electronic devices, or produce newer synthetics we will reach a materialistic utopia.

But the pace of change has accelerated enormously over the last seventy years. New discoveries in chemistry, biology, physics, and psychology follow one another so

quickly that we reel from the shock of the rapid changes. Our slow biological rhythms have been upset by the speed of modern transport and communication. First cars and cinema, then airplanes, television, and computers have helped to create a mass society to which millions conform, although their physical and mental survival is threatened by its pressures and its pace. Although increased mechanization has brought new material comforts to millions, at the same time there are large parts of the world where people still face famine. Wealthy nations, which developed high standards of living based on the exploitation of others, have found they no longer can deny entire nations or races an equal share in the world's wealth. And we now realize that this wealth is limited. Our natural resources are rapidly being depleted, and few parts of the earth have been unaffected by our exploitation of the planet. For example, penguins in Antarctica have been found with insecticide residue in their livers, and photographs taken from satellites show huge smudges of smog floating over continents. It is against this background of accelerated change that we must view the art of the twentieth century.

The International Period

One of the main causes of our
artistic decline lies beyond doubt in
the separation of art and science. Art
is nothing but humanized science.

Gino Severini

As the world entered the twentieth century, the dreams of a utopia achieved through science and industry failed to materialize. Many became disillusioned, and artists expressed this disillusionment in their revolutionary experiments. The younger artists continued to rebel against the rules of the Academy. But in addition to rejecting academic art, they were rebelling against the whole age—an age which they saw as one of uncertainty, exploitation, and increasing isolation of people from one another.

Thus art, which has always been a barometer of social change, reflected the accelerated change of our century in its multiplicity of styles and movements. Constantly changing fads and fashions, experimentation with materials and techniques, startling new subject matter or no subject matter at all—the apparent chaos of twentieth-century art—mirrored the fragmentation of our world. Some artists tried to come to terms with new social forces, others rejected them. Some turned to realism, others to fantasy. Some looked for subject matter in the mass society around them, while others rejected all subject matter.

This fragmentation and change are characteristic of the art of our century. Since the turn of the century some artists have formed innumerable small groups, each proclaiming its own theories. Hundreds of other individual artists have maintained an independence which makes it difficult to classify them into any group. Perhaps we can simplify the confusion by outlining a few main currents which run through twentieth-century art. You should keep in mind, however, that, like all such labels, these are generalizations, and an art movement or a particular artist may not fit them precisely. In addition, the terms overlap somewhat, and—to make matters even more confusing—they are often used loosely. But if we arbitrarily agree on the terms and definitions that follow, at least for our use in the remaining chapters, such terms may help make today's art world easier to understand.

Realism makes use of the artist's knowledge of perspective, light and shade, and color to reproduce as closely as possible the visual appearance of objects in space.

Abstraction begins with an object in the real world, then simplifies and reduces it to its essential lines, colors, and shapes.

15-2 Wassily Kandinsky. *Black Relationship*. 1924. Watercolor. 14½″ x 14¼″. Collection, The Museum of Modern Art, New York. Acquired through the Lillie P. Bliss Bequest.

Although all art abstracts to a degree, abstraction in the twentieth century became a style in itself.

Nonobjective art, unlike abstract art, does not refer in any way to an object. Instead, it is concerned only with line, color, mass, value, and texture arranged in such a way as to give the viewer a satisfying visual and emotional experience.

Expressionism is primarily concerned with expressing an idea or emotion rather than with reproducing reality. This way of expression is not new, but the proper name *Expressionism* is used to describe a German movement which started early in the twentieth century.

Surrealism, or visionary art, expresses desires, fears, or fantasies from the artist's inner life. These may be expressed with abstract symbols or with realistically painted images.

We will use these descriptions of varieties of artistic expression to place some of this century's divergent art styles into a few main categories.

A New Age Brings New Viewpoints

Paul Cézanne's paintings, which frequently were exhibited in Paris from the 1880s on, were widely discussed by the young painters and sculptors who had gathered there from all over Europe. His efforts to reduce volume and space to simple cones, cylinders, and planes changed their way of looking at the world. Another influence on many of these young rebels was the art of Africa (Figure 1-15). They saw in the exaggerated, almost violent simplifications of African art an escape from the constricting rules of the Academy as well as from the refined Impressionistic preoccupation with delicate fleeting light (Plate 7).

Cubism

Out of these two major influences— Cézanne's later paintings and African art— grew a movement that was given the name *Cubism* by a startled critic. It was begun by two young artists, Georges Braque (1882–1963) and Pablo Picasso (1881–1973), who later said, "We had no intention of creating Cubism, but simply of expressing what we felt within ourselves."

Picasso, having brilliantly completed an academic art training in his teens, moved from one personal style of artistic expression to another throughout his life, exploring each thoroughly before moving on to the next. In 1907, influenced by Cézanne's analytical painting and by the simplifications and distortions of African art, Picasso produced a painting which was to have a tremendous effect on the course of twentieth-century Western art. In this painting, called *Les Demoiselles d'Avignon,* or *The Young Ladies of Avignon* (Plate 31), artistic rebellion became outright revolution. First planned as an allegory of vice and virtue, the final painting was intense and stark in its distortions. It presents the figures and faces of the women in angular, jagged forms. The girl on the left is depicted in a series of overlapping planes; the central figure has eyes that look directly at us, while the nose is in profile; and the figures on the right are depicted with faces like African masks.

Cézanne had been left behind, and the essential elements of Cubism are explored in this first experimental work.

Both Picasso and Braque saw the world in a startling way, which echoed the breakdown in social patterns and the uncertainty of the new age. Just as the political radicals tried to find a new order to restructure the fragmented society, so, too, did the Cubists search for a new way to rearrange visual images. Familiar objects—tables, wine bottles, cups, violins, sheet music, and even musicians—were broken into geometric abstractions, simplified, and restructured (Figure 1-4). Picasso said, "We have kept our eyes open to our surroundings, and also our brains." Not only did the Cubists rearrange their abstracted forms, they also abandoned conventional linear perspective with its accepted vanishing points (Figure 15-1). In its place they created within each painting a new surface perspective that changes constantly and does not penetrate

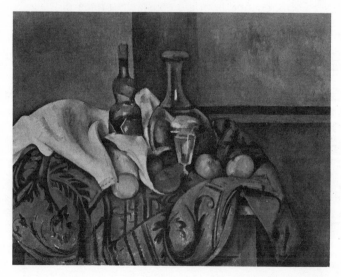

15-3 Paul Cézanne. *Still Life.* c. 1890. Canvas. 26″ x 32⅜″. National Gallery of Art, Washington, D.C.; Chester Dale Collection.

deeply into the canvas, but rather seems to come forward out of the frame. A comparison of *Ma Jolie* (Figure 1-4) with Leonardo da Vinci's *Last Supper* (Figure 11-11) demonstrates the revolutionary manner in which these young painters handled perspective.

The Cubists painted not only what they saw before them, but what they knew was there as well. Objects were opened up and shown from more than one viewpoint. For instance, a wine bottle might be painted as viewed from the side, the back, and the top, all organized into a complex, intellectually analyzed composition. Although we know that a bottle has all these aspects, never before had painters tried to combine all views of an object in one painting.

Finally, the object itself was lost as the Cubists became more interested in forms and shapes which overlap in a shallow space. Reality was rejected, and in the painting *Ma Jolie* (Figure 1-4), subtitled *Woman with a Guitar,* the figure is so broken apart that she is difficult to find, and only a few musical notes and signs are left to suggest the musical intrument.

From these Cubist paintings, which were intellectual in approach and muted in color, Picasso, Braque, and others later moved on to more expressive, colorful ways of using the abstract shapes they had created (Plate 9). As brighter colors returned to canvases, the shapes and volumes of the new language of Cubism began to be used inventively and expressively, often with humor. The rules of academic art were totally shattered. From now on, even those painters who used the academic tools of perspective and light and

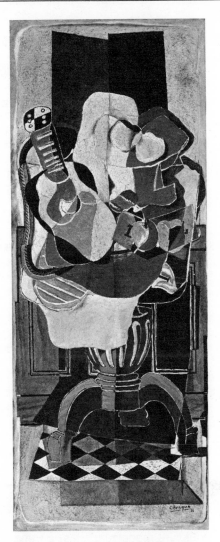

15-4 Georges Braque. *The Table*. 1928. Oil on canvas. 70¾″ x 28¾″. Collection, The Museum of Modern Art, New York. Acquired through the Lillie P. Bliss Bequest.

shade to create the illusion of three dimensions would use them more freely. Art would never be the same.

Picasso summed up the new attitude in the arts by saying, "Everyone wants to understand art. Why not try to understand the song of a bird?" Spontaneously creative in his reaction to everything he saw around him, Picasso could paint a charming young girl in a lyrical classic style, capture the pathos of starving beggars with a few lines, and then assemble a bicycle seat and handlebars into a humorous bull (Figure 4-14). With work such as the bull, Picasso introduced a playfulness, joy, and humor into art that was a refreshing change from the stuffy seriousness of David's academic painting (Figure 13-5) and the intellectualism of analytical Cubism.

The Fauves We have seen that the expression of personal emotion in art is not confined to this century. The revolutionary distortion of form and the violent color used by artists at the turn of the century gave impetus to new uses of color in expressive painting. About the time that Picasso was discovering African sculpture, other painters were influenced by the way van Gogh and Gauguin had used brilliant color. In 1905, a new movement burst on the scene with a startling exhibit by Henri Matisse (1869–1954) and eleven other artists. In the rooms full of brilliantly colored canvases, a bewildered critic noticed a small bronze sculpture modeled in classic Renaissance style. He remarked that it was like "Donatello among the wild beasts." Consequently the term *les Fauves*—the wild beasts—was applied to the painters of this short-lived movement.

Matisse's innovative use of color and strong, simplified forms *was* startling. For example, in this *Portrait of Madame Matisse* (Plate 32), he arbitrarily painted one of his wife's cheeks yellow-ochre, the other pink, and then separated them with a wide line of green down the middle of her face. Here Matisse was using color without any references to reality, and, like other Fauves, using it to its fullest intensity. This strong use of color, along with the masklike features of the face, had a direct influence on the Expressionist movement soon to emerge.

Another member of the Fauves, Georges Rouault (1871–1958), was haunted by the poverty and misery of his day. In his paintings he protested the cruelty of humans toward each other, using the degradation of prostitutes and tragic circus clowns as symbols of that cruelty. A deeply religious man, he painted many biblical characters and crucifixions in an austere style. Rouault was an Expressionistic painter in the violence of his forms and in the rich colors that emerge from his dark backgrounds. He had been an apprentice to a stained glass craftsman, and many of his paintings resemble Gothic windows. He was also an experimental printmaker who commented on the horror of war through his prints. Rouault's new graphic techniques greatly influenced twentieth-century printmaking. For instance, he would use combinations of etching and engraving in a print and would work on the plate with files, sandpaper, or anything that would scratch and texture it. This freedom of approach released printmaking from its traditional boundaries.

15-5 Georges Rouault. *The Old King*. 1916-38. Canvas. 30¼ ″ x 21¼ ″. Museum of Art, Carnegie Institute, Pittsburgh.

Expressionism

Of course, the expression of emotion has existed as long as humans have created art. Certainly the Romanesque sculptor was expressing emotions common to the Middle Ages in his carving above the door of a church (Figure 10-15). In the nineteenth century, the expression of deeply felt personal emotions and individual responses to events became fashionable. For instance, Géricault, in *The Raft of the Medusa* (Figure 13-7), showed his protest against the sacrifice of human beings for greater profit by a shipping company. Goya (Figure 13-3) expressed his horror at the cold-blooded murder of hostages by Napoleon's troops. Van Gogh, too, had poured his own emotion into painting by using strong brush strokes, pure color, and by distorting natural shapes. In *Starry Night* (Figure 1-5), for example, the stars appear as violent swirling shapes that help to express van Gogh's frenzied response to the night sky.

Edvard Munch (1863–1944), a Norwegian with a tragic sense of man's ultimate isolation in the world, expressed this alienation as well as his own anxiety and despair in both paintings and prints. His remark, ''I hear the scream in nature,'' is vividly illustrated in *The Shriek*. The open mouth of the central figure suggests howls of fear or pain, while the anonymous silhouettes on the bridge portray the coldness and indifference of the world. The torment of the lonely figure fills the atmosphere with expanding waves of terror, which are repeated in the water and sky. Thus, Munch's human beings, isolated from each other and caged in their separate terrors, become symbols of twentieth-century man (Figure 5-19).

Alienated from the dehumanized and materialistic world they saw around them, some of the young painters in Germany retreated to quiet islands or mountains and, inspired by van Gogh, Munch, and the Fauves, painted in differing individual styles

15-6 Emil Nolde. *The Prophet*. 1912. Woodcut. National Gallery of Art, Washington, D.C.; Rosenwald Collection.

that are loosely classified as Expressionism. In an art that was highly charged with emotion, they used harsh, brutally simplified forms and strong clashing colors to express the sense of conflict and tragedy they carried with them to their retreats. Their canvases, woodcuts, etchings, and lithographs expressed sadness, violence, and morbidity. For instance, one of these artists, Emil Nolde (1867–1956), in his violent religious and moral paintings, distorted the physical features of the figures to the point where they appear insane with greed, anger, or grief. These German Expressionists exaggerated color to express the intensity of their inner tension as well as to increase the symbolism of their images. Poets like Baudelaire had used words as symbols for feelings, and painters like Gauguin had used colors to symbolize emotions like fear or joy (Figure 13-19); but the Expressionists pushed this symbolism beyond reality, sometimes painting a horse red, sometimes blue.

However, the German Expressionists may have reached their greatest heights in their prints. Inspired by the newly discovered Japanese prints, they began to experiment with woodcuts, developing the art along directions which continue to influence printmaking to the present day. Often using color as well as strong black and white, they distorted their figures to bring intense emotion to the art of printmaking. One of these Expressionists, Käthe Kollwitz (1867–1945), worked mainly in black and white, and her drawings and lithographs poignantly express her championship of the poor and exploited. In her works, agonized mothers clutch starving children, and peasants are depicted revolting against rapacious landlords. Other artists, like Ernst Kirchner and George Grosz, screamed their protest against social apathy, militarism, bureaucracy, corruption, and capitalism in their prints. Through the work of such artists,

his first nonobjective work in 1910, made the statement that what is most important in art is what the viewer lives or feels while under the effect of the form and the color combinations of the painting. Kandinsky wanted painting to come as close to pure music as possible. For that reason, he called his compositions "improvisations" to emphasize their lack of subject matter (Figure 15-2). Paul Klee (1879–1940), who was more cheerful, more

15-7 Käthe Kollwitz. *Self-Portrait*. c. 1922. Lithograph. 4″ x 5½″. Collection of Stella Russell.

prints again became instruments of social protest as they had been during the nineteenth century with Daumier (Figure 5-20).

Out of the German Expressionist movement emerged a painter who was to have an important influence on the development of nonobjective painting. Wassily Kandinsky (1866–1944), who painted

15-8 Paul Klee. *Twittering Machine*. 1922. Watercolor, pen and ink. 16¼″ x 12″. Collection, The Museum of Modern Art, New York.

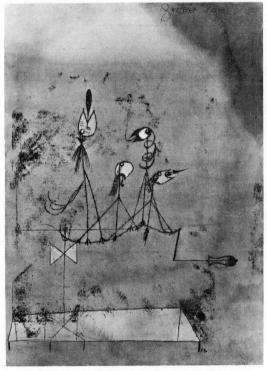

intellectual, and not as concerned with social conditions as his colleagues, is an example of how difficult it is to classify twentieth-century artists into a few neat categories. Although he was Expressionistic in his use of color and in his desire to produce certain sensations in the viewer, Klee also was drawn to nonobjective painting. In addition, there are elements of fantasy and humor in his paintings which link him with Surrealism. Klee believed that there is a kind of laughter that "can be put on the same dignified level as higher lyrical emotions." Certainly this painting of *Twittering Machine* and many of his etchings make us smile with a sense of delighted discovery.

An Expressionistic painter and sculptor who used the distortions of African art as well as strong, rather somber colors to express the tragic neurotic restlessness of his life was Amedeo Modigliani (1884–1920), an Italian who lived in Paris. Handsome, poor, dissipated, and dying of tuberculosis, Modigliani nevertheless managed to produce several abstract carved figures (Figure 14-9) and many paintings which echoed the work of the Italian Renaissance artist Botticelli in their use of nervous line and exaggerated elongations of the female body.

We will see that Expressionism had a continuing influence on painters throughout the rest of the century.

Futurism

In 1908 Wilbur Wright flew across the English Channel at about the same time that Bugatti was designing his racing automobiles. Many artists were intrigued by the new concepts of motion, and a group of young painters, anxious to escape tradition and wanting to "glorify the life of today incessantly and tumultuously transformed by the victories of science," founded the Futurist movement. In their painting and sculpture they tried to reconcile modern man with the new machines and to express their joy in the glorious speed of steam engines, automobiles, and airplanes. Influenced by the Cubists, some of these artists reduced forms to planes and painted almost abstract canvases with titles like *Dynamism of the Automobile.* Others, like Gino Severini (1883–1966), who painted multiple images to show movement, may have been influenced by the new art of the motion picture. In *Bal Tabarin,* for instance, Severini expressed the swirling movements of cancan dancers in a painting which is brilliant in color and whose forms have been broken down into Cubist planes. Only the dancers' ringlets and red lips remain recognizable, although touches of painted lace and real sequins have been added to suggest their costumes. The Futurist movement broke up under the stress of World War I, but its influence continued in the painting of Marcel Duchamp (Figure 2-17), Fernand Léger, and later machine-oriented painters.

Influenced by the Cubists and painting in their manner for a time, Fernand Léger (1881–1955) moved slowly toward a style that was to become a personal comment on

the relationship of human beings to the machine age. In his paintings he turned city buildings, smoking factories, machine parts, and human bodies into simplified cylinders, rectangles, circles, and cubes painted in brilliant blues, yellows, and red contrasted against stark white and black. His figures become static robots surrounded by pistons, crankshafts, and other machine parts. The colors and forms of Léger's painting directly influenced contemporary furniture design and advertising art in the United States in the 1940s, for his simplified forms lent themselves particularly well to poster and display art.

15-9 Gino Severini. *Dynamic Hieroglyphic of the Bal Tabarin*. 1912. Oil on canvas with sequins. 63⅝″ x 61½″. Collection, The Museum of Modern Art, New York. Acquired through the Lillie P. Bliss Bequest.

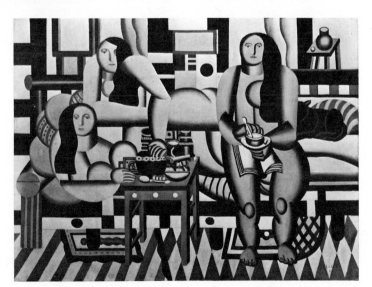

15-10 Fernand Léger. *Three Women*. 1921. Oil on canvas. 6′¼″ x 8′3″. Collection, The Museum of Modern Art, New York. Mrs. Simon Guggenheim Fund.

Sculpture

Many sculptors at the turn of the century continued to be influenced by Rodin (Figure 4-9); but there were other sculptors, such as Umberto Boccioni (1882–1916), whose work was quite different in character and represented an important break with past traditions. Boccioni's *Unique Continuity of Forms in Space* depicts a figure rushing forward in violent movement. Expressive as it is, with violent, forward-thrusting diagonals, the figure is impersonal. Movement in its abstract sense is what Boccioni was

interested in, not movement as a response to personal emotion. We become intrigued with the way the shapes are rearranged to express the action, but it is an aesthetic and intellectual interest, rather than a concern with human feelings.

The influence of the Cubist painters helped to liberate the sculpture of Jacques Lipchitz (1891–1973) from traditional images. At first, his forms became flat planes which seemed to be almost literal translations of Cubist paintings into sculpture. But later he developed a personal style in which the simplification of Cubism was combined with his own ideas about birth and growth, life and death. Lipschitz was also influenced by African art as he searched for an expression that would satisfy his need to reconcile human forms with the new geometry of science. Lipschitz's sculpture maintains organic shapes and relates to man's biological needs. At the same time the stark simplicity of this robotlike figure suggests an ominous, ruthless, machinelike force stronger than the human.

An academically trained Rumanian, Constantin Brancusi (1876–1957) joined the radical young artists working in Holland, Moscow, and Paris, who were searching for new forms of expression. Although influenced by African art, Cubism, and the new age of machines, Brancusi never gave up his deep involvement in the natural world (Figure 4-11). His *Sculpture for the Blind,* an

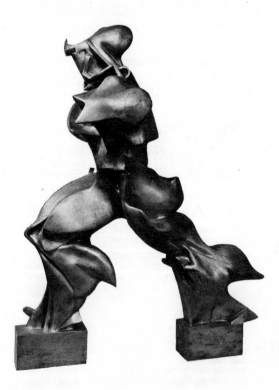

15-11 Umberto Boccioni. *Unique Forms of Continuity in Space.* 1913. Bronze. 43⅞″ x 34⅞″ x 15¾″. Collection, The Museum of Modern Art, New York. Acquired through the Lillie P. Bliss Bequest.

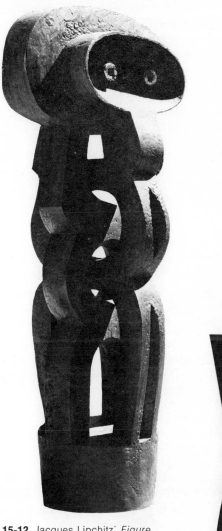

15-12 Jacques Lipchitz. *Figure.* 1926-30. Bronze 7′1¼″ x 38⅝″. Collection, The Museum of Modern Art, New York. Van Gogh Purchase Fund.

egg-shaped marble form made to be handled and enjoyed by feeling as much as by seeing, and his famous *Bird in Space* give evidence of Brancusi's deep roots in the organic world, while at the same time they explore radical new simplifications of masses.

Joining the other radicals, Naum Gabo (b. 1890) and Antoine Pevsner (1886–1962), two Russian brothers, were attracted to the analytical approach of Cubism and to the new forms of technology. Breaking with the classic sculptural tradition of depicting the human figure and wishing to bring sculpture into harmony with engineering technology, these men experimented with entirely new sculptural forms that expressed scientific methods and new materials. Pevsner's *Torso* used Cubist-inspired planes to depict the concave and convex forms of the human body with unusual materials like sheets of copper and plastic. The transparency of the material denied the solid aspects of traditional sculpture. Like the Cubist painters, Gabo and Pevsner were concerned with overlapping and combining multiple views of the same subject as well as with the relationships between mass and space in sculpture.

Sculptors in the past had expressed the social philosophies and emotions of their periods by carving or casting figures which relied on solid volumes. Now, in an age in which motion, machines, and new concepts of space preoccupied artists, creative

15-13 Constantin Brancusi. *Bird in Space.* 1928. Bronze (unique cast). 4½′ high. Collection, The Museum of Modern Art, New York.

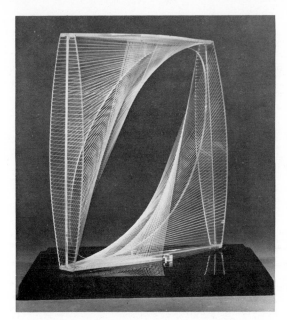

15-14 Naum Gabo. *Linear Construction No. 1* (smaller version). 1942-43. Plastic construction with nylon thread. 12¼″ x 12¼″ x 2½″. The Hirshhorn Museum and Sculpture Garden, Smithsonian Institution.

social theories as well as the use of new materials. Sculptors like Gabo and Pevsner called their sculpture *Constructivism,* to emphasize its break with tradition. Sculpture now moved into a totally new technical area, no longer depending on the older methods of modeling, casting, or carving. Now it could be built or constructed from a variety of materials in response to the new ideas of the age.

15-15 Antoine Pevsner. *Torso.* 1924-26. Construction in plastic and copper. 29½″ x 11⅝″. Collection, The Museum of Modern Art, New York. Katherine S. Dreier Bequest.

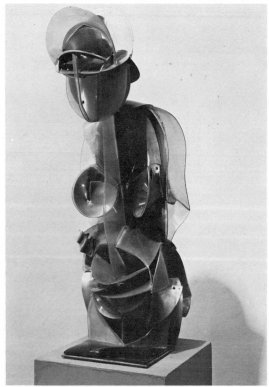

sculptors reached for new forms, new images, and new materials. No longer would mass alone be the main concern of sculptors; space now became an important element of sculptural composition. The space which could be seen *between* the forms, the space *around* the sculptured masses, as well as the forms seen *through* the implied space of transparent planes, all would be composed as carefully as the solid volumes themselves. This concern with space as a part of sculpture, which has continued to the present day, grew out of new aesthetic and

Experimental Films

Paris not only was the center of radical new movements in painting and sculpture, it also was a center of avant-garde filmmaking. Painters and writers alike were fascinated by the potentials of the new medium, and many Cubists and Surrealists tried their hands at the new art form. Artists like Marcel Duchamp, Dali, Léger, and Cocteau all experimented with cinema and brought to it their personal styles. Léger, for instance, developed his interest in machines into moving images in his film *Ballet Mechanique* (Figure 6-13). Dali expressed his usual theatrical and Surreal viewpoint, and Marcel Duchamp made a natural progression first from the painting *Nude Descending a Staircase, No. 2* (Figure 2-17), to moving ready-mades (Figure 16-2), then to his moving picture *Anaemic Cinema* in 1926.

These early film classics later were studied by creative film directors such as René Clair who absorbed the experimental attitude into his own commentaries on the absurdities we confront in our machine-dominated lives.

De Stijl **and the Beginnings of Nonobjective Art** During the years of World War I, neutral Holland had remained one of the few countries where creative activity and building could continue uninterrupted. As a consequence, Holland became a center of aesthetic and architectural ideas. Architect Gerrit Rietweld and painters Theo Van Doesburg and Piet Mondrian (1872–1944) worked closely together and in 1917 started the movement which they called *De Stijl*— The Style—which included painters and architects. Convinced that realistic or even semiabstract images had no place in the machine age, the painters and architects of

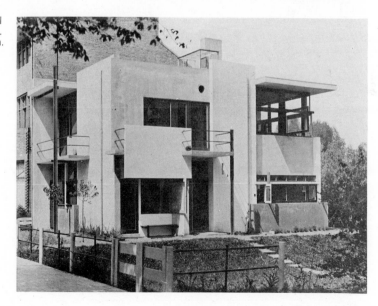

15-16 Gerrit Rietvald. International House. 1924. Utrecht, Netherlands. Foto Stedelijk Museum Amsterdam.

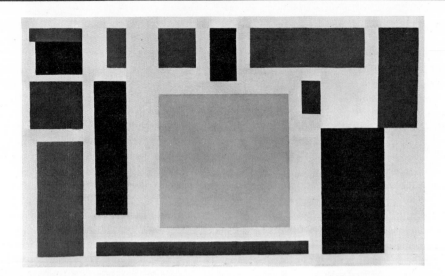

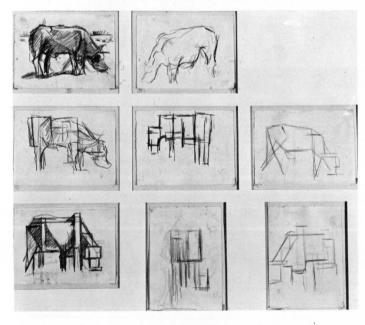

15-17 Theo Van Doesburg. *Composition (The Cow)* (above). 1916-17. Oil on canvas. 14¾'' x 25''. Collection, The Museum of Modern Art, New York. *The Cow* (left). 1916-17. Series of eight pencil drawings. Nos. 1, 2, 4, 5, 6, 7: 4⅝'' x 6¼''; nos. 8, 9: 6¼'' x 4⅝''. Collection, The Museum of Modern Art, New York.

De Stijl reduced their images and forms to simple shapes and horizontal and vertical lines, such as those in this house in Utrecht. The pencil drawings of a cow show clearly how Van Doesburg gradually abstracted the image to the final painting entitled *The Cow.* Applied to painting, architecture, and to all areas of design, this style had an impact on creative expression throughout the world that lasted for decades. Both Mondrian (Plate 8) and Van Doesburg painted canvases in which the object that may originally have inspired them completely disappeared, and the only subject became the subtle relationship of flat rectangles of color and strong dark lines grouped in a harmonious and balanced composition.

Wassily Kandinsky (Figure 15-2) had painted the first nonobjective painting in 1910, and a Russian painter in Moscow, Kasimir Malevich (1878–1935), carried Kandinsky's art of the nonobjective even further. In 1913 he exhibited a painting which showed a black square on a white background. Describing this work, Malevich stated that "It was not just a square I had exhibited but rather the expression of nonobjectivity." Malevich spent years exploring squares and their relationships to each other. In 1918 he painted *Suprematist Composition: White on White* in which he believed he had attained the ultimate in purity.

In Russia at this time, experimental art and nonobjective painting were encouraged by the Communist party. By 1920, there were more museums of abstract art and more artists working in a nonobjective manner in Russia than in any country in the world, and political radicalism was linked with artistic

15-18 Kasimir Malevich. *Suprematist Composition: White on White.* 1918. Oil on canvas. 31¼″ x 31¼″. Collection, The Museum of Modern Art, New York.

radicalism. Problems arose, however, when the new regime outlawed all such experiments, and the radical avant-garde artists had to choose either to stay in an environment that was hostile to their explorations or to leave Russia for other countries. Kandinsky, for example, left Russia to join the faculty of the Bauhaus school in Germany.

Artists in many countries shared the same need to find new ways of relating to a strange new world. Consequently, art styles no longer were broken down into strongly

national categories. Although some art movements in this century have been centered in one country or city for a period of time, the artists involved often came from varied backgrounds and were grouped together because of their common aesthetic interests rather than their common nationalities.

The International Style

The new functional International Style which developed in architecture did not appear in a vacuum. The work of Cubist and Futurist painters and the new ideas in sculpture were known to the young architects. The nonobjective painting of Mondrian and the work of the Kandinsky and Malevich also influenced architecture and industrial design. Painters, in turn, were influenced by the new

15-19 Walter Gropius, Adolf Meyer. Fagus Factory. 1910-14. Alfeld, near Hanover, Germany. Photo, Courtesy of The Museum of Modern Art, New York.

radical architects. In studying the many movements of the twentieth century, we should remember that although we may have to explore them one at a time, they were interrelated. In fact, many of the architects and artists knew one another or at least were familiar with each other's work through books and magazines. The worlds of architecture, painting, sculpture, and industrial and commercial design have continued to influence each other in this way throughout the entire twentieth century.

We have already seen in Chapter 3 how the beginnings of twentieth-century architecture go back to the development of new materials and the engineering methods of the nineteenth century. Louis Sullivan (Figure 3-16), who used new structural methods in his tall steel-frame buildings, made a statement that was to influence buildings of the future: "Form follows function."

Peter Behrens had built industrial buildings in Germany in the early 1900s that came very close to later functional architecture. Behrens's use of engineering techniques and his clean, almost mechanical lines later were transmitted through the Bauhaus school to a whole generation of young architects.

By 1903, Auguste Perret was using reinforced concrete frames and nonsupporting walls that left the interiors of his buildings free to be divided into any combination of rooms. Walter Gropius (1883–1969), founder of the Bauhaus, ran glass up to the corners of his Fagus factory building, revealing the structure of the building and achieving an appearance of lightness. This ferment of new ideas in architecture quickly spread throughout the world, influencing both artists and architects.

Chap. 15 The International Period **311**

The Bauhaus School

The Bauhaus School The Bauhaus, or "architecture house," was founded in Germany in 1919 as a school of design. Here, technology, art, and business were brought together in an attempt to bridge the gap between them and to improve the design of all utilitarian objects. With artists from Germany, Russia, and Holland on the faculty, the Bauhaus became one of the influential factors in the development of the International Style.

Inherent in the beliefs of the Bauhaus was Sullivan's principle that "form follows function." As a technical design school, the Bauhaus explored new approaches to printing, metalwork, weaving, pottery, and stagecraft and pioneered new ideas in industrial design, achieving the integration of utility and aesthetic qualities that William Morris had sought in the nineteenth century. Rather than turning back to old craft-guild concepts, the school looked forward, embracing modern technology and working with new materials and methods. Out of this school emerged architects, painters, and industrial designers who were to dominate their fields for decades and whose principles we see expressed all around us in much of contemporary design. Before the school was closed by Hitler, the faculty included many prominent names in art, such as painters like Wassily Kandinsky, Paul Klee (Figure 15-8), and Josef Albers (Plate 1); and designers and architects like Mies van der Rohe (Figure 15-25), Marcel Breuer, and Moholy-Nagy.

Bauhaus founder Walter Gropius declared, "We want to create a clear, organic architecture whose inner logic will be radiant and naked, unencumbered by lying facades and trickiness; we want an architecture adapted to our world of machines, radios and fast motor cars, an architecture whose function is clearly recognizable in the relation of its form."

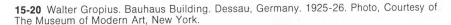

15-20 Walter Gropius. Bauhaus Building. Dessau, Germany. 1925-26. Photo, Courtesy of The Museum of Modern Art, New York.

One of the basic structural methods of the new International Style in architecture was the use of a weight-bearing cage on which the outer non-weight-bearing walls could be hung. Called curtain walls, these walls could be made of any material that would serve to enclose the space. As a result, windows and doors could be enlarged almost indefinitely, and the reduction of interior supports allowed the inside of the building to be rearranged freely to suit its functions.

Another basic characteristic of the International Style was an avoidance of applied decoration. Gropius and the architects he influenced in Europe and the United States believed that aesthetic satisfaction in a building could be achieved through a balance of solids and spaces and that nothing more was needed to make a building beautiful. Using new engineering methods, Gropius designed a building for the Bauhaus school that depended on expression of its varied functions to create an attractive design. Beginning with an open box as the basic unit, Gropius varied its volume according to its potential use and then grouped the boxes into a pleasing three-dimensional composition of cubes.

The school needed administrative offices, classrooms, studios, workshops, a library, and living quarters for both faculty and students. Instead of attempting to fit these varied uses into a group of Gothic buildings, Gropius expressed the school's needs honestly and in a revolutionary manner. The glass areas of the buildings integrate interior and exterior spaces, while their transparency permits the structural skeleton that Gropius designed to be seen from the outside. Thus the Bauhaus buildings integrate function and structure into a Mondrian-like design. By creating a structure in which the interior and exterior spaces can be viewed at the same time, Gropius also achieved the earlier Cubist goal of simultaneously showing several views of an object (Figure 1-4).

Many of the Bauhaus artists who escaped the Nazi regime came to the United States and maintained the Bauhaus ideal of the integration of architecture and industrial design as they continued to create buildings, furniture, books, and utensils.

As they had in Europe, the Bauhaus artists exerted a strong influence in all creative areas including industrial arts, theater design, interior design, and advertising. Marcel Breuer and Mies van der Rohe, for example, created furniture designs which have become classics. Herbert Bayer influenced typography and the work of younger American advertising designers. Ashtrays, lamps, tablecloths, chess sets, posters, and numerous other objects show the Bauhaus influence, and much of the mass-produced industrial art we now take for granted developed directly out of the International Style.

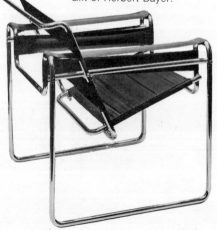

15-21 Marcel Breuer. Armchair. 1925. Chrome-plated steel tube, canvas: 28″ high. Manufactured by Gebruder Thonet A.G., Germany. Collection, The Museum of Modern Art, New York. Gift of Herbert Bayer.

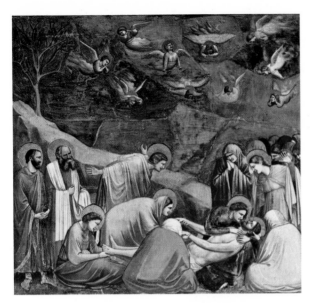

Plate 21 Giotto. *The Lamentation*. 1305-06. Fresco. Arena Chapel, Padua. Scala/New York-Florence.

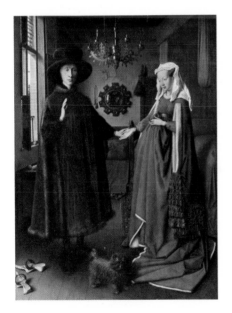

Plate 22 *Enthroned Madonna and Child.* Byzantine school, thirteenth century. Wood, 32⅛″ x 19⅜″. National Gallery of Art, Washington, D.C. Andrew W. Mellon Collection.

Plate 23 Jan van Eyck. *The Marriage of Giovanni Arnolfini and Giovanna Cenami.* 1434. Oil on oak, 32¼″ x 23½″. Reproduced by courtesy of the Trustees, The National Gallery, London.

Plate 24 Pieter Bruegel. *Peasant Wedding.* c. 1565. Panel, 44⅞″ x 64″. Kunsthistorisches Museum, Vienna.

Plate 25 J. M. W. Turner. *Burning of the Houses of Parliament.* c. 1835. Oil on canvas, 36¼″ x 48½″. Philadelphia Museum of Art, The John H. McFadden Collection. Photo, Alfred J. Wyatt.

Plate 26 Claude Monet. *Impression*. 1872. Oil on canvas, 19⅝″ x 25½″. Musée Marmottan, Paris. Studio Lourmel 77. Photo Routhier, Paris.

Plate 27 Claude Monet. *Water Lilies* (center panel). c. 1920. Oil on canvas, triptych, each section 6′6″ x 14′. Collection, The Museum of Modern Art, New York. Mrs. Simon Guggenheim Fund.

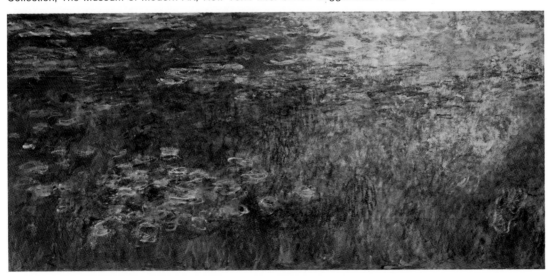

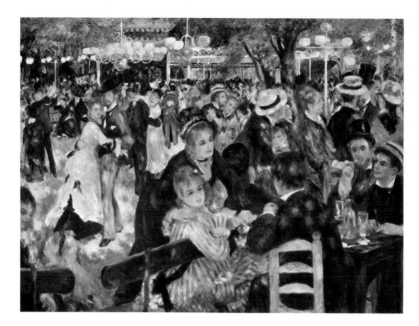

Plate 28 Auguste Renoir. *Le Moulin de la Galette.* *1876.* Oil on canvas, 51½″ x 69″. Cliché des Musées Nationaux.

Plate 29 Georges Seurat. *Sunday Afternoon on the Island of La Grande Jatte.* 1884-86. 81¼″ x 120¼″. Courtesy of the Art Institute of Chicago. Helen Birch Bartlett Memorial Collection.

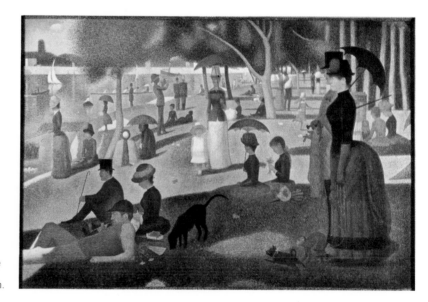

Plate 30 Vincent van Gogh. *Artist's Room at Arles.* 1888. Oil on canvas, 28½″ x 36″. Courtesy of the Art Institute of Chicago. Helen Birch Bartlett Memorial Collection.

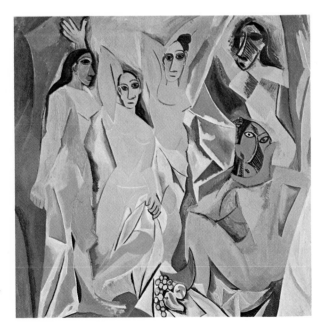

Plate 31 Pablo Picasso. *Les Demoiselles d'Avignon.* Spring, 1907. Oil on canvas, 8′ x 7′8″. Collection, The Museum of Modern Art, New York. Acquired through the Lillie P. Bliss Bequest.

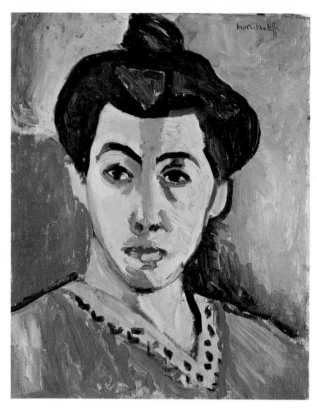

Plate 32 Henri Matisse. *Portrait of Madame Matisse, Portrait with Green Streak.* 1905. Oil. Royal Museum of Fine Arts, J. Rump Collection, Copenhagen.

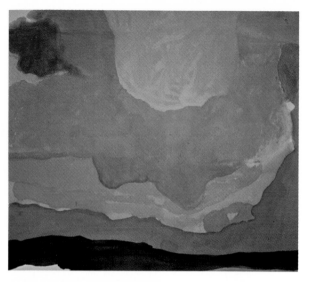

Plate 33 Helen Frakenthaler. *Flood.* 1967 Synthetic polymer on canvas, 124″ x 140″. Collection of The Whitney Museum of American Art, New York. Gift of the friends of the Whitney Museum of American Art. Photo, Geoffrey Clements.

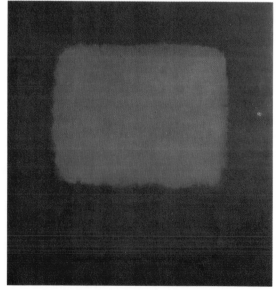

Plate 34 Mark Rothko. *Number 19.* 1958. Oil on canvas, 7′11¼″ x 7′6¼″. Collection, The Museum of Modern Art, New York.

Plate 36 Alice Trumball Mason. *Shafts of Spring.* 1955.
Collection of Stella Russell.

Plate 37 Frank Stella.
Agbatana I. 1968. Fluorescer
acrylic on canvas, 120″ x 18
Collection of The Whitney
Museum of American Art, Ne'
York. Gift of Mr. and Mrs.
Oscar Kolin. Photo, Geoffrey
Clements.

Plate 38 Victor Vasarely. *MC 12*. No. 13 of an edition of 50. Iboya sculpture. 34″ x 6″. Courtesy, Gilbert Galleries. Photo, HAMMONDBALL.

Plate 39 Stephen Antonakos. *Red Box over Blue Box, Inside Corner Neon*. 1973. Neon cubes, 49¾″ x 24″ x 28″. La Jolla Museum of Contemporary Art.

Frank Lloyd Wright An American architect who contributed many ideas to the International Style, Frank Lloyd Wright (1869–1959) developed a personal style that never fit any category. Brilliant, rebellious, and innovative, Wright was influenced by Louis Sullivan, with whom he worked for a time. Even in the early years of his career, Wright opposed the traditional architectural method which borrowed styles from the past. He believed that every building should be an expression of the needs of its owners and its functions. The Imperial Hotel in Tokyo, which Wright designed in the early years of the century, was constructed with new structural methods that were designed to withstand the earthquakes that occur in Japan. Wright's engineering was proven successful when the hotel survived the devastating earthquake of 1923. Wright also believed that materials should be treated honestly and that a building should be an expression of the materials with which it is constructed. For example, stone should look like stone and be used as a means of support rather than to cover up modern structural methods. And contemporary materials, like ferroconcrete or concrete building blocks, should be used without trying to make them look like some other material.

Because he believed that the private dwelling should be a home for the spirit as well as the body, Wright tied his houses into their natural surroundings (Figure 3-20). In this he was strongly influenced by Japanese architecture. Convinced that people must keep alive their relationship with the natural world, Wright never accepted the idea that buildings should be machines. To achieve an organic quality in his houses, he often used wood and stone, tying the lines of the houses in with the lines of the sites.

Although Wright's architectural designs changed over the years, throughout his

15-22 Frank Lloyd Wright. Imperial Hotel. 1915-22. Tokyo. Photo, Courtesy of the Museum of Modern Art, New York.

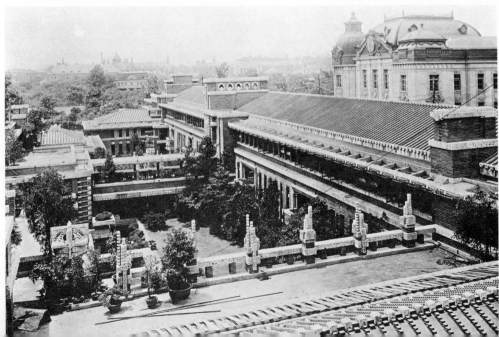

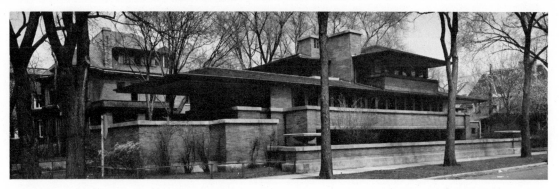

15-23 Frank Lloyd Wright. Robie House. 1909. Chicago. Photo, Courtesy of The Museum of Modern Art, New York.

career he maintained this basic belief that buildings should honestly express their purpose as well as the materials from which they are constructed. In the 1920s, for example, Wright's buildings had massive rectangular forms which had developed from his experiments with poured concrete and patterned concrete blocks. Any decorative detail came from the texture of these materials and the interplay of the blocklike masses and the open spaces. Although two later designs—the Kaufman house (Figure 3-20), which is cantilevered over a waterfall, and the Johnson Wax Tower (Figure 3-21)— show the influence of the machine-oriented designs of European contemporary architects, Wright never totally rejected his concern for natural surroundings and the spiritual needs of humans.

Wright once was asked by a student how to develop an original personal style of one's own. He responded ironically, "You can't. I invented the new architecture at the turn of the century. All you can do is learn its principles and work them." Despite the arrogance of the statement, it is true that Wright's buildings changed the course of twentieth-century architecture.

Le Corbusier In France, another architect, Le Corbusier (1887–1965), was also designing innovative functional buildings which were direct expressions of the machine age. Le Corbusier saw the house as "a machine for living in," and in his influential book *Towards a New Architecture* he urged architects to study ocean liners, airplanes, and automobiles and to move away from an architecture which was stifled by custom. Le Corbusier's Villa Savoye, one of the most famous houses of this period, best illustrates these architectural beliefs. The concrete and glass structure is close to the purist ideals of Mondrian, and the combination of its curved forms and rectangles suggests the architect's interest in

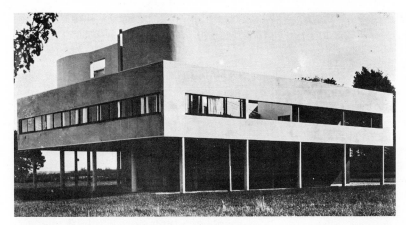

15-24 Le Corbusier. Villa Savoye. 1929-30. Poissy-sur-Seine, France. Photo, Courtesy of The Museum of Modern Art, New York.

ocean liners. The Villa Savoye has none of Frank Lloyd Wright's respect for its site; instead it seems to float above the earth, suggesting the rootless, transient quality of modern living. Many of its features, such as the slim stilts supporting the overhang, the windows in strips, and the use of concrete, were copied and adapted by later architects. Frank Lloyd Wright derisively referred to Le Corbusier's buildings as "boxes on stilts," but even he was influenced by this house, as is demonstrated by the way he used concrete and the cantilever in the Kaufman House.

Le Corbusier had a thorough knowledge of modern engineering techniques, which he used to open up the spaces of his buildings and to bring light, air, and sun into modern living. His influence on architecture was immense, but perhaps in the long run he will be remembered best for his social philosophy. He believed that not only the rich, who could afford houses like the Villa Savoye, but *all* human beings are entitled to live in buildings that will surround them with light, air, and beauty.

Dedicated to this ideal, Le Corbusier by 1915 was planning groups of inexpensive mass-produced houses made of reinforced concrete. These houses were designed to provide comfortable living in units which could be divided inside according to the needs of each family. He wrote, "If we eliminate from our hearts and minds all dead concepts in regard to the houses and look at the question from a critical and objective point of view, we shall arrive at the 'House-Machine,' the mass-production house, healthy and beautiful in the same way that the working tools and instruments which accompany our existence are beautiful."

As the movement of population to cities progressed and space became scarce, Le Corbusier gave up his early row-house concept and built vertical towers surrounded by open space. Because of his work in urban architecture, he was asked to apply his ideas of city planning to the new capital of Chandigarh in India. His work and his firm belief in the right of all persons to have decent housing are still an inspiration to city planners.

Ludwig Mies van der Rohe (1886–1969), director of the Bauhaus after Gropius, further refined the International Style, designing buildings which expressed the ideals of functionalism, but which also made use of rich materials and subtle details to bring a new elegance to the style. For the German pavilion at the International Exhibition at Barcelona in 1929 he designed what became a classic of the International Style. The plan of the small building defined its interior spaces—without isolating them from each other—through the use of steel supports, glass walls, and marble panels. The long, low, open building projects a quality of serenity and elegance through its simple lines, refined details, and sensitive use of materials. The richness of the polished marble is contrasted with chrome and glass, and the open expanse of the pool in the court is echoed in the open interior. His famous Barcelona chair and stool (Figure 7-14) were designed for this pavilion, expressing the Bauhaus ideal of carrying

good design through all aspects of a building. This sensitivity to detail and material has continued through all of van der Rohe's work. In his buildings for the Illinois Institute of Technology, in the Seagram Building in New York, and in the apartment houses on the lakeshore of Chicago (Figure 3-17), he has integrated structural materials into rational and refined compositions.

The work of these internationally famous architects, and of others who adopted their philosophies, has profoundly affected our lives. Thousands of useful objects and buildings in the last several decades have been influenced by them. Out of the chaos of changing needs, changing materials, changing technical knowledge, and changing ideals of the twentieth century, these creative minds have achieved a logical order.

15-25 Ludwig Mies van der Rohe. German Pavilion, International Exposition. 1929. Barcelona. Photo, Courtesy of The Museum of Modern Art, New York.

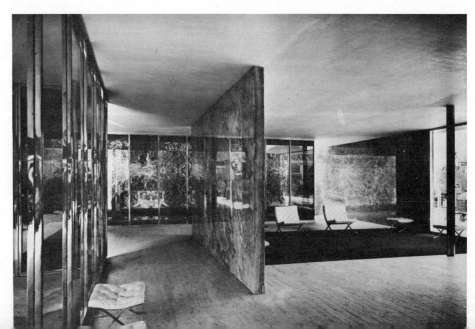

The Art of Dreams

To become truly immortal a work of art
must escape all human limits: logic and
common sense will only interfere. But once
those barriers are broken, it will enter
the regions of childhood vision and dream.

Giorgio de Chirico

While the Cubists and Futurists searched for
new ways to represent the world around
them, another influence was at work in the
world of art.

In the uneasy years after World War I,
when the hoped-for utopia failed to appear
and the world was gripped by international
tension, inflation, anxiety, and revolution,
artists and intellectuals were disillusioned
with traditional values.

Dada

A group of artists expressed their disgust in
an artistic movement which took the name
Dada. The word supposedly was found by
opening the dictionary at random, but
probably it was carefully chosen, for the
Dada artists were deliberate in their
expression of rebellion. To them, the word
meant nonart and described their total
rejection of any art of the past. Dada's

founders were laughing at the pompousness
of artists like David (Figure 13-5) and also at
the culture which supported them. Often
ironic and boisterous in their use of humor as
a tool of protest, Dada artists ridiculed the
middle-class desire for material possessions
by depicting an iron which could never work
or a cup which could never hold a liquid.

In the past, art had presented viewers with
images which came directly from the culture
in which they lived, images which they were
expected to understand. Dada artists, in
contrast, did not wish to be understood, for

16-1 Meret Oppenheim. *Object* (fur-covered cup,
saucer, and spoon). 1936. Cup, 4⅜'' diameter;
saucer, 9⅜'' diameter; spoon, 8'' long; overall height,
2⅞''. Collection, The Museum of Modern Art,
New York.

they felt they lived in an incomprehensible world, which was bound for destruction. They believed that masses of people were foolishly clinging to worn-out traditions in a world of chaos and that Dada art would help them see the absurdity of these traditions. These artists saw random happenings as governing our lives; and through their preoccupation with the accidental, they expressed the helplessness of human beings who are caught in a world they cannot understand, control, or apparently even influence in any way.

Immediately after World War I, the Dada group published the *Bulletin Dada* in which they expressed their philosophy of the nonrational and their strong antiwar and antiestablishment feelings. Dada began with poets and experimental writers but soon included painters and sculptors. "Dada was a way to get out of a state of mind, to get away from clichés—to get free," said Marcel Duchamp (1887–1968), who left behind his Cubist-inspired paintings of humans in space and motion (Figure 2-17) to concern himself with machines. In 1913 Duchamp had glued string onto a canvas and combined it with paint and varnish to recreate the childhood memory of a chocolate-grinding machine. His next step was to make constructions using ordinary mass-produced objects, combining them into what he called *ready-mades.* The first such construction consisted of a bicycle wheel fastened to a kitchen stool in such a way that the wheel could be spun easily. Duchamp's ready-mades were an outgrowth of the *collages* which he, along with Picasso and Braque, had made by pasting pieces of cloth, newspaper, and string to their

16-2 Marcel Duchamp. *Bicycle Wheel* (third version after lost original of 1913). 1951. Assemblage: metal wheel, 25½" diameter, mounted on painted wood stool, 23¾" high; overall, 50½". Collection, The Museum of Modern Art, New York; The Sidney and Harriet Janis Collection.

canvases (Figure 2-10). In this new method of assembling bits of actual objects into compositions, painters had moved away from the representation of reality itself. The question then became; which is reality and which is art? The Dada artists believed that art was found in the process of selection. Duchamp's ready-mades emphasized his belief that there is no boundary between life and art. Like the literary movement of Nihilism, Dadaism protested against a world which gave false values to life, and Duchamp's constructions expressed his disgust with assembly-line production of material goods. In bringing together everyday experiences and common objects in totally new combinations, Duchamp was commenting on the absurdity of human attachments to familiar objects in a world which he believed to be illogical.

Also commenting on human attempts to find salvation through materialism, Man Ray (b.1890) transformed a flat iron into a work of art by gluing a row of tacks to it. Here, a useful object in the hands of a Dada artist becomes nonfunctional and leads us to wonder if modern man has become nonfunctional also. Dada objects like these also posed the question of whether a culture which produces masses of material goods is the answer to human anxiety and alienation.

In addition to making these objects, Dada artists assembled nonart from the contents of wastebaskets and wrote manifestos against a world which no longer held any meaning for them. Their iconoclastic creations helped to destroy old concepts of order and reality in art. By juxtaposing art with nonsense, they expressed their view that in a world which has no reason, art has no reason, and it is useless for an artist to try to find any rules of order.

Surrealism

In the postwar years, while some artists were trying to develop a new order based on carefully composed mechanical and geometric forms (Plate 8), other artists and writers discarded all the usual traditions of control, composition, and rational order. They experimented with automatic writing, wrote poetry by drawing words at random out of a hat, and painted the world of dreams and the subconscious. Three of the artists involved in this new movement—Francis Picabia, Max Ernst, and André Breton—brought their ideas together in 1922 in a *Manifesto of Surrealism,* thereby giving a new name to the art of vision and dreams.

Relying on the subconscious as a creative force and influenced by Freud and Jung, Surrealist poets and painters tried to strip away the facade which covers up our unconscious desires. Bringing wish fulfillment to art, they used scribbles, doodles, or drips to chart vital life processes and created ambiguous landscapes from organic or sexual forms. In 1925, the first group exhibition of Surrealists contained works by such now-famous artists as Hans Arp, Giorgio de Chirico, Max Ernst, Paul Klee, Man Ray, Joan Miró, André Masson, and Pablo Picasso. Not all these men continued to paint in the Surrealist manner, and others joined the movement later, but this exhibit included the core of the group.

The subconscious, which the Surrealists tapped for their images, had been used as a source of art long before their movement began. This world of dream and the fantastic had been explored by earlier artists, such as Hieronymus Bosch (1450–1516) in *The Garden of Delights.* In this triptych, Bosch expressed his reactions to the devastating

16-3 Man Ray. *Gift* (replica; 1921 original destroyed). c. 1958. Painted flatiron with metal tacks. 6⅛″ x 3⅝″ x x 4½″. Collection, The Museum of Modern Art, New York. James Thrall Soby Fund.

plagues, death, and destruction of his time. On the left panel of the triptych, we see evil invading the world after the Creation and Adam and Eve being driven out of Paradise. On the right panel, fearful demons—half animal, half machine—endlessly punish sinful humans. The central panel is another world— a garden of joyful sexual pleasures in which sin does not exist. Although the Medieval spirit, with its fear of hell, was strong in Bosch's painting, the artist also drew on his own subconscious fantasy world to find the images with which to express that Gothic spirit.

Other artists in the past had also found their images in the depths of their own minds. Henri Rousseau (1844–1910), for example, was a self-taught artist who painted an enchanted world in which his dreams

16-4 Hieronymus Bosch. *Garden of Delights*. c. 1500. Oil on panel, triptych. The Prado, Madrid.

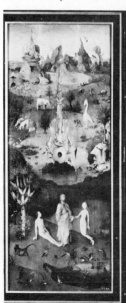
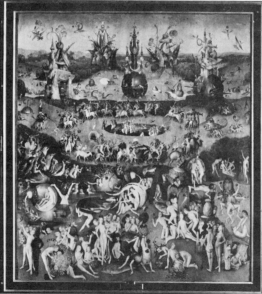
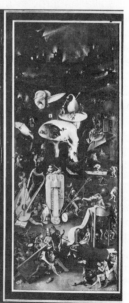

unfold in an exotic atmosphere. A customs inspector who was naive and untrained in his approach to art, Rousseau became friends with many well-known painters who encouraged him to stay close to his individual style and not try to learn academic techniques. Thus, unspoiled by exposure to traditional rules, Rousseau painted mysterious canvases, like the *The Sleeping Gypsy,* which anticipated the limitless space of later Surrealist paintings.

One of the earliest twentieth-century Surrealists was the Italian metaphysical painter Giorgio de Chirico (b.1888), who wrote, "Everything has two aspects: the current aspect we see and the ghostly which only rare individuals see in moments of clairvoyance and metaphysical abstraction." De Chirico's canvases are full of lonely space and express a sense of a menacing supernatural power. In *The Melancholy of Departure* he used distorted linear perspective to create an eerie space, broken only by shadows cast by empty buildings, with tiny figures, a train, and a clock ticking off the minutes before departure. Many of these same images are repeated in other de Chirico paintings, where speaking in a symbolic language of dreams, mystery, and ominous silence, he used a distant horizon and empty architectural settings to express the infinite time and space of the subconscious mind. There, events and feelings from the past can exist in the present without reference to everyday concepts of time and space. A poet and novelist, de Chirico also had a strong feeling for architecture, which he used in most of his paintings to create a mood. He said that among the many senses that modern painters have lost, an understanding of architecture was a vital one. To him, a landscape enclosed in an arch or seen through a window acquired "a greater

16-5 Henri Rousseau. *The Sleeping Gypsy.* 1897. Oil on canvas. 51″ x 79″. Collection, The Museum of Modern Art, New York. Gift of Mrs. Simon Guggenheim.

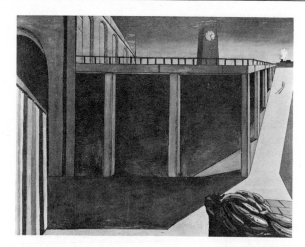

16-6 Giorgio de Chirico. *Gare Montparnasse (The Melancholy of Departure)*. 1914. Oil on canvas. 55⅛" x 72⅝". Collection, The Museum of Modern Art, New York. Fractional gift of James Thrall Soby.

16-7 Paul Klee. *Around the Fish*. 1926. Oil on canvas. 18⅜" x 25⅛". Collection, The Museum of Modern Art, New York. Abby Aldrich Rockefeller Fund.

metaphysical value, because it is solidified and isolated from the surrounding space."

Another Surrealist, the Swiss artist Paul Klee (1879–1940), who taught at the Bauhaus school, tried to free himself from the accumulation of historical styles by digging deeply into his own inner being. He wrote, "Everything vanishes around me and good works rise from me of their own accord. My hand is entirely the implement of a distant sphere. It is not my head that functions but something else, something higher, something more remote." To help keep in touch with his subconscious, Klee left himself open to new associations and new ideas throughout the painting process, developing the images which were suggested to him in a splash of color or a line. By working in this way, he could refine his painting in a disciplined manner without losing the spontaneity of accident and free association. Klee decided on a title after he had finished a painting, for he did not know at the beginning what might emerge. Like many other Surrealist artists, Klee was a writer as well as a painter and frequently expressed his belief in the importance of intuition as opposed to analysis.

Following the Surrealist doctrine of the accidental, painter-sculptor Hans (later called Jean) Arp (1887–1966) experimented with organic abstractions whose forms were often produced by tearing or cutting paper and allowing the pieces to drop onto the canvas. In these compositions he favored amoeba-like forms with curving contours, mushroom-shaped heads, and round dot eyes, or simplified egg or navel shapes. To him, art was "a fruit which grows out of a man like a fruit out of a plant like a child out

16-8 Jean (Hans) Arp. *Objects Arranged According to the Laws of Chance or Navels*. 1930. Varnished wood relief. 10⅜″ x 11⅛″. Collection, The Museum of Modern Art, New York.

of a mother.'' He disagreed with Mondrian (Plate 8), who believed that art must be carefully contrived and artificial. On the contrary, Arp's paintings, sculpture, and constructions grew out of his belief that ''art is of natural origin . . . spiritualized through man's sublimation.'' In *Objects Arranged According to the Laws of Chance or Navels,* he used flat organic shapes of painted wood made into small constructions or larger murals. But perhaps his love of nature is best expressed in his stone sculpture, with its sensuous and organic forms that are smooth and simple like waterworn rocks. Arp's free-form shapes have greatly influenced

contemporary industrial designers, but they have been copied and vulgarized so often that unfortunately they have lost some of their impact. Mass-produced cocktail tables, lamps, and ashtrays which are weak copies of Arp's elegant and subtle shapes have been made throughout the world, causing us to lose sight of the original purity of his work.

Like many early twentieth-century artists, Francis Picabia (1878–1953) moved from Impressionism to Cubism and then on to Dadaism and Surrealism. The son of a wealthy Cuban family, he owned a series of powerful sports cars and was considered the playboy of the Dada and Surrealist group. Always in revolt, Picabia cultivated his sense of the ridiculous and introduced nonsense into Dada's explorations of the irrational. His fascination with speed and machines was expressed in his paintings and drawings, which freely copied the working diagrams of engineers and combined mechanical forms in an unexpected and often erotic symbolism. In a 1919 drawing called *Dada Movement,* which depicts meters and gongs, Picabia lists the names of many of the artists who were then experimenting with new ideas in art—Matisse, Arp, Picasso, Duchamp, and Kandinsky.

Picabia was a poet as well as a painter, and, like so many of the Surrealists, he utilized the titles of his artworks as an important part of his artistic statement. Probably no movement in the visual arts has been as absorbed with words as was the Surrealist movement. Puns, free associations, and nonsense statements fascinated these artists who loved to play with words. The Spanish painter Salvador Dali (b.1904), whose explanations of his paintings are

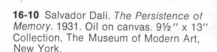

16-9 Francis Picabia. *Dada Movement*. 1919. Pen and ink. 20⅛" x 14¼". Collection, The Museum of Modern Art, New York.

purposely enigmatic, said that "all men are equal in their madness." His paintings reflect this aspect of all our lives. Neurotic, brilliant, and arrogant, Dali is a master at self-publication and has become the most widely known of the Surrealists. He joined the movement late, and many of the Surrealist artists considered him too theatrical and flamboyant to be taken seriously. Technically an extremely skilled and disciplined painter, Dali creates dreamlike landscapes filled with images from his own subconscious. In *The Persistence of Memory,* time wilts in a deserted world which goes on forever. In that world ants cavort in an empty watchcase, and a warped headlike image in the foreground suggests the last remnant of a doomed, vanishing humanity. Many of Dali's distorted shapes are related to the strange eroded rocks which can be found on the coast of Spain where he lives and where

16-10 Salvador Dali. *The Persistence of Memory*. 1931. Oil on canvas. 9½" x 13" Collection, The Museum of Modern Art, New York.

he spent his summers as a child. The ominous forms of these rocks appear again and again in Dali's paintings.

Another Spaniard, Joan Miró (b.1893), used abstracted shapes and images in his inventive Surrealist paintings which combine humor and horror, delight and nightmare. Some of the images in Miró's poetic paintings are recognizable, while others remind us of strange plants and animals, which Miró said he saw in hallucinations when he was a starving young artist. Although they are carefully composed, his paintings have a quality of spontaneity which is reminiscent of the prehistoric cave paintings of Altamira in his native Spain.

Like the other Surrealists, Miró often described his work. About the painting *Carnival of Harlequin* (Figure 2-15), he wrote, in typical Surrealist prose,

> The ball of yarn unraveled by the cats dressed as Harlequins of smoke . . . throbbing like the throat of a bird at the contact of a woman . . . at this period I plucked a knob from a safety passage which I put in my eye like a monocle . . . eyes falling like a rain of lyres . . . falling stars crossing the blue space to pin themselves on the body of my mist which dives into the phosphorescent ocean after describing a luminous circle.

Despite the apparent freedom of his work, Miró was trained in Spain in the academic tradition, and there is nothing undisciplined about his delightful and seemingly childlike paintings. Although he was anti-intellectual, passionately fond of color, and hostile to tradition, he nevertheless produced paintings,

sculpture, lithographs, and ceramics which were extremely subtle and brilliantly composed. He was also active in the world of the theater and ballet, designing sets and costumes for the famous Diaghilev ballets, and it is from this period that *Carnival of Harlequin* dates. Of all the Surrealists, Miró perhaps had the strongest influence on painters of the later Abstract Expressionist movement.

Painters of Fantasy None of the Surrealists can match the joy expressed in the paintings of Marc Chagall (b.1887), whose fairytale fantasies are based on memories of his childhood in a Russian ghetto. Brought up in the Hasidic tradition, Chagall filled his paintings with fiddlers, Talmudic scholars, and peasant women. Instead of Surrealist anxiety and hallucination, he expressed joy, festivity, love, and fun—all painted with a sensuous delight in the color and texture of the paint. In his romantic fantasies, Chagall transports us magically to the world of folklore and childhood dreams. In this he is closer in many ways to Henri Rousseau (Figure 16-5) than to the Surrealists, although they claimed him as a colleague. Actually Chagall is unique as an artist, and his compositions of simple peasant figures, floating cows and roosters are richly painted in a personal style that fits into no one group or movement. In this portrait of himself and his wife, Chagall expresses the euphoria of love with rich colors and imagery, leading us into a nostalgic world of adolescence and perennial romanticism.

The Surrealists had gloried in the unexpected and the contradictory. Certainly there was an element of shock for shock's

16-11 Marc Chagall. *The Three Candles.* 1938-40. Oil on canvas. 51″ x 64″. Courtesy The Reader's Digest Association.

bread become clouds; or a room as perfect in scale and detail as a van Eyck interior (Plate 23) may contain a huge apple or a haircomb which almost reaches the ceiling. A room full of empty discarded clothes may bulge with invisible human forms, becoming a chronicle of past events.

Painted in a meticulous, realistic style, most of Magritte's paintings present the incredible as an accomplished fact. Because there appears to be no difference between truth and illusion in his paintings, Magritte makes us suspicious of both the painted world and the real world. For example, in one painting a tobacco pipe is labeled "This is no pipe." Although on the surface this statement seems contradictory, actually it is true, since the painted image of a pipe and an actual pipe are *not* the same—the painted

16-12 René Magritte. *The False Mirror.* 1928. Oil on canvas. 21¼″ x 31⅞″. Collection, The Museum of Modern Art, New York.

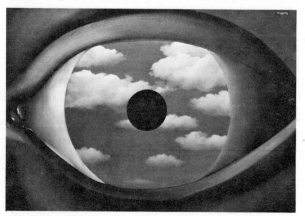

sake and of childishness in the way they expressed their rebellion against tradition. But the unexpected *is* part of life, and artists who are able to express life's contradictions can help us learn to accept them.

René Magritte (1898–1967) was another artist who used unexpected and disturbing images in his paintings. Heavy dark rocks float lightly through soft blue skies; loaves of

pipe cannot be smoked. In another canvas, painted in 1964, Magritte depicted a room with a window whose glass is broken. Through the window we can see a sunset as well as a landscape which is continued on the broken window propped against the wall. We wonder which of the two painted landscapes really exists. Whereas the Surrealist philosophy is to look for and enjoy the surprise of opposites, Magritte's interest is in the contradictions which are posed by realistic painting. In these painted commentaries on René Descartes's statement "I think, therefore I am," Magritte presents us with a world in which we see dreams as objects and objects as dreams.

The fantastic and visionary current in art represented by the Surrealists has continued to the present day in sculpture, painting, and assemblage. Just as the Surrealists protested an industrial society which destroyed human individuality so that greater quantities of material goods could be produced, so artists today protest the world of atomic destruction and the computer.

Guernica, a Universal Statement

Where do we place Pablo Picasso? He defies any kind of classification. Cubist, Expressionist, Classicist, Surrealist—any of these labels would fit him, yet none would describe more than a portion of his work. Born in Spain in 1881, he died in France in 1973, having lived there throughout his creative life, contributing to the international art world with his vitality and inventiveness. An energetic artist who worked hard until the end of his life, Picasso produced thousands of paintings, drawings, ceramics, etchings, sculptures, and lithographs in a rich and varied outpouring of artistic expression (Plate 9, Figure 15-1). In his work, lush colors alternate with muted soft tones, sketchy images of bullfights contrast with amusing ceramic pots and jugs (Figure 8-3). But it is probably for his large painting, *Guernica,* that Picasso will be best remembered.

Guernica was painted during a few weeks in the spring of 1937 after the German planes supporting General Franco had attacked a nonstrategic village in a test run of saturation bombing. The village was totally destroyed. Picasso's twenty-six-foot-long black, white, and gray painting was his memorial to those who had perished—his agonized protest against senseless destruction of human lives. The many studies which Picasso made for the painting show the gradual evolution of the images—from three-dimensional drawings of distorted, screaming mouths and fragmented bodies to the flat, abstracted shapes of the final painting. In *Guernica,* a mother clutches a dead child, a woman falls from a flaming house, and a horse dies from the thrust of a spear. The bull, a symbol of evil in many of Picasso's etchings, stands triumphantly over the dead and dying villagers, while a glaring, single light bulb stares down like a cold eye on the scene of death. It is difficult to experience from a small photograph the full impact of one of the strongest antiwar statements of our century. Universal in its images, this painting protests the destruction of human life in war and could represent a

village in Vietnam, the Middle East, or
Northern Ireland—anywhere the horror of war
kills innocent people.

As the world continued to change
violently, artists continued their search for
new forms to express their anxiety. New
images were needed to reflect the mounting
insecurity of a world which left humans
isolated and alone, shattered and torn by
forces beyond their control. In the following
chapters we will examine some of these new
forms of expression.

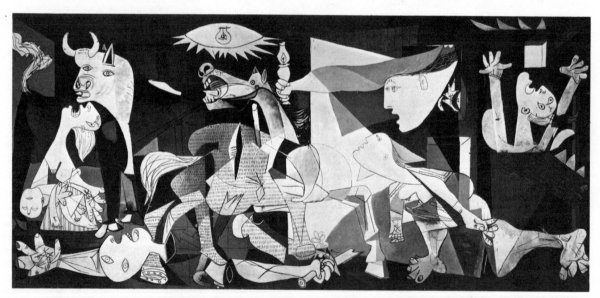

16-13 Pablo Picasso. *Guernica*. May to early June, 1937. Oil on canvas. 11'5½'' x 25'5¾''. On extended
loan to The Museum of Modern Art, New York, from the artist.

Social Protest and Figurative Art

One can analyze epoch after epoch—
from the stone age to our own day—
and see that there is no form of art
which does not also play an essential
political role.

Diego Rivera

After several years of postwar euphoria, the world slid into the Great Depression of the late twenties and early thirties. In America, even before the Wall Street crash of 1929, there was poverty, and its accompanying misery, in cities as well as in rural areas and small-town America. As the Depression gripped the country, social problems multiplied. In response, art in the United States became socially conscious, realistic, and often nationalistic.

During the first decades of the twentieth century, some American artists continued to follow the conservative artistic traditions which were modeled on European academic painting. Others turned to contemporary Europe with its radical new movements. Still others followed in the steps of the Ashcan school, which painted commonplace subject matter in rebellion against fashionable painting.

The United States also had a tradition of realistic painting to which artists such as Thomas Eakins (1844–1916) and Winslow

Homer (1836–1910) brought a new freshness by painting subjects from rural American life or from the everyday life of middle-class citizens. The Ashcan painters who followed—such as George Bellows (1882–1925) and John Sloan (1871–1951)—found even more ordinary subjects in backyards, city streets, and bars. Sloan, who preferred working people to the middle class, produced many paintings and etchings of the depressed lives of the poor.

17-1 Winslow Homer. *The Gulf Stream.* 1899. Oil on canvas. 28⅛″ x 49⅛″. The Metropolitan Museum of Art, Wolfe Fund, 1906.

In 1913 the International Exhibition at the New York City Armory brought European radical art to the United States. Thus, Americans were exposed to paintings like Duchamp's *Nude Descending a Staircase, No. 2,* which created a furor (Figure 2-17). The influence of Cubism, Futurism, and Expressionism on young artists was inescapable. Although Paris and the artistic experiments going on there would attract adventurous artists from the United States for the next several decades, at the same time many painters and sculptors began to see themselves as American artists and to believe that their art should reflect American life and problems.

Out of these currents—the academic insistence on rules, the new radical European experiments, and a delight in ordinary America—artists in the United States were slowly developing a sense of identity as creative Americans.

The Depression Years

With the Depression, the United States turned inward, preoccupied with its own misery, frightened and disillusioned by the failure of the economy as well as by the failure of the League of Nations. Hopelessness and despair were reflected in photographs like Dorothea Lange's (b.1895) *Migrant Mother,* as artists turned to social issues for their subject matter and themes (Figure 6-7). Unemployment, however, was not confined to factory workers. Artists were in the bread lines as well, and a Federal Art Project was initiated to counteract unemployment. Under this project, artists were commissioned to paint murals in public buildings. This was the first broad governmental program of support for the arts in hundreds of years.

Before the 1930s, most artistic expressions of political and social criticism in the United States had been limited to cartoons. But the Depression inspired the first American movement to combine serious artistic expression with social protest in the tradition of Goya, Daumier, and Picasso. One of the artists involved in this movement was Ben Shahn (1898–1969), whose work powerfully expressed the tragedy of human degradation and social injustice. He painted isolated city dwellers, victims of official

17-2 Ben Shahn. *The Passion of Sacco and Vanzetti.* 1931-32. Tempera on canvas. 84½" x 48". Collection of the Whitney Museum of American Art, New York. Gift of Edith and Milton Lowenthal in memory of Juliana Force. Photo, Geoffrey Clements.

injustice, and the starving wives and children of coal miners. Shahn, like many American artists of the period, incorporated the influences of Cubism and Expressionism into his paintings of social criticism. In *The Passion of Sacco and Vanzetti,* Shahn protested the martyrdom of the two immigrants who he, along with many other Americans, believed were victims of personal and political prejudice.

On the other hand, Edward Hopper (1882–1967), a follower of the Ashcan school, stayed very close to American realistic traditions, commenting on human isolation with paintings of empty city streets and lonely houses. Hopper, who supported himself for years as a commercial artist, insisted that his aim in painting had always been "the most exact transcription possible

of my most intimate impression of nature." While this may have been true, his sensitive eye carefully selected and reorganized colors, forms, and light patterns in order to convey the sense of poignant loneliness he wished to create. His point of view is that of a traveler who stands in the street watching the lives of other desperate and lonely people through the windows of all-night cafes, empty-looking houses, and flatly-lit rows of apartments. In *Early Sunday Morning,* without seeing a single person, we sense the isolation of individual humans caught in their own cycles of life and death within the alienating life of the city. Each area of the painting is reduced to the barest essentials, and the row of lonely windows and empty shops is organized into a quiet, almost formal, vertical and horizontal

17-3 Edward Hopper. *Early Sunday Morning.* 1930. Oil on canvas. 35″ x 60″. Collection of The Whitney Museum of American Art, New York. Photo Geoffrey Clements.

composition which implies, rather than depicts, the misery behind the pulled-down shades.

After the stock-market crash of the late twenties, people no longer could depend on the marvelous world of progress and its economy of expansion to give them a sense of security. With a strong personal viewpoint, Ivan Albright (b.1897) used an almost microscopic form of realism to express his response to the disintegration of the individual in a hostile world. Of *Poor Room,*

which shows a clutter of Victorian decadence seen through a broken basement window, Albright said, ''Poor Room—There is No time, No end, No Today, No Yesterday, No Tomorrow. Only the forever and forever and forever without end.'' The sense of decay and rotting flesh that pervades Albright's still lifes and figure paintings turns them into intense statements about the impermanence of material possessions and of human life itself.

As the Depression wore on, isolationists in America became politically more important, and their ideas influenced a group of artists in the Midwest. At first these artists depicted the world around them with a satirical eye, but as time passed they became more isolated and more patriotic in their outlook, turning their anger against foreign influences in art rather than toward the absurdities of the provincialism and conservatism around them.

Before becoming such a chauvinist, Grant Wood (1892–1942) painted his famous *American Gothic.* This painting, which combines humor with a respect for the hardship of farm life, shows the farmer and his wife as solemn, narrow-minded, suspicious provincials. Many such inhabitants of rural and small-town America viewed the culture of Europe with suspicion, although their ancestors had come from the Old World. Now, fearful that what they had

17-4 Ivan Albright. *Poor Room:* There is No Time, No end, No Today, No Yesterdav. No Tomorrow, only the forever, and forever and forever and forever without end. 1941-43, 1948-55, 1957-62. Oil on canvas, 48″ x 37″. Courtesy of The Art Institute of Chicago. Collection of Mrs. Ivan Albright.

17-5 Grant Wood. *American Gothic*. 1930. Oil on beaver board. 29⅞″ x 24⅞″. Courtesy of The Art Institute of Chicago. Friends of American Art Collection.

accept the dedication of one of his works because it had been painted outside the United States.

During the thirties, some areas of Midwest farm and grazing land became dust bowls because of improper farming methods that allowed the soil to be stripped by erosion. A series of drought years furthered the destruction, and drifting sand and dust storms forced families to leave what once had been treasured farms. Georgia O'Keeffe (b.1887) absorbed European influences to develop a personal style, and her paintings of barns, mountains, and whitened bones express the barren life in the southwestern states where she settled. She selects her imagery from both the manmade and the natural landscape. Whether painting a

17-6 Georgia O'Keeffe. *The White Flower*. 1931. Oil on canvas. 30″ x 36″. Collection of The Whitney Museum of American Art, New York. Photo, Geoffrey Clements.

worked so hard to amass might be lost in the Depression, they clung to their possessions, their beliefs, their morals. *The Daughters of Revolution* by Wood is a satire on the conservatism of this strata of American society. In this painting the artist depicts the severe elderly ladies as somewhat pathetic, while at the same time he ridicules the attempted gentility with which they hold their teacups. The sardonic quality of the painting hints at Wood's feud with the Daughters of the American Revolution, who had refused to

close-up view of a flower, New York skyscrapers, the bleached skulls of western deserts, or the clouds seen from a jet plane, she presents an unusual point of view and precise style that give new meaning to the objects. The smoothness of her technique, the extreme close-up view of her perspective, and the enlarged scale of the objects tend to convert most of her work into almost abstract images, which at times are intense and terrifying in their starkness.

A painter who combined European influences with native American traditions is Peter Blume (b.1906), who has always commented on contemporary human problems. Frequent travels to Italy gave Blume a Renaissance sense of space, but exposure to both Cubism and Surrealism also had an impact on his work. The importance of structure to the Cubists and

their simplification of form can be seen in his paintings, as can the unexpected combinations of images used by the Dadaists. At the same time, Blume paints in a meticulously realistic style, each of his works requiring years to finish. His paintings are documents of social protest expressed in symbols that sometimes are difficult to understand and sometimes, like the jack-in-the-box head of Mussolini in *The Eternal City,* are very obvious.

Photography—Still and Moving During the thirties, technology in both cinema and still photography improved greatly. New and faster films, new lighting methods, and more sophisticated lenses made for greater flexibility; and magazines which featured photojournalism became popular. The Farm Security Administration of the federal

17-7 Peter Blume. *The Eternal City.* 1937. Oil on composition board. 34″ x 47⅞″. Collection, The Museum of Modern Art, New York. Mrs. Simon Guggenheim Fund.

government used skilled photographers to
record the life of rural America during the
Depression years. These sensitive and
perceptive photographers produced prints
which were unquestionably fine art. Dorothea
Lange, in particular, commented on the tragic
plight of the farmers who were driven from
their homes in Oklahoma by dust storms. Her
photograph of women and children (Figure
6-7) from this period has become a classic.
Like other Lange photographs, it is realistic
and objective, for she never used gimicky
angles or lighting to increase the
expressiveness of her work. In this photo,
which is much more than a mere recording,
the faces and poses of the people speak for
themselves.

In commercial cinema, the need for mass
escapism that was felt during the Depression
led to slick sophisticated comedies and
elaborately staged singing and dancing
shows. Charles Chaplin (b.1889), however,
continued to produce satirical comedies
which depicted the lonely fate of human
beings in a hostile environment. He
commented on the world of machinery or on
the rising European dictatorships in such
films as *The Great Dictator* and *Modern
Times.* These films also describe the
loneliness and isolation of those who refuse
to conform to the dictates of the world
around them—whether it be a factory or an
oppressive political regime.

The creativity of Chaplin was matched in
another area of cinema in the twenties and
thirties. In *Nanook of the North* (1922) and
other documentaries depicting the struggle
for existence of people in difficult natural
environments, Robert Flaherty developed an
objective style of film reporting which
influenced documentary filmmakers in the

17-8 *The River.* 1937. Film produced by the Farm
Security Administration. The Museum of Modern Art/
Film Stills Archive.

1930s. Of these, Pare Lorentz (b.1905), in
particular, produced films, like *The River,*
which told the story of the ordinary person's
struggle to live during the misery of the
Depression years. The techniques developed
by these filmmakers later were used during
the years of World War II for army films and
have continued to influence documentary
filmmaking ever since.

Black American Art

Art in the United States did not just reflect
the contributions of the European settlers
who brought their cultural backgrounds to the
new continent. We have already seen
examples of the highly developed arts of the
New World Indians (Figures 14-16,14-17).
The legacy of the Black American to the

growth of our national visual art is immeasurable as well and goes far back into American history.

Many Blacks were craftsmen in colonial America, and some, like Scipio Morehead and Joshua Johnston, became outstanding itinerant portrait painters. Many portraitists of this early period recorded the faces of families in small towns and on farms, moving from town to town or from plantation to plantation.

In the later years of the nineteenth century, landscape painter Robert S. Duncanson (1817–1872) was able to go abroad for art education through the support of antislavery societies. His example encouraged other Black painters, such as Edward M. Bannister, Henry O. Tanner, and William Harper. Bannister was noteworthy as the first Black

artist to receive major recognition in a national competition. His painting *Under the Oaks* was awarded a gold medal in the Philadelphia Centennial of 1876. Henry O. Tanner, a favorite student of Thomas Eakins, became a leading painter of religious subjects, whose work influenced other Black artists well into the next century.

Despite this early activity in the arts, not until the late 1920s and 30s did American Blacks enter the mainstream of social protest in art or develop an art based on an appreciation of their own heritage. At this time they began to look searchingly into their own background and to respond with pride in paintings which reflected their strength. Archibald Motley (b.1891), for example, dealt with African themes, as did several other Black artists.

Not only artists, but intellectuals as well, reflected the growing self-respect among Black Americans in the twenties. Prominent among them was writer Alain Deroy Locke, who collaborated in 1925 with artist Aaron Douglas (b.1899) to produce *The New Negro,* an illustrated anthology of writings by Black sociologists and political scientists. The impact of this book resulted in new orientations for American Blacks, for up to this time few Black artists had incorporated the influence of African art into their work. Douglas also combined African simplifications with a personal symbolic style in murals he painted at a branch of the New York Public Library. These murals were

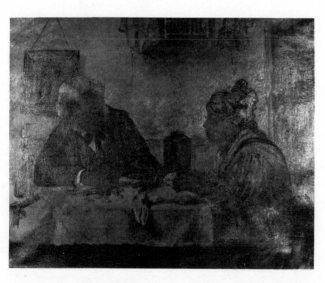

17-9 Henry O. Tanner. *Savings.* 1888–89. Oil on canvas. 22″ x 17″. Collection of Spelman College.

17-10 Aaron Douglas. *Aspects of the Negro Life* (detail). 1934. Oil on canvas. 5′ x 11″. Schomburg Center for Research in Black Culture, New York Public Library, Astor Lennox and Tilden Foundation.

exotic to an exaggerated degree and used extreme elongations and distortions, along with a pattern of mystical light which seemed to reflect the artist's deep love of his racial heritage.

This rediscovery of African culture provided inspiration for many Black American artists who sensed and cultivated a close kinship with it. Aaron Douglas, who led the way into a new era in Black art, soon was followed by Charles Alston, Charles White, Richmond Barthe, Sargent Johnson, and Elmer Brown. These Black artists, sponsored by the Works Projects Administration (WPA), contributed significantly to the development of American art of the thirties.

By 1941 Jacob Lawrence (b.1917) (Figure 1-9) had emerged as a vigorous artist who drew material from the historical background of his race as well as from everyday life. His

17-11 Charles White. *Preacher*. 1952. Ink on cardboard. 21⅜″ x 29⅜″. Collection of The Whitney Museum of American Art, New York. Photo Geoffrey Clements.

subject matter, his flat, vividly colored shapes, and his originality established Lawrence as an exceptional painter. His gouache painting *Going Home* expresses the fatigue of the train travelers with drooping shapes that contrast with strong horizontal and vertical lines. The only active figure is the man reaching hurriedly for his suitcase as the train nears the station.

Among the self-taught painters of the world, Horrace Pippen (1888–1946) may be ranked close to the French painter Henri Rousseau (Figure 16-5). Although the world he depicts is sometimes terrifying, Pippen's vision, his gift for composition, and his dramatic power give his works a deeply expressive quality.

Only a few Black American artists have limited their work to ethnic subjects. By far the larger number have worked within the mainstream of American art movements

during the twentieth century, seeing themselves primarily as American, rather than ethnic, artists.

Mexican Protest Painting

In Mexico during the late 1920s and early 1930s, the currents of revolutionary protest, ancient native art, and European fresco techniques came together in a creative movement which produced great mural painters. The work of José Guadalupe Posada (1852–1913), who was a popular engraver, also influenced these painters. Posada, powerful and passionate in his statements about the lives of ordinary Mexicans, combined fantasy, humor, religion, and social protest in many of his engravings. His art grew out of the richness of the popular culture of Mexico, which, in turn, was influenced by the ancient traditions of

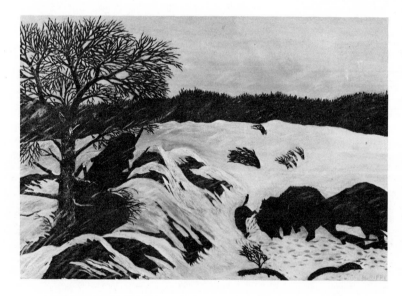

17-12 Horace Pippin. *The Buffalo Hunt.* 1933. Oil on canvas. 21¼″ x 31″. Collection of The Whitney Museum of American Art, New York. Photo, Geoffrey Clements.

CALAVERA "LAS BICICLETAS"

17-13 José Guadalupe Posada. *Calavera of the Cyclists.* Relief engraving on type metal. 5⅞″ x 10½″. Collection, The Museum of Modern Art, New York. Larry Aldrich Fund.

the Indians. The Spanish conquistadores had brought with them the typical colonizer's attitude that the only worthwhile culture was that of the homeland. Consequently, since the early days of the Spanish colonies, fashionable Mexican art had continued to look back to the art of baroque Spain (Figure 12-12). However, the vitality of the native Indian art tradition contributed greatly to the decorative riches of Mexican churches. Posada, who was in touch with the Indian culture, formed a direct link between it and the painting of Diego Rivera (1886–1957).

Rivera, who had known Posada when he was a young art student in Mexico City, had also studied in France, where he was influenced by the newly emerging theories of the Cubists. He traveled extensively in Italy as well, and the frescoes in the churches there were to have a life-long influence on his painting (Figure 5-9). In fact, Rivera was

17-14 Diego Rivera. One of a series of murals. National Palace, Mexico City. Photo, Carl Frank, Photo Researchers, Inc.

responsible for the rebirth of the traditional fresco technique in North America. His paintings show the strong influence of the formal compositions of these Italian religious paintings which had so impressed him. When Rivera returned to Mexico from Europe, he received an important assignment from the government to paint several stories of the Secretariat of Public Education in Mexico City, a project he worked on from 1923 to 1929.

Rivera's assignment to this project was the beginning of an important art movement in Mexico—a movement which used Renaissance fresco methods to depict subject matter from native Aztec legends, Mexican folk customs, as well as revolutionary social and political ideas. Scenes of revolution, peasant exploitation, and human suffering were the main themes of the important Mexican mural painters—Rivera, Orozco, and Siqueiros. Deeply involved with the Indian's struggle for a better life, these men developed a national art which reflected both the ancient history of their country and the socialist spirit of the Mexican revolutions of 1910 and 1920.

Rivera's murals for government buildings —the University of Mexico, Lerma Waterworks, government hospitals, and offices—took art out of the galleries and museums to places where it could be seen by large numbers of people. Convinced that his countrymen needed to develop a pride in their history, Rivera painted Indian myths and historical scenes that depicted the native culture, using murals in the same way that religious art in the Middle Ages was used to make the Bible a familiar part of everyday life. Although his compositions are formal, decorative, and at times stiff, Rivera faithfully chronicled the life of the peon and through his paintings brought a sense of community to the nation.

The frescoes painted by José Clemente Orozco (1883–1949) expressed their political messages with greater emotion and more dramatic images than did Rivera's murals. Trained in architecture as well as in painting, Orozco created huge murals in which crowds of peasants and workers are depicted struggling against the cold steel of bayonets and guns as if to prove that they would win by their very numbers. Orozco's works are

17-15 José Clemente Orozco. *The Modern Migration of the Spirit.* 1932-34. Fresco. 10′5″ x 10′. Courtesy of the Trustees of Dartmouth College.

powerful and brutal, filled with surging masses of humanity who strive to reach their revolutionary ideals, constantly battling against tremendous odds.

Influenced by ancient Aztec religious practices and by the cruelties of the conquering Spaniards, Orozco created figures that echo the violence and fantasy that is part of the folk tradition of Mexico. For example, the candy figures that are sold for the Day of the Dead in Mexico are similar in feeling to Orozco's skeletons and his tortured and distorted figures who protest the oppression of masses of people. He covered the walls of government buildings in Mexico with his expressive paintings. In the United States he painted murals at Dartmouth College in New Hampshire, creating a panorama of the history of Mexico in brilliant colors and striking symbols. Using greatly distorted scale, he painted overpowering figures which tell the stories of the feathered serpent-god Quetzalcoatl and of the coming of the Spaniards to Mexico. The murals also protest the destructive forces of war and the machine age. Orozco uses a graphic and dynamic style to express his anger at any form of oppression—religious, political, educational, or mechanical. The climax of the Dartmouth College murals is reached in an overwhelming figure of a militant, flayed Christ who destroys his cross, calling on oppressed peoples everywhere to arise.

After his return to Mexico, Orozco painted frescoes in various buildings in Guadalajara —frescoes that are so exaggerated in their scale, so violent and twisted in their forms, and so savage in their masses of figures that they seem to burst out of the walls of the buildings.

A younger man, David Siqueiros (1898–1974), was an artist who was just as involved in political activities as he was in painting. Siqueiros, always politically active, was even imprisoned for his political beliefs. He led in the organization of The Syndicate of Technical Workers, Painters, and Sculptors that was so much a part of the development of art in Mexico. Siqueiros's paintings are more visionary than Rivera's and Orozco's,

17-16 David Alfaro Siqueiros. *Echo of a Scream.* 1937. Duco on wood. 48″ x 36″. Collection, The Museum of Modern Art, New York. Gift of Edward M. Warburg.

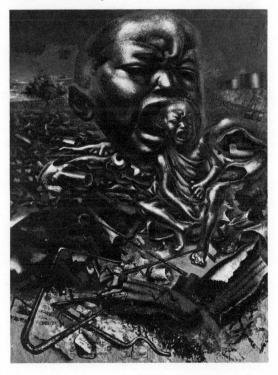

using Surrealist images to protest social injustices. Compare his *Echo of a Scream* with Picasso's *Guernica* (Figure 16-13) and Munch's *The Shriek* (Figure 5-19) to see how the three painters used similar images in quite different ways to express inhumanity and horror. Siqueiros has also experimented with new materials, using industrial enamels for his outdoor murals, which he hoped would expose his ideas and his works to the largest possible number of people. Many of Siqueiros's explorations with new materials, such as Duco enamel, had a direct influence on experiments in painting in the late 1940s and 1950s.

Artists in the United States became interested in fresco painting in the 1930s through exposure to the works of Rivera and Orozco. Supported by the WPA, they traveled around the United States painting murals on post offices and other government buildings. Most of the paintings were extremely realistic and derivative, and none reached the heights of their Mexican counterparts, particularly in the expression of social protest.

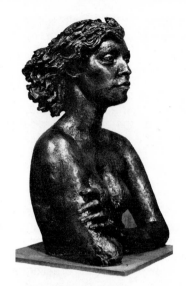

17-17 Jacob Epstein. *Oriel Ross.* 1932. Bronze. 26¼″ x 17″. Collection, The Museum of Modern Art, New York. Gift of Edward M. Warburg.

Figurative Sculpture

While the Constructivists in Europe (Figure 2-9) were exploring the relationships of nonobjective forms in space, other sculptors, both in the United States and Europe, were working with the human figure in a more realistic way.

Jacob Epstein (1880–1959), an American who settled in London in 1905, was a controversial figure almost from the beginning of his career. Although his early monumental sculptures influenced the work of British sculptor Henry Moore, Epstein's

later pieces are his most individual and expressive work. Like Rodin (Figure 4-9), Epstein left the marks of his hands and tools on the surface of the clay so that they would be transferred to the bronze cast. This technique gives a vitality to the texture of the finished sculpture.

The fertility symbol has always expressed man's eternal preoccupation with life forces. We have seen this symbol in the prehistoric Venus of Willendorf (Figure 1-14), and we see its influence again in the work of Gaston Lachaise (1882–1935), who began early in his creative life to develop the feminine

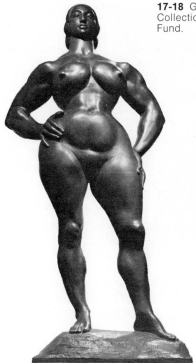

17-18 Gaston Lachaise. *Standing Woman*. 1932. Bronze. 7'4" x 41⅛" x 19⅛". Collection, The Museum of Modern Art, New York. Mrs. Simon Guggenheim Fund.

In a quite different manner, the painter Leonard Baskin (b.1922) worked in cherry wood to create a monolithic *Seated Man with Owl,* which might be compared with ancient Egyptian Ka figures (Figure 8-10). In this sculpture, both man and bird are presented in static frontal poses which give them a ponderous air of inscrutability. But whereas Egyptian sculptors left no tool marks on the stone Ka figures, Baskin revels in the gouge marks of his chisels in the cherry wood, making the process become a basic part of his work.

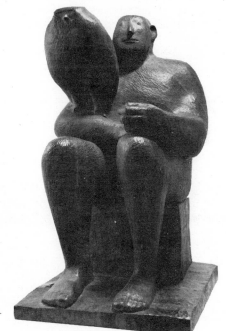

image which was to obsess him for most of his career. A female nude with mountainous breasts and thighs, but delicately tapered arms and legs, she was depicted seated in a chair, floating on a high pedestal, or as a *Standing Woman.* She is gross and heavy, a matriarchal figure, yet at the same time she stands or floats lightly with an almost classic elegance.

17-19 Leonard Baskin. *Seated Man with Owl*. 1959. Cherry wood. 30" x 17" x 17¾". Smith College Museum of Art.

Of the figurative sculptors who came to maturity in the thirties, none has been more creative than Henry Moore (b.1898), the son of an English coal miner. An early influence on Moore's sculptural growth and one that has persisted through most of his career is the Chac Mool, or Mexican Rain-Spirit, a massive stone figure with hollowed-out abdomen. The influence of this piece is evidenced in its pose, which appears in many of Moore's sculptures and in the use of cavities and negative spaces with which Moore brought a new concept of space to sculpture. The phrase *negative space* is generally used to describe the spaces between the solid forms in art. For example, the area between the arm of the *Discobolus* (Figure 9-11) and his body is a negative space. But with Moore, and with the sculptors he has influenced, the cavities and spaces themselves have become so much a

part of the sculpture that they have as strong an impact on us as the solid forms. Moore's work is highly organic, seeming to be a part of the natural world. He has explored many materials—wood, stone, bronze—and he handles each with a deep sensitivity to its innate characteristics.

During World War II Moore lived in London, where he made thousands of drawings of the families who sought refuge from the bombs in air-raid shelters and subway stations. From these drawings he developed many of his sculptures of reclining figures, mothers and children, and family groups (Figure 1-10). The simplified forms of these figures suggest the timelessness of mountains as well as the solidity of the bony structure under the human flesh. Some of his most recent figures are large bronzes which he first builds up in plaster using the method described in Chapter 4. Of his sculpture,

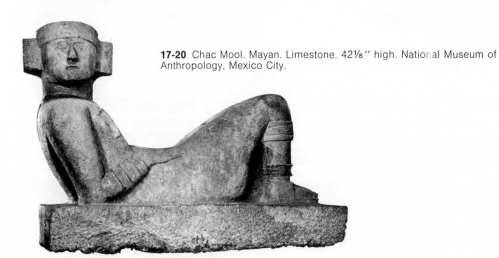

17-20 Chac Mool. Mayan. Limestone. 42⅛″ high. National Museum of Anthropology, Mexico City.

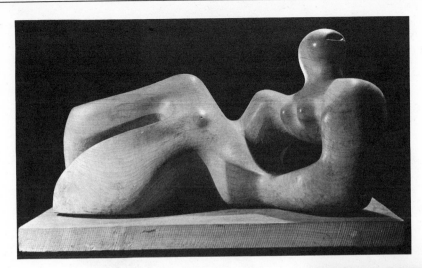

17-21 Henry Moore. *Reclining Figure.* 1935. Elmwood. 19″ x 35″ x 15″. Albright-Knox Art Gallery, Buffalo, New York.

Moore says, "Each particular carving I make takes on in my mind a human, or occasionally animal, character and personality, and this personality controls its design and formal qualities and makes me satisfied or dissatisfied as the work develops."

Two European sculptors who matured in the thirties have continued to be important international influences on sculpture. Marino Marini (b. 1901) and Alberto Giacometti (1901–1966) have used the human figure expressively to comment on human isolation and fear. In the tradition of Rodin, both emphasize surface textures. The two also have absorbed Surrealist attitudes as well as influences from early Italian figure sculpture. But their styles are quite different.

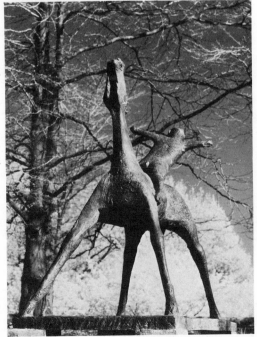

17-22 Marino Marini. *Horse and Rider.* 1952-53. Bronze. 82″ x 81″ x 46½″. The Hirshhorn Museum and Sculpture Garden, Smithsonian Institution.

Marini's subjects include female figures, portraits, and, particularly, men riding horses —horses which seem linked to the Etruscan sculpture of his native Tuscany. The sense of isolation and fear projected by these anonymous riders is not accidental. Marini watched Italian peasants fleeing from wartime air raids, and the frightened way they looked upward to watch the sky for bombers became an important gesture in his sculpture —expressing the helplessness of humans. In recent years his images have become increasingly violent and full of suffering. His stumplike vestiges of feet and hands suggest the mutilation of humans by war and make his figures appear even more isolated and mute.

The son of a Swiss painter, Giacometti created a new human image with his emaciated figures who stand so stiffly and face us so directly. His early sculpture was Surrealistic in its fantasy, but his later figures form his most characteristic work. Large or small, grouped in environments or by themselves, these figures appear alone and alienated from each other and from us (Figure 4-12). Giacometti has exaggerated the distance between the subject and the viewer by erasing the nonessential details of the human body, thereby increasing its sense of isolation. Even the space that surrounds his figures becomes a poignant part of the visual statement. As an explanation of his study of a starving dog, Giacometti said, "It's me. One day I saw myself in the street just like that. I was the dog."

Continuing the tradition of figurative sculpture, César Baldaccini (b. 1921) combined surface treatments, which stemmed from Rodin's rough textures (Figure 4-9), with his own innovative images of incomplete figures. Thus he created sculpture

17-23 César Baldaccini. *Torso.* 1954. Welded iron. 30⅜" x 23⅜" x 27⅛". Collection, The Museum of Modern Art, New York. Blanchette Rockefeller Fund.

which is far removed from traditional figure sculpture and which comments on the machine civilization from which its materials derive. Baldacini formed figures by welding together scraps of iron that he found in junkyards. The rusting deterioration of his materials suggests a comparable deterioration in the flesh of all contemporary humans. Thus the life suggested by the incomplete form becomes all the more macabre.

Although the figurative sculptures of the twentieth century did not express as strong a social protest as did the paintings in Mexico and the United States in the thirties, they nevertheless made strong comments on the isolation, paranoia, and realistic fears of modern humans caught in a world of war and grinding machines.

The Postwar World: America in Ascendancy

At a certain moment the canvas
began to appear to one
American painter after another as
an arena in which to act.

Harold Rosenberg

After World War II the main center of creative activity shifted from Paris to New York. However, this change did not happen overnight. Partly it was a result of the isolation of the United States during the Depression years and of the disruption of contact with Europe during the war. Another factor was the new sense of identity as Americans that many artists had developed while working on WPA art projects. From these shared experiences grew a sense of community, and New York became the center for the kind of informal discussion and stimulating exchange which previously had made Paris so attractive to creative individuals. Artists from other countries, such as the Mexican painters Orozco, Rivera, and Tamayo, worked and taught in New York. Many others came to visit, sharing ideas with each other. As we saw in Chapter 17, the main trend in American art during the thirties had been toward realism and social protest. However, some artists had continued during the Depression and war years to explore the possibilities of abstract and nonobjective painting, and their work became an important influence in the American art world.

New American Painting

Many important artists emerged in the United States at the end of the thirties and in the early forties. These included artists who had been born in Germany, Russia, Holland, Armenia, and other countries, as well as artists working in western states, such as California, Wyoming, and Washington. But whether they actually lived in New York or only visited occasionally, these artists are loosely classified as part of the New York school because they shared a common outlook and common artistic concerns.

Among these was an Armenian-born Surrealist whose work stands between the European-based Surrealists and the new American painters. Arshile Gorky (1904–1948) was a painter of transition whose abstract organic painting was influenced by Kandinsky (Figure 15-2), Joan Miró (Figure 2-15), the Cuban Surrealist Matta, and by Picasso. Gorky's expressive canvases contained abstract images from his childhood in Armenia—images that he developed into organic and erotic fantasies painted in a loose, free style. He brought to

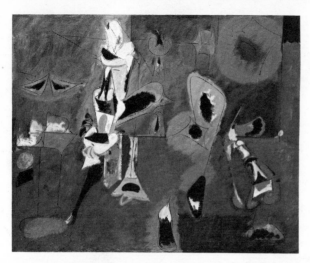

18-1 Arshile Gorky. *Agony.* 1947. Oil on canvas. 40″ x 50½″. Collection, The Museum of Modern Art, New York. A. Conger Goodyear Fund.

his painting a love of texture and of the richness of paint brushed on thickly. Compare, for example, his lively brush strokes with the tight, smooth surface of American realistic painting exemplified by Grant Wood (Figure 17-5). Gorky evolved his paintings in the automatic manner of the Surrealists, who used doodles, drips, and splashes to suggest images—drawing and painting according to impulse. In their random brush marks, these painters would see suggestions of a figure or a subject, which they would then encourage to emerge and would develop into images. This method of working by suggestion and association was important not only to the Surrealists but to those painters, such as Gorky, who were influenced by them.

Abstract Expressionism Another New York painter, Hans Hofmann (1880–1966), had been painting in a loosely brushed manner for forty years before Abstract Expressionism became a recognized style. The spontaneous effect produced by the freedom of his brush strokes was based on years of experience and technical skill. In *The Golden Wall* (Figure 2-2), rectangles of rich color are contrasted with areas of thick, loosely brushed paint. Hofmann's nonobjective paintings are highly personal, and his glowing color expresses his joyful attitude toward life. He considered the actual process of looking at a painting to be an important part of the art act. He felt that if this process is successful, the painting and the viewer will establish a relationship based on spontaneous feeling. A dedicated teacher, Hofmann influenced many younger painters through his teaching as well as through his painting.

The calligraphy of the Orient and the philosophy of Zen Buddhism were important influences on several painters at this time. According to Zen belief, when the mind and body are in accord, or centered, the hand becomes free to serve a deeper purpose, allowing the inner life of the artist to be released. This attitude toward art has been a basic part of Oriental thinking for more than a thousand years and has influenced both Chinese and Japanese painting (Figure 14-29). Mark Tobey (b. 1890), Bradley Walker Tomlin, and Morris Graves (b. 1910) were all influenced by the calligraphy and philosophy of the Orient. Tobey, who studied both in Europe and in the Orient, received from his Chinese teachers a lifelong interest in calligraphy. This interest can be seen in the "white writing" which appears over his

18-2 Mark Tobey. *The Void Devouring the Gadget Era.* 1942. Tempera on cardboard. 21⅞″ x 30″. Collection, The Museum of Modern Art, New York.

dark paintings, creating an overall texture. In *Void Devouring the Gadget Era,* painted in 1942, he comments on the twentieth century's production of materialistic trivia. In most of his work, however, the web of lines is nonobjective. Tomlin, more Cubist in his rectangular background shapes and less flowing in his lines, also has used the calligraphic approach to create flat paintings with an overall texture. Morris Graves, though more deeply involved with subject matter than Tomlin or Tobey, nevertheless has been strongly influenced by Oriental and mystical beliefs in his response to the objects of the outer world.

Other influences on the new American painting were the Expressionist painters of Europe and the transitions of color which painters like William Turner and Claude Monet developed (Plate 11 and Plate 27).

Out of these many currents—organic nonobjective painting, Surrealism, Expressionism, the rich color areas of Turner and Monet, Oriental calligraphy, and Zen Buddhism—came the style of painting called *Abstract Expressionism* which was to dominate the New York scene for a decade or more. Dribbling, spilling, splashing, and slashing, these painters were interested in the movement of the brush across or against the canvas, its load of paint, and the expressive textures which could be produced by their methods of application.

Two painters became the focal point for the new style—Willem de Kooning (b. 1904) and Jackson Pollock (1912–1956) (Plate 2). In direct opposition to the carefully composed geometric painting of Albers (Plate 1) and Mondrian (Plate 8), they brought to their painting an immediacy of emotion that

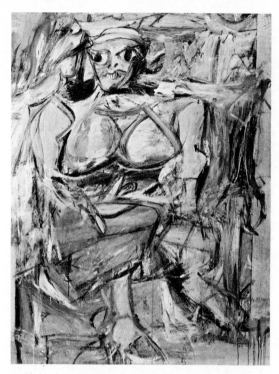

18-3 Willem de Kooning. *Woman, I.* 1950-52. Oil on canvas. 75⅞″ x 58″. Collection, The Museum of Modern Art, New York.

physically expressed in the brush strokes. This use of the larger muscles of the body, typical of Abstract Expressionism, brought energy to painting. When we view such paintings, our own muscles respond with empathy to the movements of the artist's body as he developed the painting. To feel this physically expressed energy, we should see the paintings themselves, for their large scale intensifies the impact, forcing us to become involved in the work as we look at it. Artists began to use larger and larger canvases. It seemed that the traditional easel-size painting could not contain the energy and vitality of these painters, and they had to reach beyond its restrictive borders to ever larger areas in which to express their feelings. Their canvases now were measured in feet rather than in inches. Jackson Pollock said, ''I believe the easel picture to be a dying form and the tendency of modern feeling is toward the wall picture or mural.'' Because he felt the general public was not yet ready for murals, he painted on large canvases which he considered to be a transitional step toward wall painting. Pollock's drips, splashes, and spills appear to have been painted in an intense and undisciplined fury of action. However, his paintings, with their textured surfaces, actually are carefully organized. Every one of his active drips or brush strokes is balanced by an opposing one. His color combinations are subtle, and the structure of each painting develops through the rhythm of his movements. Pollock, who often used industrial enamels and metallic paints, spread his canvases on the floor and dripped his paints from buckets, using sticks and large brushes. The resistance of the canvas to the

made the process an important part of the artwork itself. For several years, de Kooning painted in a broadly Abstract Expressionist style, with wide violent strokes angrily slashed onto his canvas. Later, in the 1950s he became almost obsessed with the image of a female. His paintings of this feminine image seem conceived in horror and painted with a sense of desperate rage that was

path of his hand forces us to reconsider the importance of the artist's association with his materials.

In somewhat the same manner as the color transitions of Monet's *Water Lilies* (Plate 27), Pollock's passages of color lead our eyes into the painting and encourage us to wander through the canvas, finding refreshment by following the myriad paths of the paint as they build up a weblike surface. Through the involvement of our eye movements, his paintings become environments which surround us. Perhaps hoping to express the fears and hopes of the midcentury, Pollock extended his painting to limitless horizons, bringing together the near and the far, the important and the trivial, to merge into a cosmic firmament. Through his work we sense the tensions of all humans caught in life of the twentieth century, as well as Pollock's own explosive personal frustrations as an artist living in a hostile world. Like all Expressionist painters, Pollock reflects not only his responses to the outer world, but his personal emotions as well.

A Parisian, Georges Mathieu (b.1921), exemplified the shift of the center of art from Paris to New York. For years artists had looked to Paris as the center of creative activity. Now they looked to New York for

18-4 Georges Mathieu. *(Untitled)*. 1958. Brush and white ink on black paper. 27⅝″ x 39¼″. Collection, The Museum of Modern Art, New York. John S. Newberry Collection.

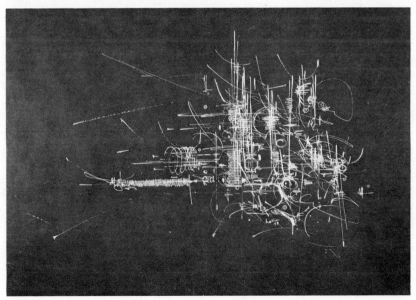

stimulus and inspiration. One of the youngest of the Abstract Expressionists, Mathieu was aptly called an *action painter* because he carried body movement to its ultimate expression. With the theatricality of Salvador Dali, Mathieu, sometimes dressed in costume, attacked his canvas with hundreds of brushes and paint tubes, dancing before it and spurting huge squirts of paint in what amounted to a choreographed performance. As a result, his motions during the creative process become as important a part of the art as the canvas itself.

As time went on, the paintings of such artists as Franz Kline (1910–1962), Robert Motherwell (b. 1915), Helen Frankenthaler (b. 1928), Joan Mitchell (b. 1926), and Adolph Gottlieb (1903–1974) grew larger. Kline and Motherwell painted enormous black shapes, somewhat like blown-up pieces of Oriental characters, startlingly contrasted against the white of the canvas.

Color Becomes a Subject After the Bauhaus school closed in the thirties, Josef Albers (b. 1888) (Plate 1) moved to the United States and continued his preoccupation with color relationships. For more than fifteen years he worked on a series of one hundred paintings of squares. The canvases, which are approximately the same size, are made up of squares which vary in size and in their relationship to each other. The greatest variation among these paintings is in the use of color, for Albers experimented with innumerable combinations of warm and cool, muted and intense color. The simplicity of the square shapes intensifies the visual relationships of the colors and makes our eyes respond to the opposition of dependency of one color on another. The optical effects of the colors are consequently exploited to the fullest. Albers recognized that in visual perception a color is never seen alone, for we perceive it only in relation to the other colors around it. As a simple demonstration of this, look at the corner of a plainly painted room. The slight variation in the intensity of the light that hits the two walls will cause some difference in the color of the two surfaces, and one wall may appear nearer, while the other looks farther away. If a warm light hits one wall and the other is in cool shadow, the tension between them will be increased. This kind of opposition is naturally intensified if complementary colors are placed next to each other, or is decreased if two colors close to each other in value and intensity are paired. Albers varied the types of colors he placed next to each other according to the effect he wished to produce.

The variety in Albers's series of squares depends not only on the combinations of colors but also on where the colors were placed in relationship to each other, the amount of each color used, and how many squares there were. Consequently, we see each square of color continuously changing in relation to the square next to it. Albers also makes use of the physical phenomenon of afterimages to cause vibrations in our eyes. For him, such experiments with color constantly renew the visual experience, and since he believes that the eye is an important part of the mind, Albers also believes that his paintings have intellectual as well as visual content.

As you can see, this type of painting avoids subject matter in order to concentrate

on color and its relationships. Since so much of the impact is involved with color, it may be helpful to you to reread the section on color in Chapter 2 and to refer to Plate 5.

Action and field painting merge in Motherwell's and Kline's work. The term *field painting* and its companion term *color field* were coined to give a name to paintings which used large, nonobjective areas of color. Often consisting of a few brush strokes or simple forms against a background of flat color or white canvas, field paintings draw us in and surround us. One brush stroke alone

may be as large as a conventional easel painting or even as large as we are. Although a huge area of color may have smaller shapes floating on it, these smaller shapes do not completely break up the larger field.

Kline's and Motherwell's black and white paintings are nonobjective, referring to no specific subject. Rather, they are concerned with the tensions and balances which develop between their positive shapes and

18-5 Franz Kline. *Two Horizontals*. 1954. Oil on canvas. 31⅛" x 39¼". Collection, The Museum of Modern Art, New York. The Sidney and Harriet Janis Collection.

18-6 Robert Burns Motherwell. *Elegy to the Spanish Republic, No. 78*. 1962. Oil and plastic on canvas. 71" x 132¼". Yale University Art Gallery.

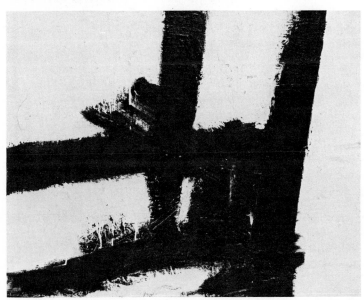

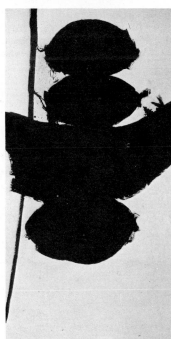

the negative spaces created by these shapes. These paintings have a raw, tough strength which is remote from the grace and finesse of artists such as Kandinsky, Malevich (Figure 15-18), and Mondrian. The physical traces of the artist's actual gestures are explicit and emphatic. The large strokes of black drawn across the white surface create tensions to which we respond physically—a pull we can feel. This sense of vitality has been typical of American painting in the twentieth century no matter what styles artists have embraced. American artists, once their energies were released from the influences of Europe, tackled art frontiers with the same youthful excitement with which their forbears had tackled the physical frontiers of the New World.

Acrylic paints came into general use in the 1950s. Although they have not replaced oils, they have given painters an opportunity to create new effects because they lend themselves to a variety of painting methods. They can be used to fill in flat areas by creating a smooth surface that is glossy or matte according to the medium used. And since they flow easily onto the canvas and dry quickly, they can be used to paint sharp edges on forms next to each other more easily than can oil paint. Also, acrylic paints can be thinned to give a transparent watery look, and if these thinned paints are used on absorbent, unsized canvas, they will sink into the fabric and produce fuzzy edges. A color-field painter who used acrylics in this manner is Morris Louis (1912–1962) (Plate 13). His pigments interact with the surface, becoming part of it, rather than remaining on top. This technique gives a particular kind of depth to the color, reducing the reflective

quality of the surface. Thus the effect of the painting on our eye is quite different from an effect in which paint remains on the canvas surface. Some painters, like Sam Francis (b. 1923), work with fluid paints, exploiting the drip of the colors to suggest the momentary, fleeting aspects of the art act itself. Like

18-7 Sam Francis. *Shining Back*. 1958. Oil on canvas. 79⅜″ x 53⅛″. The Solomon R. Guggenheim Museum.

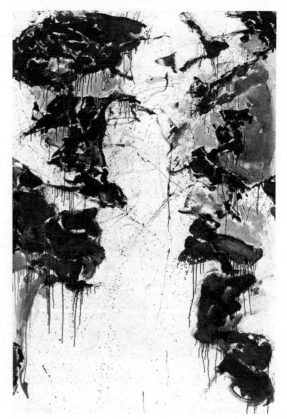

Louis and Francis, Helen Frankenthaler (b. 1928) (Plate 33), who came to color-field painting out of Abstract Expressionism, often allows her colors to soak into the canvas. Color-field painters usually create oversized works which are so large that they are not meant to be seen all at once—works that are designed to overwhelm us as we stand before them. To appreciate the painting as the artist intended us to, we must stand close enough to it so that we are surrounded by the field of paint and are visually led into it. Color-field paintings that are ten, twelve, or even as much as forty feet wide are not unusual.

The impact of *Number 19* by Mark Rothko (1903–1970) (Plate 34) is based on color sensation and large size (Plate 1). Rothko is not as scientific or intellectual in his selection of colors as is Albers, but rather takes a color and uses it for his own expressive purposes. He places vaporous, rectangular patches in front of one another, and his color, which is unrestrained by drawn lines or hard edges, spreads from one shape to the next. Often the color areas are extremely close to each other in value. Sometimes Rothko has soaked and stained the canvas with transparent paint, and sometimes he has brushed on opaque pigment. In his paintings, color is both the form and the content, the sole carrier of his ideas—developing endless variations of one theme.

In a series of large paintings, Adolph Gottlieb (1903–1974) produced images which remind us of explosions. In *Blast Two* the two main forms are separate, placed one above the other. The brilliant color and rounded form of the upper shape might represent the sun or a nuclear explosion, while the somber colors below remind us of the earth. However, no matter what these forms represent to us, their violent opposition creates a visual tension which communicates a deep sense of unease. We can project into this painting whatever anxiety is uppermost in our minds.

Painter Ad Reinhardt (1913–1967) claimed allegiance to an earlier pioneer, Alice Trumbull Mason (1904–1971). Both had

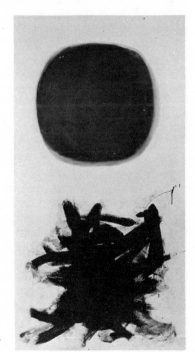

18-8 Adolph Gottlieb. *Blast II*. 1957. Oil on canvas. 3'9" x 7'5". Collection of Joseph E. Seagram & Sons, Inc.

worked in a geometric, rectangular style since the thirties. Mason's canvases have a haunting, poetic lyricism which she produced while using an extremely limited range of colors (Plate 36). Similarly, Reinhardt gradually reduced his paintings to areas of muted tones which are very close in intensity and value (Plate 35). In the 1960s he worked only in black, creating large fields of paint on canvases as big as five feet by five feet. His goal in this simplification was the refinement of painting to a single, all-consuming experience. A small photograph cannot convey the feelings one has standing in front of a solid black Reinhardt painting. Letting ourselves enter into the experience, we feel drawn into its depth and have a physical sensation of floating in a lightless, soundless void. Paintings like these were forerunners of the minimal sculpture and painting of the 1970s. As in other color-field painting the canvas surface ceases to exist for us; we feel we are floating into a mystical infinity, aware only of the visual and spatial effects created by the color.

Other painters, like Kenneth Noland (b. 1924) and Frank Stella (b. 1936), depend on large scale and total immersion in color to provide us with a visual experience. The concept of expanding and contracting intervals of color arranged in hard- or soft-edged stripes is dominant in their work. Stella paints complex patterns of stripes which are separated by light lines (Plate 37). He also uses unconventionally shaped canvases for his paintings, fitting the pattern of the stripes into the shape of the canvas or contrasting them to set up an opposing tension.

18-9 Kenneth Noland. *Song.* 1958. Plastic paint on canvas. 5'5" x 5'5". Collection of The Whitney Museum of American Art, New York.

Many of these large, bright paintings—which are sometimes called *minimal* paintings—avoid the individualization we saw in Abstract Expressionism. Often the color is applied by using masking tape to produce clean-cut outlines, and resulting surfaces suggest the anonymity of mass-produced industrial products. Other hard-edge paintings are created by repeating hundreds of small shapes.

Optical Art

Optical art and field and minimal painting share some characteristics, among them the absence of representational subject matter or the deep penetration of space. They also depend on color contrasts to produce certain physical sensations in the eye.

Israeli-born artist Agam (Yaacov Gipstein) (b. 1928) has devised an illusion which appears to respond to us when we look at it. Possibly inspired by moving billboards, which use mechanically turning louvers to change their image, Agam makes his paintings out of fixed, projecting louvers. Looking at an Agam painting from one side of a room, we see what appears be a flat painting with simple nonobjective shapes. But if we look at the same painting from another point in the room, the appearance is changed. Bridget Riley (b. 1931) also depends on optical illusions for the impact of her black and white paintings. These well-known optical

18-11 Bridget Riley. *Current*. 1964. Synthetic polymer paint on composition board. 58⅜″ x 58⅞″. Collection, The Museum of Modern Art, New York.

phenomena suggest movement where none exists and give us an intense and sometimes uncomfortable sensation as we look at the painting. This sensation is due to the vibrations caused in the eye. Modular shapes fit together into an allover pattern of color in the paintings of Victor Vasarely (b. 1908). Vasarely began by studying the paintings of Kandinsky, Mondrian, and Albers; then he developed his own style, using small shapes of color built up in a mosaic effect (Plate 38). He believes that "painting and sculpture have become anachronistic terms: it is more exact to speak of a bi-, tri-, and multi-dimensional plastic art."

18-10 Yaacov Gipstein. *Double Metamorphosis II*. 1964. Oil on aluminum. 8′10″ x 13′2¼″. Collection, The Museum of Modern Art, New York. Gift of Mr. and Mrs. George M. Jaffin.

Primary Sculpture

Minimal, or primary, sculpture grew in a logical progression out of the work of the Constructivist sculptors (Figure 2-9). The traditional human image was rejected, as if sculpture were an extension of physics, rather than a reflection of humanity. Architectural space became an arena for exploration, and the new inquiry into space resulted in a gradual stripping off of nonessential details until a primary system was evolved. Primary sculptures are projected into our awareness because they are large in scale and because they penetrate the space we occupy. Enjoying the same freedom in three dimensions as nonobjective painting occupies in two, primary sculptures involve our responses to spatial openings, to volumes, and to enclosures. Although our physical presence is not part of the design, our perceptions and reactions concern the artist. Indeed, some primary designs are intended to surround us.

Although David Smith's (1906–1965) work was too humorous and too involved in texture and organic shape for him to be classed as a primary sculptor, some of his work just before his death was close to primary sculpture in the stark simplicity of its forms and in the economy of its flat surfaces. Another sculptor, Jason Seley (b. 1919), assembles discarded automobile bumpers to form strong spatial constructions. Industrial steel girders and sheet metal forms are similarly used by British sculptor Anthony Caro (b. 1924) to produce powerful structures. Monumental in size, simple in their flat planes, and often painted with brilliant colors, these sculptures have an affinity with the paintings of Frank Stella (Plate 37) and Ellsworth Kelly (b. 1923).

Richard Lippold (b. 1915), working with thin strands of wire or string, pushed the spatial ideas of Constructivism even further. Using strands of wire or string as lines that reflect light, he floats a series of interconnecting units in space. Sometimes light focuses at the heart of the structure, while a shimmering pulsating light emanates from the outer edges of the units. In his series on the moon and sun, he plays with a theme as a musician might, creating subtle variations using the same basic forms. *Variation Number 7: Full Moon* is a creation of luminescent beauty which appears to float in midair. The shimmering quality produced by the many components is evidence of the sculptor's detailed planning, his mastery of the material, and his careful execution. Distilled from our technological age, Lippold's work reflects the best of our machine culture. This piece is ten feet high, and Lippold has produced even larger pieces which probe space in diagonal thrusts and are designed to relate to their architectural settings.

Primary structuralists run the gamut from the engineers who design by equation and computer to sculptors who create intuitively. These artists place constructions on the floor, against the wall, or suspend them from

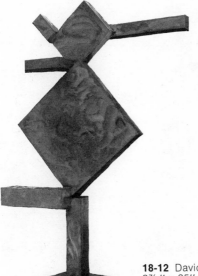

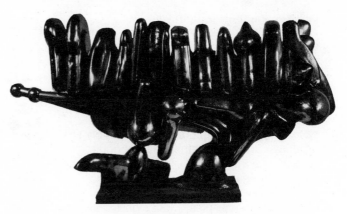

18-13 Jason Seley. *The Anatomy Lesson*. 1962. Steel (chrome plated automobile bumpers). 27¼″ high, 51¼″ wide, 21½″ diameter. Collection of The Whitney Museum of American Art, New York. Gift of the Howard and Jean Lipman Foundation, Inc.

18-12 David Smith. *Cubi X*. 1963. Stainless steel. 10′1⅜″ high, 6′6¾″ wide, 2⅞″ x 25″ x 23″ at base. Collection, The Museum of Modern Art, New York. Robert G. Lord Fund.

18-15 Donald Judd. *Untitled*. 1972. Plywood. Five boxes each 41″ x 72″ x 72″ spaced 19″ apart. Photo courtesy of the Leo Castelli Gallery, New York.

18-14 Richard Lippold. *Variation Number 7: Full Moon*. 1949-50. Brass rods, nickel-chromium and stainless steel wire. 10′ high. Collection, The Museum of Modern Art, New York. Mrs. Simon Guggenheim Fund.

ceilings, integrating them with the environment. Called serial designs, systemic sculpture, or ABC sculpture, these works rely on simply basic volumes and spaces. Their shapes are sometimes depersonalized to such an extent that the artists can turn over their drawings to a workshop that will do the actual construction of the work. In some cases, minimal sculptures, like assembly-line products, are put together with modular repeats. As a reflection of materialistic mass society, the surfaces of these works are mechanically finished, and they are assembled in multiples. Most significantly, the spectator is invited to become part of the scene—we are intrigued into wandering under, around, and through the sculpture.

By placing modular units in a straight line, sculptor Donald Judd (b. 1928) eliminates any variables, any unexpected or human qualities. The absolute predictability of his sculpture, which exists without reference to past traditions, reduces all emotional overtones to zero. What remains is a real construction in real space. Any conflicts or tensions that arise come from within us. If we find such sculpture disturbing, perhaps it is because it reminds us of our lives, which are squeezed into a manmade environment and detached from our spiritual inner world.

Related to minimal sculpture, but set apart by its bold red color and by the questions it raises about its balance, Isamu Noguchi's (b. 1904) *Cube* engages our attention and

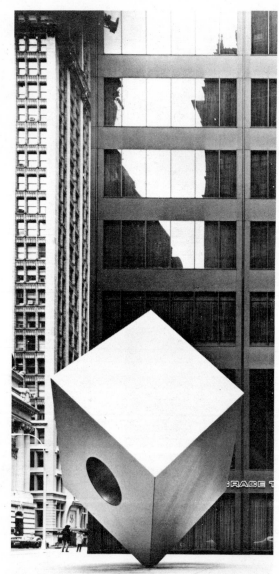

18-16 Isamu Noguchi. *Cube.* 1968. Metal. 16′ x 16′ x 16′. Photo courtesy of Helmsley-Spear, Inc.

18-17 Tony Smith. *Black Box.* 1962. Steel. 22½″ high, 32″ long, 25″ wide. Fourcade, Droll, Inc.

creates tension. Its apparently precarious position startles and disturbs us, while its huge geometric mass forces us to see its relationship to architecture.

Simply titled *The Box,* Tony Smith's (b. 1912) oversized black cube reduces to the ultimate any exploration of space. It goes nowhere, nor does it make any statement beyond its very real, dull, black volume. For those of us who find the cube enigmatic, a ladder is usually set up against its six-foot side to permit us to examine it more closely. Investigation, however, confirms our guess that *The Box* expresses nothing more than itself. It *is* a box. The next step is the *idea* of a box. Some sculptors achieved this step by no longer fabricating their structures, but by merely showing us the plans and drawings or even written outlines of schemes that would never be built. Thus the *idea* became the art. In the next chapter we will see how this trend develops into conceptual art. We should realize that many of the trends discussed in this chapter have appeared simultaneously with those that will be discussed in the next chapter.

Pop, Happenings, and Conceptual Art

The future of art seems no longer
to lie with the creation of enduring
masterpieces, but with defining
alternative cultural strategies.

John McHale

The constantly accelerating change which is such a dominant aspect of our life today is clearly reflected in the art of the late sixties and of the seventies. Abstract Expressionism had dominated art for a decade, moving gradually into optical art, color-field painting, and minimal sculpture. Of course, overlapping of artistic trends occurred, and many of the types of art discussed in this chapter appeared concurrently with the trends studied in the last chapter. But the dominant characteristic of the art scene since the late sixties has been that almost any type of art is acceptable—especially something new and different.

As a result, artists have been liberated from the rules of the past and no longer feel constrained to work in any one style. They are free to follow any line of exploration, and explore they have. This exploration is the positive side of the story. On the negative side, however, fad and fashion, nurtured by the mass media, have exerted a pressure on artists to think of something that may capture attention. Some artists have become national figures overnight, only to be forgotten when their art no longer was ''in.'' Most, however, never hit the big time and have kept on following their own creative needs—living the usual lives of economic frustration, working

at any job in order to live, never able to spend as much time in their studios as they might wish. As in show business, the star system in today's art world leaves much to be desired. The pressure to create a novelty that will be an instant success must be resisted by the serious artist.

On the other hand, a positive development in the art world since World War II has been the increase in the number of women artists who have been able to survive and grow as creative individuals. Traditionally, it had been difficult for women artists to be taken seriously, but gradually the male-dominated art world of museums, galleries, and critics has begun to accept women as professionals. In turn, women have become more accepting of their femininity and have felt less need to copy male art. Now, in the 1970s, most artists create as artists, rather than as male artists or female artists.

This chapter will attempt to touch on many of the trends in art today and on some of the most representative artists. But since artists change their styles frequently, keeping up to date is almost impossible. If the chapter seems overwhelming with its multiplicity of trends, groupings, and individual styles, it is because we live in a world of multiplicity, which the art world reflects.

Motion in Art

Humans, like other animals, are intrigued by motion. The driving rain, waving branches in the wind, the crash of waves onto a beach, a horse running across an open field—all are as fascinating now as they were to our ancestors. Motion is essential to life, even if it is the slow, almost imperceptible motion of a germinating seed thrusting a shoot through the earth.

But today we live in an age of motion unlike any the world has ever known, and our biological rhythms have been forced to adapt to new mechanical speeds. The speed with which our space vehicles rush toward a rendezvous with another planet or another spaceship is almost beyond our comprehension, while here on earth jets speed us to our destinations at velocities never even conceived of before this century. And, even if we make a conscious effort to be quiet ourselves, the world around us is constantly moving. It is no wonder, then, that twentieth-century artists have been fascinated with motion and have attempted to respond to it in their art, using the new materials of our industrialized culture.

The concept of combining sculptured figures with mechanical motion is not new. Arabian sultans had elaborate mechanical figures built for their amusement—figures that probably were inspired by Oriental creations. In the Middle Ages, the bells in clock towers were struck by mechanical figures, and during the Renaissance Leonardo designed figures for royal festivals which were moved by mechanical means.

The machine-oriented Futurist Umberto Boccioni expressed motion in his sculpture in 1913 (Figure 15-11). In 1919 Brancusi's *Bird in Space* (Figure 15-13) denied the material limitations of solid mass in its soaring form. But it was the Constructivist sculptor Naum Gabo who, in 1920, designed the first motorized sculpture—a tall shape that vibrated. Sculpture of this kind, whether moved by a motor or by natural forces, is called *kinetic* sculpture.

A pioneer in light and motion sculpture in the twenties, Laszlo Moholy-Nagy (1895–1946) built a light modulator at the Bauhaus school from reflecting metal and plastics. His construction not only is a working machine; it is also a piece of sculpture, although that was not its original purpose. Producing a complex pattern of light, it was actually designed and built as a practical machine which Nagy thought could be adapted to stage design.

In the 1930s, sculptor Alexander Calder (b. 1898) began to use industrial materials, such as sheet metal and wire, to construct his movable sculptures. Although at times he has used motors to make his constructions move, he prefers to leave their motion to the unpredictability of air currents. Calder created a totally new sculptural form that was called a *mobile* by his friend Marcel Duchamp (Figure 2-16). Rejecting the shapes of the machine world, the elements of his mobiles are gay reminders of fish, animals, leaves, flowers, and sometimes planets. The Calder mobiles are balanced systems which are set in motion by a passing breeze, by the hot air of a furnace, or even by the movement caused by someone walking past. Each shape moves independently but within prescribed orbits, and some strike each other like gongs and bells, adding an element of

The inventive Calder has designed a sixty-foot-high sculpture for Spoleto, Italy, which actually is an architectural environment. He has also designed an acoustical ceiling for an auditorium in Caracas, Venezuela, in which tremendous free-form shapes seem to float above the seats, relating the sculpture to the architectural space of the interior in a totally new manner. Before Calder, architectural

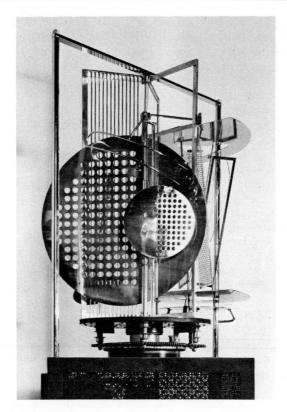

19-1 L. Moholy-Nagy. *Light-Space Modulator.* 1956. 59½" high. Courtesy of Busch-Reisinger Museum, Harvard University, Cambridge, Massachusetts.

19-2 Alexander Calder. Model for *Teodelapio,* Spoleto. 1962. Stabile: painted sheet aluminum. 23¾" x 15¼" x 15¾". Collection, The Museum of Modern Art, New York.

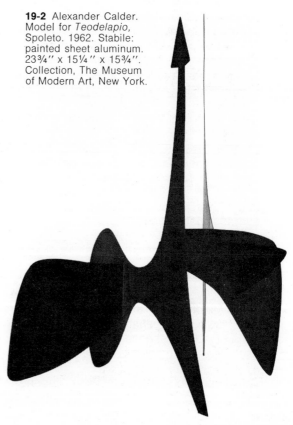

noise to the sculpture. Some of Calder's largest pieces are anchored to the ground, and the movements of their heavy forms, which are balanced on stabilized bases, are slow and stately. Calder has also built some pieces of sculpture which do not move, calling them stabiles to differentiate them from the mobiles.

sculpture had been firmly attached to the building; now it floats in midair.

George Rickey (b. 1907) is also interested in motion and balance. He groups long, tapering strips of stainless steel into such delicately balanced compositions that the

slightest air current sets them into slow, quivering vibrations.

Thus, over the last fifty years, motion has become an important feature of our artistic environment. These kinetic sculptures often consist of machines which are not functional in any way, their movement existing only to provide a visual experience. Some of these machines can perform complex operations perfectly, but at the same time they amuse us with their somewhat ridiculous uselessness. We are so accustomed to considering a machine's purpose to be the

19-3 George Rickey. *Two Lines-Temporal I.* 1964. Two stainless steel mobile blades on painted steel base. Overall height 35′2⅜″. Collection, The Museum of Modern Art, New York. Mrs. Simon Guggenheim Fund.

19-4 Trova. *Falling Man Study #53.* 1968. Nickel plated bronze. 13″ x 10″ x 9¾″. Pace Gallery, New York.

performance of a useful task that a machine that can do nothing but move seems laughable.

The *Music Machine* by Arthur Secunda (Figure 4-2) consists of wood, metal, and mechanical parts surrounding a music box. All the working parts are gilded and exposed, reflecting the way our culture delights in the wonders of electronic mechanics. Another example of kinetic sculpture can be seen in Ernest Trova's (b. 1927) *Falling Man Study: #53*. Common to all his work is an armless, sexless, featureless figure, apparently thrust by modern technology into a course of action over which it has no control. The figure is helplessly caught in a machine that threatens to destroy it.

Movement is expressed in another manner by Jean Tinguely (b. 1925), who creates kinetic sculptures which are powered through a series of actions. *Homage to New York* was constructed of old wheels, fan motors, bassinets, and assorted discards found in dumps or secondhand stores. It made music with a battered piano, issued reports from an old typewriter, gave birth to machine offspring, set itself afire, and finally self-destructed one memorable evening in the garden of the Museum of Modern Art in New York. Under the watchful eye of a New York City fireman and before an enthralled audience, *Homage to New York,* with some frantic help from its inventor, committed suicide in a flurry of movement, sound, and smoke. The activity seemed like Dada absurdity as it presented a parody of our self-destructing society. Tinguely says that for him a machine is "above all an instrument that permits me to be poetic. If you respect the machine, if you enter into a game with the machine, then perhaps you can make a truly joyous machine."

Other sculptors work with moving objects to create varying effects. Castro-Cid, for example, creates constructions of glass-encased robots made out of strips of metal; one has a plastic head that houses its motor. Robert Breer (b.1926), on the other hand, designs motorized aluminum tanks which crawl along the floor, inexplicably changing direction and frightening us with their inhuman actions. Breer has also taken

19-5 Jean Tinguely. Fragment from *Homage to New York*. 1960. Painted metal. 80¼" x 29⅝" x 87⅞". Collection, The Museum of Modern Art, New York.

sheets of plastic and spread them over similar motors, which make the sheets writhe and rustle menacingly, almost as if they were alive. Len Lye (b. 1901), a pioneer filmmaker, created whirling metal strips which scream through the air in a frenzy of activity. But in his fountain, the metal becomes a delicately balanced mobile whose rods sway gently, seeming to move spontaneously, impelled by their mechanical motor to simulate the gentle flow of water affected by currents of air. Many of these mechanical sculptures have a strong impact on us because we do not expect visual art to move. We are forced to see that a machine *can* be joyous or poetic, as Tinguely said.

Light Art

Obviously, light has always been necessary for the enjoyment of all art. But, in recent years artists have become aware of the potential of light itself as a medium. As a result, light has become a recognized medium since 1960, and light artists use their material with the same skill that other artists apply to color and paint.

Thomas Wilfred (1889–1965) was one of the first artists to conceive of light as an independent aesthetic experience. His experiments in the early part of this century led to the development of the Clavilux Lumia, an instrument on which he performed publicly as early as 1922. From the spectator's viewpoint, the Lumia Suite presents a continuously changing pattern of fading and regenerating evanescent colored light, which produces a hypnotic effect similar to that of some color-field and optical paintings.

One of the most innovative light artists working today is Otto Piene (b. 1928). In 1961, a light ballet which he created toured Europe. Later, Piene designed a light installation of thousands of individual bulbs that were programmed to coordinate with the activity onstage. Many light artists combine light and motion, and some have used light along with water to create moving compositions that delight the eye with artificially lighted waterfalls and fountains, while at the same time gratifying the ear with the sound of rushing water.

19-6 Len Lye. *Fountain.* 1959. Stainless steel. 85″ x 72″. Collection of The Whitney Museum of American Art, New York. Gift under the Ford Foundation Purchase Program. Photo, Geoffrey Clements.

The collaboration of artists and engineers that is characteristic of art today will no doubt increase, and engineering knowledge will be applied to the development of more complex motion in art. This collaboration has already appeared in a film produced by Hans Jenny, a Swiss doctor and scientist who is researching problems involving light and vibrations. Dr. Jenny's film, called *Vibrating World,* is filled with images based on natural phenomena and the use of movement in the arts.

Larry Bell (b. 1939) is a light artist of deep sensitivity. His glass cubes, which rest on transparent glass cases, are lit from within. Coated with a translucent substance that acts as a prism, the cubes create delicate effects of transparent light and color that change depending on the position of the viewer. The simplicity of Bell's forms adds to the impact of the changing color.

Another light artist, (Varda) Chryssa (b. 1933), combines theatrical skill with technical precision in neon sculpture which is composed of minimal shapes arranged rhythmically. Her inventive work comments on today's industrialization, while at the same time suggesting the ever-expanding frontiers of science and technology. Like many of today's artists who are in the forefront of experimentation, Chryssa has explored some aspects of environmental art by combining theatrical and technical elements in an aesthetically exciting spectacle. Chryssa's work in the seventies is reminiscent of the glaringly lighted environment of Times Square in New York City or the Strip in Las Vegas. For example, under the sponsorship of Intermedia 68 and the Museum of Modern Art, she designed an electromagnetic

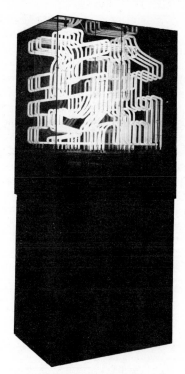

19-7 Chryssa. *Fragments for the Gates to Times Square.* 1966. Neon and plexiglas. 34½″ x 27½″. Collection of The Whitney Museum of American Art, New York. Gift of Howard and Jean Lipman.

environment in which color and light in vibrating patterns totally enveloped the minds and bodies of the participants, forcing them to become a part of the environment.

Another installation, this time at New York University, consists of thirty lighting units, which are designed to surround the viewer

with light. When you enter the cubicle, you take on the color of the environment. If you do not accept the change, your only escape is to leave it.

Light sculpture uses some of the same theories explored by optical painters, such as Bridget Riley (Figure 18-11), and color-field painters. Environmental constructions, which surround the viewer with visual sensations, are built on a large scale, producing a feeling of total immersion in the art experience.

Stephen Antonakos's (b. 1926) recent neon sculpture investigates continuous planes of light by using an industrial method of joining neon tubes (Plate 39). By juxtaposing these tubes he interrelates space, time, and light, and his art extends our concepts of what our future environment may be like.

Environments The term *environmental art* refers to constructions that usually combine painting and sculpture in architectural settings. Often the viewer can walk into these constructions. Although some environmental art is reminiscent of the antiart syndrome of the Dada movement, most of it is rooted in the artists' response to our world today. Some environments, like the tableaux of Edward Kienholz (b. 1927), place us in the role of peeping Toms. In *State Hospital,* for example, we witness an intimate scene of horror. To see the interior of this tableau environment, we have to peer through a small barred window. Our sense of guilt at sneaking a look constitutes a double bind; we feel a dreadful responsibility for the sordidness we have surreptitiously viewed. Two naked, faceless men are lying chained to their bunks, alone and neglected. The

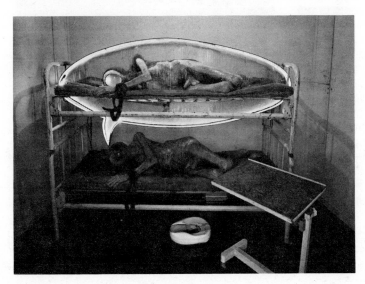

19-8 Edward Kienholz. *The State Hospital.* 1964-66. Mixed media. 8′ high. Moderna Museet, Stockholm.

overriding image here, as in all of Kienholz's work, is one of people waiting for death, disintegrating before our eyes. Our own macabre fascination with what we see provides an additional element of terror.

The construction of environments like these requires skill in painting, sculpture, architecture, and theatrical design. Such combinations of techniques provide another example of how the separation of the arts is breaking down after centuries of specialization. Like Keinholz, George Segal (b. 1924) also creates tableaux of humans in an environment, but rather than presenting dramatic incidents, he reveals the banality of our surroundings. Perhaps he does this in an effort to find some reason in the rituals of everyday life. His anonymous white plaster casts of humans anticipated the current style of magic realism and also contain elements of pop art. Segal seems to be saying that if we scrutinize the nondescript aspects of our lives we may be able to find a way to take logical action, thereby losing some of the helplessness we feel in our world. In their commentaries on contemporary culture both Segal and Kienholz are inheritors of the social-protest painting of the thirties.

Working in a totally different environmental manner, a little-known self-taught artist, Clarence Schmidt (b. 1923), has created a series of grottoes within a cavelike house in Woodstock, New York. Schmidt lives in his creation, adding to it continually as he burrows into the earth. His environment has become a living echo of himself. Here again the line between art and reality has become almost impossible to detect.

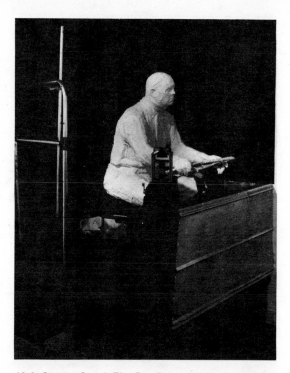

19-9 George Segal. *The Bus Driver.* 1962. Figure of plaster over cheese cloth; bus parts including coin box, steering wheel, driver's seat, railing, dashboard, etc. Figure, 53½″ x 26⅞″ x 45″. Wooden platform, 51⅛″ x 51⅝″ x 75⅝″. Overall height, 75″. Collection, The Museum of Modern Art, New York. Philip Johnson Fund.

Assemblages and Happenings

Assemblages and happenings may have had their beginnings in Cubist collages and in constructions like the one Dadaist Kurt Schwitters (1887–1948) completed in his home in Germany around 1924. Titled a "cathedral of erotic misery," it was dedicated to his friends. Along with bits of their discarded clothing, which he cast in plaster, Schwitters assembled refuse and debris to

19-10 Kurt Schwitters. *Cherry Picture*. 1921. Collage of colored papers, fabrics, printed labels and pictures, pieces of wood, etc., and gouache on cardboard background. 36⅛″ x 27¾″. Collection, The Museum of Modern Art, New York. Mr. and Mrs. A. Atwater Kent, Jr., Fund.

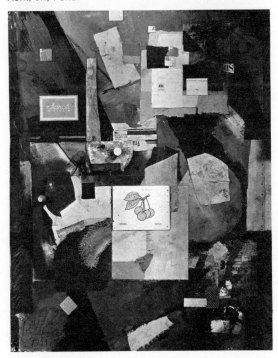

form little grottoes and spatial environments which he called *Merzbau.* The crumbling papers in Schwitters's collages hint at the disintegration of our civilization and at our own personal disintegration. Schwitters deliberately threw out traditional notions of beauty as a gesture against the artistic authoritarianism then prevalent.

The refuse of our industrial culture possesses great variety, and its debris appeals to many artists as a substitute for traditional materials. These artists use the discarded elements of society—the rind of an orange, bits of advertisements, broken dolls, even old cars—combining them with paint to create collages and *assemblages.* Art created from such trash is not expected to last long. Jean Dubuffet's (b. 1901) statement that "anything can come from anything" explains the attitude of artists who create assemblages. Neither painted nor sculpted in the traditional sense, assemblages are made of bits of wood, cloth, photographs, household objects, machine parts, stuffed animals—anything that appeals to the artist.

Several Pop artists have made memorable contributions to assembled sculpture. Joseph Cornell (b. 1903), who has concentrated on the box, creates works that are usually glass-fronted and loaded with odds and ends that he has collected. With this collected material he creates dreamworld assemblages filled with personal associations. At the same time, he uses some aspects of Cubism, such as geometric abstraction and multiple images. Containing mirrors, his three-dimensional constructions create an intimate and magical world.

19-11 John Chamberlain. *Essex*. 1960. Relief, automobile body parts and other metal. 9′ x 6′8″ x 43″. Collection, The Museum of Modern Art, New York. Gift of Mr. and Mrs. Robert C. Scull and Purchase.

For years, comedian Jimmy Durante tore apart a piano onstage to the delight of nightclub audiences. Similarly, Jean Tinguely built a machine that committed suicide (Figure 19-5), and César exhibited a compressed auto. In each of us there is an element that enjoys seeing a building torn down, or cars crashing in a movie, or slapstick movies of destruction. Possibly the artists who are involved with destruction are commenting on the violence and conspicuous consumption of our civilization. Edmund Feldman discusses why this trend may have developed:

> Obviously, tearing down good buildings, ripping trees out of the landscape with bulldozers, scarring the earth with open-pit mining, disfiguring men's faces in prize fights, producing goods which break easily, testing thermonuclear bombs and missiles, and other normal activities which involve destruction or preparation for it are strangely attractive to many of us; otherwise they would not be so widespread. Some artists, then, are engaged in seeking a constructive version of the all-too-human impulse to dismember things. Artists may not always know the import of their work: But civilization operates through them nevertheless, exploiting their fascination with materials and processes for what are, hopefully, humanizing ends.

Destruction dominates John Chamberlain's (b. 1927) assemblages. *Essex* is an early stage in the process of machine destruction. Dead automobiles from junkyards provide the raw materials from which Chamberlain bends, welds, and builds up his sculpture. Thus his works become a kind of action sculpture in which decayed or fragmented forms have a macabre fascination for us as we experience the destruction vicariously.

Happenings When the distinction between the medium and the subject of the artwork fades, the material from which it is fabricated no longer matters. If the medium really has become the message, then the actual production of art is what counts. And this *happening* may occur anywhere—in the theater, the streets, the supermarket, on the beach. As in traditional theater, the major participants are selected for their suitability to the needs of the plan, and props and costumes are gathered or constructed. Usually there is a general plan but no rehearsal, and the happening is performed without a predetermined audience or script. It is an art that sometimes is closer to life than to artifice.

Early happening artist Allan Kaprow (b. 1927) says that the events he stages grew out of his work in assemblage in which he used such materials as "painted paper, cloth and photos, as well as mirrors, electric lights, plastic film, aluminum foil, ropes, straw; objects that could be attached to, or hung in front of, the canvas along with various sounds and odors. . . ." He realized also that the "gallery has given way as a place for staging happenings to a craggy canyon, an old abandoned factory, a railroad yard, or the oceanside."

Kaprow planned a happening at Nassau Community College in 1969 in which he attempted to entrap images of aircraft moving over the abandoned airstrips at Mitchell Field. With the help of students, the old airstrips were renewed with asphalt, so that Mitchell Field appeared to be an active airfield on which Kaprow hoped to encourage planes to land. Thirty women were stationed at intervals on the field, holding large mirrors aimed toward the sky. After hours of waiting to trap images, however, the women gave up without a single air encounter. Not all happenings, it seems, can develop into success stories, no matter how carefully the plans are laid. The excitement, however, when everything jells and one event builds into another gives the happening, like improvisational theater, an unpredictable potential.

In a few short years the happening has become a part of American folk culture, perhaps because it reflects the sense of chaos we observe in our society. And as with pop art, the images and ideas of happenings have been picked up by the mass media.

Pop Art

Pop art by definition is opposed to so-called fine art. The Pop style focuses on items of popular culture, such as movies, billboards, machines, comic books, and advertising. Pop artists examine our everyday world and report it directly, with neither satire nor antagonism, but with such intensity that the spectator frequently becomes conscious for the first time of what he sees around him every day.

Pop art, a phenomenon of the sixties, depends on the use of large scale to increase its impact. Thus it thrusts into the foreground those parts of our culture which we have happily learned to ignore, by depicting them as many times larger than their original dimensions.

In his sculpture, Claes Oldenburg (b. 1929) calls attention to the character of ordinary objects by taking them out of

context, changing their scale, or transforming their composition from hard to soft (Figure 4-16). One of his early pieces was a *Hamburger* made out of painted plaster of paris and enlarged to four times normal size. This work had a wide influence on the art world of the fifties.

Oldenburg's Store, a New York establishment rented in 1961, was filled with plaster food and other products of the artist's fertile imagination. Explaining his role as storekeeper, Oldenburg said that although his pieces were usually displayed in galleries, ''that is not the place for them. A store would be better. . . .'' Everything Oldenburg sees is saturated with meaning, and he has turned things inside out, upside down, or changed their substance or scale. Art critic Max Kozloff has said of Oldenburg:

> With Claes Oldenburg, the spectator's nose is practically rubbed into the whole pointless cajolery of our hard-sell, sign-dominated culture. Oldenburg may even be commenting on the visual indigestibility of our environment by his inedible plaster and enamel cakes and pies.

Another characteristic of Pop art is the repetition of images in patterns reminiscent of the rows of mass-produced packages seen in the supermarket. Andy Warhol (b. 1930) was a pioneer in using multiple-images and in container art as well. He began his art career in advertising and later made use of his commercial training in his paintings. Since 1961, his subjects have included Coke bottles, soup cans, Brillo boxes (Figure 7-17), and the prepackaged symbol of

19-12 Claes Oldenburg. *Hamburger with Pickle and Tomato.* 1963. Painted plaster. 6'' x 6'' x 6''. Collection of Carroll Janis. Photo courtesy of the Sidney Janis Gallery, New York.

Hollywood, Marilyn Monroe (Figure 1-17). Some of his pieces are paintings on two-dimensional surfaces, but many are executed in a mixture of materials and methods, such as commercial lithography and silk-screening. For example, the Brillo boxes are made of plywood with silk-screened labels. In this way Warhol has removed the artist's touch from the art, not scientifically like Seurat (Plate 29), but with an industrialized approach. He believes that ''painting is essentially the same as what it has always been. . . . All painting is fact, and that is enough; the paintings are charged with their very presence. The situation, physical ideas, physical presence.''

Andy Warhol is not the only Pop artist to have used the Coke bottle as an image. The Coke culture is a reality, and the Coke bottle is such a commonplace object in our world that archaeologists of the future may well assume—from the large number of bottles present in the ruins of our civilization—that the Coke bottle was an object used in a communal religious ritual. Charles Frazier (b. 1930) comments both on Coca-Cola and Hollywood in one work.

This painting by Jasper Johns (b. 1930) of his studio follows a tradition which has continued from the Renaissance to the present—that of an artist painting the surroundings in his studio (Figure 1-2). Using current imagery, however, Johns attaches the cans in *Studio I* as ready-mades.

The work of James Rosenquist (b. 1933) (Figure 1-11), who initially was an outdoor sign painter, performs the same function—magnifying images and forcing us to look at the carbon-copy quality of our lives, at the

emptiness of the containers which surround us, and at the endless assembly-line products of which we have become a part. In *F-111* he covers all four walls of a room with blown-up images of food, automobile tires, spaghetti, a mushroom cloud, and a little girl being initiated into the rites of grown-up artificiality.

Jim Dine's (b. 1935) art, like that of Rauschenberg and Johns, is rooted in Abstract Expressionism. Having started his career with happenings staged within an invented environment, Dine found himself outdone by later practitioners and turned to paint to reinforce his images. Retaining the stock accessories of the theater—stage-set colors and actual props—Dine uses paint and modeling materials to remind the spectator of commonplace objects like toothbrushes (Figure 5-14). Adding no glamour to the subject, his work combines antiart objects with the immediacy of action painting. For instance, in one of his

19-13 Jasper Johns. *Studio I.* 1964. Oil on canvas with objects. 6'1½'' x 12'1''. Leo Castelli Gallery, New York.

19-14 Robert Indiana. *Love.* 1966. Carved aluminum. 12″ x 12″ x 6″. Courtesy of the artist. Photo, Eric Pollitzer.

assemblages, Dine set a lawnmower against a canvas painted with green and permitted the paint to drip off the canvas onto the mower as if art must include not only paint and canvas but also anything attached to the canvas.

Anonymity is another feature of Pop art. Robert Indiana, born Robert Clark in 1928, exhibits paintings of stenciled signs that reveal nothing about the artist except what can be read into his choice of subjects. Thus, particularly in Indiana's work, Pop echoes the bland character of our commercial surroundings as contrasted with the highly individualized creations of traditional art. Indiana is absorbed by word images that suggest the stark simplicity of flashing neon signs. The words ''eat,'' ''love,'' and ''die'' are rendered in clashing, precise, hard-edged colors. His image of *LOVE* has become so much a part of the popular American scene that few realize that it was originally the creation of this Pop artist. Other Indiana word images are bitter indictments of modern life.

Some Pop artists draw upon more personal techniques, frequently associated with action painting and the world of commerce. Robert Rauschenberg (b. 1925), for instance, uses collage techniques, the commercial silk-screen process, and paint to create images. His paintings involve collage combined with attached objects—a stuffed eagle, an electric fan—along with painted areas. As in Dada, the prevailing theme is nonmeaning, the art of the absurd.

The most impressive sculptor associated with pop art is George Segal, whom we have discussed as an environmental sculptor. After working for a number of years with Kaprow, Segal left happenings to build environments into which he placed his sculptured people. These environments, like his *Bus Driver* (Figure 19-9), frequently are assembled from junkyards and are filled with Coke machines, cans of oil, and other Pop images. But his figures are always modeled from life, being cast into precise plaster replicas of ordinary people, who seem to be produced in multiples like the containers of Pop art.

Marisol (Escobar) (b. 1930), perhaps the most inventive sculptor of them all, has created her own distinctive style that involves wood, plaster, paint, photographs, and

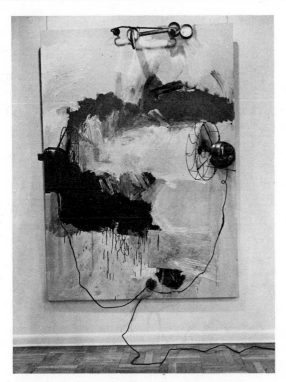

19-15 Robert Rauschenberg. *Pantomime.* 1961.
Combine painting. 84″ x 60″. Private Collection.
Photo courtesy of the Leo Castelli Gallery, New York.

unpredictable accessories (Figure 4-5). Her
works are penetrating studies of personalities
of our day, satirizing the stuffed animal hero
—that empty image of leadership—which is
forced into a display demanded by the
public. Her portrait of *President Johnson,* for
example, is a devastating satire of his need
to be loved by the masses, and *The
Generals* ridicules military heroes of the past.

Conceptual Art

Over the last hundred years, through a series
of major struggles, the Western artist
gradually has released himself from some of
the restraints which society imposes on the
creator. Impressionism, in its revolt against
the rules of the French Academy, first gave
artists a chance to select and paint their
subjects as they wished (Figure 1-18).
Gradually artists were begrudgingly allowed
the privilege of producing art which could not
be easily identified by the public (Figure 1-4).
Still later, artists proclaimed their intent to
produce art that had no recognizable subject
(Plate 1).

Now, *conceptual art* takes one more step
toward freeing the artist from all restraints. In
it, art exists as ideas rather than as objects.
This art of the idea gives us no actual
artwork to be permanently displayed for
evaluation. Like the live performance of
theater or happenings, once the audience
has experienced the event, the art
disappears. Similarly, as in drama, poetry
reading, or music, the event can never be
repeated in exactly the same way. In
conceptual art, the idea itself is sufficient
reason for its being.

Social problems are the conceptual artist's
concern, as they have been the concern of
many artists throughout the ages. The
conceptual artist speaks his protest in the
language of today.

One concept artist, Les Levine (b. 1936),
comments on the American way of life— the
Coke culture—in the sixties and seventies.
The die-stamped quality of machine-
produced products has resulted in a
conformity which disgusts most artists, yet

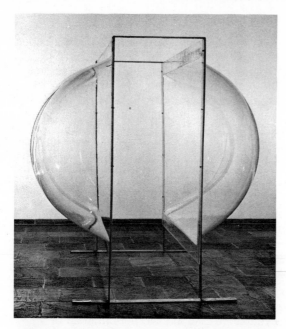

19-16 Les Levine. *Star Machine*. 1966. Plastic and steel. 84½″ high, 120″ wide, 87″ diameter. Collection of The Whitney Museum of American Art, New York. Gift of the Howard and Jean Lipman Foundation, Inc.

the American material standard is the acknowledged goal for many people. To show his contempt for the materialism of our culture, Levine creates disposable art with a minimum need for commitment.

One of Levine's most celebrated works of the sixties was sponsored by the New York City Department of Parks. It consisted of removing ten sheets of plastic from a vacant lot, in stages, over a period of thirty days. On the last day, the earth was dug away for a building. According to Levine, the rationale for this event was the breakdown of material and spiritual values in today's society. In exchange, our culture has selected the synthetic, which is, of course, disposable, so nothing of any worth is left once our rituals are over.

In 1972, Levine put together a multimedia exhibition in five parts called *The Troubles: An Artist's Document of Ulster*. One phase, called *High Noise Torture Chamber,* was a darkened room in which participators could hear the noises used during interrogations of prisoners in Ulster in Northern Ireland. These were noises which isolated the prisoners from communication and thus were designed to break their wills. In artwork such as this, Levine recreates certain contemporary social conditions in order to bring our attention to political problems.

Taking his idea from a television series on an American family, which had been put together out of 300 hours of film, Vito Acconci created a three-week series of *Following Pieces*. For each Acconci chose a figure in the art world at random and followed him throughout the day. He then made a report of his findings, which he mailed to art critics. The written report was the only means by which the art activity was recorded. In another event, Acconci, communicating with a woman in a nearby room through an electronic intercom system, persuaded her to wrap fifty yards of rope around her body until she was fully imprisoned. His goal was to establish interaction between himself and his subject. Apparently he succeeded.

Great Salt Flat was one of the many projects conceived by Dennis Oppenheim. This event consisted of covering a New York City asphalt parking lot with a natural substance—salt. As Oppenheim explained, "If nature has undergone an assault by modern technology, why shouldn't nature retaliate to attack technology?" Later investigation of the site revealed that the salt had disappeared.

Many contemporary artists, particularly conceptual artists, who have been influenced by the new views of the world that are provided by jet planes, spaceships, and satellites, create works of art that can only be seen or photographed from a plane. For example, Walter de Maria made a huge drawing in the sand of the Mojave Desert that was eroded by winds within a month of its completion. Today the only remaining record of the drawing is a photograph taken from a plane. De Maria's work reflects a similarity to the Indian sand paintings which are destroyed at the end of the ceremonies for which they were created.

In a reaction to the Soviet Union's Iron Curtain, the Bulgarian expatriate Christo (Yavachef) (b. 1935) planned a giant *Valley Curtain* to span the space between two mountains in Colorado. Christo, with a sense

19-17 Christo. *Valley Curtain.* 1971-72. Grand Hogback, Rifle, Colorado. Steel cables, nylon polymide. 1250' wide, 185-365' high. Photo, Shunk-Kender.

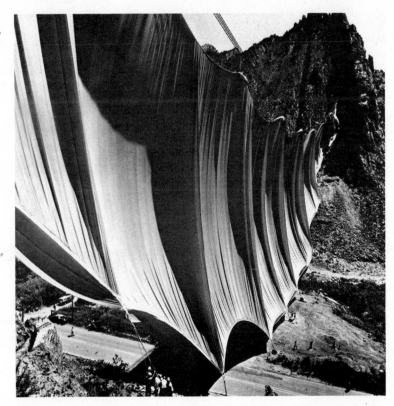

of the theatrical, wanted to find an arena where art could happen within a specific time period and with means of his own choosing. His plan was to hang the curtain across the valley so that it would conceal as well as act as a barrier to pedestrian and vehicular traffic. In order for this to be done, two towers with concrete anchor caps were constructed as points of suspension for five steel cables, each a quarter of a mile long. The 250,000-square-foot curtain that hung between these towers was made of orange nylon.

The *Valley Curtain* confronts us with the paradox that so frequently is a part of both conceptual art and earthworks. The curtain gave an appearance of being functional, although in reality it did not have any purpose. Although it appeared to block passage and view, it did not do so completely, for the material from which it was made was translucent, and the curtain was hung so that an area was left open for cars to pass through. Most important, the *Valley Curtain,* instead of being a theatrical device which delivered or delayed a spectacle, *was* the spectacle itself. In the same way, Christo packaged cliffs in Australia: instead of making a container for the work of art, the package itself became the artwork.

From these descriptions of projects by conceptual artists you can see that many would need substantial financial support and cooperation from private institutions and the public. However, since conceptual art rebels against the art world's traditional terms, financing often is impossible to obtain.

Earthworks, Waterworks, Skyworks Many contemporary artworks take place somewhere between the conceptual level and the semipermanent invasion of our natural environment. Conceptual art exists mainly in the planning and single occurrence of an event; once experienced it is rarely repeated. *Earthworks,* on the other hand, involve some significant, and often enduring, change in the ecology of an area.

An example of an environmental conceptual event is a work executed by Dennis Oppenheim, called *Annual Rings.* This work consisted of concentric rings the width of a snow shovel which were cleared on a section of the frozen St. John River at Fort Kent, Maine. Of course, this drawing in the snow could last only until the spring thaws melted the river's snow and ice.

In its fascination with the gigantic, conceptual art has moved out of the galleries and museums to encroach on vast areas of earth, water, and sky. Large-scale art has come to a natural climax in *earthworks—*a catch-all phrase which describes technological alterations to the land, sea, or air on a large scale.

Throughout history the artist's image frequently has been derived from his environment or from his interaction with it. Today a number of artists prefer to work on an environmental scale, using the natural world itself as their medium. Like engineers, architects, or farmers, they want to change the face of the earth. The earth sculptures they create may consist of trenchs in a dry lake, redirected streams of water, enbankments of land, or merely photographs of natural geological sites. These artists seem to represent a protest against artistic

traditions and, more recently, against planet-wide ecosystems. Like happenings, many of these events are too vast or too transient to be experienced permanently by many people. Earth sculptures, like conceptual art, are limited by the economic resources needed to support them.

Robert Smithson (b. 1938) is a major innovator in the relatively new phenomenon of earthworks. He is preoccupied with spirals, which he sees as moving from a path as close to us as our own cells of heredity, out to the vastness of the spiraling nebulae. In *Spiral Jetty* (Figure 1-19) Smithson fuses the spiral with his dedication to ecological factors, making the statement:

> My works have been based on a dialogue between the outdoors and the indoors . . . I'm not interested in reducing art to a set of ideas. I prefer making something physical, and the world is a part of the process. . . . Art will become less isolated and deal more in relationships with the outside world, out of the white room of the gallery into spaces that are natural.

Pulsa, a Yale-University-based group that designs waterworks for night display, is vitally involved in works of art which involve today's technology. In a four-acre pond in the Boston Public Gardens they have rigged up fifty-two speakers, programmed by digital computers, that produce a glittering display of water, sound, and light by responding to the sunlight or electric lights that happen to fall upon the water. Thus these waterworks combine chance events with the aesthetic potential of art. Pulsa's future plans include working in the ocean to create a light and water environment in which all physical boundaries can dissolve. No specific limit will exist, only ambiguities in space.

In the spirit of Duchamp's Dada readymades (Figure 16-2), an artistic organization called N. E. Thing Co. has a division called A.C.T. (an acronym for "aesthetically claimed things"), which proclaims anything it chooses to be a work of art. One of the waterworks identified by A.C.T. is a lake with a plastic tube through which electric wiring is strung to illuminate the water. Two bathing beauties photographed on the site complete the work of art.

Caught up in a world of rockets, space technology, and interplanetary exploration, some artists have turned their attention to the cosmos as a field for artistic exploration. Forrest Myers, for example, directed four arc lamps into the air through a spectacular volume of twenty billion cubic feet. He plans another work, to be called *Rocketpiece,* which will consist of four rockets, positioned a mile apart, that will be launched at the same time, leaving behind four smoke trails which will dissipate as the rockets disappear into space.

Thinkworks Thinkworks are expressions of art which yield only information. This form of art involves us by stimulating our thought process to such an extent that we may even forget that the artwork exists only in the idea. The medium thus becomes the message. Joesph Kossuth imparts ideas by transferring a negative photostat to canvas to communicate words like "water" or "nothing." Kossuth explained that "what is seen is the presentation of the information.

The idea exists only as an invisible ethereal entity.''

Nihilworks are art works that self-destruct. A few years ago at Alfred University, Robert Smithson researched legendary accounts of a lost continent and roughly determined its imagined silhouette from records. Students collected a number of large, smooth, round rocks which were positioned on a quicksand bed in the approximate shape of the lost continent. Slowly, these rocks sank into oblivion. This type of art raises questions about permanence in art: Was the event still authentic art after the rocks were no longer visible? Can a work of art be justified if someone only remembers the art form? Did the possessions of an Egyptian pharaoh lose their worth when they were buried in his tomb? Much of what is going on in art today —from happenings to Jean Tinguely's *Homage to New York* (Figure 19-5) to nihilworks—makes questions such as these worth considering.

The term *archworks* is applied to fantastic visions of avant-garde architects, such as Frank Lloyd Wright's plan for a mile-high skyscraper. There is nothing new about this visionary approach to architecture. In 1775, for instance, Claude-Nicholas Ledoux produced fantastic plans for cities and factories that attempted to solve problems most architects would not grapple with until the late nineteenth century. And Le Corbusier's 1920 plan for rebuilding Paris still is contemporary in its handling of problems of urban crowding. Artists like these—whether architects, craftsmen, sculptors, and so on—who leap forward in their imaginations in an attempt to solve

artistic and social problems are often precursors of what is to come (Figure 20-20).

Thus, through the new trends in optical art, kinetic sculpture, light art, electronic music, conceptual art, earthworks, and skyworks, our traditional ideas of what art *should* be have been exploded. Faced with the sense of helplessness which pervades our society, conceptual artists seem determined to strike back at this overwhelming world by creating worlds of their own.

The Black Experience

As always, the issues affecting society continue to preoccupy artists. Not surprisingly, then, the Black experience is a social phenomenon which is reflected in art. It represents the long-overdue surfacing of a suppressed group whose members offer us an opportunity, through creativity, to participate vicariously in some of their ideals, needs, joys, sorrows, and day-to-day experiences. Hale Woodruff (b. 1900), who was given educational grants to study with Diego Rivera, reveals the influence of the Mexican painter's strong murals in his famous Amistad mural. Woodruff later developed a more abstract style in which he combined the vitality and the unique design sense of African art with his own technical skill and a contemporary approach. Artists such as Robert Carter, William Williams, Jim Danmark, Samantha Lewis, Mahler Ryder, and Romare Beardon are finding new creative outlets. Black art now refuses to be confined within predetermined boundaries, and Black artists explore many creative

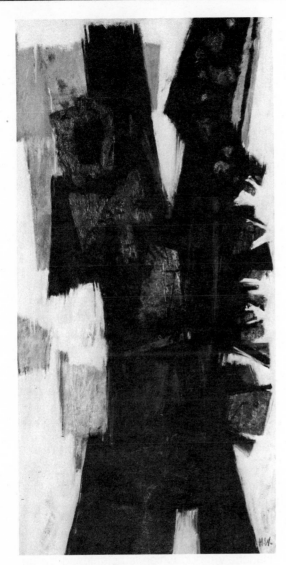

19-18 Hale Woodruff. *Shrine.* 1967. Oil on canvas with gold leaf. 20″ x 40″. Collection of Mrs. Edwina Ferguson, New York.

avenues. Only recently allowed full access to the art world, Black artists, like women artists, now are part of the mainstream of American art. Some are primarily concerned with aiding their people in their struggle. One of these, Elizabeth Catlett (b. 1919), confirms that she has gradually reached the conclusion that art is important only to the extent that it helps in the liberation of her people. "Art for me now must develop from a necessity within my people." Others, like Lovett Thompson, stayed in touch with their racial heritage while at the same time dealing with contemporary problems that affect all segments of society. *The Junkie,* whose face is reminiscent of African sculpture (Figure 19-20), speaks to us all.

19-19 Hazard, Benjamin W. *Wipeout.* 1968. Lithograph. 18″ x 24″.

Other Styles, Other Trends

Many other styles and trends exist in art today, and groups or individuals often follow one line of thought for a period of time and then move on to another interest. One of these trends is realism, which has continued to be a part of American art through all the changes of the twentieth century. Even during the heyday of Abstract Expressionism, when it was almost impossible for realistic painters to find galleries in which to exhibit their work, painters like Andrew Wyeth (b. 1917) continued to paint recognizable objects and the ordinary people of rural America.

Wyeth's use of realism can be seen in *Christina's World* (Figure 5-10), in which the artist expresses the hardships and isolation of the handicapped. His precise tempera technique establishes a matter-of-fact world, yet he imbues the figure of the crippled girl with pathos. But, realistic as it is in detail, Wyeth's painting uses exaggerated perspective in the high horizon and the wide vista of the sky to increase the sense of distance between Christina and the house. A visual tension is developed which expresses the physical struggle of her inching progress toward her home. The impact of Wyeth's paintings is heightened also by the stark simplicity of their composition and by the frequent suggestion of forces beyond the factual details he presents.

Magic realism, or superrealism, is another current trend in which the painter exploits our camera-oriented responses but takes us beyond that vision. At first glance Philip Pearlstein's (b. 1924) painting may strike us as a mere copy of a photograph. Certainly it

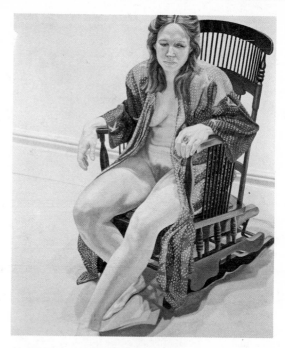

19-20 Philip Pearlstein. *Female Model in Robe Seated in Platform Rocker*. 1973. Oil on canvas. 72″ x 60″. Collection Allan Frumkin Gallery.

has the harsh quality of snapshot light and shadow. But, on deeper scrutiny we see that he uses this type of lighting to achieve a sharper, heightened reality which emphasizes certain features of the model to produce the desired emotional effect—a rather heavy, melancholy mood which is heightened by the downward glance of the eyes and the drooping hand.

Frank Gallo's (b. 1933) realistic sculptural forms are executed in polyester, reinforced with fiberglass and wood. Thus he creates somewhat conventional forms with unconventional materials. His surfaces are dense and opaque, and the figures are always painted and deliberately pretty. Occasionally, they are placed on real props, creating a juxtaposition of an art object with a real environment.

An important trend in art today is the new interest in craft methods—ceramics, weaving, and stitchery, for example—and their use by artists who traditionally had used only paint or other conventional art materials. *Objects USA* was the first of many museum exhibits to show that the line between *art* and *craft* no longer exists. Sculptors crochet and quilt, blow glass, or weave environments. For example, Paul Harris sews figures out of canvas and burlap. Then, after stuffing and painting them, he places them in chairs, rooms, or stuffed-fabric forests. Painters may use the dye techniques of craftsmen (Figure 7-9), and weavers and potters may create art objects that go far beyond the usual definitions of applied art.

Visionary painters, in a reaction against the huge scale of color-field painting and product-oriented pop art, have created miniatures in which tiny figures and animals appear in seemingly real, yet unreal,

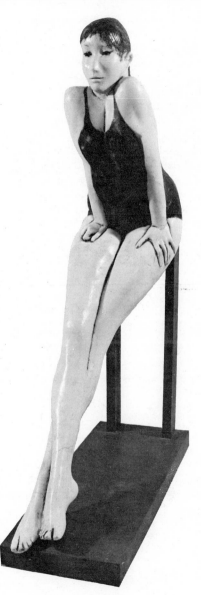

19-21 Frank Gallo. *The Swimmer*. 1964. Polyester resin. 65″ high, 16″ wide, 41½″ diameter. Collection of The Whitney Museum of American Art, New York. Gift of the Friends of the Whitney Museum of American Art and the artist.

surroundings. Similarly, ceramic sculptors like David Gilhooley and Louise McGinly (b. 1922) create myths and legends, chronicling the joys, hopes, or desperate fears of imaginary animal-people (Figure 4-7).

Sculptor Dewain Valentine (Plate 10) uses the manmade medium of plastic to cast jewellike forms which can be variously arranged and interlocked. Because plastics do not have traditional associations in the art world, they present a fresh, innovative medium with which the sculptor can experiment. The forms in Valentine sculpture range from geometric to organic; some are tightly confined shapes, others are fluid.

So it is apparent that today no one style in art is dominant. Although instant communication keep artists all over the world in touch with each other's work so that they influence one other, the climate of the seventies seems to have freed artists to be themselves, to blaze their own creative trails. Museums and galleries recognize these changes and no longer are as concerned with their own images as they once were. Instead they are willing to show a greater variety of styles, techniques, and approaches than ever before. And just as no one art style dominates the scene today, so, too, no one city is the art center for the world. The result is a healthy variety of styles and trends. Although this variety may confuse us, how much more stimulating it is to be able to look at our world through the eyes of so many different individuals. It would appear that the pressures toward conformity that are so typical of the computer age have heightened rather than stifled artists' imaginations.

Art and the Environment

The roadside strips, the consumer
products, the billboards, the fantasy
cars, the monster junk piles are all
portraits of us, not someone else.
There is no "they."

George Nelson

Now, in the last quarter of the twentieth century, our scientists and technologists have developed instruments of incredible sensitivity. We can photograph living cells so small that for us to see them they must be enlarged 14,000 times with electronic cameras; we can send television pictures back from planets; we can transplant hearts. But how do we, as sensitive human machines, function within our environment? What are our surroundings like, and how do they affect us? What is the quality of our life? Are we content, creative, and outgoing, or are we suspicious of others, violent, or unfulfilled? And what about art in the world? Is it truly part of our world? Are we surrounded by beauty in our daily lives, or do we live in mess and mediocrity?

As rational beings, we can, to some extent, control our surroundings. We may be at the mercy of social or economic forces, but we, as citizens, can work to change our society. One decision we can make is whether we will continue to allow our cities to become places of chaos, or whether we will change them to provide surroundings in which people can truly *live*. It can be done. The citizens of Portland, Oregon, decided that there was no reason why their city should not have a waterfall, which would give city dwellers a chance to experience the joy of climbing over, around, and in its rushing water.

Anyone who drives through an American city, or through a small town, or along a cross-country highway will agree that a large portion of our lives is spent in chaotic, ugly surroundings. We may well deplore what is happening to the natural beauty of our country and how our communities have been changed from the human scale and uncluttered quiet of early Colonial towns to today's ugly spread-out roadscape.

The ecological environment in which our forbears lived, and to which our biological rhythms are still keyed, is gone. For example, the vast forest, broken by streams and meadows, that once covered the eastern United States has disappeared, and the sprawling manmade environment that has replaced it bears no resemblance to it. Can our individual human systems stand this kind of change? Are we, like the dinosaurs, doomed to extinction because of changes in our environment—changes that we ourselves have brought about?

We now realize that our culture's dedication to the production of material

goods threatens not only our own living space, but already has resulted in the destruction of many species of animals and plants. We have the technology and knowledge to change the earth, and we have learned to manipulate nature to our advantage, but until recently we had failed to see that our manipulations could destroy both nature and us. Inherent in the harmonious operation of our whole environment must be an awareness of the interdependence of all life. Our society, in general, and industry, in particular, only recently have accepted the idea that ecological responsibility is as important as technological progress.

The environment which twentieth-century humans have created for themselves seems designed to produce more and healthier machines rather than more and healthier humans. Consequently, we are apt to feel helpless when faced with the electronic age, losing our sense of value as individuals. Isolated and alienated from others, like the figures in Giacometti's *City Square* (Figure 4-12), we have tended to let things happen to us rather than to insist that we must have some control over our environment.

It has been shown that for their physical and emotional well-being, humans need green plants and open spaces. The overcrowded ghetto, the lonely room in a broken-down hotel, or the sterile box in a new high-rise apartment—such surroundings turn the humans who live in them into

20-2 Lawrence Halprin. *Forecourt Fountain* (People's Fountain). 1968. Portland, Oregon.

apathetic beings who give up the drive to live, to change things, to grow. That we need and want the open space is shown by the thousands of us who have taken up hiking and camping. Even here, however, we have upset the ecological balance—mountain slopes are being eroded, streams polluted, and animal habitats destroyed—to such an extent that usage of many wilderness areas must now be limited.

Environmental Disaster?

Environmentalists and population experts believe that our present growth patterns ultimately will lead to disaster. Experts at the Massachusetts Institute of Technology have said that unless we can stop the growth of our industry and our population, the human race will face death within three generations. Scientific tests have shown that dogs need ten square feet of space in which to live, and chickens two square feet, or else they become neurotic and sexually maladjusted. How much space do humans need? We do not know the answer yet. Perhaps we have already passed the danger point in some of our urban areas.

We must also discover the answers to other questions: Are aesthetic values essential to human well-being? How do our visual surroundings affect us? Does it damage us to look out onto ugly cluttered cities, mediocre small towns, or sterile suburbia?

To discover how people react to aesthetic conditions around them, psychologists tested the same group of people in an "ugly" room

and in a "beautiful" room. When the subjects were in the ugly room—with its dirty gray walls, overhead glaring bulb, torn shade, refuse, unemptied ashtrays, unswept floors, and empty boxes—their reactions to pictures of other people were negative, and they saw them as expressing displeasure. On the other hand, their responses to the same images were positive and pleasant when they viewed them in the attractive room. This experiment suggests that the visual unattractiveness of most cities may be a factor in the hostility that humans show toward each other in our urban society. If people who stay in an ugly room for fifteen minutes become uncomfortable and irritable and perceive the same displeasure in others, it is not difficult to imagine what happens when a person spends his whole life in ugly surroundings.

Other scientists performed tests which showed that children respond positively to examples of aesthetically satisfying art and that their own creativity and sensitivity were enhanced when they were exposed to excellence. With the kind of visual environment with which so many children are surrounded today, what kind of adults will they become? Will they be able to *see?* Will they enjoy the patterns of light and shade on a wall, the structure of a shell, the color of the sky at sunset? Or will they develop such a protective reaction against their chaotic surroundings that they no longer will be open to visual pleasure? And will they, in turn, avoid involvement with their fellow humans— even when one of them is being murdered?

The pollution of mass-produced objects has been with us ever since the assembly-line was developed. Andy Warhol and other pop artists have commented on the endless duplication of our surroundings— the repetition of our mass-produced products (Figure 7-17). There is no question that the duplication of objects threatens to engulf us and that we must devise ways to keep our refuse from covering the globe. Compacting refuse to form building material and converting gas from waste into fuel are partial answers, but the final solutions may require us to change our values and to give up some of our conveniences in order to save the environment.

At the same time, there is no inherent reason why factory methods cannot produce attractive goods just as well as ugly ones. A wine bottle, for example, may be elegant and slim, pleasant to look at and to pour from. Furniture, likewise, can be handsome as well as utilitarian (Figure 7-3). Charles Eames's formed-plywood chair, which has been in production since the late 1940s, is a classic piece of attractive utilitarian furniture that was designed to be produced with assembly-line techniques. Kitchen utensils, china, and tableware can also be mass-produced in attractive designs, and will be if we demand them (Figure 1-8). Packaging, too, can be aesthetically pleasing, and, although our consumer society depends on advertising, there is no reason why messages from manufacturers must be blatant visual assaults on our senses.

Just as our synthetic landscape is a product of our lives, so the way we live is reflected in our surroundings. Indeed, ugliness in cities, towns, and along highways seems to be a modern phenomenon. Medieval and Renaissance towns may have

20-3 Contemporary commercial design. Walter Landor Associates, San Francisco.

20-4 Package design. Walter Landor Associates, San Francisco. Photo, Jeanne Riemen.

been dirty and crowded, replete with pungent odors, but they were built to a human scale and responded to the human need for a busy public life and a quiet private life as well. Gardens, trees, and flowers were part of the environment, and open fields and forest were just beyond the city walls.

Venice, for example, is a city which is still organized in much the same way it was hundreds of years ago. Here each neighborhood has its own plaza, around

20-5 Palazzo della Ragione and Piazza delle Erbe. Padua, Italy. Italian State Tourist Office.

which community life revolves. The trees, markets, cafés, and the human companionship that the plazas offer are reached by streets through which no cars move. Here humans can find all the vitality, bustle, and stimuli they need. The canals with their busy traffic are the main arteries, providing mass transportation for people and goods without the noise and exhaust of the cars and trucks of other cities.

Speed and Its Effects Today, however, we live in a world of mechanical motion in which we are always moving or are reacting to motion around us. To live with such continual movement has produced a profound change in our adjustment to the external world, and frequent changes in velocity and direction tend to make it difficult for our systems to adapt. We know that the inner tempo of human animals is a biological, cosmological rhythm, keyed to the movement of the tides, the moon phases, night and day, and the slow changes of the seasons. Perhaps the sense of disequilibrium seen in the work of

many artists today reflects a sort of speed sickness caused by denial of that tempo.

Speed, the wonder and the curse of our society, has changed our lives. But has the change been for the better? Can we balance the comforts and ease of living which the private automobile gives us against the pollution—both physical and visual—which the automobile culture has brought? For example, two-thirds of downtown Los Angeles is given over to the automobile—in streets, freeways, and parking lots. Expressways separate one neighborhood of a city from another with concrete barriers that carry roaring cars. But is this necessary? Mass transportation could carry us more efficiently, more comfortably, without polluting the air, and would leave room for green space within the city. Garages could be spread around the city's edge and electric transportation could carry people to its center. Parks, such as this one in Oakland, California, could be built on top of garages to provide open green areas where people could stroll or sit and relax. In many cities, large offices and apartment buildings are now being built with parking on an underground level, malls and parks on another level (isolated from the streets), and with bridges going from one building to another or across busy streets.

Going even further, a few cities have banned cars from certain areas in an attempt to restore a human scale and to provide pleasant places for people to congregate. Fresno, California; Rotterdam, Holland;

20-6 Kaiser Center roof garden. 1960. Oakland, California.

way, blocks of tree-shaded walks and little oases are provided for pedestrians. In Portland, Oregon, eight blocks of malls, miniature parks, and plazas connect two waterfalls, creating areas for rest, human interchange, stimulus, and refreshment in the middle of downtown. Rockefeller Center in New York, though its buildings are huge and dehumanizing in scale, does provide city dwellers with flowers and trees and, in winter, with a glimpse of skaters. An office building in San Francisco has placed a garden in its setback where office workers can eat lunches in the sun or listen to street musicians. Small open spaces like these provide us with a moment or two of respite

20-8 Frank Lloyd Wright. Lloyd Center shopping mall. 1960. Portland, Oregon. Photo, Morley Baer.

20-7 Shopping center mall. 1964. Fresno, California. Photo, Fresno County & City Chamber of Commerce.

Coventry, England; and many other cities have constructed pedestrian-oriented shopping areas where people can wander comfortably, undisturbed by cars, or can sit on quiet benches or in cafés surrounded by flowers, sculpture, and fountains. Store owners, who were fearful at first that such malls would hurt their sales, have discovered that the pleasant new environments have been good for business. In both Philadelphia and Minneapolis, several city streets have been linked and cleared of traffic. In this

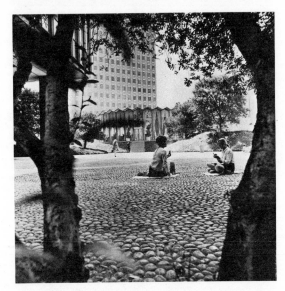

20-9 Financial District, San Francisco. Photo, San Francisco Visitors Bureau.

and indicate that urban planners *are* concerned with the survival of the human spirit as well as with physical growth and progress. To change our cities radically, future architects and city planners and the corporate clients they serve will have to respond to human psychological needs as much as to the needs of industry, commerce, and the automobile.

But motion can also be exciting and can be expressed poetically in architecture. The winglike sculptural shapes of Eero Saarinen's airline terminal building for TWA in New York are exciting but not overwhelming. Its open spaces, ramps, and varying levels can accommodate moving groups of people but also allow space for other people to sit and watch the crowds while waiting for arrivals and departures. In the structure there is a visual excitement provided by the architectural forms and the spaces thus defined that is increased by the movement of people—an appropriate quality in such a building.

Human Need for Identity What qualities do Venice, the pueblo of the American Southwest, or an unspoiled village have in common? Human scale, an ordered relationship of all parts to the whole, and above all a sense of identity with a settled place are qualities which they share. That sense of identification with their surroundings adds stability to the lives of the people who live there. Some of this stability derives from

20-10 Eero Saarinen. Trans World Airlines Terminal Building. 1962. Kennedy International Airport, New York. Photo, Trans World Airlines.

symbolic buildings in the community, buildings that give a focus both visually and emotionally. The beliefs of the people who lived in a Medieval town, for example, were expressed in their cathedrals which took years of community effort to build, and whose spires dominated the town. Without some fixed point in our lives with which we can identify, we feel fragmented and insecure; but today there are few such stable elements in our environment. Change is constant, and the large symbolic buildings in our cities are often sterile commercial structures that dwarf the older, more identifiable landmarks. Even churches, which used to give emphasis to towns and provide visual focus, now are engulfed by surrounding buildings. No wide plazas or far-off perspectives pull our eyes toward the churches, and all sense of the dramatic is lacking. Compare a view of a downtown church or the city hall in your community with the complex of buildings that once crowned the Acropolis in Athens (Figure 9-6) or with the plaza outside St. Peter's in Rome (Figure 12-11). Does the modern structure have any of the drama of these older public spaces and buildings?

In the suburbs, a similar problem exists. There, houses are all of approximately the same size, general plan, and height. Streets, which once grew out of human needs— following foot paths or cow paths—now are usually preplanned and laid out before the houses or towns are even built. And, as in the cities, public buildings no longer provide focal points but often are built to blend with their surroundings, even if those surroundings are rows of ranch houses. An exception is Le Corbusier's chapel at Ronchamps, which is a dramatic and exciting focal point with its sweeping curved roof (Figure 3-18).

A few attempts have been made to create symbolic groupings out of commercial, civic, cultural, or educational buildings. For example, Lincoln Center and Rockefeller Center in New York and Boston's Government Center provide some emphasis and focus. However, most such modern efforts to supply this kind of drama and focus have not been successful. In Brazil, the new capital of Brazilia was built with contemporary architecture, open malls, sculpture, and fountains; but it has failed to provide a sense of intimacy, and housing for government workers there is in blocks of anonymous flats.

In contrast is Florence, Italy, where the dome of the cathedral and the towers of churches and palaces appear above the busy market, over a plaza full of people, or framed at the end of a narrow street. This perspective gives us a sense of excitement and leads us toward the buildings through an approach scaled to humans (Figure 11-5).

Theaters, opera houses, and sports stadiums, which draw people together in great numbers, pose special problems for planners. The art of large-scale design lies not only in attending to the mechanical needs of people in crowds, but also in minimizing confusion, inconvenience, and danger. Spaces must be created to make people feel that the facility was planned for them and not for automatons. A city is large and frustrating, exhilarating and depressing, and the individual, lost in its vast and often monotonous routine, needs to be publicly reminded that he is a human being with a

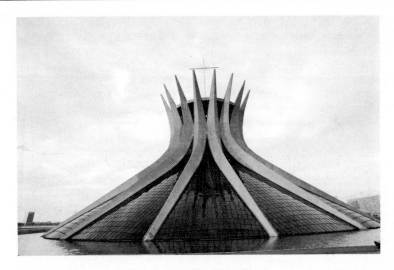

20-11 Oscar Niemeyer. The Cathedral. 1971. Brazilia. 120' high. Photo, Luis Villota, Photo Researchers, Inc.

20-12 Lincoln Center Plaza. Left, the Metropolitan Opera House, 1966. Right, the Vivian Beaumont Theater, 1965. Lincoln Center for the Performing Arts, Inc. Photo, Bob Serating.

20-13 Museum of Modern Art. 1939. New York. Photo, David E. Scherman.

capacity to experience emotion arising from large-scale collective efforts. Lincoln Center, New York's cultural complex containing Philharmonic Hall, New York State Theater, and the Vivian Beaumont Theater, is grandiose and austere. Surrounding a huge plaza that contains a tall fountain, the buildings create an overwhelming and anonymous grouping that has no scale or familiar details to which we can relate. The monumental scale, instead of inviting us to enjoy, weakens our sense of personal value and makes us feel uncomfortable.

On the other hand, Frank Lloyd Wright's Solomon R. Guggenheim Museum in New York is designed with flowing curves and with a doorway keyed to human beings which invites us to enter (Figure 1-7). The arrangement of the building, in which elevators carry viewers to the top so that they can walk down a sloping, circular ramp to see the paintings, is frankly expressed on its exterior. Its top-heavy shape would be disturbing except that it is balanced and tied to the ground by the low mass to the side, which includes offices and library. But the building can only be seen clearly from the park across the street. How much more elegant and inviting it would be if the space around the building could have been planned to give us glimpses of it as we approached on foot or by bus.

Thus we see that a single building in a city as huge as New York can be individually impressive, but it will lack full impact when the area surrounding it cannot be planned or arranged to enhance it. In the same way, the Museum of Modern Art in New York is a handsome building with a pleasant courtyard and garden where people can wander or sit surrounded by sculpture. It is a haven in the middle of the city, provided you have the price of entrance. But the building itself, which invites us inside as we look through the glass front, had to be uncomfortably sandwiched between existing neighboring buildings. Individual projects like this can give a bit of relief to the otherwise deadening effects of the city, but they are much more effective when the entire area can be planned.

Team approach to planning Separation of the visual and environmental arts into the isolated fields of architecture, painting, sculpture, city planning, and landscape design—each art producing its own specialized practitioners—is typical of the scientific attitude which developed during the eighteenth century. Today we are beginning to realize that these arts cannot be separated successfully. Le Corbusier (Figure 15-24) stated that "architecture, painting and sculpture have been unfortunately disassociated or separated for centuries—the movement of time and events now unquestionably leads them towards a synthesis." Technology calls for specialization, but many now believe that a team approach, with artists and technical experts working together, will make it easier for us to create surroundings which will enrich and refresh the human spirit rather than crush and alienate it.

The Growth of Cities How did our cities develop in such an inhuman way? When did they change from groupings of buildings oriented toward human needs to what we see today? As trade expanded during the Renaissance, mercantile and commercial needs became more important than human needs. Hastening the change was the concept that logic, reason, and science can provide the ultimate answers to all problems. This belief led to urban plans which were laid out in grids, or, as in the case of Paris, in a star pattern of radiating boulevards. Although wide boulevards designed for marching armies and exhibitions of power by kings and emperors are impressive, and although they can be lined by shaded walkways, they do not help develop a sense of neighborhood life any more than do modern freeways.

In the United States, small towns, and even county and state boundaries and roads, were surveyed using a grid system. One reason for this was the natural desire of the settlers to impose a human design on the frightening vastness of our continent. The kind of plan that was popular at the time was the Renaissance concept of logical scientific order, an idea which disregarded the organic needs of humans.

Another nineteenth-century concept—that the machine was a god—also influenced the way our cities grew. Thus cities, rather than being planned for people, were planned for better production, distribution, and selling of the products created by the machines. As the machine took over their lives, people became apathetic and felt they had no control over how they lived. Accelerated change was too difficult to fight, and specialists, bred by science and technology, insisted that they knew best. More scientific and mechanical progress, greater production of consumer goods, and larger plants, factories, transportation systems, and commercial centers became the goal. At the same time, the economics of land development, based on private profit, controlled the manner in which cities and suburbs developed.

City Planning Early pioneers in city planning refused to accept the idea that peoples' lives were unimportant. In the nineteenth century, Ebenezer Howard and Raymond Unwin planned garden cities outside the industrial areas of Britain as self-contained towns where people could live near their work, have the necessary services for day-to-day

living, but still be surrounded by greenbelts and have their own gardens. Unwin's early garden cities and Clarence Stein's and Henry Wright's Sunnyside Gardens—a nonsegregated, economically mixed community built on Long Island in 1928—formed the models on which the many new towns built in England after World War II were based.

In the 1930s Frank Lloyd Wright proposed to phase out the city and to provide an acre of land for every citizen. At that time the population of the United States could have been settled on the available acreage. Wright's idea was that people should till the soil and produce food even if they were employed in manufacturing. Today, some cities in Europe do provide inhabitants with allotments of land outside the city where they can grow vegetable or flower gardens and with tiny weekend cabins where they can get away from the city.

In the nineteenth century, the urge to escape from the city led to the development of the suburbia that now surrounds all our cities. The more affluent people fled from the industrial and commercial centers, where soft coal smoke belched from factory chimneys. This flight of middle-income families from the city has left the inner city to the poor, who cannot afford to leave, and to the rich, who are segregated in expensive developments. City property frequently is owned by people who live elsewhere—absentee landlords—who do not care about the quality of life lived by their tenants. The less advantaged citizens of the central city are so busy earning a living that they have little time or energy left for the civic action necessary to force change. Gradually the city loses taxes, loses

20-14 Stevenage, England ("new town"). Wide World Photos.

shoppers, and becomes a center for daytime office life, leaving large areas deserted at night.

Nor have the suburbs turned out to be all they promised. Originally planned to provide space, light, air, gardens, and a healthy environment for families who could afford them, suburbs now are often land-eating monsters that provide some of these comforts for their residents, but at a price our society can ill afford. For example, the widely spread facilities of suburbia call for two cars per family; thus they add to fuel consumption and pollution. The distance of these communities from the city, which increases as suburbia spreads, has led to more highways which in turn cut up the land as well as bring more cars into the downtown area. In addition, the similarities in economic, social, and cultural outlooks of suburban residents deprive them of the stimulus of encounters with people of differing life-styles.

20-15 Daly City, California. Photo, HAMMONDBALL.

Most planners now believe that if the variety and activity of city life could be combined with pleasant surroundings and safe, comfortable neighborhoods, cities could be revitalized.

Neighborhoods A neighborhood of five to ten thousand people is generally considered to be a manageable size for a city, or for small satellite towns or suburbs. A certain number of services are needed to support everyday life—a health clinic, a branch library, and schools—while the neighborhood must be integrated into a larger community in order to provide for higher education, fully equipped hospitals, and larger and more extensive commercial and manufacturing facilities. This kind of neighborhood grouping grew naturally in older cities. In newer cities, however, that were developed according to the grid pattern and that contain large apartment houses, widely spaced shopping centers, and streets full of traffic, it is almost impossible for a comfortably-sized neighborhood to grow up spontaneously. Another factor that has inhibited the development of truly organic neighborhood communities is the segregation that is a part of our city scene, whether it is segregation based on color or on economic level.

Le Corbusier's master plan for Chandigarh, the new capital of the Punjab in India, divides the city into sections that are about the size of a village and that respect the centuries-old living patterns of the inhabitants. Each section has a market, a park, blocks of housing, paths for pedestrians, and roads for slow traffic. Faster

traffic is separated from the neighborhoods, and large businesses, governmental, cultural, educational, and medical facilities are centrally located. Because of high land values, such a spread-out plan would not be suitable for every situation. For this reason, clusters of tall apartments, like the one Le Corbusier designed for Marseilles, are often built to allow for more open space around them.

But how can we make urban life more pleasant without building a whole new city? Planners, trying to make neighborhoods more livable, have suggested placing a kiosk at the intersection of several blocks to provide a place where residents could pick up milk, newspapers, aspirin, cigarettes, and perhaps some groceries—anything that would cut down on door-to-door deliveries and short trips by car. Mail could be picked up there, and automatic mailing machines would save trips to the post office. A tree or two, a few benches, a bus stop, a car-pool stop, and a bulletin board could make these kiosks neighborhood meeting places and could help the residents get to know each other. The old corner store would thus be redesigned. In New York, the residents of a block of old brownstone apartment buildings combined all their backyards to create a large, shared green space. Thus, at the same time that they created a pleasant place to sit or play, they developed a sense of community— something that is rare in the anonymous city. Since our cities did not develop as organic communities, we will have to plan along such lines to improve the quality of urban life so that it approaches that which exists naturally in a city like Venice.

Another problem, that of building attractive housing that can be rented or sold at a reasonable price, is one of the greatest social challenges we face. Large numbers of our citizens are improperly housed, and our present economy cannot provide adequate private housing. The approaches to public or moderate-cost housing that have been tried so far usually have resulted in huge, inhuman developments that have created more problems for residents and communities than they have solved. In an attempt to deal with this problem, an integrated, moderately priced housing development—St. Francis Square—was financed by a labor union.

20-16 St. Francis Square, San Francisco. International Longshoremen's and Warehousemen's Union project.

Other examples of good low-cost housing can be found in Scandinavia, where public housing is widely built and well planned to meet human needs. There, cooperatives and trade unions, as well as the government, have built housing. As a result there are innumerable pleasant, well-planned city neighborhoods, towns, and, in fact, whole regions where the needs of humans of all ages have been anticipated and where people can afford to live comfortably. These examples prove that the human race *is* capable of solving the problem. The question is whether we really want to tackle it with all our inventiveness and technical knowledge, convinced that it is one of our most important goals.

New systems of construction Some creative designers and architects have suggested new methods of building which might lower the cost of construction. When R. Buckminster Fuller (b. 1895) designed his geodesic dome, it was considered revolutionary. Built for the United States pavilion at Montreal's Expo '67, it spanned an area nearly 300 feet in diameter (Figure 3-23). Since then, Fuller's domes have been built in all sizes and out of many different materials. Fuller based his system on late nineteenth-century discoveries of tetrahedron configurations in organic chemistry. He considers the tetrahedron structure to be naturally stronger than the cube structure, which tends to collapse, and consequently needs bracing. Tetrahedrons, in contrast, are naturally stable. Today Fuller's dome concept is accepted as a lightweight, strong structural system which can be used to enclose large spaces quickly and inexpensively using prebuilt modular units.

Modules have been used in building ever since sawmills standardized wood cutting. The Crystal Palace (Figure 3-14), built in London in 1851, was based on *modules,* or sections which fit together interchangeably. Modules can be prebuilt in factories and fitted together easily at the site, which speeds construction and cuts labor costs. Buildings using multiples, prefabricated sections, precut parts, or various combinations of these are now common as well. Not only buildings, but furniture, too, can be made in modules (Figure 7-12).

20-17 Eriksberg. Uppsala, Sweden. Photo, Swedish Information Service.

Using modular systems, Israeli architect Moshe Safdie (b. 1938) has designed complete housing units which fit together in a variety of ways, providing different floor plans for the individual units. Safdie's Habitat '67 was a prototype of modular housing built for Expo '67. Its precast reinforced concrete boxes, which were fitted with kitchens, wiring, plumbing, doors, and windows, were swung into place by a crane and attached to one another with rods and cables. Along with the obvious advantages of units like these that can be fitted together so easily, Safdie's design takes other urban human needs into account. These Habitat units are human in scale, allow for privacy, and avoid monotony —all important features for urban dwellers. Safdie planned pedestrian malls to join the units and provided covered parking underneath. He believed that groups of Habitats could be clustered around city parks, and residents could walk on pedestrian overpasses or on paths through open spaces to reach shopping and community facilities. He has applied this principle to housing developments in several countries.

Another method of using modules was originated by Italian architect Pier Nervi (b. 1891), who has developed a system of layers of fine steel mesh sprayed with cement mortar to prefabricate the modular sections of his curved rib framing. Based on organic forms, the structural systems which Nervi designs to carry the weight of roofs across wide spans are elegant and airy. He first used this method in 1932 in Florence for a municipal stadium. Since then he has created many different types of structures, among them a wool factory, an exposition hall, and the Palazzo dello Sportivo for the 1960 Olympics in Rome. The modular ribs of the Palazzo are prefabricated, as are the piers which transmit the thrust from the roof.

Nervi is one artist who is hopeful about the possibilities that modern technology opens for us. He does not fear that humans will become spiritually impoverished as a result of technological progress. Nervi envisions a city of tomorrow in which the residential buildings will have clean and honest construction, made lively and gay through their relationship to streets, plazas, and gardens. He envisions that such a city

20-18 Moshe Safdie. Habitat. 1967. Montreal. Photo, Canadian Government Travel Bureau.

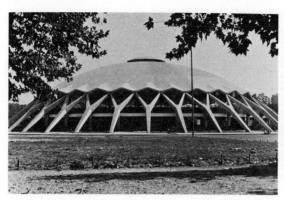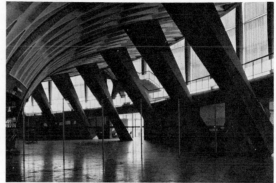

20-19 Pier Luigi Nervi. Sports Palace. 1958-59. Rome. Photo, Italian State Tourist Office.

would have a few large public buildings which would serve ''the highest and most significant expression of the new architecture.''

Looking toward the future To achieve this new kind of city, we might even take a few chances on visionary schemes. Space flight seemed visionary not so long ago, so perhaps some of today's more inventive architectural schemes may be worth exploring. Architects have envisioned cities which burrow underground, hang from poles, or seem to float in the air. Architect Paolo Soleri's (b. 1919) designs suggest complete cities of enormous vertical elements tied together by automatic transportation systems. His forms are unusual, often cylindrical or hemispherical, and are totally alien to our usual concept of cities. Other architects have suggested self-contained houses which could plug into central utility masts and could be taken along when the family moved.

Now that we know that much of our environment—our cities, our highways, and our towns—is obsolete, unattractive, and actually is causing harm to our bodies and spirits, we should be able to use our advanced techniques to rebuild and reshape our surroundings so that human experience can be widened and deepened. Even as individuals we can make a difference. For example, a man who worked in a large government office found that instead of driving to work he could paddle a canoe across a river, hide the canoe in the bushes, and then walk to his office. When he discovered that a small stream that entered the river near his mooring place was polluted by the waste dumped from his office building, he spent months writing letters, making phone calls, and visiting officials to ask for an improved waste disposal system. Finally, he was successful in convincing others that the stream was important or that he would pester them until they did

20-20 Paolo Soleri. Arcosanti, a city for 3,000 people. Started in 1970. Reprinted from *Arcology: The City in the Image of Man* by Paolo Soleri, by permission of The M.I.T. Press, Cambridge, Massachusetts.

something. Now the stream runs clear.

The old attitude that you can't fight city hall is out of date. We may not get what we want all the time, but even the smallest change helps. Here are some examples of what can be done. The citizens of San Francisco decided that they would allow no more elevated freeways in the city and stopped one in midair. Now there is talk of tearing it down because it blocks enjoyment of the waterfront. A small town decided that aesthetic values are important and hired a well-known architect to design an award-winning firehouse. Another city bans cars in part of its main park on Sundays so that families can rediscover the fun of walking, hiking, and riding bicycles without the danger, fumes, or noise of cars. None of these changes happen because "they" decide to do them. Hours of effort are required—attending city planning meetings, ringing doorbells, and writing letters. The change will happen because we and other ordinary people decide that our visual environment matters to us and that aesthetic pleasure in our surroundings is necessary to our personal well-being.

The choice is up to us. We can bring art back into the world and create an aesthetically pleasing environment for ourselves. There was a time when art *was* a vital element of everyday life—humans wove baskets to store grains, fashioned jars to hold wine, and decorated the stools on which they sat. Their lives were enriched by the beauty of the objects around them. Today we realize that art again can become a part of our daily lives, enhancing the buildings we live and work in, the utensils we use, even the highways we drive along. To bring art to our everyday lives involves choice, commitment, and work on the part of citizens who care—those of us who want art in our world.

Exercises and Activities

The following exercises and activities are included as suggestions for classroom use or outside assignments. Although the activities are arranged by chapter, some of them are broad in scope and may require reading of various chapters in order for the student to adequately understand or complete the assignment. Instructors may wish to make assignments from this list or to use the list as a guide for creating their own activities. Students may wish to use the activities and questions to review the text or to expand their own comprehension and appreciation of art. However it is used, it is hoped that this material will make the course more interesting and enjoyable.

Part I Humanity and Art: Creation and Response

Chapter 1 What Is Art?

The instinct to create art has been common to human beings throughout history. A study of the expressive needs of the artist and of our responses as viewers will help us have a deeper enjoyment of art.

Frequent exposure to art expands our artistic horizons. Visit your school and public libraries and become familiar with their art books and art magazines; study illustrations of old and new works.

1. Attend an art exhibit in a local gallery or museum. Write a review, explaining why you do or do not like certain pieces of art. Be specific. Then read an art critic's review of the same exhibit. Do you agree with the critic's evaluation? How do your responses differ?

2. Some universal themes have occupied artists from Stone-Age times through today. List some of these themes that you find illustrated in this or other books.

3. What psychological, emotional, and aesthetic factors do you feel are involved in the appreciation of art? Can you explain why some masterpieces seem to have universal appeal?

4. Picasso's *Ma Jolie* and Leonardo's *Mona Lisa* are both portraits of women and masterworks in their time. Explain in what ways they differ and some historical factors that may explain these differences.

5. Find five artworks in this book that have been inspired at least in part by the natural environment. Which appear to be duplications of nature? Which works reinterpret or abstract details from nature?

6. To experience how varying viewpoints affect your perception of a subject, set up a still life arrangement of four or five objects. Make a simple drawing of it from three different views, noting the changes that you see in the shapes, lines, and arrangements of the objects as you change your viewpoint.

Chapter 2 The Artist's Language

Line, shape, mass, color, value, and texture are all tools used by artists to express ideas and emotions. Some familiarity with these concepts will help you understand the technical problems an artist faces and will help you look at art with greater understanding.

1. Cover a sheet of paper with lines, using pencil, chalk, charcoal, pen and ink, and paint. Vary the thickness, length, direction, and spacing of the lines. Notice how the lines produce different effects.

2. Inside of small squares draw groups of lines that express joy, sorrow, excitement, humor, confusion, tension, or other emotions. Analyze what types of lines express each emotion best.

3. Linear perspective has been used by painters to create the effect of three dimensions on a two-dimensional surface. To understand how artists use this method, place some solid objects, such as books, boxes, etc., on a table. Try to see where the horizon line and vanishing points lie, and make a simple drawing of the objects in perspective. Think of ways you might vary the perspective to create different effects.

4. The traditional color wheel places the primary, secondary, and tertiary colors in a certain relationship. Using poster paints, mix these colors, paint them on pieces of paper, and paste them in the order shown on the color wheel (Plate 5).

5. Take two complementary colors and mix them with each other, producing a series of equal steps from one color to the other. Mix as neutral a gray in the middle as is possible with your pigments (Plate 5).

6. Set up a simple still life. Look at it to see how you might express a personal feeling by varying the colors. Choose two of the types of color schemes listed below and create two small color compositions to express your feelings.

 a. Strongly contrasting values and hues.
 b. Analogous hues and values.
 c. Cool colors with warm accents.
 d. Warm colors with black and white accents.
 e. Opposite colors with black and white accents.
 f. Monochromatic color with a wide value range.

7. The way in which varying types of shapes are combined produces different effects. To see how artists use shape as an expressive tool, draw groups of shapes inside small rectangles. Draw one arrangement that is balanced, another that suggests chaos.

8. Mass is used in the three-dimensional arts of sculpture and architecture. The illusion of mass often is also created in painting. Using clay, wood, or cardboard, make two compositions in which mass is used to create (a) a calm, quiet effect and (b) an exciting effect of tension. Or paint two compositions creating the illusion of mass and producing these same effects.

9. Using chalk and sheets of newsprint, make rubbings of actual textures. Cut and paste these, creating an interesting composition.

Part II Changing Techniques, Changing Forms

Chapter 3 Architecture

Architecture is the art of enclosing space in a pleasing and useful manner. Throughout history humans have developed many methods of construction to meet their varying needs.

1. List several ancient and modern structural methods. Draw simple diagrams of each.

2. What qualities of twentieth-century construction distinguish it from past methods? List examples.

3. Locate several buildings in your community that copy historical styles of architecture, such as Gothic or Renaissance. Can you tell if old methods of building were used, or is the historical detail merely applied on the surface?

4. Locate and sketch other buildings that appear to use more contemporary structural methods. How do these methods and materials vary from the older methods you have studied?

5. Learn to read an architectural plan and to understand the symbols for windows, doors, solid walls, closets, steps, etc. Learn how scale is used in a plan.

6. Look at house plans in magazines. Pick out one you would like to live in, and compare it with one you dislike. What features do you like about it? Are the rooms conveniently placed? What would the traffic flow be like? Do you think the house would be reasonable in cost, or are there features that probably would make it expensive to build? How would you change it to meet your needs?

7. Draw a plan of a public or school building. Pick out the features you would change to make it more convenient, and draw a revised plan showing these changes.

Chapter 4 Sculpture

Sculpture is a three-dimensional art form that developed as the earliest art expression in many cultures. Appreciation of sculpture results from familiarity with it as well as from an understanding of the methods the artist uses to express ideas and feelings.

1. Select five sculptural works from this book that appeal to you and explain why they do.

2. Although sculpture serves no functional use, as does architecture, it has served society since prehistoric times in other ways. List some of these ways.

3. The materials for creating sculpture can be found in any environment. What are the traditional sculptural materials? What materials and processes are unique to twentieth-century sculpture? Compare old and new materials, and discuss how contemporary and ancient sculpture differ.

4. Using a clay, papier-mâché, soft wood, or soap, create a sculptural form that recreates a recognizable natural object. Using any of these same materials, and the same subject, create an abstract sculptural form.

5. Using twentieth-century materials, create a three-dimensional form that relates to contemporary technology.

Chapter 5 Drawing, Painting, and Printmaking

Drawing is a basic skill that has been used by artists throughout history in several ways: as notes and studies for paintings, sculpture, prints, or architectural works; as a plan of a final work; as an art medium that stands by itself. An exploration of drawing methods will help you understand the need for this skill in art.

1. Different drawing materials have varying degrees of flexibility. Use several media, such as pencil, pen and ink, crayon, and poster paints, to create a full range of values from black to white. Arrange them in one-inch squares in nine equal steps. Notice the differences in effect and the difficulty of creating tone with some media.

2. Each drawing medium is capable of producing distinctive textures. These may be expressively manipulated by the artist. Divide a large sheet of drawing paper into rectangles. Find a texture in your environment that pleases you, and try to copy it in pencil, crayon, ink, or paint. Using the same media, create new textures.

3. Colors make a direct appeal to the emotions and have come to be associated with various feelings. Select a black and white photograph or reproduction that conveys a specific mood to you. Using any medium, make a simple composition based on the photograph, using a color scheme that expresses the mood.

4. The color of a subject may be interpreted by the artist in many different ways in order to express a personal feeling or emotion. Set up a still life and draw it in simple outline form. Fill in the outlines, using any three contrasting colors at full intensity, widely separated on the color wheel. Repeat the same grouping in an analogous color scheme and note the difference in effect.

5. Each form of printmaking—woodcut, etching, engraving, stencil, lithograph, or collograph—offers a different potential for creative expression. Explain the differences between these types of printing. How does engraving differ from etching both in method and final effect?

6. Select from the prints reproduced in this book three works that appeal to you, and explain your reasons for these selections.

7. Create a mixed-media composition using a combination of at least three techniques and materials.

Chapter 6 Art through a Lens

The art of photography developed slowly. Originally aimed at duplicating the painting styles of the mid-nineteenth century, it gradually became a separate art medium. Many of the same artistic principles that apply to painting apply to photography as well.

1. The principle of the camera was first explored in the Renaissance device known as the *camera obscura*. What was the principle on which it was based? How was it applied to later cameras?

2. Photography is both an art and a science. Explain the apparent contradiction in that statement.

3. The operation of a camera is related to the functions of the human eye. Define or diagram the relationship between them.

4. Select several photographs from a magazine or from your own photographs. Which do you believe qualify as works of art? Explain your reasons for your choices.

5. Cut out photographs that you like from magazines. Select ones that create different moods. Analyze how the photographer used the camera to create each mood.

6. An illusion of life can be produced through the medium of the motion picture. How did motion-picture photography develop out of Eadweard Muybridge's early experiments with multiple photographs? What are the advantages of cinematography and/or television over still photography? Explain the space-time concept involved in cinema and television.

7. Television commercials offer creative possibilities to the artist. Describe and analyze six commercials—three effective and three not effective. To what factors do you attribute their success or failure?

Chapter 7 Art in Function

Any piece of art or craft that is both useful and pleasing can be called functional. The range extends from handcrafted utensils or clothing to factory-produced objects made for mass consumption.

1. Many of the principles of design and the materials used for handcrafted or industrial products are based on the natural environment. Find examples in this book and elsewhere. Discuss the way in which these basic principles are applied to one specific piece of functional art.

2. Explain the place of proportion in the design of useful objects. What was the Greek Golden Section? Can you find an object that seems to reflect this principle?

3. On what basis are materials and processes usually selected for industry and/or crafts? Locate an example of the industrial arts that seems honestly to express the material from which it is made. Find one that attempts to copy another material.

4. What is meant by the concept "Form follows function"? How does it apply to industrial design? How does it apply to handcrafts? Locate one example of machine-made art and one of handmade functional art that seem to you to express this concept successfully.

5. How may our man-made environment be affected by industrial design? What effects may industrial design have on the ecology of our natural environment? What changes do you think could be made in our attitude toward the functional arts that might improve our environment?

6. The instinct for self-decoration is basic to all humans. What were humanity's earliest wardrobes, and what function did they serve? Pick the costume of one historical period and explain why you think it reflected the social conditions of the time. What items of apparel have developed as a result of changing life-styles in modern times?

7. The communication arts are all based on an exchange of information. Find examples of successful communication of ideas through visual means—in magazines, advertisements, and so on. What methods are used to communicate the ideas?

Part III Changing Ideas, Changing Art

Chapter 8 Prehistoric and Ancient Art

The earliest art appeared as human beings expressed their feelings about the world around them. As life grew more complex, the materials they used to express these feelings became more sophisticated.

1. Of what did the earliest art consist? What were the materials and functions of that art? Would you consider the art of our earliest ancestors to be simple and childlike? If not, in what way do you think it was skilled and expressive?

2. Locate two examples of contemporary art that deal with themes similar to those of prehistoric or ancient times. How does the modern work differ from early art, and in what ways is it similar?

3. Describe the construction of Stonehenge. What structural method was used?

4. The civilizations of Egypt and Mesopotamia developed at the same time, in locations not far from each other. What is meant by the terms *Fertile Ribbon* and *Fertile Crescent*? How were they important? When Herodutus stated that "Egypt is a gift of the Nile," what did he mean?

5. Contrast the architecture, sculpture, and painting of these two cultures from the viewpoints of material and style. Explain the reasons for their differences.

6. Create a simple painting based on a subject from everyday life, using some of the spatial concepts of the Egyptians.

Chapter 9 The Classic Past

The art of the Classic Greeks reflected their philosophy of moderation and the Platonic concept of ideal beauty.

1. Discuss the Greek architectural principles of unity and proportion that are demonstrated in the design and decoration of the Parthenon.

2. How do the three Greek orders differ? List and define the terms that describe the different parts of these orders.

3. Explain the concept of ideal beauty in relation to Greek art, naming specific works of art. Are there similarities between Greek art and other aspects of Greek culture? In what way is that ideal expressed in the sculpture and architecture of the Golden Age of Greece? How did the art of the Hellenistic period differ from that of the Golden Age?

4. Roman civilization was influenced by earlier cultures, but took elements from these cultures and used them to express Roman dominance over an extensive empire. What features did Greek and Roman art have in common? What features from other civilizations did the Romans incorporate into their art? What are some of the Roman engineering innovations?

5. Explain the origins of the arch, how it is constructed, and how it was used in Rome.

6. Create in clay, cast stone, or soap a sculptural work of art inspired by Greek or Roman art.

Chapter 10 The Middle Ages

Christian art of the Middle Ages incorporated a variety of cultural influences, making use of symbols and images from earlier cultures. These elements were adapted to the needs of the new religion, and out of them grew a new style of architecture and a new kind of art.

1. Explain the historical reason why early Christian art incorporated so many cultural influences. Give examples of images that derived from other cultures and were absorbed into Christian art.

2. Using colored chalks to suggest the effect of a fresco, sketch some early Christian symbols.

3. Cut out half-inch squares from advertisements, searching for varied colors and textures. Paste these small pieces on cardboard to form designs or representations of figures. Notice how you must simplify forms in order to represent them with mosaic squares. Study an early Christian mosaic and see how form was developed.

4. Locate old dishes and bottles of different colors. Wrap them in many newspapers, and break them into fragments with a hammer. Glue them onto a wooden surface in a satisfying mosaic design.

5. Explain how the Romanesque style of architecture originated and how it varied throughout Europe. What earlier structural systems influenced it?

6. Describe and draw a diagram of the Gothic structural system. Name and explain the function of the parts.

7. Using pieces of tissue paper, paste up a design for a stained-glass window. Use this as a guide to make a window from colored glass and leading available in craft shops.

8. Locate examples of Romanesque and Gothic Revival churches in your community. Describe how they use the elements of these styles. Sketch a floor plan of one, and compare it with a plan of an actual Gothic or Romanesque church.

Chapter 11 The Renaissance

The humanist approach to art and life was a dominant feature of the Renaissance, and Greek art and philosophy had a strong influence on artists.

1. What factors were responsible for the development of the Renaissance attitude? How was it reflected in the art? Describe one example of Renaissance sculpture, painting, or architecture, and contrast it with one work of art from the Middle Ages.

2. How was Renaissance architecture influenced by Classic Greek art? Cite specific examples. Find a building in your community that has Renaissance details, and sketch some of them.

3. The Renaissance discovery of the mathematical laws of perspective changed the character of Western art by bringing science into the studio. Using examples from this book, discuss the effect of this discovery of perspective on painting and on relief sculpture. How did the Italian concern with perspective and idealized form affect the art of northern Europe?

4. Analyze the use of perspective in a Renaissance painting or print from northern and from southern Europe. Trace the work, and make a diagram of its perspective, using paper wide enough to incorporate both right and left vanishing points. Can you see differences in the way southern and northern Europe used perspective?

5. Excavations in Rome unearthed important works of Classical Greek sculpture. How did these works influence Renaissance creativity? Discuss at least two Renaissance works of sculpture, tracing the influence of Greece and Rome on them.

Chapter 12 The Age of Baroque

Baroque art represented a rebellion against the art of the High Renaissance.

1. During the High Renaissance, the beginnings of both Mannerism and Baroque can be seen in the art and attitudes of the time. List some of these changes. What is meant by the statement "Michelangelo was born with one foot in the Renaissance and the other in the Baroque era"? Cite examples of his work that support this statement.

2. What was the relationship between the Mannerist styles of El Greco, Tintoretto, and Parmigianino and earlier artists, such as Titian? Mention details of their work that show this relationship.

3. How does the Baroque style in painting, sculpture, and architecture differ from that of the Renaissance? Compare specific works of both periods.

4. Explain how elements of the Greek orders of architecture were used in Baroque and later periods. How did this differ from their use in ancient Greece?

5. Select a Renaissance work such as Raphael's *School of Athens*. Using colored chalk or paint, create a new composition from it in which Renaissance colors are changed and the subject is reorganized in the Baroque style.

6. How was landscape used in Venetian and Flemish painting? Cite examples.

Chapter 13 The Age of Revolution

During the eighteenth and nineteenth centuries, Europe's economic, political, industrial, and social organization changed radically. These changes were reflected in the art of the times.

1. Select a passage from the *Discourses* by Sir Joshua Reynolds that seems particularly relevant to today's world. Explain your reasons for choosing that passage.

2. Locate some buildings or photographs of buildings that show Palladio's influence on architecture.

3. How were such artists as Goya and Turner influenced by the earlier works of Velázquez and Rembrandt? How were they affected by the new spirit of the age?

4. Discuss some art movements of this period that expressed the conflict of the age between industrialization and nostalgia for the past. Analyze two art works.

5. The Impressionist painters of the nineteenth century developed a technique that created the illusion of light, color, and atmosphere. How did it differ from earlier painting techniques? Give examples.

6. Draw a still life in outline. Using poster paints, create an illusion of light on the objects, applying dabs of pure color next to each other. See if your eye mixes the dots to form an area of color. If it does not, alter the proportions of the colors until you achieve the color you wish.

7. Sketch a view of part of a room. Using thick poster, oil, or acrylic paint, create a composition using the technique of impasto.

Chapter 14 Art in the Non-Western World

The influence of Greece, Rome, and the Renaissance dominated Western art well into the nineteenth century. Slowly Western artists became aware of, and influenced by, the art of other cultures. Now the art of all areas of the world is accessible to us.

1. Most non-Western art, particularly that of the Orient, is not concerned with producing an illusion of three dimensions on a two-dimensional surface. Locate works of art in this book that use Oriental concepts of space. How do they differ from Renaissance spatial representation? What other cultures have been unconcerned with representing three-dimensional space?

2. Create a composition of objects in space. By minimizing hue, value, and intensity differences, try to suggest that the objects are lying on the surface, rather than receding into the picture.

3. Explain why the term *primitive* does not accurately describe the cultures of Africa, Oceania, and native America. Working with wood, clay, or stone, create an artwork that echoes the work of one of these areas.

4. Discuss the impact of African art on the art of the Western world. Give examples of this influence.

5. Describe African artists' use of certain types of exaggeration and abstraction for expressive purposes. Create a carving, a papier-mâché mask, a head covering, or a piece of jewelry using similar expressive tools.

6. Create in clay or soap a three-dimensional figure reminiscent of the art of Mesoamerica.

7. On a simple loom made from a picture frame with yarn stretched between nails, weave a wall hanging using native American designs.

8. Fashion a clay pot using the coil method, smoothing its surface. If a kiln is not available, air dry the pot and paint it with poster paints using designs inspired by native American motifs.

Part IV Rushing toward the Future: Art in the Twentieth Century

Chapter 15 The International Period

The accelerating tempo of events started by the Industrial Revolution increased during the twentieth century and brought about dramatic changes in art all over the world.

1. Trace the growth of one new style of art that emerged during the first two decades of the twentieth century. Discuss in detail two artists who worked in that style.

2. Explain in what way exposure to African art was an important force in the development of twentieth-century art; give examples. Explain what aspects of Oriental art influenced twentieth-century artists.

3. Draw a composition in the style of Cubism, superimposing in one drawing at least three views of an object. Include interior and exterior aspects and top, side, and front views, presenting a familiar object in a new way.

4. Europe was the scene of many regional art movements, but one grew into what was called the International Style. What is meant by that term? How did the style start, and how did it influence painting, architecture, sculpture, and the industrial arts?

5. Using poster paints, create a simple still life in at least two of the styles that developed in the first quarter of the twentieth century.

6. One of the most powerful architectural forces of this century was expressed in the philosophy of Frank Lloyd Wright. What was his philosophy, and how did it influence other architects? What was the influence of the architectural ideas of Le Corbusier?

7. What was the Bauhaus? How did it influence twentieth-century art? Cite examples.

Chapter 16 The Art of Dreams

Following World War I, while the Cubists and Futurists searched for new ways to reflect the changing world, a strong negative philosophy developed. It was expressed in nonart and in the art of the subconscious in movements such as Dadaism and Surrealism.

1. Search for and quote passages of poetry or fiction that deal with the same themes as appear in Surrealism and Dadaism.

2. Create a construction of objects emphasizing nonart values.

3. Explorations into the psychology of the subconscious influenced the Surrealists. What qualities do you find in this art that illustrate some of the theories of Freud and Jung?

4. Create a work of art in any medium that reflects the world of your dreams.

5. Many artists have blended various styles, such as combining abstraction with Surrealism. Analyze a work of art that uses a combination of styles. Discuss the content and imagery as well as the design elements of line, color, and form.

6. Using the technique of collage, combine sections of magazine reproductions into a composition based on abstract Surrealism.

7. The creation of the illusion of deep space has appeared throughout art history. What Surrealist painters used this technique? Create a composition in color or in black and white using perspective, changing hues, and values to create an illusion of deep space, but using images from the world of dreams and fantasy.

Chapter 17 Social Protest and Figurative Art

Themes of social protest have occupied artists from the eighteenth century on. During the thirties, many artists in North America and Mexico expressed their concern about existing social conditions.

1. Some artists use their art as the vehicle of social protest, while others are only concerned with form and style. Select examples of these two approaches from the artists discussed in this book, giving reasons for your choices. Is one approach more valid than the other?

2. Pick out a modern artwork of social protest. How did the artist use the elements of design to communicate his message?

3. The traditional fresco technique was revived by Mexican painters to serve a particular purpose. Why was the technique particularly appropriate to their work? How did they use it? How did their art influence painting in the United States?

4. Both Picasso's *Guernica* and paintings by Orozco expressed horror at the senselessness of war. Describe your reaction to both, comparing a work of Orozco with *Guernica.*

5. How did changing concepts of the human body affect the figurative sculpture of the twentieth century? Give examples.

6. What contributions were made by technology to the art of the thirties? Select two artists and discuss their work from this viewpoint.

7. How was photography used as a means of social protest?

8. Read a novel of protest that describes the social conditions existing between World War I and World War II. Discuss the art of the period in relation to the book. Does the art mirror in visual form the conditions described in the book? If so, how?

Chapter 18 The Post-war World: America in Ascendency

After World War II the center of influence in world art shifted from Paris to New York. New styles in art centered there, influenced by the work of artists who gathered from all over the United States and Europe.

1. Abstract expressionism was an important force in art in the 1950s and 60s. Compare and contrast the work of Jackson Pollock and Willem de Kooning. Analyze how their work is similar and how it differs.

2. Create in oils, acrylics, or enamels a painting in the style of Pollock. To get the full impact of the muscular involvement of his work, you will need a large area of paper or canvas.

3. Working on unsized canvas with thin acrylics or dyes, create a composition in which the paints blur, blend, or soak into the cloth surface. Compare the spatial effect of such a painting with that of the color webs of Pollock. How do they differ?

4. Using masking tape to produce the straight edges of hard-edge painting, create a work in this style, using geometric shapes.

5. Modifications of earlier geometric abstraction and nonobjective art can be seen in the style of Op art. Using graph paper or your own ruled squares, experiment with small units of color. Create an illusion of three dimensions by varying the sizes and colors of the units. Superimpose three-dimensional louvers made of paper or cardboard to create more exciting visual effects.

Chapter 19 Pop, Happenings, and Conceptual Art

The avant-garde of today, like that of any period, is concerned with innovation and with rebellion against established concepts. Today the pace of change in every area of life has accelerated, and art reflects that acceleration with a multiplicity of styles.

1. Happenings, assemblages, kinetic art, light art, conceptual art, earthworks—all have their followings. Realistic painting also exists in the style of magic realism. Discuss two of these movements. What were their predecessors in earlier styles, if any? List prominent artists and their works.

2. The public usually has resisted the most pioneering artistic efforts. Can you account for public mistrust and lack of interest in the works of experimental artists? In view of the general resistance to innovative art, how do you account for the popularity and acceptance of other new media, such as cinema, radio, and television?

3. The style of Pop art deals with everyday associations, slogans, and images. Can you think of other popular slogans as significant as the *LOVE* theme of Robert Indiana? Create a work of art in paint, sculpture, or any combination that uses Pop images or slogans.

4. Create a work of art in which motion—either natural or mechanical—is an important element.

5. Conceptual artists often consider the concept to be the final work of art. Plan and outline a conceptual artwork.

6. With several other people, create a happening.

7. Many individual and regional styles exist in art today—expressing the artist's reactions to the social conditions of the day, creating a world of myth, or depicting the outer world realistically. No one style is dominant. Create an artwork in any medium, based either on a familiar style or in your own personal style.

Chapter 20 Art and the Environment

Design is a total social activity, the mirror of every society. If a portrait of ugliness is part of what we really are, then design or lack of it is the process that has brought us there.

1. Study the history of your community from the point of view of the environment. Consult old photographs in the library or local historical society. Talk with earlier residents of the area to determine the extent of change. Is the community more or less attractive than it was? Which human needs are better met today, and which are neglected?

2. Make a collage from magazine illustrations representing some aspect of the contemporary scene that concerns you.

3. Choose a contemporary social or environmental problem. Write a short story or poem dealing with it or paint a picture that expresses your concern.

4. Create an assemblage using materials that reflect your interest in some phase of our environment, whether man-made or natural.

5. Prepare a television program dealing with a significant environmental or social problem. Present it to the class with sound effects (if possible), visual aids, and perhaps taped interviews with relevant persons.

6. Choose a natural setting in your community. Design a structure that could be incorporated into that setting without damaging the environment. Sketch the exterior, and make a plan of the interior living or activity space to show the circulation pattern of people and the functions.

7. Artists are either directly or indirectly involved with the culture in which they live, often furnishing guideposts for change. From your exposure to art of the world, select an artist whose work interests you. Read biographical and critical material and study the artist's work. Analyze how he reflected his own individuality while responding to the changing currents of the time in which he lived.

8. Ultimately, the kind of environment we live in depends on people. What do you think that you as an individual can do to create a better environment?

Glossary

abstract art Art that is not primarily concerned with representation of nature, in which the artist selects and exaggerates certain aspects of reality in order to provide a visual experience by means of line, color, and form.

Abstract Expressionism A style of painting that developed in the United States between 1950 and 1960. It combined spontaneous personal expression with either abstracted or nonobjective shapes painted on large areas of canvas.

Academy The official school of art in France in the eighteenth century that set forth rules dictating the style in which artists could work, controlling the art scene by refusing to exhibit any work that did not follow these rules. The term *academic art* is now used loosely to describe any conservative art.

Acropolis A Greek word meaning hill town or fortified hill, applied to the upper section of a Greek city that usually contained the temples. The Acropolis at Athens is the best-known example.

acrylic paint A synthetic resin paint which, along with polymer paint, is frequently used by artists today in place of traditional oil paint. Quick drying and durable, it can be used on a great variety of surfaces. Helen Frankenthaler and Morris Louis are painters who use acrylic paints.

Action painter Any painter active in the 1950s and 60s who painted on large canvases, flinging, brushing, and dribbling the paint, using the large muscles of the body. Jackson Pollock was a well-known Action painter.

aesthetic Having to do with beauty as opposed to usefulness, or moral or emotional content.

altarpiece A screen, a series of painted panels, or a sculpture placed on or behind the altar in a church. Usually decorated with religious subjects.

analagous colors Hues that are close to each other on the color wheel, such as blue, blue-violet, and blue-green.

aperture In photography, the opening that admits light into the camera. The size of the aperture controls the amount of light that reaches the film.

apse The semicircular or polygonal area at the end of a building. First used in Roman *basilicas,* later copied by Christian church builders. The apse of a Gothic cathedral was roofed with complex *vaults* and often had small chapels opening off it.

aquatint A print or an area in a print which is textured by coating the metal plate, from which the print is made, with rosin dust. The plate is then heated and etched with acid, producing an allover textured tone.

arcade A series of arches supported by columns, standing free or attached to a wall for decoration. First used by the Romans, later incorporated into Christian churches and Renaissance buildings.

archaic The earliest period of Greek art from the eighth to the sixth centuries B.C. Also used of the early stages of art in any civilization.

architecture The art of building with solid materials, enclosing space in a useful and pleasing way.

atmospheric perspective Also called aerial perspective. A method of creating an illusion of three-dimensional depth and space on a two-dimensional surface, using color and light and shade. Objects painted in intense, warm colors with strong contrasts of dark and light appear close to the viewer. Light, cool colors with less contrast make objects appear farther away.

balance The visual balancing of colors, shapes, or masses to create a sense of equilibrium.

balloon framing A lightweight wooden frame of milled lumber nailed together to support the walls, floors, and roof of a building. Developed during the nineteenth century and still used today.

baptistery A building used for baptism in the Christian church, usually circular or polygonal in shape. The baptistery in Florence, Italy, is a famous example.

Baroque A style of art in Europe during the seventeenth century known for its dramatic light and shade, violent composition, and exaggerated emotion. Caravaggio was a Baroque painter.

barrel vault A roof over a square or rectangular area consisting of a continuous round arch of stone or brick that spans the space between the walls. Widely used in Romanesque churches.

base In architecture, the lowest part of a column. Made of stone, in ancient temples it protected the wood from the moist ground.

basilica A rectangular Roman assembly hall containing rows of columns that divided it into aisles, usually with a raised platform and semicircular area at one end. Early Christian churches were based on the basilica.

batik A method of producing a design or image on cloth. Wax is painted on the cloth, and the material is immersed in dye. When the wax is removed, the areas that had been covered by it remain the original color of the material.

binder The material used in paint that causes the *pigment* to adhere to the surface.

bisque Ceramics that have been fired at a low temperature, usually in preparation for receiving a *glaze.*

buttress A solid masonry support, usually square, built against a wall to counteract the outward thrust of the wall and roof. Used extensively in Romanesque and Gothic churches. See also *flying buttress.*

calligraphy The art of writing in a decorative manner. Used particularly in relation to Oriental characters, which are written with a brush. Calligrapher: one who creates decorative lettering.

camera obscura A device developed during the Renaissance to project an image through a small hole onto a surface from which it could be traced. Forerunner of the modern camera.

cantilever A structural method in which beams or sections of a structure project beyond their support and are held in place by weight on the attached end.

capital The top part of a *column,* usually wider than the upright section, generally carved. Different civilizations used a variety of decoration on capitals. See also *Greek orders.*

cartoon A drawing that is used as a guide for a large artwork, usually drawn the same size as the finished work. Also a humorous or satirical drawing.

carving A sculptural method in which the image is formed by removing material from a block, using sharpened tools. The opposite method builds up or adds material to create the sculpture.

caryatids Whole female figures supporting the roof of a building. The most famous are in the porch of the Erechthion in Athens.

casting The process of pouring a liquid material into a *mold,* causing it to take the shape of the mold when it hardens. Used for metals, clay, and synthetic materials. An important method in metal sculpture.

catacombs A series of subterranean tunnels used for burial. Those in and around Rome were used by the early Christians for worship; they contain many paintings.

cella The main room in an ancient Greek temple, containing the ritual image of the god or goddess.

centering The method of supporting an arch while it is being constructed. Once the *keystone* is in place and the arch becomes self-supporting, the centering is removed.

ceramics Any object formed of clay, hardened by baking. Ceramic sculpture, pottery, tiles, and building materials may be built up by hand, formed on a potter's wheel, or formed in molds.

charcoal A drawing material made from charred wood. Used since prehistoric times for drawing on a variety of surfaces.

chiaroscuro (kee-á-roh-skóo-roh). An Italian word meaning light and dark. In painting and drawing, the use of light and dark areas to create the illusion of light and shade.

cinematography The art of expressing emotion or communicating meaning through moving images made with a motion-picture camera.

Classical In general, the art of ancient Greece and Rome. In particular, the art of Greece of the fifth century B.C. It can also mean any art that is based on a carefully organized arrangement of parts, with special emphasis on balance and proportion. See *Neoclassicism.*

collography A method of printing from a flat surface onto which a variety of materials have been attached. When damp paper is pressed against the surface, a print with indented areas is produced.

color What we perceive when our eyes sense the waves of visible light reflected from a surface. As the light hits the object, our eyes absorb certain colored rays, while others are reflected. This causes us to see the *hue* of that reflected wave, such as red, yellow, or blue. Color is also formed by coating a surface with a *pigment* that reflects certain rays. See also *spectrum, hue, value,* and *intensity.*

Color-field painting A style of painting of the 1960s and 70s that used large areas, or fields, of color to surround the viewer with a visual experience of color.

color wheel. An arrangement of the *hues* of the spectrum, usually twelve. Placed in a circular pattern, with *complementary colors,* such as yellow and violet, opposite each other.

column An upright, usually cylindrical, support for a roof or upper portion of a building. In Classical architecture it was made up of a *base,* a *shaft,* and a *capital,* and generally was made of stone. Today a column may be made of reinforced concrete or metal.

complementary colors The hues that appear opposite each other on the *color wheel,* such as orange and blue, red and green, yellow and violet. When mixed in equal amounts, these hues form a neutral gray.

composition The ordered grouping of line, color, shape, or mass in the visual arts. Composition implies an effort on the part of the artist to organize the parts into a whole, whether the result appears carefully organized or free and spontaneous.

conceptual art A work of art or an event conceived in the mind of the artist, sometimes produced in visible form, but often merely presented as a concept.

Constructivism An art movement, overlapping *Cubism* and *De Stijl,* based on the use of nonobjective, often technological, shapes and

new materials. In sculpture, the artwork was constructed rather than being cast or modeled. Naum Gabo and Antoine Pevsner were the best known of the group.

contour The edge of a form or group of forms in painting or sculpture.

corbelled arch. A method of spanning an opening by placing each stone or brick so that it projects slightly beyond the one below it.

Corinthian One of the Greek orders of temple architecture, which used slender *columns* topped by elaborate *capitals* decorated with carved leaves. Copied extensively in Roman and Renaissance times.

Cubism A style of painting developed in 1908 by Picasso and Braque, who built up still lifes and figures with cubelike shapes. Joined by other artists, the Cubists later depicted objects with flat, often transparent areas, frequently showing several views of the subject in one composition.

cuneiform A form of writing with wedge-shaped characters carved in stone or pressed into clay tablets. Used in ancient Assyria, Babylonia, and Persia.

Dada An early twentieth-century art movement ridiculing contemporary culture and conventional art. Originally antiart, many of its adherents later became Surrealist artists.

daguerreotype An early photograph in which the photgraphic image is fixed on a plate of metal.

De Stijl An art movement started in Holland during World War I, using *nonobjective* geometric shapes. Piet Mondrian painted in this style.

design The organization, structure, or composition of a work of art or object of use. Industrial or commercial design refers to the activity of planning and designing objects for factory production and commercial use, whereas graphic design applies to design for

printing. Also used to describe the decoration applied to objects.

direct painting A painting method in which undiluted paint is applied directly to the canvas instead of being built up in layers of transparent *glazes.*

dome A hemispherical roof supported on columns or walls. The Pantheon in Rome, the church of Santa Sophia in Constantinople and the *stupa* of Sanchi in India have famous domes.

Doric The oldest *Greek order* of temple building, in which the column has no *base,* is heavy, and is topped with a simple flat *capital.* The Parthenon in Athens is the best-known Doric temple.

drypoint A type of *printmaking* in which a sharp needle is used to cut a groove into the metal plate. The rough edge of the groove catches the ink, giving the printed line a soft edge.

earth colors Paint colors derived from colored earth. Usually browns, reds, and yellows.

earthenware A type of rough *ceramic,* used for pottery and some sculpture; fired at a low temperature.

earthwork Sculpture involving the moving of earth in large amounts to shape it into an image or composition.

easel painting Any painting that is small enough to be painted on an artist's easel, as opposed to a large wall painting.

eclectic A style of art, particularly of architecture, in which parts are chosen from earlier styles and combined into a new whole.

edition In printmaking, the number of prints taken from one block or plate; usually numbered consecutively.

enamel The method of applying ground glass to metal, fusing it with heat into a shiny, colored surface.

encaustic A method of painting with *pigments* in wax; used by the Romans for funeral portraits.

engraving The process of making grooves in a material either to decorate it or to create an image from which prints can be made. Also the print that is made by pressing paper onto an inked wood or metal engraving.

entablature In Classical architecture, the horizontal section between the *columns* and the roof.

entasis In Greek architecture, the slight swelling of a column shaft to counteract the optical illusion that makes straight lines appear to curve inward.

environmental art Art that forms or represents a total visual environment, usually large, and frequently combining light and sound with paint and sculpture.

Expressionism A style of art important at the beginning of the twentieth century, emphasizing the artist's expression of personal emotion. Also applied to art of any period that is particularly concerned with the expression of group or individual emotion.

facade The front exterior of a building, usually containing the main entrance.

Fauvism A style of painting in the early twentieth century characterized by the use of large areas of brilliant, strong color, often with violent, distorted shapes. The name comes from the French word for "wild beasts." Henri Matisse and Georges Rouault were well-known Fauvist painters.

ferroconcrete A building material consisting of concrete with metal rods or mesh embedded in it. Also known as reinforced concrete.

fish-eye lens A lens used in photography to achieve a distorted image in which the central portion of a circular image is magnified.

flying buttress A masonry arch used on Gothic churches to counteract the outward thrust of the *vault* of the nave by carrying the force to a vertical support.

focus A point of convergence or center of attention. In photography, the degree of sharpness of an image.

foreshortening A method of representing an object on a two-dimensional surface so that it appears to be projecting toward the viewer. Developed by Renaissance painters.

form In two-dimensional art, any defined area on a picture surface, whether flat or creating the illusion of solid, three-dimensional mass. In three-dimensional art, any solid part of the composition, or the overall shape of the composition.

forum In Rome, the marketplace or public place of a city, the center of judicial business.

fresco A painting technique in which *pigments* are brushed onto wet plaster, drying to become part of the surface of the wall.

frieze In Classical art, the central portion of the area between the columns and the roof, usually decorated. Any horizontal area of decoration.

functional art Any art that fills a utilitarian need and is aesthetically satisfying.

Futurism A style of painting and sculpture in the early twentieth century that represented and interpreted modern machines, particularly those that moved. An attempt to represent movement and speed with nonmoving materials.

geodesic A structural system based on tetrahedrons; developed by Buckminster Fuller as an alternative to and improvement on cube structure. Used to create *domes*.

gesso A mixture of glue and chalk painted on panels or canvas as a base for *tempera* and other paints. It may be pure white or tinted.

glaze In painting, a thin, transparent coat of *pigment*. Traditionally used in oil painting since the 1500s; now possible with synthetic paints. In *ceramics,* a mixture of minerals painted onto clay that fuse into a glasslike substance when fired in a *kiln.*

Golden Section A ratio for determining pleasing proportions in art; the size of the smaller part

relates to the size of the larger part as the larger part relates to the whole (A:B = B:C). Originally used by the Greeks, it was employed by Renaissance and later artists.

Gothic A style of architecture that spread throughout most of Europe between the twelfth to sixteenth centuries. Characterized by an interlocking system of stone arches, *vaults,* and *buttresses* that carried the weight and thrust of the building, enabling buildings to reach great heights. Gothic cathedrals were constructed by communal efforts and expressed the religious faith of the time.

gouache (go-ahsh). A form of watercolor paint in which the *pigments* are made opaque by adding zinc white; in contrast to pure watercolor, which is transparent.

gravure A form of commercial printing from an etched plate. The ink is transferred to the paper from the depressed areas of the plate, as opposed to letterpress printing, in which the raised areas of a plate transfer the ink to the paper.

Greek orders Three types of architectural structure developed by the Greeks: the *Doric, Ionic,* and *Corinthian.* Although the orders varied in proportion and decoration, they all consisted of vertical *columns, capitals,* and a horizontal *entablature* between the columns and the roof. Copied and changed by later architects, they have been used in various forms throughout Western architecture. See *Doric, Ionic,* and *Corinthian.*

greenware Clay objects that have been air dried and are ready for the first, low-temperature firing in a *kiln.*

groined vault A structural method of roofing a square area. Two *barrel vaults* of the same dimensions intersect at right angles, producing edges called groins. Introduced by the Romans and used by Romanesque church builders.

halftone A metal plate used for reproducing illustrations in commercial printing. The image is photographed through a grid, which breaks down the areas of tone into various-size dots. The plate is etched, leaving the dots raised. When inked and run through a press, the plate transfers the image to paper with all the gradations of tone of the original image.

happening An event, generally unrehearsed and without predetermined script, produced by artists. It may include light, sound, props, and costumes and may involve audience participation.

highlight The lightest area of a painting. Usually refers to the spot where the brightest light is reflected from an object or figure.

horizon line In linear perspective, the imaginary level toward which all the parallel lines receding into the picture seem to converge. Along the horizon line there may be several *vanishing points.*

hue An identifiable color on the *color wheel* or *spectrum.* Also, the element of a particular color that separates it from others.

idealization The representation in painting or sculpture of objects or figures in a simplified, perfected style, particularly characteristic of Greek sculpture of the fifth century B.C.

illuminated manuscript Any decorated manuscript, particularly those of the Medieval period, in which religious scenes, daily life, animals, flowers, and humans were favorite subjects.

image A visual representation of an object, figure, or event in painting, sculpture, photography, or any visual art.

impasto Thickly applied paint.

Impressionism A style of painting developed in the last half of the nineteenth century that tried to capture the quality of light as it plays across landscapes and figures. Its followers used small strokes of contrasting color placed next to each other to create the illusion of vibrating light.

inlay Any material set into another material, particularly wood or metal set into the surface of an object to decorate it.

intensity The degree of purity or brilliance of a *hue,* also called *saturation.*

investiture The outer, fire-resistant mold used in the process of metal *casting* in sculpture.

Ionic One of the Greek styles of temple architecture; characterized by slender, fluted shafts and *capitals* decorated with carved spiral shapes.

keystone The central wedge-shaped stone in an arch, the last one to be put in place. When the keystone is inserted, the temporary supports holding up the arch may be removed, and the pressure of the wedge-shaped stones against each other will hold the arch in place.

kiln An oven in which clay objects are baked to harden them. Simple outdoor kilns are fired with wood, while complex gas and electric kilns are capable of reaching extremely high temperatures under highly controlled conditions.

kinetic art Art that includes movement as part of the composition, whether provided by air, motors or human muscles.

lacquer A clear, hard-finish resin used to coat wood or metal. May also be mixed with pigment to give brilliant colors. Oriental artists used coats of lacquer over wood in furniture and sculpture as well as in dishes.

lens The part of the camera that gathers and concentrates the light to produce an inverted image on light-sensitive film.

letterpress A method of printing in which the ink is transferred to the paper from raised type or from a raised image etched on a plate, as opposed to *gravure,* which uses grooves to hold and transfer the ink.

line A mark made by a moving point, pencil, brush, or pen. Also, the edge between two forms or the silhouette edge of a form.

linear perspective. A method of determining or representing the size of objects as they recede in space. Imaginary parallel lines drawn at a right angles to the viewer appear to converge at a *vanishing point* on the *horizon line.* Widely used by painters during and after the Renaissance to create the illusion of space on a two-dimensional surface. Oriental art and most contemporary art usually is not concerned with linear perspective.

linecut In printing, a metal plate used to reproduce images that consist only of lines, such as drawings, woodcuts, or architectural plans.

Linotype A machine that casts type for printing in the form of *slugs* of one-piece lines, already spaced for printing.

lintel A structural member that spans a rectangular opening between two posts, columns, or walls.

lithography A method of printmaking based on the antipathy of grease toward water. The image is drawn with a greasy crayon on a grainy plate or stone, which then is chemically treated so that it will accept the printing ink only where the crayon has been used. The image is transferred under pressure from the stone to damp paper.

lost wax A method of casting in which wax is used to form the sculpture. Heat-resistant material is built up around the wax to form a *mold.* When this mold is baked, the wax runs out, leaving a hollow space that reproduces the original.

Mannerism A style of art in Western Europe in the sixteenth century that rejected the Classic balance and moderation of Renaissance art and was characterized by exaggerated, distorted, and highly emotional images.

masonry Stone or brickwork used in building.

mass A three-dimensional form that has actual

physical bulk. Also, the illusion of weight and bulk created on a two-dimensional surface.

mausoleum A large and elaborate tomb, usually for a person of great importance.

Medieval Characteristic of the Middle Ages in Europe between the fourth and the late fifteenth centuries A.D.

medium The material, method, or techniques used by an artist to create a work of art. Also, the material used to dilute paint, such as water or turpentine.

minaret A tower outside a *mosque* from which Moslems are called to prayer.

minimal art A style of twentieth-century sculpture and painting that uses an extremely limited range of shapes and colors.

mixed media The use of several different materials, methods, or techniques in one work of art.

mobile A sculptural construction incorporating motion. The parts of the construction are moved by currents of air or by motors. Alexander Calder is the best-known mobile artist.

module A unit that is standard in size and can be fitted into another similar unit to form a larger composition. Used in building and in furniture.

mold The hollow form or cavity in which a liquid or pliable material is shaped or cast to create sculpture, jewelry, or ceramics.

monochromatic A color scheme that uses only one hue in varying degrees of light and dark.

mosaic A surface decoration made of small pieces of glass, tile, or stone set in plaster or mortar. Used widely throughout history for decorative floors and as wall decoration.

mosque A Moslem religious building, usually incorporating towers, pools, and fountains as well as the central hall.

mural A wall painting, usually large, which may be painted with any kind of paint. Often confused with *fresco,* which refers only to a painting done on a wet plaster ground.

nave The central aisle of a church. In Gothic cathedrals, the nave was much higher than the side aisles. Amiens cathedral is a well-known example of a Gothic nave.

Neoclassicism A style of art in the eighteenth century that revived the Classical art of Greece and Rome in painting, sculpture, and architecture. Many government buildings in Washington, D.C., such as the Lincoln memorial, are Neoclassic.

niche A recess in a wall; usually contains a piece of sculpture.

nonobjective A style of art in which no object is represented. It became an important force in art in the early twentieth century and continues to be so today. Piet Mondrian, Jackson Pollock, and Ad Reinhart are examples of different types of nonobjective painters.

oil painting A method of painting developed in the sixteenth century in which pigment is combined with one of a number of oil mixtures. Applied to a surface, it dries to form a continuous film. Oil paint is still widely used today.

Optical art Also called Op art. A style of art in the late 1960s and 70s characterized by flat shapes of contrasting colors or values placed next to each other to cause vibrations in the eye.

perspective See *linear perspective* and *atmospheric perspective.*

pier A heavy masonry support, usually square.

pigment A dry coloring material, made from a variety of organic or chemical substances, which is mixed with some form of liquid and a binding material to form paint, ink, crayons, or pastels.

pilaster A decorative non-weight-bearing column attached to a wall.

pile weave A form of weaving in which loops are left on the surface and are cut to form a soft

texture. Usually used in rugs.

plan In architecture, a view of the layout of space in a building, drawn as if looking down on it.

plane Any flat or level surface.

plastic Synthetic materials with varying qualities that are used in the functional arts as well as in painting and sculpture. Also used as a general term to describe any of the visual arts. Also, any material that has the characteristic of being easily formed or manipulated, such as clay.

Pop art A style of painting and sculpture in the 1960s that used popular and commercial symbols and images as subject matter.

porcelain A form of thin, delicate ceramic, created from fine clays and baked at an extremely high temperature. The potters of the Orient have produced porcelain for centuries.

post and beam A type of wooden construction using two upright posts and one horizontal beam to span a space.

Postimpressionists. A group of artists active in the late 1800s who painted in varying personal styles, who were linked mainly by their rejection of *Impressionism.* Some, such as van Gogh and Gauguin, were most interested in personal expression, whereas others, such as Cézanne, were more concerned with composition and structure.

pottery The art of making utensils and vessels of clay; also called *ceramics.* Also, a type of ceramic made of relatively coarse clay and fired at a rather low temperature.

potter's wheel. A circular metal, wood, or stone disk that revolves by foot or motor action on which a potter shapes wet clay into a vessel.

Pre-Columbian art Art produced in North and South America before the European invasions of the sixteenth century.

prehistoric art Art created before written history; the only record of many early cultures. Cave paintings and rock paintings in Europe and Africa, carved implements, and statuettes are examples of prehistoric art.

primary colors The hues that can be mixed to produce all other hues. In painting, the primary colors are red, yellow, and blue.

print A multiple impression made from a *wood block,* a *lithographic* stone, or by *etching* a plate. Usually signed by the artist.

printmaking The process of making prints, generally done by the artist himself or under his careful supervision. Also called graphics.

proportion The relationship of one part of a work of art to another and of each part to the whole. See *Golden Section.*

ready-made *Dada* works that combined several manufactured objects into one construction. A method of working developed by Marcel Duchamp.

reinforced concrete See *ferroconcrete.*

relief sculpture Sculpture in which the three-dimensional forms are raised from a flat background, as contrasted to free-standing sculpture. The relief may be low, called bas-relief, or high relief, in which the forms are raised far above the background.

reliquary A small box, casket, or sculptural object that contains a religious relic.

Renaissance The period in Europe between the fourteenth and the sixteenth centuries; characterized by a rebirth of interest in *Classical* art and philosophy. A scientific attitude dominated, and art expressed balance, harmony, and the importance of individual humans.

rhythm The repetition, either regular or varied, of visual elements, such as lines, shapes, or colors. As in music, visual rhythm is an expressive tool, important to the creation of an aesthetically pleasing work of art. The repeated *pilasters* on the Coloseum in Rome are an example of rhythm in architecture, while the figures in Michelangelo's *Creation of Adam* show the use of a more subtle rhythm

in painting.

Rococo A style of art popular during the eighteenth century in which delicate colors, curving shapes, and sinuous lines created ornate decoration on interior surfaces, silverware, and furnishings. Paintings of the period were elegant and pleasant, reflecting the life of the aristocracy.

Romanticism A style of art lasting from the mid-1700s into the nineteenth century, emphasizing individual emotions expressed in a dramatic manner. Exotic subject matter and scenes of distant places were common, and the movement rebelled against the established art of the times.

sans serif A letter, especially in printing, that has no cross strokes at top or bottom.

saturation See *intensity*.

scale The size, or apparent size, of an object relative to other objects, people, or its environment. In architectural drawings, the ratio of the dimensions to the full-size building; for example, one inch equals one foot.

scriptoria The rooms in Medieval monasteries where manuscripts were copied and decorated.

secondary colors Three hues on the color wheel formed by mixing the *primary* colors in equal amounts: green, violet, and orange.

sfumato The hazy blending of light and dark tones in a painting, creating soft and indefinite edges.

shade A color that is low on the *value* scale; a dark color.

shaft In architecture, the upright portion of a *column*, usually cylindrical.

shape Any area defined by line, color, tones, or the edges of forms.

silk screen Also called serigraphy. A process of printmaking in which stencils are applied to silk that is firmly stretched across a frame. Paint is forced through the unblocked portions of the screen onto the paper beneath.

steel cage Also called steel frame. A structural method in which steel supports, placed in a post and *lintel* system, are connected to produce a strong self-supporting framework. Nonsupporting walls, floors, and roof are attached to the frame. Used extensively in contemporary construction.

stele A free-standing upright stone or pillar, usually bearing an inscription or relief decoration.

stencil An image or design cut out of a stiff material. Paint is forced through the holes in the stencil to reproduce the cut image. Used for hand printing on cloth, paper, or walls, and in *silk-screen* printing.

still life A painting of ordinary objects such as bottles, flowers, fruit, and so on. Also, the arrangement from which such a painting or drawing is made.

stoneware A type of coarse *ceramics*, fired at a high temperature.

stupa The earliest type of Buddhist religious building, probably derived from the Indian funeral mound. Erected in places made sacred by a visit from Buddha. The stone roof was in the form of a *dome*.

Surrealism A style of painting that developed in the early twentieth century; based on subject matter from dreams, fantasy, and the subconscious. Its images often appear unrelated and startling. De Chirico was a Surrealist painter. Many artists incorporate some Surrealist qualities into other styles.

symbol An image or sign that stands for something else, or the visible sign of something invisible.

tapestry A woven hanging made on a loom using several bobbins that carry yarns of different colors, permitting the weaver to produce free-form designs. Known since Egyptian times, the technique has been widely used in Europe since the thirteenth

century to produce large wall hangings depicting religious or secular subjects.

tempera A painting method popular before the invention of oil painting in which the *pigments* are bound by the use of an emulsion of egg yolk instead of oil. Still used today by some artists.

tertiary colors The six hues that are formed by mixing the *secondary colors:* yellow-orange, yellow-green, blue-green, blue-violet, red-violet, and red-orange.

texture The surface quality of an object, or the representation in paint of that surface.

thrust The pressure of one part of a structure against another part; the outward or downward pressure of weight.

tint A light hue, or a color with a large amount of white mixed in it.

truss A framework of beams, bars, or rods arranged in triangles. Used to span the space between post or walls, supporting floors or roofs. Triangular construction is more rigid than that using only right angles.

tusche A greasy black liquid used to paint images on a lithographic stone or plate in preparation for printing.

vacuum forming A method of shaping sheet *plastic* into sculpture. The plastic is heated and softened, then pulled against a *mold* by vacuum machine, which causes the plastic to take the shape of the mold as it cools. An industrial technique adapted to art.

value The measure of lightness or darkness of a color.

vanishing point The point on the *horizon line* at which parallel lines appear to converge.

vault An arched covering spanning two walls, constructed of a series of continuous arches.

vehicle A liquid or emulsion used as a carrier of pigments in a paint; used interchangeably with the term *medium.*

votive statue A statue dedicated to a god or goddess in fulfillment of a vow or promise.

Many Greek statues were originally votive statues.

wash A thin, transparent layer of paint. Wash drawings combine wash and line.

watercolor Any paint that uses water as a *medium.* Generally applied to paint formed of *pigments* mixed with a gum *binder* and diluted with water to form a transparent film, as opposed to *gouache,* which is opaque.

woodcut A print made from an image cut into a block of wood. The ink is transferred from the raised surfaces onto the paper.

Bibliography and Suggested Readings

Chapter 1

Berenson, Bernard. *Seeing and Knowing.* Greenwich: N.Y. Graphic Society, 1968.

Ehrenzweig, Anton. *The Hidden Order of Art.* Berkeley and Los Angeles: University of California Press, 1967. Interesting insights into the creative process and the psychology of the artist.

Elsen, Albert. *The Purposes of Art.* 3d ed. New York: Holt, 1972. An engaging, personalized viewpoint, introducing art history in terms of the universal themes of the artist.

Fuller, Buckminster. *Ideas and Integrities.* Englewood Cliffs, N.J.: Prentice-Hall, 1963. A leading and innovative architect of the last quarter century shares his philosophy in readable prose.

Gombrich, E. H. *Art and Illusion.* 12th ed. London: Phaidon, 1972. Lucid and intelligent treatment of the subject; well illustrated.

Hauser, Arnold. *The Social History of Art.* 4 vols. New York: Vintage, 1957–58. An important sociological approach to art history.

Chapter 2

Albers, Josef. *Interaction of Color.* New Haven, Conn.: Yale University Press, 1971. A lifetime of devotion to color experiments discussed by the Bauhaus authority of color.

Anderson, Donald. *Elements of Design.* New York: Holt, 1961. Excellent survey of design with many fresh perspectives.

Birren, Faber. *Color, Form, and Space.* New York: Reinhold, 1961.

Itten, Johannes. *The Art of Color.* Translated by Ernest Van Haagen. New York: Reinhold, 1961.

Judd, Deane B., and Wyscewski, Gunter. *Color in Business, Science, and Industry.* 2nd ed. New York: Wiley, 1963.

Kepes, Gyorgy. *Language of Vision.* Chicago: Theobold, 1944. Pioneer Bauhaus designer presents fundamentals.

Chapter 3

Periodicals

Arts and Architecture.
Architectural Record.
Progressive Architecture.

Conrads, Ulrich, and Sperlich, Hans. *The Architecture of Fantasy.* New York: Praeger, 1962.

Giedion, Sigfried. *Space, Time, and Architecture.* Cambridge, Mass.: Harvard University Press, 1963.

Gropius, Walter. *The New Architecture and the Bauhaus.* Boston: Branford, 1937. Classic study by the founder of the Bauhaus.

Hamlin, Talbot. *Architecture through the Ages.* New York: Putnam's, 1953. Classic survey of architecture.

Le Corbusier. *Towards a New Architecture.* New York: Praeger, 1970. Leading twentieth-century architect explores his philosophy.

_____. *The Modular.* Cambridge, Mass.: MIT Press, 1968. An approach to architecture, based on a universal human scale.

Wright, Frank Lloyd. *The Natural House.* New York: Horizon, 1958. Pioneer architect defines the organic system.

Chapter 4

Itten, Johannes. *Design and Form.* New York: Reinhold, 1964. The foundation course of the Bauhaus school.

Kepes, Gyorgy, ed. *The Nature and Art of Motion.* New York: Braziller, 1965.

Moholy-Nagy, Laszlo. *The New Vision.* New York: Wittenborn, 1967. Bauhaus pioneer in design presents his innovative approach.

Read, Herbert. *A Concise History of Modern Sculpture.* New York: Praeger, 1964. A selected presentation in readable style.

Seitz, William C. *The Art of Assemblage.* New York: Museum of Modern Art, 1961. The museum curator defines a typical medium at mid-century.

Chapter 5

Periodicals

Art in America.
Art News.
Arts Magazine.

Canaday, John. *Mainstreams of Modern Art.* New York: Holt, 1959. *New York Times* art critic presents a fascinating personal account of art from the late eighteenth century to the mid-twentieth century.

Mayer, Ralph. *The Artist's Handbook of Materials and Techniques.* 3d ed. New York: Viking, 1970. Survey of traditional materials and techniques.

Peterdi, Gabor. *Printing Methods Old and New.* New York: Macmillan, 1959.

Read, Herbert. *A Concise History of Modern Painting.* New York: Praeger, 1959. Selective survey.

Chapter 6

Bourke-White, Margaret. *The Photographs of Margaret Bourke-White.* Greenwich: N.Y. Graphic Society, 1972. Memorable gallery of works prefaced by insights into her life.

Feininger, Andreas. *Successful Photography.* Englewood Cliffs, N.J.: Prentice-Hall, 1954. Successful teacher-photographer's text on know-how for the student.

Gernsheim, Helmut, and Gernsheim, Alison. *The History of Photography.* New York: McGraw-Hill, 1969. Full account of photographic history to the mid-twentieth century.

Halas, John, and Manville, Roger. *Technique of Film Animation.* New York: Hastings, 1968. Clear and well-organized text.

Karsh, Yousuf. *Karsh Portfolio.* Toronto: University of Toronto Press, 1967. Gallery of famous subjects by the well-known photographer; biographical summaries with each portrait.

Lyons, Nathan. *Photographers on Photography.* Englewood Cliffs, N.J.: Prentice-Hall, 1966. Many of the top twentieth-century photographers share their views.

MacDonnell, Kevin. *Eadweard Muybridge.* Boston: Little, Brown, 1972. Still views and multiple photographs.

Morgan, Douglas O., and Morgan, David Westall. *Leica Manual.* 15th ed. Dobbs Ferry, N.Y.: Morgan and Morgan, 1972. Complete information for the 35mm enthusiast.

Ross, R. J. *Television Film Engineering.* New York: Wiley, 1966. Lucid and well-organized text.

Souto, H. M. R. *Technique of the Motion Picture Camera.* New York: Hastings, 1967. Like the others of the series, this text is clear and complete.

Steichen, Edward. *A Life in Photography.* Garden City, N.Y.: Doubleday, 1963. Magnificent illustrations include portraits of famous personalities, with short autobiographical material.

Wooley, A. E. *Photographic Lighting.* 2d ed. New York: Amphoto, 1971.

Chapter 7

Periodicals

Advertising Age. Weekly newspaper for the trade.

Craft Horizons. Monthly periodical dealing with craft design.

Design Quarterly. Highlights of fine design.

Interiors. Furniture and interior design.

Vogue. Fashion magazine leader.

Women's Wear Daily. A must for the fashion trade.

Baker, Stephen. *Advertising Layout and Art Direction.* New York: McGraw-Hill, 1959. Excellent survey of the advertising art field.

Brewster, Arthur J. *Introduction to Advertising.* New York: McGraw-Hill, 1954. Principles and practices of advertising.

Fitz-Gibbons, Bernice. *Macy's, Gimbel's, and Me.* New York: Simon & Schuster, 1967. An outstanding advertising executive writes a swiftly paced account of her rise in the industry.

Frey, Albert Wesly. *Advertising.* New York: Ronald Press, 1970. Good, clear account of the advertising process.

Jenkins, Luisa, and Mills, Barbara. *The Art of Making Mosaics.* Princeton, N.J.: Van Nostrand, 1957.

Karasz, Mariska. *Adventures in Stitches and More Adventures, Fewer Stitches.* New York: Funk & Wagnalls, 1959.

Kenny, John B. *Complete Book of Pottery Making.* New York: Chilton, 1949. Clear, comprehensive; leading text for decades.

Kleppner, Otto. *Advertising Procedure.* Englewood Cliffs, N.J.: Prentice-Hall, 1973. Leading reference for many years; voluminous survey of advertising.

Lester, Katherine Morris, and Kerr, Rose Netzorg. *Historic Costume.* Peoria, Ill.: Bennet, 1967. Excellent summary of the history of costume; good illustrations.

Meilach, Donna Z. *Contemporary Batik and Tie-Dye.* New York: Crown, 1973.

———. *Contemporary Leather: Art and Accessories.* New York: Crown, 1971.

———. *Macramé: Creative Design in Knotting.* New York: Crown, 1971.

———. *Papercraft.* New York: Crown, 1967.

Meilach, Donna Z., and Erlin, Snow Lee. *Weaving Off-Loom.* New York: Crown, 1973. Crown's Arts and Crafts Series are all lucid, well-organized, and excellently illustrated texts.

Motley. *Designing and Making Stage Costumes.* New York: Watson Guptill, 1964. Interesting text; beautiful illustrations.

Nelson, Glenn C. *Ceramics, A Potter's Handbook.* 3d ed. New York: Holt, 1971.

Payne, Blanche. *History of Costume.* New York: Harper, 1965. A complete history from ancient times to the twentieth century.

Quant, Mary. *Quant by Quant.* New York: Putnam's 1966. Readable book by the British designer.

Rottger, Ernest. *Creative Wood Design.* New York: Reinhold, 1961.

Schiaparelli, Elsa. *Schiaparelli.* New York: Dutton, 1954. Autobiography by a prima donna of the fashion world.

Von Neuman, Robert. *Design and Creation of Jewelry.* Philadelphia: Chilton, 1972.

Chapter 8

Aldred, Cyril. *Development of Ancient Egyptian Art*. London: Tiranti, 1962.

Childe, V. Gordon. *The Dawn of European Civilization*. 6th ed. London: Trubner, 1958.

Frankfort, Henri. *The Art and Architecture of the Ancient Orient*. Baltimore, Md.: Pelican, Penguin, 1955.

Ghirshman, Roman. *The Arts of Ancient Iran from Its Origins to the Time of Alexander the Great*. Translated by Stewart Gilbert. New York: Golden Press, 1964.

Lange, Kurt, and Hirmer, Max. *Egypt*. New York: Abrams, 1956.

Leroi-Gourhan, Andre. *Treasures of Prehistoric Art*. New York: Abrams, 1967.

Chapter 9

Arias, Paolo. *A History of 1000 Years of Greek Vase Painting*. New York: Abrams, 1963. Comprehensive, well-illustrated work.

Beazley, J. D., and Ashmole, Bernard. *Greek Sculpture and Painting to the End of the Hellenistic Period*. Cambrdige, Mass.: Cambridge University Press, 1966.

Dinsmoor, W. B. *Architecture of Ancient Greece*. London: Batsford, 1950. The standard work on the subject brought up to date.

Lawrence, Arnold. *Greek Architecture*. Pelican History of Art. New York: Penguin, 1957. A basic text.

Richter, Gisela. *A Handbook of Greek Art*. Rev. ed. London: Phaidon, 1960.

_____. *Sculpture and Sculptors of the Greeks*. New Haven, Conn.: Yale University Press, 1950.

_____. *Archaic Greek Art*. New York: Oxford University Press, 1949. Lucid, well-organized, and illustrated. These texts and all others by her have remained invaluable aids since their first publication in 1929.

Robertson, D. S. *A Handbook of Greek and Roman Architecture*. Cambridge, Mass.: Cambridge University Press, 1954.

Chapter 10

Beckwith, John. *Early Medieval Art*. New York: Praeger, 1964. Lucid, well-organized text.

Frankl, Paul. *Gothic Architecture*. Translated by Dieter Pevsmer. Pelican History of Art. Baltimore, Md.: Penguin, 1962.

_____. *The Gothic*. Princeton, N. J.: Princeton University Press, 1960.

Grabar, Andre. *The Beginnings of Christian Art*. Translated by Stewart Gilbert. London: Thames & Hudson, 1967.

_____. *Byzantium: Byzantine Art in the Middle Ages*. Translated by Betty Forster. London: Methuen, 1966.

Panofsky, Erwin. *Abbot Suger on the Abbey Church of St. Denis and Its Art Treasures*. Princeton, N.J.: Princeton University Press, 1946.

_____. *Gothic Architecture and Scholasticism*. New York: Meridian, 1957.

Rice, David Talbot. *Art of the Byzantine Era*. New York: Praeger, 1963.

Swift, Emerson. *Hagia Sophia*. New York: Columbia University Press, 1940.

Chapter 11

Berensen, Bernard. *Italian Pictures of the Renaissance*. London: Phaidon, 1957. The long-established text on the subject of Italian painting.

Huyghe, Rene. *The Larousse Encyclopedia of Renaissance and Baroque Art.* New York: Putnam's, 1964. Excellent general treatment of the subject.

Marle, Paimond van. *The Development of the Italian Schools of Painting.* 19 vols. New York: Hacker, 1971. Comprehensive treatment of the subject.

Pope-Hennesy, John. *Italian Renaissnce Sculpture.* London: Phaidon, 1958. Good, complete survey of scupture of the period.

Rykwert, Joseph, ed. *Alberti's "De re Aedificatoris."* Ten Books on Architecture. London: Tiranti, 1955. Invaluable source book of the time.

Thompson, Daniel. *Cennino Cennini.* New York: Dover, 1954. Translation of Cennini's handbook for the craftsman-artist. Original document of the period.

Vasari, Giorgio. *The Lives of the Most Eminent Painters, Sculptors, and Architects.* New York: Simon and Schuster, 1959. Fascinating chronicle and source book of the day.

Wittkower, Rudolph. *Architectural Principles in the Age of Humanism.* 3d ed. London: Tiranti, 1962. Intriguing, scholarly exploration of harmonic ratios in music and architecture.

Chapter 12

Bazin, Germain. *Baroque and Rococo Art.* New York: Praeger, 1964. Good general text.

Kitson, Michael. *The Age of Baroque.* New York: McGraw-Hill, 1968. Survey text.

Friedlander, Walter, *The Age of Poussin.* New York: Abrams, 1964.

———. *Caravaggio Studies.* Princeton, N.J.: Princeton University Press, 1955. Both studies are perceptive views of significant Baroque painters.

Kubler, George, and Soris, Martin. *Baroque Art and Architecture in Spain and Latin America.* Baltimore, Md.: Penguin, 1959. Good regional study.

Millon, Henry. *Baroque and Rococo Architecture.* New York: Braziller, 1961. Clear introduction to the subject.

Portoghesi, Paolo. *The Rome of Borromini.* New York: Braziller, 1968. Brilliant study.

Rosenberg, Jakob. *Rembrandt.* Cambridge, Mass.: Harvard University Press, 1948. Insightful treatment.

Rosenberg, Jakob; Silve, Seymour; and Kuile, E. H. *Dutch Art and Architecture.* Baltimore, Md.: Penguin, 1966. Excellent regional study.

Wittkower, Rudolph. *Art and Architecture in Italy.* Baltimore, Md.: Penguin, 1958.

———. *Gian Lorenzo Bernini.* London: Phaidon, 1955. Penetrating specialized study of the exponent of Baroque sculpture and his age.

Wolfflin, Heinrich. *Principles of Art History.* 1932. Reprint. New York: Dover, n.d. Classic comparison of the Renaissance and the Baroque.

Chapter 13

Brion, Marcel. *Art of the Romantic Era.* New York: Praeger, 1966. Well-illustrated study.

Canaday, John. *Mainstreams of Modern Art.* New York: Holt, 1959. Fascinating personalized chronicle of the Romantic period through 1900.

Friedlander, Walter. *From David to Delacroix.* Cambridge, Mass.: Harvard University Press, 1952. Definitive text for the period.

Rewald, John. *The History of Impressionism.* New York: Museum of Modern Art, 1967.

———. *Post-Impressionism.* New York: Museum of Modern Art, 1962. Fundamental survey.

Reynolds, Sir Joshua. *Discourses on Art.* Edited by Robert Wark. San Marino, Calif.: Huntington Library, 1959. Founder of British Academy discusses his philosophy of art.

Chapter 14

Boas, Franz. *Primitive Art.* New York: Dover, 1955. Classic study of non-Western art; reissued and translated into English.

Dockstader, Frederick. *Indian Art in America.* 3d ed. Greenwich: N.Y. Graphic Society, 1968. Comprehensive approach to American Indian art.

Douglas, Frederick H., and D'Harnoncourt, Rene. *Indian Art of the United States.* New York: Museum of Modern Art, 1970. Introduction to Indian Art.

Drucker, Philip. *Indians of the Northwest Coast.* New York: McGraw-Hill, 1955. Interesting presentation of Indian art with much background material.

Fraser, Douglas. *Primitive Art.* New York: Doubleday, 1967. Incisive survey.

Inverarity, Robert B. *Art of the Northwest Coast Indians.* 2d ed. Berkeley and Los Angeles: University of California Press, 1967. Thorough treatment of the subject.

Lee, Sherman E. *A History of Far Eastern Art.* New York: Abrams, 1964. Excellent introductory survey of the scope of Oriental art.

Leuzinger, Elsy. *Art of Africa.* New York: Crown, 1967. Comprehensive introductory survey of African art; profusely illustrated.

Linton, Ralph, and Wingert, Paul S. 1946. Reprint. *Arts of the South Seas.* New York: Museum of Modern Art, 1972.

Rowland, Benjamin. *Art and Architecture of India.* Pelican History of Art series. Baltimore, Md.: Penguin, 1970.

Sickman, Laurence, and Soper, Alexander. *Art and Architecture of China.* Pelican History of Art series. Baltimore, Md.: Penguin, 1971.

Willett, Frank. *African Art.* New York: Praeger, 1971. Good coverage.

Wingert, Paul S. *Primitive Art.* New York: Oxford University Press, 1962. Pioneer scholar in African art surveys the field.

Chapter 15

Bayer, Herbert; Gropius, Walter; and Gropius, I. *Bauhaus, 1919–1928.* Boston: C. T. Branford, 1959. Written by founders of the Bauhaus; based on the Museum of Modern Art exhibition in 1938.

Blake, Peter. *The Master Builders.* New York: Knopf, 1960.

Crespelle, Jean Paul. *The Fauves.* Greenwich: N.Y. Graphic Society, 1962. Lucid text on the movement.

Rickey, George. *Constructivism: Origins and Evolution.* New York: Braziller, 1967. Innovator in kinetic art traces the development of the style.

Seltz, Peter. *German Expressionist Painting.* Berkeley and Los Angeles: University of California Press, 1959.

Seltz, Peter, and Constantine, M. *Art Nouveau and Design at the Turn of the Century.* New York: Museum of Modern Art, 1959. Surveys of the movements.

Chapter 16

Arp, Hans. *On My Way.* New York: Wittenborn, 1948. Sculptor-painter discusses his art of surreal imagery.

Barr, Alfred, Jr. *Fantastic Art.* New York: Arno, 1969. Museum of Modern Art curator discusses the art of dreams and the irrational world.

Hamilton, George H. *Painting and Sculpture in Europe 1880–1940.* Baltimore, Md.: Penguin, 1972. Covers Western modern art to World War II.

Janis, Sidney. *Abstract and Surrealist Art in America.* New York: Arno, 1944. Traces the abstract movement in the United States.

Kandinsky, Wassily. *Concerning the Spiritual in Art.* New York: Wittenborn, 1947. Pioneer abstractionist explores his philosophy.

Motherwell, Robert. *The Dada Painters and Poets.* New York: Wittenborn, 1951. Insights into the nonart movement and philosophy; essays and poetry.

Raymond, Marcel. *From Baudelaire to Surrealism.* London: Methuen, 1970. Commentary on the literature of the period.

Rubin, William. *Dada and Surrealist Art.* New York: Abrams, 1969.

Chapter 17

Arnason, H. H. *History of Modern Art.* Englewood Cliffs, N.J.: Prentice-Hall, 1969. Comprehensive survey to the present.

Brown, Milton. *American Painting from the Armory Show to the Depression.* Princeton, N.J.: Princeton University Press, 1970. Survey of realistic art.

Butcher, Margaret Just, and Locke, Alain. *The Negro in American Culture.* New York: Knopf, 1956. Ethnological background material.

Catlett, Elizabeth. "The Negro Artist in America." *American Contemporary Art,* April 1944. Seen from the perspective of a black artist.

Dover, Cedric. *American Negro Art.* Greenwich: N.Y. Graphic Society, 1969. Good survey; many illustrations.

Geldzahler, Henry. *American Painting in the Twentieth Century.* New York: Museum of Modern Art, 1965. Interesting survey of American painting.

Greenberg, Clement. *Art and Culture: Critical Essays.* Boston: Beacon, 1961. Fascinating philosophy of a leading contemporary art critic.

Haftmann, Werner. *Painting in the Twentieth Century.* 2 vols. New York: Praeger, 1961. Comprehensive overview.

Hughes, Langston, and Meltzer, Milton. *A Pictorial History of the Negro in America.* 3d ed. New York: Crown, 1972.

Janis, Sidney. *They Taught Themselves.* New York: Dial, 1942. Discusses Black self-taught artists. Well illustrated.

Locke, Alain. *The New Negro.* New York: Arno Press, 1968. Anthology of the period with illustrations by Aaron Douglas.

Chapter 18

Doesburg, Theo van. *Principles of Neo-Plastic Art.* Greenwich: N.Y. Graphic Society, 1968. Proponent of abstraction-nonobjective art discusses his philosophy.

Mondrian, Piet. *Plastic Art and Pure Plastic Art.* New York: Wittenborn, 1945. Leader of the de Stijl movement illuminates his theories.

Vasarely, Victor. *Vasarely.* Neuchâtel: Editions du Griffon, 1965. Study of Op art by a pioneer Op artist.

Many of the books recommended for earlier chapters apply here also.

Chapter 19

Fine, Elsa Honig. *The Afro-American Artist: A Search for Identity.* New York: Holt, 1973.

Gardner, Helen. *Art through the Ages.* 5th ed. New York: Harcourt, 1970. This text remains a favorite for students of art appreciation and art history.

Janson, Horst W. *History of Art.* New York: Abrams, 1969. The definitive text for art history students and an excellent foundation for the beginning student in art.

Knobler, Nathan. *The Visual Dialogue.* New York: Holt, 1971.

Kozloff, Max. *Renderings: Critical Essays on a Century of Modern Art.* New York: Simon and Shuster, Clarion, 1969. Essays on art and artists.

Read, Herbert. *Art and Alienation.* New York: Viking, 1969. The role of the artist in society.

Sandler, Irving. *The Triumph of American Painting.* New York: Praeger, 1973. Good accounts of individual movements.

Chapter 20

Blake, Peter. *God's Own Junkyard.* New York: Holt, 1964.

Halprin, Lawrence. *Cities.* New York: Reinhold, 1972.

Jacobs, Jane. *The Death and Life of American Cities.* New York: Random, 1961. A controversial view of city planning.

Mumford, Lewis. *The City in History.* New York: Harcourt, 1961. Comprehensive survey of cities throughout history.

Neutra, Richard. *Survival through Design.* New York: Oxford University Press, 1954.

Rudofsky, Bernard. *Streets for People.* Garden City, N.Y.: Doubleday, 1969.

Index of Names and Works

Note: An italic page number indicates that an
illustration appears on the page.

Index of Subjects